Animism Volume I

Edited by Anselm Franke

Sternberg Press

Contents

Preface

How does the conceptual distinction between "nature" and "culture," so typical of modernity, inform the perception of limits in artistic practice and visual culture? *Animism* interrogates two key processes in aesthetics—animation and conservation, movement and stasis—against the backdrop of the anthropological term "animism" and its historical implications. For what is mere fiction in modern aesthetics, for so-called "animist practices" is actual relations. What is commonly referred to as the most "fictional" of imaginary productions—the animated universes of film, the effect of the "life-like" in artistic objects and images, the creation of fantastic worlds in which objects are alive and things can speak—then assumes a sudden "documentary" value, by way of which the question of "relationality," which also played a significant role in recent art history, can assume a new qualitative dimension.

This project had begun to take shape in Antwerp in 2006. The ongoing discussions were extended to Bern, Vienna, and Berlin, the places of subsequent versions of the exhibition, one building upon the other. It is the result of a collaborative effort between artists, writers, curators, and institutions. It was shaped through other projects, exhibitions, and collaborations, and many have given us the opportunity to further discuss the issues at stake in artistic and academic contexts during the process of the development. We wish to thank all of those for the imprint they left on the project.

The present publication accompanies the exhibition in Antwerp and Bern. The publication does not document the exhibition, but rather translates it into the medium of a book. It seeks to lay a foundation from which further questions can be asked. It shifts between different registers and vocabularies, mainly, aesthetics and anthropology. The vast majority of the contributions have been conceived in response to the project, complemented by first-time translations of relevant texts.

We'd like to thank all artists, authors, organizers, and collaborators. We'd also like to thank Sternberg Press, the translators and copy editors, and the graphic design studio NODE Berlin Oslo.

–The Curatorial Team

Much Trouble in the Transportation of Souls, or: The Sudden Disorganization of Boundaries

Anselm Franke

For most people who are still familiar with the term "animism" and hear it in the context of an exhibition, the word may bring to mind images of fetishes, totems, representations of a spirit-populated nature, tribal art, pre-modern rituals, and savagery. These images have forever left their imprint on the term. The expectations they trigger, however, are not what this project concerns. *Animism* doesn't exhibit or discuss artifacts of cultural practices considered animist. Instead, it uses the term and its baggage as an optical device, a mirror in which the particular way modernity conceptualizes, implements, and transgresses boundaries can come into view.

The project interrogates the organization of these boundaries through images, attempting to fill the space of a particular imaginary and phantasy within the dominant aesthetic economy with a concurrent historical reality. It does so because an exhibition about animism that upholds a direct signifying relation to its subject is doubly impossible: Animism is a practice of relating to entities in the environment, and as such, these relations cannot be exhibited; they resist objectification. Putting artifacts in the place of the practice gives rise to a different problem: Whatever way an object may have been animated in its original context, it ceases to be so in the confines of a museum and exhibition framework by means of a dialectical reversal inscribed into these institutions, which de-animates animate entities and animates "dead" objects. Instead, this exhibition attempts to imagine what a quasi-anthropological museum of the modern boundary practices might look like. The exhibition sees animism as node, a knot that, when untied, will help unpack the "riddle of modernity" in new ways, helping us to understand modernity as a mode of classifying and mapping the world by means of partitions, by a series of "Great Divides."

The cultural particularity of modernity derives from the naturalization of these divisions and separations; that is, from their appearance as distinctions a priori—as if natural and outside history—which pervade all levels of symbolic production, with far-reaching effects on aesthetics and language. The positivism of the modern description of the world relies on the imagination of a negative, which is the result of the same divisions, and becomes equally naturalized. It was through the idea of animism that modernity conceived a good part of this negative, condensing that imagination in one term. Of particular importance for our project is to see this imaginary not merely as a fiction, but also a fiction made real.

Animism is a term coined by nineteenth-century social scientists, particularly the anthropologist Edward Tylor, who aimed to articulate a theory on the origins of religion, and found it in what was to him the

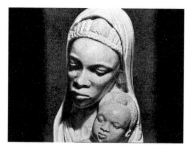

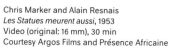

Chris Marker and Alain Resnais
Les Statues meurent aussi, 1953
Video (original: 16 mm), 30 min
Courtesy Argos Films and Présence Africaine

"When men die, they enter history. When statues die, they enter art. This botany of death is what we call culture." *Les Statues meurent aussi*, which was censored for more than a decade, was commissioned by the literary review and publishing house, Présence Africaine, which was set up in 1947 in Paris as a quarterly literary review for emerging and important African writers. Présence Africaine's publications signaled a new, post-colonial status for French and francophone thought, embracing the notion of *négritude*. *Les Statues meurent aussi* strives to connect the death of the statue with the rise in the commercialization of African art.

primordial mistake of primitive people who attributed life and person-like qualities to objects in their environment.[1] Tylor's theory was built on the widespread assumption of the time that primitive people were incapable of assessing the real value and properties of material objects. Animism was explained by its incapacity to distinguish between object and subject, reality and fiction, the inside and outside, which led to the projection of human qualities onto objects. The concept was inscribed into an evolutionary scheme from the primitive to the civilized, in which a few civilizations had evolved, while the rest of the world's people, described by Tylor as "tribes very low in the scale of humanity," had remained animist, thus effectively constituting "relics" of an archaic past. This evolutionary scheme would soon be taken up by psychology in its own terms, asserting that every human passes through an animist stage in childhood, which is characterized by the projection of its own interior world onto the outside.

The colonialist connotations of the term have led some to suggest that we abandon it once and for all. This has been necessary for a related term, the "primitive." But in animism, there is more at stake than in the modern discourse on its primitive other, although they overlapped at crucial points. The challenge in using the concept today is to maintain a perspective that does justice both to non-modern practices that animism presumably characterized, and to premises of modernity from which it originated. For this reason, one needs to bear the many dimensions of the term in mind and allow them enter into a constellation akin to a montage.

The first dimension is the animism of the anthropologists of the nineteenth century, like Tylor; the "old" animism of modernity, a category in which Western imagination and phantasy, politics, economy, ideology, scientific assumptions, and subjectivities fuse. Between this

1 Edward Tylor, *Primitive Culture*, 2 vols., (London: John Murray, 1871).

"old" animism and the cultural practices that it sought to describe and classify, we find a gap marked by colonial subjugation, appropriation, and misrecognition. The practices at stake are ones that need to be understood independently of their description by anthropologists, although the two have, of course, become historically entangled. There is also a "new animism," which proclaims to have come closer to the realities of the cultures in question, which seeks to take "animist" cultural practices seriously (and often struggles to come to terms with the enduring assumptions underlying the old), considering forms of relational knowledge, and, above all, *practices* different from those predominant in modernity. This distinction between "old" animism and "new" animism, between the animism Western anthropologists conceptualized and what they referred to, is mirrored in the relation of so-called indigenous societies to the term: While many resent the use of the term for its colonial connotations and accusations of savagery, it is also increasingly utilized in political struggles of indigenous groups within the political structures inherited from colonial modernity.[2]

And on yet another register, there is the animism *within* modernity's image culture, as an aesthetic economy, and a way of imagining, which gives expression to collective desires and articulates commonsensical schemes, determining the possibilities of recognizing other subjectivities, and how life processes can be conceptualized. On this plane, it is important to distinguish between an economy of images that is a symptomatic reaction to the effects of modernity, a compensatory displacement and transgression of the boundaries and fragmentation modernity inflicts, and the critical reflection of those very borders in art. As this distinction can never be absolute, it must remain in question and permanently renewed. Throughout the book and the exhibition it accompanies, these different dimensions are put under scrutiny.

For the moderns, animism is a focal point where all differences are conflated. This conflation makes for the negativity of animism, which therefore breeds powerful images and anxieties: the absorption of differ-

2 Notably the frequent indigenous uprisings in Ecuador since 1990, which evolve around struggles for the legalization of land holdings, and in which animism is posited as a social and political alternative to neoliberal economic reforms.

At the center of Harun Farocki's video *Transmission* is the touching of stone, as he makes portraits of monuments all over the world with which people interact in performative exchanges of sorts and with different purposes, from the Vietnam Memorial in Washington to the Devil's Footprint in the Frauenkirche in Frankfurt. In *Ein Tag im Leben des Endverbrauchers*, Farocki constructs the twenty-four hours of a day of an average consumer through German advertising films.

Harun Farocki
Transmission, 2009
Video, 43 min
Courtesy the artist

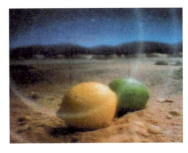

Ein Tag im Leben der Endverbraucher, 1993
Video, 44 min
Courtesy the artist

ences is a womb-phantasy endowed with horrific as well as redemptive qualities, strong enough, however, to yield ever-new separations, ever new Great Divides. For the so-called animists, however, animism has nothing to do with the conflation of differences, but with their negotiation in ways that, more recently, have also become of increasing importance for the former moderns. For the moderns, the animation of things

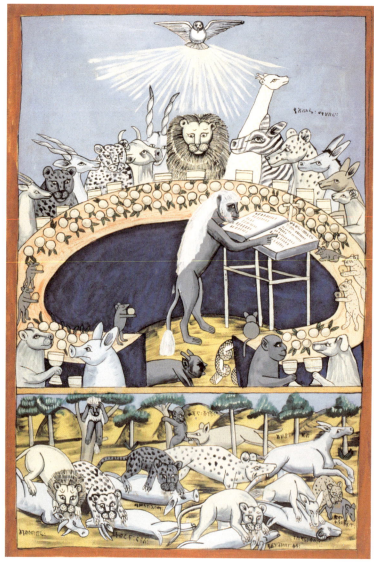

African Judaism and Christianity were enriched by writings not included in the Hebrew bible, such as *The Book of Jubilees*. *The Book of Jubilees*, also known as *The Little Genesis*, is thought of having been composed some time between 175 and 140 BCE, and it is preserved in the Ethiopian language Ge'ez, which is still the liturgical language of the Ethiopian Orthodox Church. From *The Book of Jubilees* we learn that before the Fall, animals were able communicate with each other in a "common tongue." It was only on their expulsion from the Garden of Eden that the mouths of cattle and birds and of "everything that walks or moves, were shut." The picture by an anonymous Ethiopian painter invokes a tradition of church-trained artists who follow and actualize century-old conventions to this date. The line that separates the communion of animals in the upper half of the picture from the lower half inevitably also calls forth speculations and associations about the mythical origins of the modern divide between culture and nature, between the communion mediated by social contracts and the "state of nature" in which every creature, in its struggle for survival, is ultimately at war with others.

Anonymous (geographical origin: Adis Abeba, Ethiopia)
Assembly of the animals, 1965–1975
Oil on linen
Courtesy the Tropenmuseum, Amsterdam

destroyed the subject, and only by the destruction of animism, and of animated things, can the free subject of modernity be constituted.

What Makes Modernity Modern?

What does it mean to be modern? A categorical distinction between nature and society, social scientists generally assume. Only they differentiate between facts, the universal laws of nature and matter, and cultural symbolic meanings or social relations. The knowledge of the indisputable, universal truths of nature is acquired through objectification, by distinguishing what is inherent to the object from what

Tom Nicholson's *Monument for the Flooding of Royal Park* is a work about colonial Australian history, telling the story of the expedition by the infamous explorers Burke and Wills who started in Melbourne in 1860 to cross the interior of the continent for the first time. Until today, the numerous monuments that were erected for these two men continue to physically impose themselves in public space. *Monument for the Flooding of Royal Park* is a proposal for an imaginary monument referring to a part of the history that is usually left untold—the death of the two explorers through their misuse of a particular plant, nardoo, a desert fern prepared as food by Aboriginals. Burke and Wills failed to add an essential step in the preparation of nardoo that would gradually lead to their death. The proposed monument consists of the temporary flooding, and subsequent growing of nardoo in Royal Park in the center of Melbourne creating a red field of nardoo plants.

Tom Nicholson
Monument for the flooding of Royal Park, 2009
Inkjet prints
Courtesy the artist and Anna Schwartz Gallery, Melbourne

3 Bruno Latour, *We Have Never Been Modern,* trans. Catherine Porter (Cambridge, MA: Harvard University Press, 1993), 99–100.

belongs to the knowing subject and has been projected onto the object. What is not objectified remains unreal and abstract. Only what can be objectified has a right to be called "real"; everything else enters the realm of "culture," the subject's interior, or "mere" image, representation, passion, fiction, fancy, fantasy. It is this dissociation of the subjective from the realm of nature and things that simultaneously constitutes the self-possessing subject, liberated from the chains of superstition, phantasy, and ignorance. The very act of division, the gesture of separation, produces at once an objectified nature composed of absolute facts and a free, detached subject: the modern, Cartesian self. Modernity is modern insofar as the destruction of superstition and its embodiments (exemplary in the figure of the fetish) resulted in the establishment of a triumphal world of indisputable facts brought to light by the power of reason applied in the sciences. As long as objects were endowed and animated by social representations and subjective projections, they annihilate the subject; only the destruction of those ignorant ties emancipates the subject and raises it to the status of the "free" modern self.

In his several books that engage with the modern divide between nature and culture, Bruno Latour describes the historical scenarios that can serve as a backdrop scenography to our understanding of the role of animism in the constitution of modernity. The bifurcation of nature and culture, and the subsequent purification of each domain (by way of objectification), Latour asserts, make moderns "see double." Every modern must take sides, and perceive the world either from the side of the object (where everything is fact), or of the subject (were everything is "made," constructed), either from nature with its determinate, indisputable, and eternal laws (to which science provides access), or from the society of social agents who can construct their world freely (in politics and culture); but each perspective sees the two domains of nature and culture as absolutely separate, from mutually exclusive points of view that one can not occupy at the same time without falling "back" into animism and an archaic past. The modern idea of animism must appear then as a necessary result springing from the separation between nature and culture, as a category that allowed the moderns to name those who did not make the same distinction, those who assigned social roles to non-human things, and as a category that made them imagine the collapse of the boundaries they had installed.

> *For Them, Nature and Society, signs and things, are virtually co-extensive. For Us they should never be. Even though we might still recognize in our own societies some fuzzy areas in madness, children, animals, popular culture and women's bodies (Donna Haraway), we believe our duty is to extirpate ourselves from those horrible mixtures.*[3]

It is this extirpation, the ongoing separation and "purification" of the two domains of subjects and objects, that characterizes the process and progress of modernization as such, which received its canonical formulation by the thinkers of the Enlightenment and the positivist, rationalist sciences. "[The] Enlightenment's program was the disenchantment of the world. It wanted to dispel myths, to overthrow phantasy with knowledge," write Adorno and Horkheimer in *Dialectics of Enlight-*

enment. They continue: "The disenchantment of the world means the extirpation of animism." The price paid by the moderns for cutting off their social ties to nature was that this nature, together with its social representations, lost its meaning; what they gained was the belief in the universality of their knowledge, and, above all, the freedom to manipulate and mobilize nature in ways unthinkable in pre-modern contexts.

Anne-Mie Van Kerckhoven
Stranger than Life, 2009–2010
Video, 3 min
Courtesy the artist and Zeno X Gallery, Antwerp

Anne-Mie Van Kerckhoven has been working with the image-space situated right under the surface of the representations of women in mass media, structured by the relation between sex and technology. Her imagery explores layers of deep memory that bear the force to collectivize private interiority. She investigates the dynamic forces of language, and the politics in the aesthetics of ecstasy and the obscene.

The moderns, Latour tells us, are literally homeless as they live in a contradictory world composed of a "unifying but senseless nature," while on the other, they experience a multiplicity of cultural representations "no longer entitled to rule objective reality."

> *The world had been unified, and there remained only the task of convincing a few last recalcitrant people who resisted modernization—and if this failed, well, the leftovers could always be stored among those "values" to be respected, such as cultural diversity, tradition, inner religious feelings, madness, etc. In other words, the leftovers would be gathered in a museum or a reserve or a hospital and then be turned into more or less collective forms of subjectivity. Their conservation did not threaten the unity of nature since they would never be able to return to make a claim for their objectivity and request a place in the only real world under the only real sun.[4]*

4 Bruno Latour, *War of the Worlds: What about Peace?*, trans. Charlotte Bigg (Chicago: Prickly Paradigm Press, 2002), 9.

The Great Divides

The Great Divide is what separates modern and premodern societies, positing civilization on one side of the abyss, and the primitive and archaic on the other.

> *In order to understand the Great Divide between Us and Them we have to go back to that other Great Divide between humans and nonhumans [...]. In effect, the first is the exportation of the second.[5]*

5 Bruno Latour, *We Have Never Been Modern*, 97.

That the internal (nature/culture) and the external (modern/pre-modern) Great Divide were mirroring each other would also mean that they were upheld by largely the same techniques: The people who found themselves on the other side of the external Great Divide would be subject to the same protocols of objectification as a nature rendered objec-

tive in the laboratory. The resulting quest for symmetry is what gave birth to modern anthropology, which had to qualify itself within the ruling milieu of the rationalist, positivistic sciences. Tylor's conception of animism therefore was firmly based in an objectivist rationalism: Since the people and culture in question did not make the same categorical distinction between nature and culture, since they treated objects as if they possessed the capacity for perception, communication, and agency, Tylor could conceive of animism as a "belief," as an epistemological error, and could locate his primitive "origin" of religion there. Nonetheless, there needed to be a supplement, since the cultures in question were still human, which meant they could not be objectified in similar ways to objects of nature. Since Western ontology itself and its dualism were far from being in question at this point, however, the cultures on the other side of the Great Divide had to be inscribed into an evolutionary scheme; they had to become "pre-modern." Thus, Tylor located his animists among the "lower races," and "savages." But this evolutionary scheme was not his invention; the "backwardness" of non-modern cultures had been a common conception as early as the sixteenth century in the context of the emergence of Western modernity and mercantilist capitalism. All that Tylor did was clothe it in a scientific narrative. Animism was thus progressively inscribed in a set of imaginary oppositions that enforced and legitimized Western imperial modernity, constituting a spatial-geographic "outside," and a primitive, evolutionary "past."

Animism, much like the category of the "primitive," was thus not so much a description of a social order of a past archaic or present primitive form of culture, but an expression of the need and desire to find them. The modern conception of animism says much less about those it presumably described objectively, than about modernity and the distinctions that upheld its cosmography. Animism and the primitive were much sought for mirrors, by means of which modernity could affirm itself in the image of alterity. In the heyday of European colonialism, the invention of a non-existent unity of the animist primitive along an imaginary historical arrow of progress constituted a key to legitimizing the actual subjugation of the colonized as much as it was necessary to provide the moderns with an image that could confirm their identity. It mattered little whether the denigration was reversed and instead idealized as a "paradisic state of nature" (which can switch at any moment into the state of nature as the brutal struggle for survival beyond any social contracts), as compensation for the evils of modernity, or liberation from the constraints of civilization.

The Space of Death and the Theater of Negativity

As much as that image of animist primitives and their savagery unified the "rest" on the modern's side of the Great Divide, it inflicted terror on those locked inside of it. Imaginary appropriation licensed real subjugation; the objectivist "tyranny of the signifier" that had enthroned enlightened reason would enact the savagery it had imputed to its Others. The flipside of the disenchanted, static, enlightened realm of objective facts is equally imaginary, that darkness as of yet untouched by the light of reason. The regime of positivist signification sees its opposite in

Many of Klaus Weber's works are reflections on the nodes between bodily perception (nature) and states of mind (culture), for which he frequently turns to the borders between human and vegetative and animal life. He explores bio-chemical aspects of social life and subverts normative perceptions as well as understandings of art by transferring them into the registers of other-than-human forms of life, and inscribes them into systems of intoxication. *Double Cactus* is a piece consisting of two San Pedro (*Trichocereus pachanoi*) plants, which contain mescaline, grafted together at the top end, thus reversing the very direction of grows. Mescaline was first synthesized in 1919, and is best known through the Peyote cactus, which was used in ancient Mexico and is a vital part of the ceremonies of today's Native American Church.

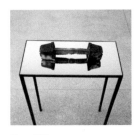

Klaus Weber
Double Cactus, 2006
2 grafted San Pedro cactuses,
blued iron, mirror
Courtesy the artist

"wildness," just as the bifurcation of nature and culture finds its negation in animism. The result, in both cases, is the creation of a space of negativity. "Wildness challenges the unity of the symbol, the transcendent totalization binding the image to that which it represents. Wildness pries open this unity and in its place creates slippage. [...] Wildness is the death space of signification,"[6] writes anthropologist Michael Taussig:

> *This space of death has a long and rich culture. It is where the social imagination has populated its metamorphizing images of evil and the underworld: in the Western tradition Homer, Virgil, the Bible, Dante, Hieronymos Bosch, the Inquisition, Rimbaud, Conrad's heart of darkness; in northwest Amazonian tradition, zones of vision, communication between terrestrial and supernatural beings, putrification, death, rebirth, and genesis, perhaps in the rivers and land of maternal milk bathed eternally in the subtle green light of coca leaves. With European conquest and colonization, these spaces of death blend into a common pool of key signifiers binding the transforming culture of the conquerer with that of the conquered. But the signifiers are strategically out of joint with what they signify. "If confusion is the sign of the times," wrote Artaud, "I see at the root of this confusion a rupture between things and words, between things and the ideas and signs that are their representation."[7]*

In his seminal study of the rubber boom in the Putuyamo region in Amazonas, Taussig describes how, through the arrival of the colonial regime and capitalist exploitation, this imaginary death space was systematically turned into a reality. It is this passage from the imaginary to reality, the process through which images turn into operational maps by means of which we understand, rule and ultimately, create a world that this project, in seeking to explore the imaginary and the historicity of animism, must focus on.

In the death space created at the modern colonial frontier, the imagery (the social representations and the connections they uphold with the world) of the destroyed society and its cosmography fuses with the imagery of the conquering world, creating restless hybrids through which, in discontinuity, continuity and memory are preserved.

The imagery brought to the colonial space of death by the Europeans has its own distinct European genealogy. The extirpation of animisms in the colonial world was preceded by the extirpation of animisms within the West: The imagination of the death space has been shaped by the struggle for Christianization, by images of martyrdom and the experiences of the witch hunt and the Inquisition, which produced a "theater of negativity", in which the European imaginary of evil was born. This theater would find ceaseless continuitation in the Enlightenment and secular modernity, in the progressive exorcisms of all states of mind that resisted the Christian, and later, the modern discontinuity between humans and nature.

Within Europe, the division of the modern cosmography into an imaginary black and white, night and light, was enacted as a progressive frontier. The boundary of the modern world generated an imagery at its internal margins correlative to the colonial death space, but yet articulated in more familiar morphologies of the "night of the world" –

6 Michael Taussig, *Shamanism, Colonialism, and the Wild Man: A Study in Terror and Healing* (Chicago: University Of Chicago Press, 1987), 219.

7 Michael Taussig, *Shamanism, Colonialism, and the Wild Man*, 10.

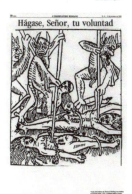

León Ferrari
L'Osservatore Romano,
2001 – 2007
Collages on paper
Courtesy the artist

These works on paper consist of pages from the Vatican daily *Osservatore Romano* featuring articles on modern life and morality overlaid with old images of the Apocalypse, the Last Judgment and the Expulsion from Eden as well as engravings of the Inquisition. The horrors of hell interpreted by the Old Masters become here the illustration of ecclesiastical news. Ferrari's collages refer to the historical role of Christian institutions in the colonizing of the Americas and the continuity of terror in later forms of suppression such as the military dictatorships.

8 Michel Foucault, *History of Madness* trans. Jonathan Murphy and Jean Khalfa (London: Routledge, 2006), xxix.

what much later would become the "unconscious". This space is populated by dismembered bodies, by fragmentation, scenarios of disintegration, and the like, providing a monstrous mirror to objectification, discipline, mechanistic fragmentation, and political terror. The unreal, delirious, diabolic night of darkness created by the empire of enlightened reason, however, was always also a space of transformation and transgressive fantasies, as Taussig describes in the work mentioned above; a space of heightened, even delirious animations and sensuous, mimetic ecstasies. Both aspects shaped the imaginary that would later find its conceptual expression in the concept of animism.

The Modern Boundary Replicated

The logic of the Great Divide would find another correlate in the exemplary institution of modernity, the asylum and psychiatry, and the fantasy of animism as the conflation of the modern distinctions would once again be a key accusation that sustained the power of the institutional machine. Michel Foucault wrote a history of this Great Divide, separating the normal from the pathological, reason from unreason in modernity. There are, in his exposé in the *History of Madness*, several clues to the working of the modern boundary regime. He attempts to write the history of madness starting from the point *not* of the later imaginary of indifference, but where madness and reason were still unseparated, where the experience of madness was not yet differentiated, not yet marked by a boundary that cut it off. He attempts to return to the gesture of partition, the caesura that creates the distance between reason and unreason in the first place, the original grip by which reason confined unreason in order to wrest its secrets, its truth, away from it.

> *We could write a history of limits—of those obscure gestures, necessarily forgotten as soon as they are accomplished, through which a culture rejects something which for it will be the exterior; and throughout its history, this hollowed out void, this white space by means of which it isolates itself, identifies it as clearly as its values. For these values are received, and maintained in the continuity of history; but in the region of which we could speak, it makes its essential choices, operating the division which gives a culture the face of its positivity.[8]*

What is most relevant in Foucault's description for the present context is that there arises in it an explanation how the logic of partition creates the space of silence of an exchange being brought to a halt, that is being filled by the monological discourses and institutions congruent to the division; he asserts that these discourses and institutions are indeed the result of the primary partition, spanning and administering the very abyss that made them possible. The partition lines of the Great Divides, it seems, must be replicated on different scales without which their management and overall organization would not hold together: They must run through the interior of each subject, through the body, the family, the nation, through modern culture at large, and finally, through humankind. This replication on various scales helps us see more clearly that none of the scissions remain absolutely static; indeed, they must be

MENSAJE «URBI ET ORBI» DEL SANTO PADRE JUAN PABLO II EN LA SOLEMNIDAD DE LA NAVIDAD, 25 DE DICIEMBRE DE 2000

Cristo ha venido a traernos la paz

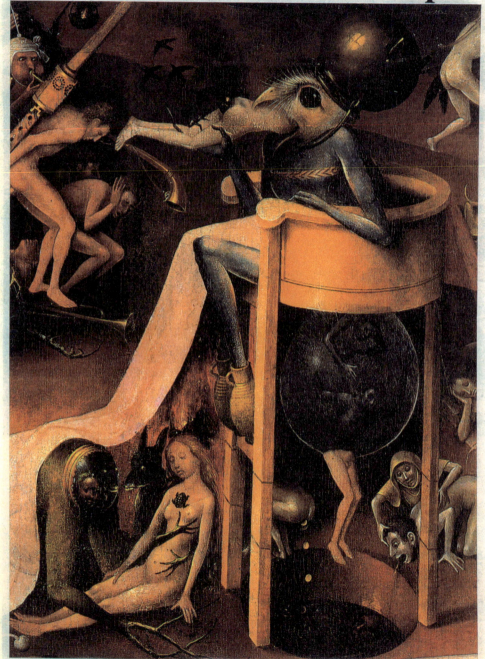

"El Infierno", postigo derecho del tríptico
"El Jardín de las Delicias", detalle, El Bosco

Pío XII: el martirio del silencio

Sólo poniéndose en el plano de la fe se puede valorar correctamente su actuación

Emilia Paola PACELLI

«Tace aut loquere meliora silentio»: «Calla o di algo que sea mejor que el silencio», reza una famosa consigna: estas parecen ser las palabras más ricas, las más densas de sabiduría, más aun, de Sabiduría, con S mayúscula, que vienen inmediatamente a la mente cuando se reflexiona, con ánimo recto y juicio objetivo, sobre el llamado «silencio» —o, si se quiere, «silencios»— que algunos, como es sabido, imputan a Pío XII.

Y no por azar queremos referirnos aquí a la Sabiduría: porque es imposible valorar correctamente y encuadrar en su justa perspectiva la actuación y el magisterio del Papa Pacelli sin poner en el plano de la fe, es decir, sin tener en cuenta un dato imprescindible: esa soberana visión teológica de la Iglesia, de la historia y del mundo que, orientando desde dentro las directrices de su pontificado, constituye su entramado sólido, unitario, presentando al mismo tiempo la clave para una exacta lectura y comprensión. Visión teológica, como explica el cardenal Siri, «que es esencial para alcanzar de modo objetivo el máximo de verdad y, por tanto, de luz en el camino a seguir», «visión de fe, llevada a las últimas y justas consecuencias, (...) iluminada por la presencia de Dios-» y que —conviene subrayar—, precisamente por ser auténtica, no es absolutamente sinónimo de leja-

do en la ascesis más rigurosa para neutralizar la tentación de un «gesto clamoroso y teatral», que ciertamente daría satisfacción, pero de efectos catastróficos por sus costes humanos, para rechazar, es decir —como se expresó mons. Valerian Meystowicz—, «el camino del aplauso» y elegir «muy sabiamente... el camino del deber».

Pero hay situaciones particulares en la historia de los hombres en las que las condenas públicas o las vehementes invectivas de los profetas, mucho más fáciles y gratificantes frente a sí mismos y frente al mundo, lejos de ser de alguna utilidad o ayuda, más bien resultan completamente perjudiciales, en cuanto causa potencial de indecibles sufrimientos para muchos seres humanos y, por tanto, inexcusables ante Dios.

testimonio que dio de Pío XII, en mayo de 1964, el siervo de Dios don Pirro Scavizzi, y nuevamente publicado por el padre Rotondi el 1 de junio de 1986.

Al volver a Roma del frente ruso por segunda vez, en 1942, con el tren hospital en el que trabajaba como capellán de la Orden de Malta, visitó al Papa para informarle del éxito de la misión de ayuda a los perseguidos, realizada secretamente por encargo del mismo Pontífice, y sobre los horrores nazis en Austria, Alemania, Polonia y Ucrania. Don Scavizzi declara textualmente lo siguiente:

«El Papa, de pie junto a mí, me escuchaba emocionado y conmovido; alzó las manos al cielo y me dijo: "Diga a todos, a todos los que pueda, que el Papa agoniza por ellos y con ellos. Dígales que muchas veces he pensado en fulminar con la excomunión el nazismo, en denunciar ante el mundo civil la bestialidad del exterminio de los judíos. Hemos escuchado amenazas gravísimas de represalias no contra Nuestra persona, sino contra los pobres hijos que se encuentran bajo el dominio nazi. Por diversos trámites, nos han llegado encarecidas recomendaciones para que la Santa Sede no tome una actitud drástica. Después de muchas lágrimas y muchas oraciones, he llegado a la conclusión de que una protesta de mi parte no sólo no habría ayudado a nadie, sino que habría suscitado las iras más fe-

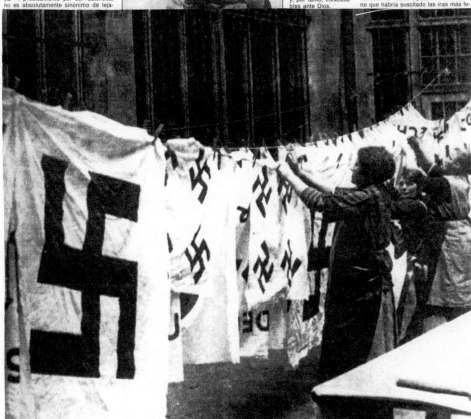

Svásticas nazis al sol, 1935,
fotografía del archivo Hulton Getty.

León Ferrari
L'Osservatore Romano, 2001–2007
Collages on paper
Courtesy the artist

negotiated and replicated permanently. Finally, their logic becomes implicit within the cognitive mapping of the world ("an obscure gesture," which constitutes the positive and negative, the social implicit and the explicit), and in order to describe them without operating within their registers, one must return to the point before the scission, before the de-coupling of elements such as body and mind, subject and object, humans and nonhumans, reason and unreason in order to think their entanglement and unity. In this lies the potential significance of animism beyond its symptomatic, pathologized articulation as a transgressive phantasy where differences conflate. For there are, in the practices referred to as animist, indeed relations that constitute experiences of difference not marked by the proliferating Great Divides.

Foucault's history of the separation that gave rise to the modern institution of psychiatry also entails an aspect relevant to the question of relationality and difference. The relation established by the modern discourses to the absolute differences they postulate is monological: psychiatry speaks *about* madness, not *with* madness. Madness is objectified; what the psychiatrist speaks is the language of objective facts, which can no longer account for subjective experiences. Indeed, key symptoms of modern pathologies are a response to such objectification, which is experienced as the threat of petrification and immobilization.

The boundaries of all Great Divides stir not only scientific interest, but are populated by anxieties in the form of images, figures, the threat of mimetic infections, in which the order of rationality is always put at risk, and defended by an extension of its rule. The modern subject, in its laboratory situations deprived of dialogic relatedness, becomes armored in defense of its unity, and this defense is symptomatically displaced into the border-imagery. The anxiety about the border itself is what defines the morphology and symbolic economy of its images— and these images become templates for the inscription of otherness. The threat of machinic dismemberment is displaced into the anxiety of the body given over to the fluid and fragmentary, and to emergent relational subjectivities, against which the subject builds up an "armor of anaesthetization" (Susan Buck-Morss) that upholds its unity in a reiterated gesture of defense. These "Others" are the symptomatic articulation of the rationalist boundaries; they encompass in the interior the so-called unconscious, the sensuous, emotional, and sexual, and in the exterior, the racial other, the subaltern.

Whelped in the Great Divides, the principal Others to Man, including his "posts," are well documented in ontological breeding registries in both past and present Western cultures: gods, machines, animals, monsters, creepy crawlies, women, servants and slaves, and noncitizens in general. Outside of the security checkpoint of bright reason, outside the apparatuses of reproduction of the sacred image of the same, these "others" have a remarkable capacity to induce panic in the centers of power and self-certainty. Terrors are regularly expressed in hyperphilias and hyperphobias, and examples of this are no richer than in the panics roused by the Great Divide between animals (lapdogs) and machines (laptops) in the early twenty-first century C.E. Technophilias and technophobias vie with organophilias and organophobias, and taking sides is not left to chance.[9]

León Ferrari
L'Osservatore Romano, 2001 – 2007
Collages on paper
Courtesy the artist

9 Donna Haraway, *When Species Meet* (Minneapolis: University of Minnesota Press, 2008), 10.

Jan Švankmajer is internationally known for his animation films, among the best-known are his version of Lewis Caroll's *Alice's Adventures in Wonderland* from 1988. Švankmajer's surreal, Kafkaesque, nightmarish and yet humorous journeys into the unconscious are populated by things and hybrid figures that lead uncanny lives of their own. In parallel to his filmmaking, Švankmajer has always produced artworks and objects, ranging from drawing and collage, to sculptures, ceramics and tactile objects, which equally inhabit the borderlines of familiar physiognomic worlds.

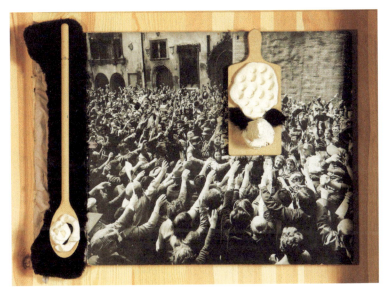

Jan Švankmajer
The Power of a Request, 1990
Mixed media
Courtesy Athanor – Film Production Company, Llc

Life

The backdrop against which to understand the nineteenth-century conception of animism is ultimately the partition of life from non-life, and its many offsprings and differentiations. The distinction between life and non-life is perhaps the most fundamental one in modernity, explicitly as well as implicitly qualifying its notions of objectivity and the laws of nature, the divisions between subjects and objects, material and immaterial, human and non-human. It is, at the same time, the most unstable of divisions, having an instability that finds its expression in bioethical debates, technophobias, and the gothic imaginary and unique importance the experience of the "uncanny" holds in modern aesthetics as a borderline condition in which the inanimate turns out as animate and vice versa; and which, in Freud's canonical interpretation, has consequently been explained as a "return" of animistic convictions.

l'étrange

> *For anyone undertaking a genealogical study of the concept of "life" in our culture, one of the first and most instructive observations to be made is that the concept never gets defined as such. And yet, this thing that remains indeterminate gets articulated and divided time and again, through a series of caesurae and oppositions that invest it with a decisive strategic function in domains as apparently distant as philosophy, theology, politics, and –only later– medicine and biology. That is to say, everything happens as if, in our culture, life were what cannot be defined, yet, precisely for this reason, must be ceaselessly articulated and divided.[10]*

> *In our culture, man has always been thought of as the articulation and conjunction of a body and a soul, of a living thing and a* logos,

10 Giorgio Agamben, *The Open: Man and Animal* trans. Kevin Attell (Stanford: Stanford University Press, 2004), 13.

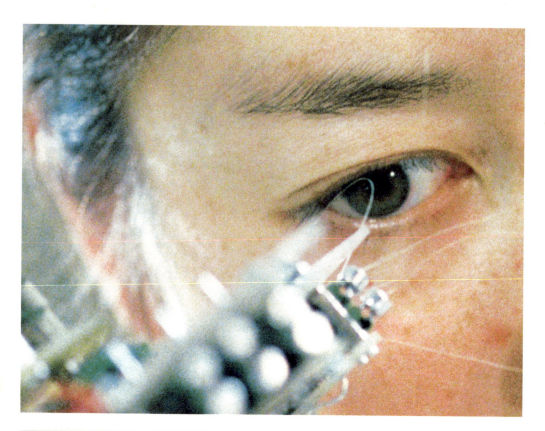

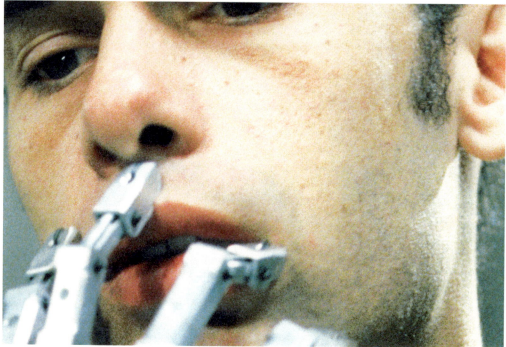

Daria Martin
Soft Materials, 2004
16 mm film, 10 min 30 sec
Courtesy Maureen Paley, London

Soft Materials by Daria Martin shows an encounter between machines and humans. This film work was shot in the Artificial Intelligence Lab at the University of Zurich where scientists research "embodied artificial intelligence." What looks like an extraordinary choreography is a laboratory process through which the robots acquire new functions by interacting with human bodies. The woman and the men in the laboratory are highly trained in movement and body awareness. These performers shed skins of soft fabric, bearing their joints like the frank structure of a machine, and then, naked, they perform a series of dances with the robots. Creating intimate relationships that are in turn tender, funny and eerie, they bend flexible human fantasy around tough materials. The film provokes speculative responses around the notorious question of "man and machine," the animate and the inanimate, blurring traditional borders between technological and human media through seductive and unexpected sensual and mimetic interactions.

11 Giorgio Agamben, *The Open: Man and Animal*, 16.

12 William McDougall, *Body and Mind: A History and A Defense of Animism*, (M.B. Methuen, 1911), 3.

of a natural (or animal) element and a supernatural or social or divine element. We must learn instead to think of man as what results from the incongruity of these two elements, and investigate not the metaphysical mystery of conjunction, but rather the practical and political mystery of separation. What is man, if he is always the place -and, at the same time, the result - of ceaseless divisions and caesurae? It is more urgent to work on these divisions, to ask in what way - within man - has man been separated from non-man, and the animal from the human, than it is to take positions on the great issues, on so-called human rights and values.[11]

The segmentations of life have a common background in what has dominated European Christian debates for centuries: the question over the character and composition of the soul (in Latin, *anima*, from which the word animism is derived), which was seen variously as an entity distinct from the body or as its animating principle, or both at the same time. Radically simplifying the quarrels over the nature of souls, what is tantamount to the milieu of rationalist positivism in the nineteenth century was its gradual disappearance from center stage in an evolving modernity. The soul could not be objectified since it had no apparent material reality that conformed to its latest metaphysical designs. When the anatomists during the Enlightenment opened up the body, there was no evidence of it. The soul could not be objectified, and thus it retracted into the realm of the subjective interior, and was secularized in the notion of the psyche and self. As a consequence, the very definition of "life" was put at stake—for the "hard" sciences, life had to be explained without making reference to an immaterial force (which the vitalists were still defending through concepts such as the *élan vital*), it had to be explained through mechanical, biochemical processes and their inherent laws alone. It is against this background of (often vulgar) materialism that one must understand the characterization of animist relations to matter and "objects" as a "belief" and an epistemological "mistake" that had no objective claim to reality, disregarding the experiential dimensions of those relations and the questions they may pose.

But to describe the primitive ghost-soul as either matter or spirit is misleading; if these terms are to be applied to it, we must describe it as a material spirit. This is, of course, a contradiction in terms, which we can resolve by recognizing that the peoples who believe in the ghost-soul have not achieved the comparatively modern distinction between material and immaterial or spiritual existents.[12]

Images, Media, and the Return of the Repressed

Nineteenth-century rationalist science frequently referred to the soul as an image:

It is a thin, unsubstantial human image, in its nature a sort of vapour, film or shadow; the cause of life and thought in the individual it animates; independently possessing the personal consciousness and volition of its corporeal owner, past or present;

capable of leaving the body far behind, to flash swiftly from place to place; mostly impalpable and invisible, yet also manifesting physical power, and especially appearing to men waking or asleep as a phantasm separate from the body of which it bears the likeness; continuing to exist and appear to men after the death of that body; able to enter into, possess and act in the bodies of other men, of animals, and even things.[13]

13 Edward Tylor, *Primitive Culture*, vol. 1, 429.

This is a description that, with minor alterations, would be applicable in almost all its features to the photographic and cinematographic image. Though substantial, the photographic image, too, moves through time and space, appears as a phantasma bearing likeness, continues to exist after death, and has a certain physical and mediumistic power to "possess" other bodies, as any observation of a crowd in a cinema suffices to show. Is there a relation, and if so, of what kind, between the Great Divides and modern technological media? Is there a relation between the "disenchantment" of the world, the retraction of the soul to subjective interiority, and the objectivist stance? The canonical accounts of the industrialized, rationalized modern world frequently come to that conclusion. Is there, however, a connection, or even a similar process happening to images, regarding their status in modernity, and their technologies?

According to Bruno Latour, the division of nature and culture, and the subsequent purification of the two domains of subjects on the one side, and things on the other, is only possible by a repression of the middle ground, the mediation that connects subjects with objects in multiple forms. "Everything happens in the middle, everything passes between the two, everything happens by way of mediation, translation and networks, but this space does not exist, it has no place. It is unthinkable, the unconscious of the moderns."[14] Objectification, that is, the purification of the domains of subjects and things, of life and non-life, is made possible by suppressing mediation, symbolic meanings, and images: the moderns "had in common a hatred of intermediaries and a desire for an immediate world, emptied of its mediators."[15] Latour accounts for these mediators and their networks in his ethnography of science, tracing the tools, technologies, and chains of reference that create new associations between humans and things borne from modernity's laboratories. Latour's mediators are always *graphs*— modes of inscription that make things talk, and through which a reference can be mobilized.

14 Bruno Latour, *We Have Never Been Modern*, 37.

15 Bruno Latour, *We Have Never Been Modern*, 143

There is another, more general aspect, however, to the realm of mediation and associations. Images—in all their aggregate conditions, as sign, work of art, inscription, or picture that acts as a mediation to access something else; as social representations, symbols, *schemes*; from their role in cognition, the sensuous body and mimetic exchange, to the image as an object that, as a mediator, acquires an agency of its own— are what any relation presupposes, since we have no direct access to the world. Images, whether merely mental or materialized, are, by definition, boundaries: conjunction and disjunction at the same time, creation of a difference, and creation of a relation. They organize, uphold, cross, transgress, affirm, or undermine boundaries. The particularity of the Great Divides, however, makes the image in modernity the subject of a particular economy, of a split, a schizophrenic regime. For the im-

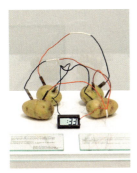

Victor Grippo
Tiempo, 1991
Potatoes, zinc and copper electrodes, electric wires, digital clock, painted wooden base, glass vitrine and text
Courtesy Alexander and Bonin, New York

Victor Grippo was a major figure in Argentinian art in the second half of the twentieth century, a period characterized by the military dictatorship and poverty. Grippo's work instilled a political resonance in domestic items such as tables, and he maintained an alchemical interest in workaday materials and natural objects. Among the materials he frequently worked with were potatoes. "The potato-battery related to the generative energy of a native foodstuff that became the staple food of the poor the world over, in a certain sense the constitutive matter of the world."

16 Bruno Latour and Peter Weibel, eds., *ICONOCLASH: Beyond the Image Wars in Science, Religion and Art* (Cambridge, Massachusetts: MIT, 2002), 16.

17 Michael Taussig, *Defacement: Public Secrecy and the Labor of the Negative* (Stanford: Stanford University Press, 1999), 43.

age in modernity is never allowed to embody the function of a mediator per se, organizing both processes of subjectification and objectification in ever-fragile constellations.

Images, too, must take sides: as neutral windows adequately representing the objective world (by way of divine or machinic inscription producing an uncontaminated mimetic accuracy that reduces the deceptive to a minimum), or as mere subjective representations, with no claim to an objective world; that is, in the last instance, as an animistic mirror of sorts, a projection of interiority onto the outer world, reduced to the picture plane. The status of photography provides perfect evidence of this ever-shifting status: Either the photograph is seen as a merely machinic product, over which consequently no right of authorship can be claimed (as was the case in the early days of photography), or it is seen as the expression of a subject (as made constitutive at a later stage). The machine in this instance either records the world neutrally, objectively, or it is the willful instrument of a subject's intention, although surely such division can only be maintained conceptually, never in practice. In each case, the turning point, the infrastructure of a complex chain of mediations, is blended out.

We are digging for the origin of an absolute—not a relative—distinction between truth and falsity, between a pure world, absolutely emptied of human-made intermediaries and a disgusting world composed of impure but fascinating human-made mediators.[16]

The schizophrenia derived from the repression of mediation in its own right finds its ultimate articulation in iconoclasm and anti-fetishism, two distinctively modern stances to which Latour has also devoted significant work. It is in these figures that the link between the fate of the soul and the fate of the image under the rule of objectivism are linked: that is, when images are endowed with souls.

On the level of pictures, the fetish is the embodiment par excellence of a forbidden hybridity, of the "horrible mixture" outlined above. It represents what for modernity is an impossibility, at least conceptually: a fact that is also constructed, made. The fetish is the figure of an image-object subjectively made and falsely endowed with an objective reality, an agency, a subjectivity and life of its own. In order for it to be real, no human hand is allowed to have touched it. The desire for an unmediated, non-relational access to nature and truth calls for the destruction of false images. In the face of the fetishistic power of imagery, the moderns shift between an omnipotence and impotence that replicates their relation to nature: either "they make everything," or "everything is made and they can do nothing" (Latour). The destruction of the accused images breeds only ever-new imagery; and worse, in the last instance, it is only in the act of destruction that the image gains the power of which it is being accused. The "very act of critique often adds to the power of the critiqued."[17] In modernity, there is always either too much or too little to an image. Either they are nothing or everything. Worse, in their strong belief in the power of the fetish, so much so that it demands destruction, the moderns turn into fetishists of a higher order: The fetishist knows well that fetishes are made-up, constructed, relational, and mediated. The urge of the enlightened

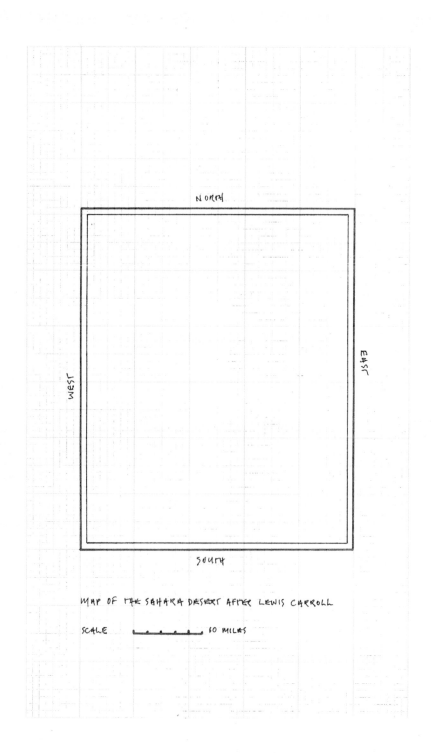

Art & Language
Map of the Sahara Desert after Lewis Carroll, 1967
Ink on graph paper
Courtesy the artist and Lisson Gallery, London
Private Collection, Nantes

The work by Art & Language refers to Lewis Carroll's perhaps best-known poem, *The Hunting of the Snark*, which evolves around an empty map of an ocean. In *Map of the Sahara Desert after Lewis Carroll* (1967), Art & Language transform Carroll's map of the ocean into a map of a desert—a map, that is, with the exception of cardinal points and scale, empty, thus creating a short-circuit between the internal and external sign-relations. And as much as the systematizing demonstration of the coordination among sign-relations leaves us in permanent oscillation between its various registers, the iconoclastic emptiness of *Map of the Sahara Desert after Lewis Carroll* breeds new images, inevitably inviting the imagination to populate a blank territory.

18 Theodor Adorno and Max Horkheimer, *Dialectic of Enlightenment*, trans. Edmund Jephcott (Stanford: Stanford University Press, 2002), 5.

19 Theodor Adorno and Max Horkheimer, *Dialectic of Enlightenment*, 6.

anti-fetishist to destroy the fetish re-institutes a paradoxical belief. The facticity and rationality that inhabits the world in which fetishism has been destroyed is replaced by a new fetish, ever more powerful than the previous one: objectivity, a form of knowing that is absolute and non-relational, bracketed off from history and social context. Inscribing these facts once again into the historicity of knowing and science, Latour brings the fetishistic "heart of darkness," which Europeans had so successfully placed in their imaginary of the Other, back home again. "But the myths which fell victim to the Enlightenment were themselves its product."[18]

In modern technologies of mimetic reproduction, the borderline condition of all modern imagery finds its ultimate technological expression. The destruction of images and the repression of mediators not only produces the paradoxical reversal where the power of images is proliferated in the act of their destruction, but also yields unprecedented desires for the production of new images, in which the experiential dimension of modernity is expressed, confirmed, and overcome. The technological media are themselves the product not merely of a technological advance, but of these desires that are the direct outcome of the logic of the divides. Modern imagery—as with any set of images—constitutes a meridian point of simultaneous association and dissociation in which objectification and subjectification blend, although this blending happens only in constellatory flashes, preparing a rescission, which re-inscribes them on either side of the divides. This meridian point is a political battlefield; it holds both dystopian and utopian potential. It is a site of constant dialectical reversals, of intense unrest, nervousness, and anxiety. The image becomes at once the very site of the "horrible mixture" and its decomposition.

The key to understanding the knot at the meridian point of modern imagery is the experiential dimension of modernity. Industrialization and rationalization produced a segmentation and fragmentation of the senses, mirroring the effect of the "disenchantment" that objectification and modern iconoclasm had on our perception of the world. The band that holds time and space together breaks, and with it, symbolic unity, resulting in a generalized condition of social disembeddedness. Alienation is the concept that describes the experience of the modern objectified world and the splitting of that experience into isolated categories such as agency, object and observer, self and nonself. Social alienation is the price of modernity, as well as being the precondition and symptom of modern power relations:

> *Human beings purchase the increase in their power with the estrangement from that over which it is exerted. Enlightenment stands in the same relationship to things as the dictator to human beings. He knows them to the extent that he can manipulate them.*[19]

> *Not only is domination paid for with the estrangement of human beings from the dominated objects, but the relationships of human beings, including the relationship of humans to themselves, have themselves been bewitched by the objectification of the mind. Individuals shrink to the nodal points of conventional reactions and the modes of operations objectively expected of*

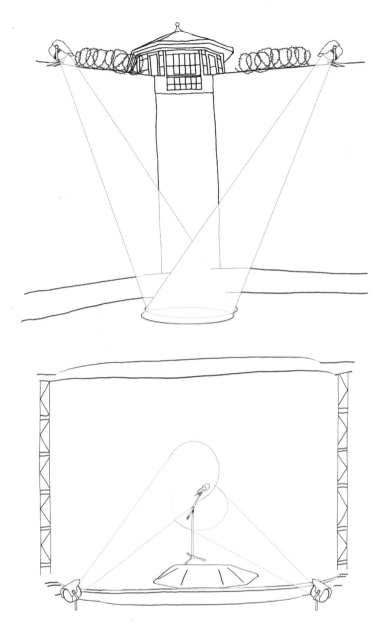

What are the techniques of isolation? [...] a common denominator of those techniques was the visualisation of the object. [...] So any method of creating an image of someone or something [...] begins with pointing a spotlight at the object. It becomes brighter than its surroundings, more detailed, easier to observe. [...] you can exchange the spotlight in vice/virtue with a camera, or a microscope but the mechanism stays the same. [...] I found a photo of a prison yard. It was lying upside down. The spotlight was pointing at the sky and first I thought the image depicted a stage. Then I turned it 180 degrees and found it was a prison. [...] I used the photo as a blueprint for the drawing. For the animation I choose a centrifugal spin, as it's a common scientific method of isolating cells from each other. [...] the presentation involves a video beam with which the drawing is projected onto the paper. It utilizes the technique of the light-beam as is used in the prison yard and on stage. The artwork is part of the very same system that it's criticizing.
– Natascha Sadr Haghighian

Natascha Sadr Haghighian
vice/virtue, 2001
Digital video projection, 1 min 5 sec
Courtesy Johann König, Berlin

them. Animism had endowed things with souls; industrialism makes souls into things.[20]

Unification through objectification takes the form of extinction coupled with conservation. Extinction because the conceptual denial of otherness inscribed real others into the continuum of objects, and if the destructive force thus unleashed did not result in direct or indirect genocides, it nevertheless destroyed the subjectivities (and cosmographies)

20 Theodor Adorno and Max Horkheimer, *Dialectic of Enlightenment*, 21.

in question (if not once and for all). The simultaneous conservation in institutions of modern knowledge, such as museums, archives, and exhibitions, did not run counter to this destruction; it merely gave it an adequate expression, through which the power of inscription could become manifest.

Life and Death on Display

This is where an exhibition about animism must begin. It must use the concept of animism as the mirror of modernity that it was from the outset, while at the same time disempower the relations that the powerful imaginary of the term upheld. The projection and exportation of animism onto the imagined Heart of Darkness out there, at the other side of the Great Divides, must be reversed, and similar to the concept of fetishism, animism must be "brought back home." The economy of the imaginary of the Great Divides must become visible *in the* modern imaginary, so that the relations enforced by the foreclosing of relations can come to the fore. And insofar as the position of animism in the geography of the Great Divides links the question of life and non-life with that of the object and the subject, it must focus on the dialectics of objectification (mummification, petrification, reification, and so forth) and animation in modern imagery.

A powerful, if somewhat sentimental root-image situating the dispositifs of objectification within which such a dialectics unfolds is the butterfly—symbol of the psyche, of life undergoing metamorphosis. In order for the butterfly to become an object within a static taxonomy, and for it to enter the material base of such taxonomy; that is, the archive, exhibition, and so forth, it must be conserved. Its fixation requires mummification, and it is "installed" at its place within the grid of the taxonomy (the modern cosmography) by the needle that pins it to the display. The needle is a figure for the act of objectifying signification. If this requires actual killing, there are also various forms

Wesley Meuris' series of designed cages for animals are derived from the artist's engagement with zoological classifications, taxonomies and systems of knowledge. As architectural propositions, they turn these meditations on scientific classification into a question of relationality: What is the mode of knowing we have about the object on display, and what creates the spectatorial enjoyment of seeing animals in captivity? Since the cages are empty, however, the scene of such reflection is transferred to the imagination: We have to give shape to the animal in question in our minds, using the enclosed architectural habitat as an inversed script that gives shape to a life-form, thus engaging in a form of spectatorial empathy that displays like these normally foreclose.

Wesley Meuris
Cage for Pelodiscus sinensis, 2005
wood, glass-tiles, glass, water, lighting and ventilation
Public collection, Alcobendas, Madrid

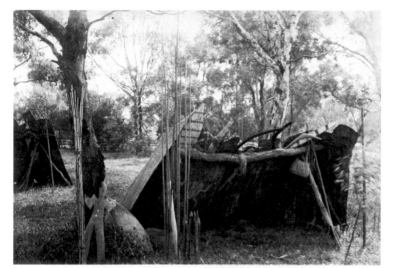

The piece *Drawings and Correspondence* by Tom Nicholson evolves around a particular drawing and its history. The drawing is found on photographs taken of an ethnographic display at the Melbourne Zoo in the 1880s, inside a mia mia. It is supposedly an authentic native work. The research into the micro-history of the drawing and its shifting symbolic meanings open a panorama of Australian colonial history and the dispositifs that uphold its continuity.

Tom Nicholson
Drawings and Correspondence, 2009
Charcoal drawings and off-set printed artist's book, excerpt
Courtesy the artist and Anna Schwartz Gallery, Melbourne

of "social death," which leave biological life intact while depriving the subject/object in question of the *Umwelt* (Jakob von Uexküll) that constitutes its life, of the web that constitutes its being in relationality. This is the objectification of life we find in the ethnographic displays during the era of the grand world fairs, and such are the enclosures of the zoo. They are displays of objectification because they enclose and isolate—yet another phenotype of the disciplinary institutions and enclosures described by Michel Foucault as the engines of modern power—and because they foreclose the possibility of dialogic relationships, and deliver the object on display to consumption and spectacle clothed in educational terms.

The entire discipline of anthropology, it has been claimed, is implicated in an objectification in which extinction (cultures doomed to

21 Edward Curtis, *The North American Indian*, Introduction, 1907

22 For further elaboration on the myth of the camera stealing the soul, see The Museum of the Stealing of Souls, http://stealingsouls.org/.

23 See Bruno Latour, Peter Weibel eds., *ICONOCLASH*.

24 Roland Barthes, *Camera Lucida: Reflections on Photography*, trans. Richard Howard (New York: Hill and Wang, 1981), 13–14.

25 Jacques Derrida, *Specters of Marx, the State of the Debt, the Work of Mourning, & the New International*, trans. Peggy Kamuf, (London: Routledge, 1994), 6.

In *Mother Dao, the Turtle-like*, the viewer sees how the colonial machinery was implanted in the Dutch West Indies between 1912 and about 1932. More than 260,000 meters of 35mm documentary nitrate film footage from the Dutch film archives served as Monnikendam's source material. The documentary starts with a shortened version of the legend of the inhabitants of Nias, an isle to the West of Sumatra. It was told that the earth was created by Mother Dao, who "collected the dirt off her body and kneaded it on her knee into a ball. This was the world. Later, she became pregnant, without a man, and gave birth to a boy and a girl. They were the first people. They lived in a fertile world." Much of the footage used

disappear as civilization and modern progress inevitably progress) and conservation are merely the flipsides of one and the same coin, creating what Paul Ricoeur has envisioned as an "imaginary museum" of mankind. The intimacy of extinction and documentary inscription and conservation characterizes ethnographic film as well as photography—as famously illustrated by the case of photographer Edward Curtis and his pictures of North American native cultures, which he thought were at the brink of extinction, a "vanishing race." "The information that is to be gathered [...] respecting the mode of life of one of the great races of mankind, must be collected at once or the opportunity will be lost."[21] The pictures themselves express the borderline, simultaneously reaching out and upholding it—the border between "us" and "them," and between an imagined past, a present mastered by modernity, and a future that holds no more place for "them." The pictures become, in an uncanny sense, the borders themselves.

Curtis's pictures have frequently been invoked in debates over the myth of the camera stealing the soul.[22] This myth, ascribed to natives world-wide, once again links image with soul, and is an expression of the modern belief in the continuity, as well as the rupture, between magic and technology—an instance, once more, of the modern "belief in belief," a blindness to the world-producing power of relational practices, which already structures the "fetishism" discourse.[23]

On another, general register, the connection between photography and death, the "uncanny" status of photography in that it transcends the boundaries of time and space, absence and presence, life and non-life, has been subject to intense debates that need no reiteration in detail here. Earlier, I noted that modern technological images are themselves a meridian point of sorts in regards to the separation of object and subject, a transgression or even dissolution of that very division; and that, nevertheless, this dissolution upholds, confirms, and re-does the scission, having to dissolve the tension in the direction of either pole. However, the technological image cannot be wholly "subjectified." It is not, and cannot be, neutral with respect to the two poles of the subject and object, life and non-life, since it is itself the inscription of an objectification. Roland Barthes gives an account of this when he says:

> In terms of image-repertoire, the Photograph (the one I intend) represents that very subtle moment when, to tell the truth, I am neither subject nor object but a subject who feels he is becoming an object: I then experience a micro-version of death (of parenthesis): I am truly becoming a specter.[24]

Of specters, we know that they are halfway between life and death, disembodied souls roaming the sphere of the living, bound to return. They are alive only in relation to the deprivation of life, having been withdrawn from the status of a subject across various registers—a "thing," as Derrida invoked with Hamlet,[25] but a thing that is real only in the Lacanian sense. Specters inhabit the space of death, the space of negativity, of the un-cohered, thus being denied entry into a circle that binds together a community of the living, and dissociates it from its outsides.

Museums and photography, as two examples of modern dispositifs of the conservation of "life," are haunted, afflicted by the specters

of objectification, by the return of animism, which here takes the form of the "uncanny" return of a repressed life turned into a spectacle. This "hauntedness" is a key to the ways in which media and institutions built the modern social imaginary—in circumscribed confines, giving way to the desires to overcome alienation, the desires for the re-animation of a de-animated, de-mobilized world, thus re-populating the deadened, disenchanted, objectified world with its monstrous images of hybrids and phantasies of returns and speed-deliriums. And in so doing, ever-actualizing the imaginary of animism as the Heart of Darkness, ripe with anxieties and fears of regression, which demand ever-more re-assuring objectifications and enclosures: No photographic image without its spectral quality, and no museum in which one is not invited to contemplate the skeleton of a dinosaur coming back to life.

The node in which objectification—the fixation, conservation, and mummification of life—meets the transgressive desires for re-animation, re-creation, mobilization, and transformation, however, finds its ultimate technological expression in film, and what André Bazin has famously referred to as its "mummy complex." The "mummy complex," it is often assumed, refers to a universal of art: the desire to provide a defense against the passing of time, and, ultimately, death. The symbolic victory over death is supposedly a "basic psychological need in man."[26] However, we should not be too quick to agree, and instead, should return to the question of psychology and art at a later point.

It is cinema, however, that gives ultimate expression to "the great Frankensteinian dream of the nineteenth century: the recreation of life, the symbolic triumph over death."[27] In the cinematic synthesization of movement creating an illusion of life, the negative returns animated, redeemed in phantasmagoric and symptomatic form: images, souls, states of mediality. Having lost the right for a claim to reality, they assume the form of hybrids between life and non-life, fiction and reality. Cinema, from its outset, is populated by zombies, Frankensteins and man-machine hybrids, and mummies deserting their graves. Every coming-alive of the dead—or, in other terms, every re-subjectification of a "dead" object—however, is a confirmation of the "proper" boundary that keeps them firmly apart: The Frankensteinian dream does not undo the subject-object dichotomy; rather, it qualifies it. It is the symptom of a bourgeois hegemonic perspective that has internalized the logic of the divide and turns the tension, the antagonism between *rigor mortis* and phantasmagoric animation into an aesthetic economy endlessly reiterated. The Frankensteinian dream is congruous to the structure of the commodity, and rather then overcoming its paradigms, it channels the anxieties it produces by providing a phantasmagoric displacement of relations that have previously been displaced.

Art occupies a special position within the modern geography marked by the Great Divides. It shares many of the characteristics of the status of images described above, but midway between subject and object, it is dissolved into the direction of the fictional, imaginary, and subjective, where it fuels hopes for re-instituting the sovereignty of experience. The modern institution of art acquires its relative autonomy thus; for the price of being rendered politically inconsequential, its effects must remain in the realm of interiority and the imagination. Much of the history of modern art can be aligned with a contestation of that very boundary drawn around its legitimate place—the over-

to be shown in the Netherlands as an illustration of the beneficial effect of the Dutch presence in the East Indies. Monnikendam lifts the original travelogue and colonial documentary out of its original context, showing the extent of the capitalist exploitation of the native's bodies, and reversing the relations inscribed in these images.

Vincent Monnikendam
Mother Dao, the Turtlelike, 1995
Film transferred to video,
87 min 36 sec
Courtesy the artist

26 André Bazin, *What is Cinema?* vol. 1, trans. Hugh Gray (Berkeley and Los Angeles, California: University of California Press, 1967), 9.

27 Noël Burch, *Life to Those Shadows* (Berkeley and Los Angeles, California: University of California Press, 1990), 12.

Louise Lawler's *All Those Eyes* shows the brightly lit Jeff Koons sculpture of Michael Jackson with his chimp Bubbles, and the Pink Panther in the foreground. From another photograph of the same scene but taken from a different angle, we realize the setting is not a museum hall, but a private storage room. If the viewer assumes a subject, it is that of the collector, whose relation and proximity to objects contends with the "value" invoked by the authorship of the work. Lawler leads us into a mirror cabinet not merely of gazes, but also of what Karl Marx has famously referred to as the phantasmatic "fetish" character of the commodity, the capitalist animation of things.

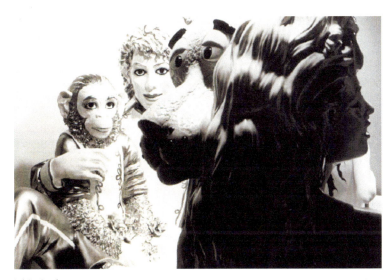

Louise Lawler
All Those Eyes, 1989
Gelatin silver print,
Courtesy of the artist and Metro Pictures

coming of the stigma of the fictional (leading to yet another genealogy in line with the Frankensteinian dream, the dream of total representation and a "cosmic, fourth dimension," represented by the quest for the Gesamtkunstwerk, the synaesthetic total work of art), and the crossing of the boundary between art and life. This is the point of origin from which the numerous contestations of modern dichotomies in the modernist project stem, and to date, always return.

There is a magic circle being drawn around the institution of art that renders it exceptional while inscribing it into the logic of separation. Objects of art always magically confirm their status as art. It can thus be explained how Sigmund Freud arrived at the conclusion that in art, modernity preserved a place for animism, for in art, we have retained an animistic relation to pictures and objects alike. The regression to "earlier states" (historically and subjectively) and the conflation of differences between fiction and reality, the self and the world; all this becomes possible as long as it is institutionally framed and cannot make claims to objective reality, in which case it would likely be rendered pathological, but at least cease to be "art" in the modern sense of the word—the form of art that, according to Adorno, was made possible by the secularization of the Enlightenment. What would elsewhere appear as outright regression can serve cultural advancement within these institutional confines, under the condition that it is bracketed off from everything else.

Insofar as aesthetic resistance to social rationalization (cultural modernity versus social modernity) takes the form of a dialectics, its attack on the latter remains bound to its own myths. This can be confirmed by a most schematic survey of the role animism plays in the modernist imaginary: a reconciliatory and transformative force in the face of alienation, a phantastic horizon for a better, utopian, animated modernity. From the Romantics to the Russian Avant-Garde, from Primitivist Modernism via the Surrealists to Psychedelia, animism frequently appears on a (troubled) quasi-mystical horizon in which it was

inscribed by the modernist myths, variously as a displaced key or a transgressive phantasy, an engine that fuels the imaginary of a liberation, of an "outside" to modern enclosures and identities. But the animism in question remains the phantasy of otherness, a romantic antidote; and if one border is transgressed or even undone in a stroke, others are erected or fortified in the very same act.

Insofar as aesthetic resistance in the modernist predicament was modeled on an opposition to the objectifying, partitioning stance of modernity, it remained difficult for the adversaries to act outside the modernist myths. When the Surrealists staged their anti-colonial exhibition "La Verité sur les colonies" in 1931, to show that Europeans had fetishes too, they succeeded less in bringing the Heart of Darkness home, than in continuing to enhance the myth of "childish," regressive "relics," working towards a conflation of the Other by way of an alleged "unconscious." The institutions capable of exhibiting the fetish of the moderns have yet to be invented. Symmetry between modernity and its Others is never possible so long as one stays within the former's dialectical confines. The resolutely anti-modern, as Latour asserts, only confirm the modern's own myths dialectically: They indeed believe that the moderns have rationalized and disenchanted the world, that it is, in fact, populated by soulless zombies.

Paul Sharits
Transcription, 1990
Felt pen on paper
Courtesy private collection and
M HKA, Antwerp

In 1981 Paul Sharits sent to Josef Robakowski the sheet of a film score, suggesting him to use it to shoot a film. Eventually, the film was made in 2004, in memory of the American structuralist with whom Robakowski collaborated at the end of the 1970s. Sharits based its structure upon close synchronicity between musical and visual layers. During the screening subsequent tones of Frederic Chopin's Mazurka op. 68 nr. 4 are accompanied on the screen by eight corresponding colors.

Paul Chan
Untitled (after St. Caravaggio), 2003–2006
Digital video projection, 2 min 58 sec
Courtesy Greene Naftali, New York

In his video work *Untitled (After St. Caravaggio)*, Paul Chan refers to the genre of the still life, denying the *nature morte* of stillness and immobility by exploding the composition as the figs and their leaves, the grapes, and, finally, the basket itself levitate into air.

Poet and painter Henri Michaux experimented with drawing under the influence of various psychoactive substances, above all mescaline. He asserted that the effect of the drug was "so wholly visual that they are vehicles of the purely mental, of the abstract," further explaining that "mescaline diminishes the imagination. It castrates, desensualizes the image. It makes images that are 100 percent pure. Laboratory experiments."

Although Michaux asserted that the experience of mescaline "eludes form," that "it cannot be seen," he agreed to collaborate on a film commissioned in 1963 by the Swiss pharmaceutical company Sandoz (best known for synthesizing LSD in 1938) in order to demonstrate the hallucinogenic effects of mescaline. It is the only venture in film by Michaux. In charge of the filmic translation of Michaux's prescriptions was director Eric Duvivier whose other films include an adaptation of Max Ernst's collage novel *La femme 100 têtes*.

Henri Michaux and Eric Duvivier
Images du monde visionnaire, 1963
Video, 38 min
Courtesy the artists and Novartis AG

The photographs from Bialowieza Forest depict a location that through history has been greatly infused with myths and metaphors. The forest dates back to 8000 BCE and is the only remaining example of the original lowland forest that once covered much of Europe. Situated in Eastern Poland it contains a great diversity of plants, animals and insects, as well as thousands of species of fungi and vascular plants, many of these elsewhere extinct. Over the years the forest has been described in literature and travel accounts as a sylvan Arcadia, an asylum, a pristine Eden, a sacred grove and a dark and alien impenetrable wilderness. This work can be seen as a continuation of Joachim Koester's practice in which an imaginary site is paradoxically investigated through its material reality.

Joachim Koester
Bialowieza Forest, 2001
Laminated photographs
Courtesy Musée des Arts Contemporains de la
Communauté française de Belgique, Grand-Hornu

They take on the courageous task of saving what can be saved: souls, minds, emotions, interpersonal relations, the symbolic dimension, human warmth, local specificities, hermeneutics, that margins and the peripheries. "[28]

28 Bruno Latour, *We Have Never Been Modern*, 123.

Tony Conrad
Egypt 2000, 1986
Digital video projection, 13 min
Courtesy Galerie Daniel
Buchholz, Cologne

The First Intermediate Period, around 2000 BC, was the occasion for a remarkable constellation of innovations in Egyptian thought and civil order. For the first time both men and women won rights of private ownership, of marriage, and of entry to the afterlife (with a proper burial). Remarkably, individuals began reflecting in writing on the world around them, and the first introspective literature appeared. Egypt 2000 invokes this mixed space of gender, identity, and death, from which it literalizes the visual seduction of the viewer.
– Tony Conrad

29 Sigmund Freud, *Totem and Taboo*, trans. James Srachey (London: Routledge and Kegan Paul, 1950), 64.

Art and Psychology

All social representations, insofar as they bear a mythical structure, are to be explained by psychology. In canonical art history, the question of animism and the boundary between life and non-life is therefore discussed under the parameters of psychological universals. Art, it is understood, derives from the need to resist time and triumph over death. The desire to bring time to a standstill, to conserve and fix, is as much at the root of art, as is the desire to animate, to re-create life, to gain access to the forces of creation. These psychological universals are inextricably linked to motion and stasis, and their negotiation and dynamics in works of art. This scenography is populated by mythical figures, captured, for instance, in the animating gaze of sculptors Pygmalion and Daedalus, on the one hand, and the chthonic monster Medusa, whose gaze petrified life, on the other. Anthropomorphic projection and visualization, objects that appear to "return one's gaze," works of art that assume a subjectivity of sorts, or instances of "the uncanny" in which something inanimate seems to "come back" to life, are all perfectly familiar cases that do not present a real challenge to the discipline of art history as long as the primary boundary between reality and fiction is upheld. The question of "life" poses itself as "mere" symbolic production, always in terms of the "life-like," and has consequences not for the "real" world, but for the reality of the subjectivity of perception and its "primitive roots," for which Freud gave the canonical description in relation to animism when he asserted:

The projection outwards of internal perceptions is a primitive mechanism, to which, for instance, our sense perceptions are subject and which therefore normally plays a very large part in determining the form taken by our external world. Under conditions whose nature has not been sufficiently established, internal perceptions of emotional and intellective processes can be projected outwards in the same way as sense projections; they are thus employed for building up the external world, through they should by rights remain part of the internal world. [...][O]wing to the projection outwards of internal perceptions, primitive men arrived at a picture of the external world which we, with our intensified conscious perception, have now to translate back into psychology.[29]

Any journey into the animist universe of the unconscious must therefore remain a confirmation of this split between the real and the unreal, as long as the unconscious remains unconscious, as long as its existence is assumed as a fact, rather than as a production resulting from a particular boundary-regime. The anti-psychological stance within modernist art history has struggled with this logic as long and insofar as it remained tied to gestures of transgression. The paradigm of psychology as laid out by Freud led to another symptomatic genealogy—that of ecstasy. Once again, it is inextricably linked to the imaginary of animism (in this book, the question of ecstasy, animism, and aesthetics is discussed in an exemplary way through Sergei Eisenstein's analysis of the art of Walt Disney). In states of ecstasy and intoxication, the very boundary that separates the self from the world is undone, and interiority is exteriorized. The trip is a figure of transgression in which

re-mobilization, re-animation, re-enchantment and metamorphosis are brought about by an unleashing of the boundaries that confine the subjectivity of perception, providing an immediate experience of the world-making power of images, transforming a mute world into dia-logic excess. This "dialogue" temporarily unleashes experiences of me-diality, in which subject and object appear as mutually constitutive and keep changing sites. The ecstatic undoing of the boundaries of the sub-ject through intoxication, extreme physical states, eroticism, or spir-itual ecstasies represents a major resource for modernist art.

There is, however, a different trajectory, perhaps more fruitful for a re-evaluation of animism; one that is less caught up in the logic of the symptomatic and compensatory transgression, and the dialectical con-firmation of the modern's own myths. This different trajectory makes clear that the modernist cultural response to the objectifying stance derives from a similar set of configurations. An influential part of the modernist iconography is directly derived from the rationalization of the movements of the living body, and the objectifying "inscription of life." This link is discussed in the frame of situating modern animation in the present book by the exhibition's co-curator Edwin Carels. The physiological motion studies of Étienne Jules-Marey and Eadweard Muybridge gave expression to the experiential dimension of the mod-ern fragmentation of time and space. Such "expression," however, was not their primary aim; instead, their target was a rationalization of the economy of the working body to achieve increased efficiency in pro-duction—these "inscriptions of life" served as the blueprint for Tay-lorism, the theory of management that analyzes and synthesizes work-flows. Not merely the decomposition of the visual field characteristic of modernist iconography, cinema also passed through this applied sci-ence that would have the most profound impact on the body and the human sensorium.

Technology at the Meridian Point

It was Walter Benjamin who conceived of these two registers of mo-dernity together, for Taylorism and the related emergence of a variety of physiological and psychological tests placed technology at a me-ridian point in which subject and object were no longer separated, but subjected to management, giving rise to new forms of subjectivi-ties. Benjamin maintained a perspective that saw more than merely a dystopian dimension in these configurations that linked subjectivity and technology. He proclaimed the necessity of inversing the Taylor-system, and changing it from a system of optimizing subordination to the machine into one of creative invention: If a subject was tested for its specific aptitudes that found no application within the given sys-tem, these applications and professions would have to be invented. His thinking of technology in relation to the subject bears the charac-teristics of a profane form of ecstasy; it rejects the psychological essen-tialism attached to the critique of modern technology from the outset. And, indeed, the physiological and psychological tests were a blue-print for thinking the animation of subjects through their actualization by means of technological inscriptions. Nor has the question of their creative use, in times where the paradigm of the test has been univer-

Felix-Louis Regnault was a physician who applied chronophotography to study culture specific human loco-motion and produced what is widely recognized as the first "ethnographic foot-age" at the Paris Exposition Ethnographique de l'Afrique Occidentale in 1895. He at-tempted to create a scientific index of race, suggesting in 1900 that all museums collect "moving artifacts" of human behavior to study and exhibit. *All savage people make re-course to gesture to express themselves; their language is so poor that it does not suf-fice to make them understood [...]. With primitive man, ges-ture precedes speech [...]. The gestures the savages make are in general the same every-where, because these move-ments are natural reflexes rather than conventions like language.*

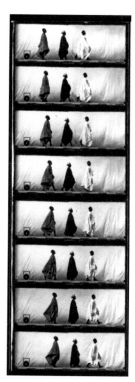

Félix-Louis Regnault
Hommes nègres, marche, un-dated, Duplicate on flexible transparent film
Courtesy Cinémathèque Française, Paris

Poet and painter Brion Gysin, the inventor of the Cut-up technique and a major source of inspiration for the Beat generation, was a life-long promoter of the Sufi trance master musicians, to whom he was was introduced by Moroccan painter Mohamed Hamri. Gysin and Hamrin opened the restaurant *The 1001 Nights* in Tangier (which closed 1958), where the musicians would regularly perform.

Brion Gysin
Untitled (Man in the desert), undated
Chinese ink, felt pen and watercolor on paper
Courtesy Galerie de France, Paris

salized in the form of digitized profiling, lost any of its actuality since. This is a form of technologically aided animation through subjectification, which presents a different paradigm from the compensatory, symptomatic one of the Frankensteinian dream and aesthetic economy of animation it gave rise to.

"In the cinema, people whom nothing moves or touches any longer learn to cry again." In his work on technology and the cinema, Walter Benjamin conceived of a possible emancipatory potential of the mass media, envisioning a process inverse to the inscriptions of Marey: from image/technology to physiological motion and experience. Benjamin insisted that technology has to be transformed from a means of mastering nature into a medium for "mastering the interplay between human beings and nature." "The expropriation of the human senses that culminates in imperialist warfare, fascism can be countered only on the terrain of technology itself, by means of perceptual technologies that allow for a figurative, mimetic engagement with technology at large, as a productive force and social reality." Yet rather than redeeming experience at the price of "rationality," he made the registers of human embodied experience the measure of technology and media, with a view on new forms of collectivity and transformed relations between nature and humanity. The very impulse to theorize technology is part of Benjamin's techno-utopian politics, through which he seeks to re-imagine the aesthetic in response to the technically changed sensorium.[30]

Benjamin conceived of the body as a medium in the service of imagining new forms of subjectivity. Negotiating the historical confrontation between the human sensorium and technology as an alien, and alienating regime requires learning from forms of bodily innervation. Innervation is understood as the conversion of affective energy into somatic, motoric form; such as the transformation of the experience of

30 See: Miriam Bratu Hansen, "Benjamin and Cinema: Not a One-Way Street," in *Critical Inquiry* 25, (University of California Press, 1999): 306–345; and Miriam Bratu Hansen: "Of Mice and Ducks: Benjamin and Adorno on Disney," *South Atlantic Quarterly*, 92 (1993): 27–61.

an image into physiological motion and emotion; where bodily sensation and technologically-produced images constitute not irreconcilable counterparts, but an integral "body-" and "image-space." Benjamin invested cinema with the power of innervation, by means of which the technological apparatus can be brought to social, public consciousness as the "physis" of a transformed collectivity, which has its "organs" in technology. Experimenting with psychotropic substances, such as hashish, was for Benjamin one way of subjecting the experience of innervation to auto-experiments and self-regulation. Unlike several of his contemporaries and successors who experimented with drugs, Benjamin treated the effects of intoxication as symptoms and effects rather than metaphysical truths. The experience of intoxication destabilizes the boundaries of the self, and transforms the parameters of time-space perception as well as the relation between people and things, exhibiting a structural affinity with the synaesthetic effects of the cinematic experience at the intersection of the physiological and psychological.

"Innervation," in Benjamin's terms, was ultimately linked to his notion of a collective sphere of imagery, in which, by means of constellatory flashes—the dialectics of seeing, profane illumination—he conceived of a sphere of "absolute neutrality" with respect to the notions of subject and object. What Benjamin conceived of, in other words, is a politics of the meridian point, the dissolution of modernity's notorious "seeing double" by means of a "stereoscopic vision" that brings the two domains of subjects and objects into the dialectical constellation in which they came to be historically productive, and by means of which they gave birth to the modern world. In this attempt, he preceded Bruno Latour, who proclaimed the need for a "symmetric" anthropology of modernity. He refers explicitly to anthropology for it is the only discipline that is used to thinking together the most diverse boundary practices in one great whole (the cosmographies of the "others," for whom nature and culture and so forth are not distinct), a virtue that no other discipline, by way of their implication in the modern logic of division, is capable.

Ken Jacobs
Capitalism: Slavery, 2006
Digital video projection, 3 min
Courtesy the artist

Ken Jacobs is a filmmaker who works as a quasi-archeologist of the effect media and technology had on the human sensorium. He equally takes into consideration the modes of production and forms of power congruent with technological media and their history.
Capitalism: Slavery pictures a stereograph image of a cotton plantation, whose animation by means of digital technology endows these images with a spectral presence – brought back to life, but still mute.

We Have Never Been Modern

An anthropology of the modern world; that is, a comprehensive, synthetic view of the organization of its boundary-practices, becomes possible only once we have come to realize that "we have never been modern."

> *Century after century, colonial empire after colonial empire, the poor premodern collectives were accused of making a horrible mishmash of things and humans, of objects and signs, while their accusers finally separated them totally—to remix them at once on a scale unknown until now.[31]*

31 Bruno Latour, *We Have Never Been Modern*, 39.

The practice of modernity, Latour asserts, is diametrically opposed to its conceptualization and self-description. While accusing other collectives of the mishmash they make between categories whose distinction for us holds sacred values, they set up a practice that intertwined culture and nature on a previous unknown scale. The "official" version of modernity is but a mode of classification that allows one to do the opposite of what one says. Modernity also made an absolute split between theory and practice, between de facto practices and their juridical, conceptual framework. The conceptual register of modernity keeps on erecting borders, purifies fields of knowledge, insists on disciplines, and so forth; while in their practices, they work on creating assemblages, "hybrids," or "collectives" that conceptual machines can not simply account for. This allowed the moderns to mobilize nature without due democratic discussion on the impact of this mobilization, without mediation and representation of "things," thus producing an unprecedented amount of new "hybrids," of "quasi-objects," of chains of associations in which subjects and objects are mutually constitutive, which contain both subjective and objective aspects, and span the divide between culture and nature in multiple ways. It is only with the proliferation of these "hybrids," overwhelming us in the form of the ecological crisis, that protocols of strict division, of "purification," gradually lose ground and cease to be opera-

"The Romanticism of the nineteenth century already contains this fantasy that we now confuse with scientific reality." The work of French caricaturist J. J. Grandville, who satirized the ambitions and pretensions of modern man in his illustrations of the 1830s and 40s by way of personified animals and plants was a favored source for Marcel Broodthaers. He appropriated Grandville's satirical images in two slide projections of 1966 and 1968. The 1968 projection *Caricatures-Grandville* juxtaposed slides of satirical drawings by Grandville and Daumier, among others, with photographs of the 1968 student demonstrations.

Marcel Broodthaers
Grandville, 1967
Slideshow, 80 slides
Courtesy Estate Marcel Broodthaers, Brussels

tional, thus enforcing a re-evaluation of modernity, and an inscription of all that it bracketed off—the unified nature of non-relational facts—back into history.

> The essential point of this modern Constitution is that it renders the work of mediation that assembles hybrids invisible, unthinkable, unrepresentable. Does this lack of representation limit the work of mediation in any way? No, for the modern world would immediately cease to function. Like all other collectives it lives on that blending. On the contrary (and here comes the beauty of the mechanism to light), the modern Constitution allows the expanded proliferation of the hybrids whose existence, whose very possibility, it denies.[32]

According to Latour, science, by way of its construction of "indisputable" facts, holds democratic politics in an iron grip, limiting the collective concerns that can be negotiated to human affairs alone, while bracketing off all other agencies that participate, and indeed hold together, the "common world." To bring the sciences back into politics, Latour calls for a "parliament of things," in which the work of the sciences is not the presentation of objective facts that supposedly "speak for themselves" and end all other debate by suppressing the necessary mediation that makes them "speak" in the first place, but rather the "socialization of nonhumans," their enrollment and subsequent mediation in a social realm extended to "things."

Is Bruno Latour suggesting yet another "return" to animism, a form of political order that is based on a dubious animation of things? Is the "parliament of things" not a regressive fiction reminiscent of the animated universes of Walt Disney, where everything comes to life and things act like people, or to one of the techno-utopian fantasies of a Charles Fourier?

> Before my readers begin to get a disquieting impression that they are being pulled into a fable where animals, viruses, stars, and magic are going to start chattering away like magpies or princesses, let me emphasize that we are in no way dealing with a novelty that would be shocking to common sense. [...] I am proposing, very reasonably, to make this mythic contradiction [between mute things and speaking facts] comprehensible by restoring all the difficulties that a human encounters in speaking to humans about nonhumans with their participation. [...] I do not claim that things speak "on their own," since no beings, not even humans, speak on their own, but always through something or someone else. I have not required human subjects to share the right of speech of which they are so justly proud with galaxies, neurons, cells, viruses, plants and glaciers.[33]

Latour calls for a parliamentary model—composed of "spokespeople," mediators, and mediums—that accounts for the enrolment of nonhumans in the constitution of the common world. For the modern imagination, this is nothing short of a horror scenario. Not only does Latour ascribe things agency, but with their agency, he lets them get so close to subjects that the subject becomes virtually unimaginable other than in

Jean-Ignace-Isidore Gérard (1803–1847), better known by the name of his comedian grandfather, Grandville, is synonymous today with the twin methods of the personified animal and the "bestialized" human in modern illustration. In his satirical caricatures of the 1820s and early 1830s, but also in his later book illustrations such as those of the La Fontaine fables, J.J. Grandville addressed the question of social groups and types. In this, he was strongly influenced by physiognomist theories of the day, including the writings of Lavater and Gall. While the "animal metaphor" already held some currency in French social satire during his life-time (see Louis Huart's "Museum Parisien" of 1841), Grandville stands out for his thorough exploitation of the theme of organic metamorphoses from man to animal, man to plant and vice-versa. Along with the exploits of Honoré Daumier and Gustave Doré, Grandville's daring use of anthropomorphism in illustration had an influence on generations of illustrators and animators to come, from the Frenchman Ernest Griset, the Englishmen John Tenniel and Edward Lear, the Pole Ladislaw Staerwicz and finally the American Walt Disney.

32 Bruno Latour, *We Have Never Been Modern*, 34.

33 Bruno Latour, *Politics of Nature: How to Bring the Sciences into Democracy*, trans. by Catherine Porter (Cambridge: Harvard University Press, 2004), 67.

Marcel Broodthaers
Grandville, 1967
Slideshow, 80 slides
Courtesy Estate Marcel
Broodthaers, Brussels

a communion with things, taking us right back into the realm of those "horrible mixtures." And nevertheless, this is not a "return" to animism, not to the "old"; that is, the modern version of animism, to be sure. For what we confront here has nothing to do with the conflation of differences, but with their increase, and with the demand to equally increase the tools for political representation that are capable of accounting for, and recognizing, what were previously mere mute objects, as social agents that have a significant share in the making of the common world. Taking into account things as co-authors of the social means to ask the question of social constructivism, of our making of the world, of the production of relations anew, always maintaining the stereoscopic view that keeps the mutual constitution of humans and nonhumans in sight. This does not require a "return" to historically surmounted ways of relating to the world, but taking into account the submerging of relational modes of knowledge through modern boundary-practices. What Latour does not account for, in this respect, focusing as he does on the chains of references and steps of mediation undertaken through the inscriptions of scientists in their laboratory, is the realm of sensuous correspondences, the importance of non-linguistic embodied communication, which were so central to Benjamin's investment with both technology and the "language of things."

For Benjamin, the language of things refers to the manner in which we are addressed by an object, the way in which an entire structure for the living world finds expression in the world of things. Being affected by the language of things has its roots in the "mimetic faculty." For there is no dialogic form of relationality if there is no account of the very dependence of human language on the address we receive from things, deriving from a non-linguistic form of knowing in which the relationship between subjects (active) and objects (passive) is reversed;

Hans Richter
Ghosts before breakfast, 1928
Video (original: 35 mm film), 7 min

Our things in our hands must be equals, comrades
—Alexander Rodchenko, 1924

For Hungarian film theorist Béla Balázs, film gives visual shape to a physiognomic quality in both the animate and inanimate: "[In film,] all things make a physiognomic impression on us, whether we are conscious of it or not." This physiognomic quality, however, was, for Balázs, an anthropomorphic projection, in line with expressionist theories that saw an "animated mirror" (Georg Simmel) in all modern art. For French film theorist and filmmaker Jean Epstein, they are not merely mirrors, but also assume the status of characters in the (human) drama: "Through the cinema, a revolver in a drawer, a broken bottle on the ground, an eye isolated by an iris, are elevated to the status of characters in the drama. [] To things and beings in their most frigid semblance, the cinema thus grants the greatest gift: life. And it confers this life in its highest guise: personality."

In *Ghosts Before Breakfast* (*Vormittagsspuk*, 1928), Hans Richter stages a revolt of things, showing everyday objects turning against their users in a cinematic ghost hour of sorts. Teacups and saucers drop on the floor and break, beards appear and disappear, positive film changes into negative. Clothes desert their wearers, and strip them of the all-important markers of their bourgeois identity and dignity: the absence of hats releases a state of anarchy and "unreason." But before noon strikes, reason, order, and serenity are restored: "In the end the old hierarchy of person-master over the object-slave re-established itself. But for a short time, the public entertained a niggle of doubt about the general validity of the usual subject-object order."

Vertov's *Soviet Toys* (1924) is generally assumed to be the first Soviet animated film. It is a propaganda film in which Vertov reacts to the introduction of limited forms of capitalist enterprises by Lenin's New Economic Policy, and is both an iconoclastic and a literalist illustration of the animated fetish-character of commodities described by Marx.

The theory of animism as one of the animation of "dead" matter was developed in the midst of the consolidation of commodity capitalism in Europe and North America. The commodity, as Karl Marx provocatively proposed, was not dead matter because it was animated by a "fetishism of commodities." There is a structural parallel between the commodity fetish and the cinematic image. Marx's commodity fetish derives its uncanny animation by displacing a social relation (of labor) into an inert object: "A definite social relation assumes [...] the fantastic form of a relationship between things." Hiding its means of production equally grants the cinematic image the animated quality it has for the viewer.

Dziga Vertov
Soviet Toys, 1924
Video (original: 35 mm film), 10 min 40 sec

Reto Pulfer
Dichtr mit Fugulit und Hydrgraph, 2007. (Detail).
Raku-ceramics, b/w analog photo fiber paper, silk, organic
materials, black velvet, wooden board.
Courtesy the artist and Balice Hertling, Paris

In Reto Pulfer's works, things press close onto consciousness, and states of consciousness dynamize things. No interior, but passages between states of mind, words, materiality, things. In these passages, there are multiple forces at work, elementary as well as symbolic, that produce a drifting and shifting of signs and sensations, uncohering and re-cohering meaning, experience and memories. Those drifts can be intensified through further short-circuits between signs and things, between sounds and textures, structured by systems of notations that become templates for a space that calls various presences forth.

who, in everyday custom, translate their texture into human language, into faculties. There is no such thing as ecstasy: We are always already outside our selves with things, because they structure our habits, experiences, and, finally, our language, which, according to Benjamin, contains an archive of sensuous correspondences. For Benjamin, there is thus a continuum, not a rupture, between sensuous correspondences, the body as a medium, and the medium of language.

In ascribing language only to humans, in submerging mediality across the registers of experience, in denigrating sensuous knowledge to mere "relics," we submerge our capacity for "relatedness," and we gain a freedom of a paradoxical nature, the freedom to modernize. For it is in this domain of the a-semiotic that the question of relationality will always also pose itself if one doesn't want to run into the danger of a new form of politically hazardous positivism that accepts as speech only what can be positivised by means of a writing device. This is, of course, also the field in which the questions discussed above become relevant to the field of aesthetics, understood as encompassing the whole spectrum of possible relationality between the registers of the sensuous, affective, and cognitive. This domain, in its political implications, concerns the entire realm of habitual behavior, of the internalization of modes of relation and emotional dispositions, the very schemes by which we make sense of the world. It is in this realm that the boundary between the implicit and explicit is being drawn by way of the entire spectrum of everyday gestures and practices. This boundary defines the margin of political negotiation in any parliamentary setting—for what is implicit, what "goes without saying," what is taken for granted as

Without Persons consists of two computer generated male and female voices discussing the concepts of "being-in-the-city" and "being-with-others." Two monitors show a liquid—reminiscent of milk—whose shape is generated in response to the voices. The plasmatic liquid assumes ever-new forms, seemingly organic and animated by the mechanical voices, while the text contrasts the yet undifferentiated experience of the world of the early infant with the vision of a world devoid of persons. A dissonance is created between the content of the spoken word—a discussion about "being" and relating to others—and the "disembodied," clearly synthetic voices. This disaccord is further enhanced by the semblance of an organic link between the images and the sound, which refers to living beings, and the obvious machine support of the installation.

34 Donna Haraway, *When Species Meet*, 27.

35 Bruno Latour, *We Have Never Been Modern*, 137.

36 Rane Willerslev, *Soul Hunters: Hunting, Animism, and Personhood among the Siberian Yukaghirs* (Berkeley and Los Angeles: University of California Press, 2007), 187.

Luis Jacob
Without Persons, 1999–2008
two-channel video installation
Video, 22 min 45 sec
Courtesy Birch Libralato, Toronto

background condition, that which organizes perceptions, skills, and actions before mobilizing "positive," declarative knowledge defines what can be recognized, responded to, and negotiated. According to Donna Haraway, the language of bodies produces its own truth, particularly in the realm of relationality between different species:

> *The truth or honesty of nonlinguistic embodied communication depends on looking back and greeting significant others, again and again. This sort of truth or honesty is not some trope-free, fantastic kind of natural authenticity that only animals can have while humans are defined by the happy fault of lying denotatively and knowing it. Rather, this truth telling is about co-constitutive natural cultural dancing, holding in esteem, and regarding open those who look back reciprocally. Always tripping, this kind of truth has a multispecies future.*[34]

Beyond Mirror Worlds

Once animism is released from the modern cage that defines it as either "erroneous thinking" with the respect to the reality of objects or as a question of projecting subjectivity, the concept opens up a very different set of problems, at the core of which lies not subjectivity of perception (leading to ever-new mirror-games), but perception of the subjectivity of the so-called object. These subjectivities are not to be conceived in anthropomorphic forms, but rather in relation to the available and possible forms and *dispositifs* of recognition. Trying to give an answer to the question of defining "human," Latour answers:

> *The expression "anthropomorphic" considerably underestimates our humanity. We should be talking about morphism. Morphism is the place where technomorphisms, zoomorphisms, phusimorphisms, ideomorphisms, theomorphisms, sociomorphisms, psychomorphisms, all come together. A weaver of morphisms—isn't that enough of a definition?*[35]

Besides the concept's potential to act as a stereoscopic mirror for the understanding of modern boundary-practices, anthropology has revived the concept of animism, understood as "relational epistemology." There is, as anthropologist Rane Willerslev asserts, a danger in these accounts of replicating the projection of a romantic sentiment paired with assertions of scientific universality escaping cultural relativism that still denies the very claim of the ontologies in question that the relations they uphold to non-human subjects are real, and not merely a transference of social metaphors onto the world, by means of which the difference between self and Other is absorbed.

> *We can only have an experience of a world if we are conscious subjects of experience who can distinguish between ourselves as subjects and an external world that transcends our subjective experience of it. Otherwise, the experiencing subject and the object of experience would conflate, would become one, thereby making any experience of the world impossible.*[36]

Anselm Franke 49

To be sure, all cultures draw boundaries, and organize and negotiate differences. All cultures objectify, and draw a line between what is real and what is imaginary in ways that constitute these realms mutually. However, they differ in the way these differences are organized, and only the moderns are known for having operated through the bifurcation of nature and culture, and the derived system of equally categorical Great Divides, monologic in their structure and form of relationality. That the societies described as animist do not ascribe to such forms of difference a priori does in no way mean that these differences do not exist; rather, they have to be created constantly through everyday practices. These practices are basically mimetic, if mimesis is understood as a faculty and sensuous-cognitive process:

> *Mimesis is essentially relational in that the imitator has no independent existence outside or separate from the object or person imitated; and yet the imitator is constantly being thrown back on himself reflexively, without ever achieving unity. Thus mimesis offers assimilation with otherness while also drawing boundaries and distinguishing oneself. Animism demands both, and without mimesis the very basis of animistic relatedness is therefore likely to break down. This is not to say that mimesis is identical with animism. We can and do imitate things without being animists for that reason. Rather, what I am arguing is that mimesis is and must be a prerequisite for animistic symbolic world making. [...] Mimesis, therefore, is the practical side of animism, its world-making mechanism par excellence.[37]*

Control Society

Since the 1970s, the question of relationality has taken on new forms within the realm of what previously was characterized as industrialized modernity. With the decline of industrialism, the rise of post-Fordist modes of production and immaterial labor, and the end of the "disciplinary regime," the very site occupied by animism previously as a romantic counterpart to the objectified, disenchanted world has experienced a significant shift. From being the negative of modernity, the focal point of its imaginary opposites, animism has become a resource for the expansion of capitalist modes of production into the realm of relationality governed by affects and subjectivations. It is now most common again to talk about souls and communicative, collaborative practices; government papers speak of the embodied mind and the unity between body and soul. Mimetic and passionate engagement has become a quotidian request, through which conformity is being produced. In the passage from the "disciplinary society" to the "society of control," the relation between inside and outside has partially been reversed—it is only that the self, the subject, remained at its place, and now finds itself in a position of negativity, in constant need to positivize itself by means of inclusion into the existing web of productive social relations.

What had been achieved by feminist theoreticians and practitioners, among those whose attacks on the notorious modern dualisms have shown significant effects, became increasingly incorporated standards

Grigory Alexandrov
Jolly Fellows, 1934
Video (original: 35 mm film),
96 min

Certain tropes govern animated worlds. One of the laws can be described as exaggeration of cause and effect. A second rule emphasizes the animation itself: everything turns out to be more alive than you think. A third and most fundamental principle of animation is that the whole "animated" world is joined together, bound not merely by the ropes of "cause and effect" but by the "carcass" upon which it is all constructed, the phonogram. The animated universe sings, with its many voices, a single, very catching, tune. When Grigory Alexandrov (the assistant to Sergei M. Eisenstein for more than a decade) made his first film in 1931, he translated the laws of animation derived from the study of the art of Walt Disney, among others, to the real-life universe of the Soviet Utopia, creating a genre of musical comedies that has been referred to as "Stalinist animation".[38]

37 Rane Willerslev, *Soul Hunters*, 191.

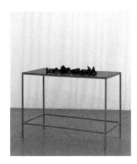

Lili Dujourie
Initialen der Stilte 5, 2008
MDF, metal and clay
Courtesy the artist and Galerie
Nelson-Freeman, Paris

Initialen der Stilte consists of a gray functional table upon which a heap of objects is laid out. They are earthen in color and resemble scraps of clay peeled off a rolling pin—curved little flakes of earth, the edges of which are gently ripped. From afar, the table looks like an operating table or a doctor's instrument tray, and the jumble of earth-like, curled skin or broken body parts. The haphazard placement of the curved flakes means that some appear convex, some concave. A dynamic is created; the individual elements appear to be in movement like the limbs of one body. Both in mythology and in the scriptures, clay was the material with which divinity made man. There is, in Dujourie's use of clay, the idea of a return to the very beginnings. Under the work's title, *Initialen der Stilte* (Initials of silence), we may read the scraps of clay as testimony to the gods' and God's shaping of man and woman, to the essence of the body, which, through the ages, has been objectified and silenced.

in the mantras of a capitalist mode of immaterial production, now centering on the production of social relationality. This has given rise to new forms of "clinical animisms," in which the paradigm or relatedness has become a modality of social production, which no longer has an articulable dimension of negativity, of imaginary outsides. In the society of control, it is negativity that is interiorized as the conditioning through the disciplinary enclosures is replaced by increasingly implicit forms of self-management. Power now operates by the fear of falling outside, no longer by enclosing an inside. It operates by means of implication and innervation, providing the frames in which the productive relations are to take place, while the very frames remain out of the reach of being negotiable. Yet these frames are flexible and can adapt if a critical mass applies force. Critique, already hurt by the waning power of its iconoclastic gestures, must remain local and responsive. The relational paradigm has long entered the officially accepted doctrines of culture in which few of the old oppositions can be upheld.

The field of social production has turned increasingly into an animist mirror-world of sorts, with the subject being the animating frame of its own world. Looking into the world as the mirror of the self has become the modality of interiorization. The rise of the green economy as the next capitalist frontier will do its part in creating new quasi-animist forms of governmentality. All this can be explained as a mimetic, morphological adaptation of power, spinning the wheel of dialectics between resistance and form of power further, now in the process of appropriating the transformative forces of relationality and the mimetic. The outlines of the new regime, as in the old, can once again be traced negatively, by means of its congruent pathologies. The neurotic boundary-syndrome is replaced by the mode of depression, which Jennifer Church has described in terms of being able to see a reflection of the romantic, trangressive role animism had once played: as "false one-ness with the world." It is false, because it is a oneness in which the subject is ultimately deprived of agency, of the possibility to act and relate, a subject being locked into an immobilized time-space by means of subjectification, rather different from the immobilization experienced by objectification that gives rise to neurosis and paranoia, yet which is strictly correlative. One battlefield of the future will be the boundaries of the self in search for the tools to resist the interiorization of the structures of power implicated in the flows of relationality. And yet one must not forget that these developments remain rather local phenomena, and that outside the "postmodern" mobilization of "clinical" animism induced in new forms of subjectification, what awaits us everywhere is history. Despite the postmodern amnesia of a capitalism turned green, the conflicts of modernity are far from pacified. History's battlefields need new modes of recognition, and understandings of production and transformation of relational cosmographies under the modern traditions and conditions of war. It is against this backdrop that animism, as a grand narrative of sorts, may become a necessary epic for the society of control, a tool for the tackling of the qualitative, political aspects of relationality.

38 Based upon extracts from Anne Nesbet, *Savage Junctures: Sergei Eisenstein and the Shape of Thinking* (London: I.B. Taurus and Co Ltd., 2007).

Étienne-Jules Marey,
Goeland volant obliquement dans la direction de l'appareil, 1887
Original ink drawing on Bristol board
left: *Empoisonnement d'un animal (espèce non précisée)*, undated
Original photograph on lampblack
Courtesy Cinémathèque Française, Paris

Theses on the Concept of the Digital Simulacrum

Florian Schneider

1.

The deceptive nature of the digital image is not evoked by a certain resemblance between original and copy, or reality and its simulation. No matter whether faithful or unfaithful, the similitude of the simulacrum seems no longer a question of likeness or unlikeness. Instead, similarity has turned into simultaneity; it has become a question entirely occupied by time: synchronized time and temporal command.

The digital image is characterized by a promise of instant availability in so-called real time that comes along with the idea of global compatibility. Today, the illusionary character of the image lies in the proclamation of immediate access to the recorded data as well as in the idea of unlimited exchangeability bypassing any actual resemblance.

2.

The realm of the digital is organized by discrete signals, and it has to result in a limited amount of data. The illusion of instant availability is based on a prompt compression without sensible delay and without any kind of processing, development, or conscious manipulation over time. It stands for a dramatic diminuition of raw data that are reduced to what various algorithms of the format may identify as useful information according to recurring patterns. Allegedly useless information is discarded without further notice; this negotiation happens constantly and without a public possibility to interfere.

3.

The process of reduction used to characterize the act of creation: As framing, focussing, composing, it was supposed to structure the image and define visibility, to produce meaning and to give order to what would be otherwise considered unsolicited. With the digital simulacrum, these traditional techniques are backing out and they become subject to automatization themselves. Ironically, the act of photography regresses to the state it was conceived of at its very beginning: rather than the product of an act of creation, the image itself is a simple reproduction, a soulless replica, and the photographer appears just as a prolongation of the machine.

4.

The elimination of uncontrolled and uncontrollable creativity over time seems to allow the re-inscription of the ancient property regime of the original into the copy. Neither iconicity, nor indexality nor symbolicity are any longer inherent in the image; they are attached to the image post festum and with a relevant effort afterwards or independently from the act of creation. The singularity of the image, its documentary function, appears as a supplement that is added only in the form of separate metadata.

These metadata appear as coordinates that have to be synchronized in order to anchor the digital image that is always on the move in a real life that otherwise would have no connection to reality. It becomes obvious that metadata are the surplus value that is to be appropriated and expropriated from the images.

5.

Contemporary image production is condemned to pose the question of property at the intersection of two axes: property that becomes increasingly a matter of imagination, and images that are subject to ongoing propertization.

In an economy based on imaginary property, the real abstraction of the exchange has turned into its opposite, the real-time exchange of data that are abstracted from the image that does not portray or equal anything anymore. What matters instead is the instant comparison of metadata that are divested and transformed into relational value.

Relational value is everything but beyond measure. In fact, it solves a fundamental problem: how could one quantify the appropriation of images in terms of value if what is produced is immaterial or merely affective, let alone imaginary? What can be counted, measured, and traded are indeed the relations generated from the abstraction of metadata out of images.

The passage from real abstraction to the abstract reality of an economy of metadata inverts the laws of exchange: The solipsism of the exchangers is replaced by gregarious networking; the constancy of the commodity form has become precarious and unstable always threatened by decay; exchange and use are no longer separated in time, but happen simultaneously; the principal of exchangeability is outsourced from the commodity itself and its abstract singularity to all its potentially ubiquitous and simultaneous relationships.

What reveals itself is nothing but the common in the commodity form.

6.

Consequentially, the simulacrum has lost its potential to challenge and overturn the privileged position, and open up to the lived reality of the sub-representational domain. On the contrary, the privileged position of ownership, no matter whether legitimate or illegitimate, has seized the subversive power of the simulacrum.

In the society of control, permanent availability has replaced the idea of representation. That means that the attempt to re-present has expanded beyond any limit of gravitation, and it contracts in the notion of real-time. This is only possible because of a shift: what is in fact subject to control are just images rather than the lives of individuals themselves; while the micro-mechanisms of diciplinary power are concerned with the production of a self, the society of control operates through profiling: instead of copies of an original, these profiles are animated images of a self that need to be multiplied infinetely in order to satisfy the insatiable demand for omnipresence, which renders possible the very idea of control.

7.

The subversive potential that once characterized the simulacrum has been dispelled to an imaginary area below the noise margin. Here, in a state of exile, it enjoys a regained freedom of movement that is opposed to the very idea of purification through compression. Rather than the border of the image towards an underground territory that is unconscious or whatever, the noise margin folds into a spatio-temporal matrix in which data is pointless in the three dimensions, of solicitation, purpose, and meaning. In a fourth dimension the linearity of time has collapsed: too early, too late, in any case, a false time that is radically opposed to real-time. In the society of control, this is the area of retreat for any resistance against communication.

Biometry and Antibodies
Modernizing Animation /Animating Modernity

Edwin Carels

"From the invisible atom to the celestial body lost in space, every-thing is subject to motion… It is the most apparent characteristic of life, it manifests itself in all the functions, it is even the essence of several of them." Étienne-Jules Marey[1]

1 Quote from Marey's intro-duction to Animal Locomotion, cited in Martha Braun, *Picturing time: the work of Étienne-Jules Marey* (1830–1904) (Chicago, London: University of Chicago Press, 1992).

In our contemporary culture of ubiquitous media, where all social spaces have become saturated with pixels and screens, moving animat-ed images play an essential role in orchestrating desire and regulating behavior. As a stylistic category animation is now more popular than ever, as a strategic method it is increasingly pervading our daily lives. Infographics are moving beyond screens and monitors to animate both social and private spaces. Little LED-indicators turn all types of objects into active presences. Precisely in this agitated period of constantly in-novating mobility and communication systems, media-archeology of-fers a welcome perspective to situate the effect of new media configura-tions in our digital era. From the good old cartoon factory to the most recent technologies of crowd control, from the cinema to the daily bar-rage of computerized information: reconfiguring both living and dead objects into a controlled flow remains the very motor of modernity. Animation functions not just as a visual language, it is more impor-tantly also a cognitive principle, a training technique that puts matter and mind into motion.

Eadweard Muybridge
Movement of the Hand; hands changing pencil, ca. 1887
The University of Pennsylvania series, plate 536
Courtesy of Christine Burgin Gallery, New York

At Walt Disney World for instance, biometric measurements are taken from the fingers of guests to keep customers from sharing their admission tickets from day to day. This kind of monitoring of behavior is not just an outgrowth of the animation industry, it is also at the very origin of it. The first concern of both Muybridge and Marey, two key figures in developing techniques to analyze and synthesize photographed movement, was to improve camera-methods for motion cap-

A. Bertrand à Namur, clockmaker
Apparent Solar Time, ca. 1870
Albumine business cards, glued on cardboard
Courtesy Thomas Weynants collection/Early
Visual Media, Ghent

ture. In the second half of the nineteenth century, physiologists helped the industry to develop ergonomic practices to increase the efficiency of soldiers and the productivity of the workmen. Even *"les ouvriers"* had to leave their factory not once, but three times, before the Lumière Brothers were satisfied with their imprint on the so-called first film. The urtext of the *cinématographe* thus became a documented case of discretely orchestrated crowd control, which very likely was also applied to the activity inside this successful factory of glass plates for the photo-industry.[2]

The other "first film" best remembered, *L'arrivée du train* (1895), can also be read as emblematic for the standardization of time, as railroad companies needed to maintain schedules over longer distances, where as up until then every city's time zone differed from the next by

2 All three versions are on the DVD *The Lumière Brothers' First Films (1895–1900)* (Kino on Video, 1999). See also Harun Farocki, *Workers leaving the Factory/Arbeiter verlassen die Fabrik* (1995).

minutes and seconds. "The rationalization of time characterizing industrialization and the expansion of capitalism was accompanied by a structuring of contingency and temporality through emerging technologies of representation," claims Mary Ann Doane in her study on the emergence of cinematic time.[3] Frederick Winslow Taylor, the proclaimed first scientific manager and management consultant, would later begin producing stopwatches himself to provide to his clientele. In live action cinema, time is a reproduction of the actuality that was present in front of the camera. In animation, time is a pure product, produced by the interaction of the camera and the projector. The overwhelming success of the American cartoon from the mid-twenties onwards is above all the result of a drastic rationalization of the production process, in parallel with the relocation and reorganization of the live action film. Innovations such as the use of transparent celluloid for the active parts of the drawing, the application of the pegbar, the detailed division of labor, the standardization of the length, all helped to attain a constant production flow.[4] With Walt Disney as its captain of industry, the Taylorization of production methods peaked on all levels, from the application of quicker graphic methods, to the introduction of synchronized sound, turning technical innovation into a quality label, a unique selling point.

3 Mary Ann Doane, *The Emergence of Cinematic Time: modernity, contingency and the archive* (London: Harvard University Press, 2002), 11.

4 See Donald Crafton, *Before Mickey: The animated film, 1898–1928* (Cambridge Mass: MIT Press, 1982).

A Lyrical Revolt

In 1929 the Walt Disney studio produced the first episode of the *Silly Symphonies*, their first real success due to the perfect symbiosis of music and image. This *Skeleton Dance* is the first animated cartoon to use non-post-sync sound. The music came first.[5] It immediately followed Disney's initial experiment with sound, *Steam Boat Willy* (1928), in which a childishly cruel Mickey forces animals as well as objects into the role of musical instruments. In *Skeleton Dance* one of the graveyard characters even uses the bones of a colleague to perform a xylophone solo. To Disney standards, the cheerful choreography of the surprisingly elastic performers in this animated ossuarium remains a rare example of anarchic freedom in a Disney-context, an experimental film not produced with any particular audience in mind.

Also in 1929, but on the other side of the ocean, an aspiring avantgarde artist slaved over hundreds of black and white drawings to animate an imaginary creation myth, inspired by Samoan motifs. Upon arrival in London the adventurous New Zealander Len Lye was soon adopted by a circle of modernist artists. Lye abandoned his original plan to continue globetrotting to meet the Russian constructivists. Instead, he happily took on the role of an exotic "primitive" himself and challenged his new audience with an idiom that was completely alien to most of them. After two years of drawing and shooting, Lye presented his first film to the London Film Society in December 1929, a conflation of the absolute, radically abstract film experiments of the Bauhaus and tribal art from the Maori's and Aboriginals. The title *Tusalava* in Samoan signifies that everything comes full circle; all things are looped and remain the same. During his visit to the island, before coming to Europe, Lye had drastically decided to give up figurative drawing and had started to develop his own work.[6] The mere formal emulation of tribal art was soon enhanced by a strong attention

5 The composer was Carl Stalling who adapted parts of Edvard Grieg's *The March of the Trolls* and not Saint-Saëns's *Dance Macabre* as is sometimes attested.

6 Roger Horrocks, *Lye Len: a biography* (Auckland: Auckland University Press, 2001), 61. "Lye happened to be in Samoa around the [same] time as the American filmmaker Robert Flaherty, who was living with his family on the island of Savaii making the feature length documentary *Moana*, and the American anthropologist Margaret Mead, who was in American Samoa doing fieldwork for her book *Coming of age in Samoa*. Both [were] later criticized for their romantic preconceptions."

Animism

Walt Disney, Silly Symphonies: *The Skeleton Dance,* 1929
Video (35mm film original), 5'30"
© Disney Enterprises, Inc. All Rights Reserved

left: Len Lye
Tusalava, 1929
16mm reduction from 35mm
film, 10 min
Courtesy Len Lye Foundation/
Govett-Brewster Art Gallery/
New Zealand Film Archive

to rhythm and pulse through the diverse media Lye turned to. Eventually he would prefer to define himself as a "motion composer," using all sorts of media without restriction. For the première Lye invited a score from his compatriot and future collaborator Jack Ellit, but the combination of two pianos and a "talkie apparatus" never materialized, and was abandoned afterwards. Since then, the film has been usually shown soundless, and albeit praised by Hans Richter, was soon overshadowed by Lye's subsequent musical collage films. Then, after more than three decades, a scientific documentary filmmaker pointed out to Lye how much the movement of his figures resembled the activity of viruses, and that he had presciently visualized a biological reality. Antibodies in action! Lye considered he had intuitively translated into his work knowledge communicated via the "old brain," an untrained understanding of vital processes. Or as Jean-Michel Bouhours noted: "The principle of self replication explains all of the images that an artist produces: in this case, the work is the symbolic finalization of a cellular impulse, what the philosopher Henri Bergson identified in *Creative Evolution* as the *élan vital,* whose representation is, in Bergson's view, beyond the grasp of logical thought."[7] Animation is ideally suited to visualize such a deeper, different "nature," inaccessible to live action cameramen.

7 Jean-Michel Bouhours and Roger Horrocks, *Len Lye* (Paris: Editions du Centre Pompidou, 2000), 199.

Both *Tusalava* and *Skeleton Dance* are celebratory demonstrations of animation's potential to suggest actions beyond the obvious parameters of physiology. Swallowed by a skeleton's mouth, the viewer is

Edwin Carels 61

warped into a universe where nature's laws are no longer univocally fixed. No matter how unlikely it is to see bones waggle and reassemble, or to observe the morphing of cellular monsters, these films do exercise an enchantment on the viewer.

But all these wonders need to be carefully orchestrated. Film can follow a partition of music to the single frame. Animation is by definition the result of a systematically calculated, quantitative method of production. Eisenstein understood this irony all too well, when he applauded the plastic omnipotence of Disney's early sound shorts: "Disney is a marvelous lullaby for the suffering and the unfortunate, the oppressed and deprived. For those who are shackled by hours of work and regulated moments of rest, by a mathematical precision of time, whose lives are graphed by the cent and the dollar. ... Disney's films are a revolt against partitioning and legislating, against spiritual stagnation and greyness. But the revolt is lyrical. This revolt is a daydream. Fruitless and lacking consequences."[8]

The Disney studio would continue to innovate and expand technological control, but soon all anarchy was evacuated from their universe. Mickey had to adapt to wearing white gloves and metamorphosis was no longer an option for most figures. Narrative gradually became more conventional too and in the feature films the "orphan" syndrome (identification with the loss of a parent) soon became the standard trope to manipulate audience emotions. Lye on the contrary would leave drawn animation behind and—by lack of any means—start to work camera-

Len Lye
Particles in Space, 1957–1979
16mm film, 4 min
Courtesy Len Lye Foundation/
Govett-Brewster Art Gallery/
New Zealand Film Archive

less, wildly experimenting with reprinted and tinted found footage that he edited to stunning kaleidoscopic effect. Through his radical use of the medium, Lye wanted to unleash energy and bombard the viewer with dynamic impulses. In a later phase of his career, he played an important role in the development of kinetic art in New York.[9] Eventually, Lye returned to black and white filmmaking, and to the conviction that his "old brain" could intuitively visualize internal, biological processes. As if composing a primitive sort of cardiogram, Lye channeled his somatic signals onto strips of film by scratching these with ritual fervor.

8 Sergej Eisenstein, *Eisenstein on Disney* (India: Seagull Books Pvt.Ltd, 1993), 4.

9 Roger Horrocks, *"Lye Len – a biography,"* 106–107. "It was (this) photograph in Edwin J. Kempf's book Psychopathology that inspired Lye to start making kinetic sculpture. Kempf's caption described the object as a 'copulation fetish by (an) impotent negro paranoiac' instructed by God to build the 'first church of perpetual motion.'"

The titles *Free Radicals* (1958) and *Particles in Space* (1979) indicate that Lye now consciously wanted to tap into the cellular or even atomic dynamics within the human body. He created these final films by doing the one thing every filmmaker wants to avoid at all cost: scratching the emulsion, which normally destroys the photographic illusion and focuses all attention on the materiality of the image.

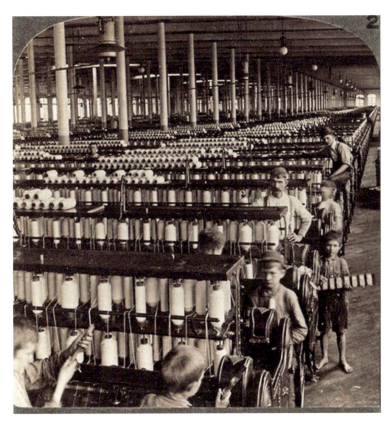

Ken Jacobs
Capitalism: Child Labor, 2006
Digital video projection, 14 min
Courtesy the artist

And yet, no matter how unconventionally film is treated by such artists, without obedience to the steady, regulated rhythm of the projection apparatus, no illusion of movement or artificial life is possible. Animation is always the result of an interaction between machine and human perception. As an obsessive archeologist, the filmmaker Ken Jacobs plays with these historically determined interactions between mind and matter, physiology and technology. At the same time he sketches the industrial complex that generated these conditions of the modern experience. In for instance his video-diptych *Capitalism: Slavery* (2006) and *Capitalism: Child Labor* (2006), Jacobs takes us back to the machine room of the Industrial Revolution and evokes some of the fundamental characteristics of modernity: exercising control through systematized mass production, the systematic exploitation of nature and human labor, imposing a global, strict time regime, standardizing work methods, etc. For the consumer however, it was

only the final product that counted. As Tom Gunning notes: "The speed of such industrial transformation made it appear magical, occluding the unskilled labor regulated by the factory system to perform repetitive and limited tasks. Skill seemed to be absorbed by the circulatory logic of the factory itself, as each task took place within a chain of rationalized labor."[10]

10 Tom Gunning, "Tracing the Individual Body," in *Cinema and the Invention of Modern Life,* ed. Leo Charney, et al. (Berkeley: University of California Press, 1996), 17.

In his recent series of video-vignettes (relatively short works that explore a single, albeit stereographic, still image) Jacobs reanimates the culture that generated these views, analyzing and synthesizing both formally and figuratively some found materials. While atomizing and re-configurating Victorian stereophotographs of a cotton plant or a textile factory, he exploits the effect of repetition and imposes a paralyzing, monotonous flicker on the visitor, who soon feels trapped inside his mechanical optics. From the harvesting of cotton to the production of threads, these two video-works explore the industrial complex from the inside. In his digital filmmaking, Jacobs often reprises the same structuralist critique as he already demonstrated in his canonical film *Tom Tom, the Piper's Son* (1969–71): the deconstruction of a found image offers both a close-reading of the materiality of the image with all its intrinsic esthetic qualities, and an exteriorization of the ideological regime behind the depicted. Another recurring strategy of Jacobs, becoming even more pronounced in recent works, is the exploration of threedimensional effects, translated to a single screen.[11] With these works, Jacobs both explicitly manipulates yet completely depends on the collaboration of the viewer. The image only comes about when image, machine and human perception are perfectly calibrated. The experience is at once captivating and lib-

11 In 2008 Ken Jacobs directed two new, feature length variations on his original *Tom Tom, the Piper's Son: Return to the scene of the Crime*, and *Anaglyph Tom (with Puffy Cheeks)*. This last title demonstrates one of the diverse techniques Jacobs is recently (re-) investigating besides his patented process "eternalism" and films to be watched cross-eyed, without interface. See for instance: *The Scenic Route* (2008), *The Guests* (2008) and *Brain Operations* (2009).

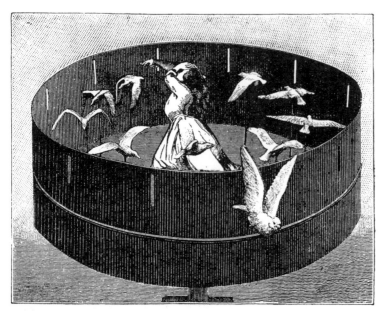

Max Ernst
"...sous mon blanc vêtement, dans mon colombodrôme, vous ne serez plus pauvres, pigeons tonsurés. Je vous apporterai douze tonnes de sucre. Mais ne touchez pas à mes cheveux!"
Rêve d'une petite fille qui voulut entrer au Carmel, plate 34, 1930
© SABAM Belgium 2010

erating. As Jonathan Crary describes in his study on the nineteenth-century cultural shift in vision and modernity: "The desired effect of the stereoscope was not simply likeness, but immediate, apparent *tangibility.*"[12]

12 Jonathan Crary, *Techniques of the Observer on Vision and Modernity in the Nineteenth Century* (Cambridge Mass: MIT Press, 1992), 123.

The Flight of the Avatar

While Disney was maximizing on the synaesthesia between sound and image, and Len Lye was animating his unique hybrid of tribal art and modern abstraction, Max Ernst provoked a blurring of categories through his collage novels. The first, *La Femme 100 Têtes,* appeared in, again, the year 1929.[13] Collage, a popular pastime ever since the reproduction and circulation of printed images intensified in the industrial era, had become a staple of the artistic avantgarde since early Cubism, and Max Ernst already demonstrated its potential since the early days of Surrealism. In his series of books, he systematically subverted the (then already nostalgic) status of the engraved illustration, the standard visual format before photography took over its place in the mass media. In the same period, Ernst also introduced his avatar Loplop, an avian creature that frequents his paintings and collages. Bird imagery was already present in his earliest Dada works, but became most prominent between 1928 and 1932. The shape of the totemic figure alternated frequently, the most recurring visualization was in the form of a wing-like hand, associating optics with flight, the bird's eye view. Loplop's function was to disrupt the single authority of the author/artist and offer the viewer a second vantage point.

13 His second collage novel was *Rêve d'une petite fille qui voulut entrer au Carmel (1930),* and his third, *Une semaine de bonté in 1934.* This practice of collages based on old engravings was continued in the work of, among others, avantgarde filmmakers Harry Smith, Bruce Conner and currently Pat O'Neill.

The appearance of the bird was usually highly stylized, but in his second graphic novel one collage explicates Ernst's notion about Loplop in a quasi-technical configuration. The manipulated image represents a zoetrope with threedimensional sculpted birds in varying positions inside. Through a subtle blending of images one bird appears to flee from the "dovecote" and a girl is found trapped inside. Instead of looking from the outside into the revolving drum, she finds herself in the epicenter of it, and covers her eyes with her one hand, while reaching out with the other. Like his avatar would liberate itself from gravity and observe the world from all directions and perspectives, Ernst is here again disrupting the conventional scopic regimes. Breaking the rules of the optical toy, he appeals for a more haptic experience, personified by a dizzy dancer inside a circular diorama.[14] Yet, the original zoetrope image—recycled from the science magazine *La Nature*—already displayed a more tactile quality than the traditional two-dimensional figures inhabiting such spinning drums since William Horner first invented this spatial elaboration of the flat phenakistiscope (allowing for multiple viewers) in 1834. Originally baptized the Daedalum, this optical toy only started to generate impact when in 1887 the American developer, William F. Lincoln reintroduced it under the name "zoetrope." It was Marey himself who sculpted that same year a series of plaster pigeons in order to present his motion analyses in a giant zoetrope for the *Académie des sciences.*

14 The caption under the collage reads: "... sous mon blanc vêtement, dans mon colombodrôme, vous ne serez plus pauvres, pigeons tonsurés. Je vous apporterai douze tonnes de sucre. Mais ne touchez pas à mes cheveux!"

The iconography of Marey's research work, particularly the chronophotographs, had a strong impact on modern art, starting shortly after his death with the Futurists adopting the typical fractured

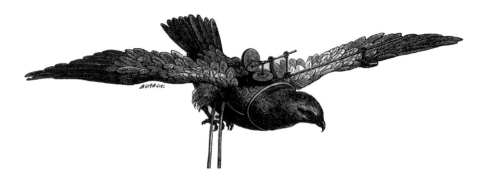

Étienne-Jules Marey
Buse volant avec l'appareil qui signale les mouvements décrits par l'extrémité de son aile
Source: Étienne-Jules Marey, *La Machine animale.*
Paris: Coulommiers, 1873
Courtesy Cinémathèque Française
Private collection

figuration as a code for signaling speed. Paradoxically modern art often made a travesty of what was essential to modernity. Regarding the aesthetic resonance of Marey, Martha Braun remarks: "Ironically, his imagery, so grounded in positivism and so rigorously analytical, served those very artists who vociferously rejected positivism and its claims to a higher form of knowledge."[15] The founder of French cinémathèque, Henri Langlois acknowledged this ambivalent legacy—the double use of a medium as both an objective tool and as a catalyst for individual subjectivity—but also re-established the importance of Marey through two major exhibitions.[16]

While Max Ernst typically questioned the culture of the engraving through his collages, Walter Benjamin concurrently revaluated the status of the photographic for his, "A Small History of Photography" (1931). Inspired by the Surrealists, and fascinated even more by the deceptively straightforward work of Atget, Benjamin promotes the unique properties of the medium as distinctly different from human perception. With this he implied that human sight does not register all visual information consciously. Thus the automation of sight invites a different, more interpretative reading: "It is through photography that we first discover the existence of this optical unconscious, just as we discover the instinctual unconscious through psychoanalysis."[17] Likely inspired by the chronometric photographs of Muybridge and Marey, Benjamin's analogy between photography and psychology is a rather rhetorical one, developed further most notably by art theorist Rosalind Krauss. In her sharp critique of the modernist canon in art, she makes explicit reference to the colombodrome collage.[18]

Before he coined the term "optical unconscious," Benjamin adopted the concept of "innervation" for his 1929 text *Surrealism*, already referring both to psychoanalysis and neurological theories at the same time. In medical terminology, "innervation" indicates both the distribution of supply of nerve fibers or nerve impulses to a body part—with the cornea as the most dense innervated tissue in the body—and the stimulation (of a nerve, a muscle or body part) to action. It is often a re-

15 Braun, 277.

16 An exhibition *A l'occasion du 125e anniversaire d'Étienne-Jules Marey – 300 années de cinématographie; 60 ans de cinéma* at Musée de l'Art Moderne in 1955. Then a monographic exhibition in 1963 in the Palais Chaillot, attached to the Cinémathèque Française. In 2000 Laurent Mannoni curated a large exhibition including a lot more works involving the graphic method in the Espace Elektra. See, Laurent Mannoni, *Étienne-Jules Marey: la mémoire de l'oeil* (Paris: Cinémathèque Française, 1999).

17 Walter Benjamin, "A Small History of Photography," in *One-Way Street and Other Writings*, trans. Edmund Jephcott and Kingsley Shorter (London: New Left Books, 1979), 243.

18 Rosalind Krauss, *The Optical Unconscious* (Cambridge Mass: The MIT Press, 1994). As one of the co-founders of the theoretical art review *October*, Krauss consistently influenced the debate on modern art's selective canon.

ciprocal phenomenon, the simultaneous excitation of one muscle with the inhibition of its antagonist. "Imagined as a two way process, Benjamin's concept of innervation may have less in common with Freudian psychoanalysis than with contemporary perceptual psychology, reception aesthetics, and acting theory, in particular the Soviet avant-garde discourse of biomechanics. ... In line with ideas such as those Eisenstein was developing, Benjamin discerned a notion of a psychologically "contagious" or "infectious" movement that would trigger emotional effects in the viewer, a form of mimetic identification."[19]

19 Peter Osborne, *Walter Benjamin, critical evaluations in cultural theory* (London: Routledge, 2004), 340.

Even more than regular live action film, animation is a conscious, direct appeal to the viewer, who on the one hand finds much less "unconscious" information in an image where nothing is accidental, everything is generated, and on the other hand is required to identify (with) artificial movements. Just as a collage imposes the need for active interpretation, animation is also a distinct format which activates, and functions through combinatorial aesthetics, linking individual frames in order to experience movements that only exist in the mind of the beholder.

Le sphygmographe de Marey, gravure extraite de *La Méthode graphique*, 1878. (Coll. privée).

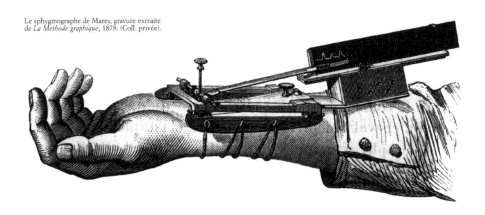

Anonymous
Marey's sphygmograph
La Méthode graphique, 1878
Courtesy Cinémathèque Française
Private collection

From Illusion to Hallucination

"The debate about the dispositif seems to take for granted that a theory of the cinema is above all a matter of epistemology—of determining the cinema as a source of knowledge about the world. Any theory of cinema is by definition 'epistemological.'"[20] Cinema is only one of the outcomes of a long series of optical inventions, most of which were aimed at demonstrating new observations about physics, biology and physiology. Taking aside the aggressively patent-producing Edison (turning invention itself into a Taylorized business), the inven-

20 Thomas Elsaesser, "Between Knowing and Believing: The Cinematic Dispositif after Cinema," (Unpublished paper, 2008).

tors of animations such as the thaumatrope, phenakistiscope, zoetrope etc. were never intending to claim the mass medium of the twentieth century. Even the Lumière brothers were at first notoriously skeptical about the commercial potential of their new observation tool. The development of the early technologies of the moving image was a consequence, not a target of the positivist approach to the human body and the standardization of its functions through countless tests and observations. The same attention for systemization, rules and exceptions led to the publication of *On the Origin of Species* (1859). For Darwin the notion of life became an autonomous, generative process, a self-regulating mechanism with an inner logic that could be analyzed and explained. The inspiration for this revolutionary theory Darwin found in his observations while breeding pigeons.

The year Darwin dethroned god, Étienne-Jules Marey was just starting as a scientist presenting a doctoral thesis on blood circulation, which would be his main field of research for the first ten years of his career.[21] After that Marey started to focus on muscle movement, which resulted in *La Machine Animale* (1873) where he illustrated the mechanics of both human and animal locomotion on land and in the air with his innovative graphics. From the very beginning of his scientific activity, he was already inventing contraptions to translate living movement into graphic notation, starting with improving the

21 Étienne-Jules Marey, "Recherches sur La Circulation du sang à l'état physiologique et dans ses mal," see: Mannoni, "Étienne-Jules Marey," 28.

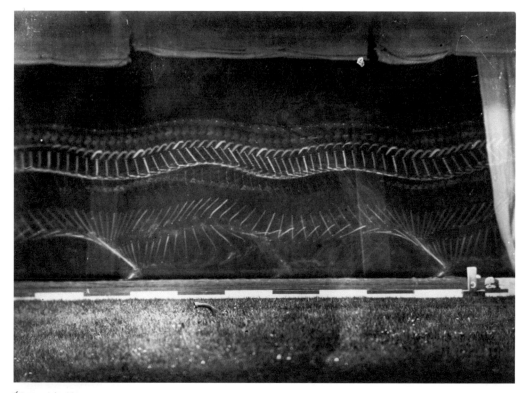

Étienne-Jules Marey
Étude cinématique de la marche de l'homme
Source: Marey, "Analyse cinématique de la marche,"
Comptes rendus de séances de l'Académie des sciences,
session of May 19, 1884
Courtesy Cinémathèque Française
Private collection

22 Laurent Mannoni, "Die Graphische Methode: eine neue Universalsprache," in *Notation: Kalkül und Form in den Künsten,* ed. Dieter Appelt, Peter Weibel, Hubertus von Amelunxen, and Angela Lammert, (Akademie der Künste, ZKM, 2008), 326.

23 Mannoni, "Étienne-Jules Marey" 38. "Tout ce qui regarde, tâte, écoute, compte, pèse et mesure à été requis, mis sur pied et braqué dans ces parallèles de l'assiégeant: dynamograhie, chronographie, densigraphie, hypsographie, calorigraphie—toutes les graphies."

24 Mannoni, "*Étienne-Jules Marey,*" 41.

sphygmograph (first introduced by Karl von Vierordt). The cinema or *bioscope* ("watching life") was neither the first, nor the last optical toy championing a scientific name with Greek or Latin origins. Obsessed with automating the graphic recording of life in all its manifestations, invention became Marey's second trade, constructing highly original mechanisms to capture the mechanic characteristics of his subjects. With his odograph for instance, he could record the number, length, and frequency of steps taken by a person walking. For each type of animal movement in his "animated bestiary"[22] a new device was needed to register its physiological characteristics. His friend Nadar noted after a visit to Marey's studio (before he moved to his much bigger *Station Physiologique* premises): "all that can observe, touch, listen, count, weigh and measure is summoned there, set up like an artillery army, ready to target: the dynamograph, the chronograph, the densigraph, the hypsograph, the calorigraph—all the graphs."[23] From Marey, life was motion, and therefore he firmly disagreed with vivisection or mutilation, as this would destroy exactly the phenomenon he wanted to analyze. As he was convinced that all dynamics in life involved chemistry and physics, he argued they could be measured, the only problem being the impact and friction of his recording devices on his subjects. Photography provided the solution. Marey wanted to record, not stop movement. Reproducing it was yet another approach to analysis. In 1867, long before he turned to the zoetrope, and later the projection of his chronophotographic images, he already inserted notations derived from his polygraph into a Duboscq lantern to illustrate at the Sorbonne the dynamics of blood.[24] Dissatisfied with the limited amount of images on discs for projection, such as the zoopraxinoscope that Muybridge had been using extensively in public lectures since 1879, Marey started work on a mechanical film projector in 1892.

For his official experiments, Marey rarely applied the apparatuses he conceived on his own body. Nor did he question his own senses, by which he interpreted his recordings. A generation earlier physiologists already focused on this aspect. In 1829 for instance, Joseph Plateau defended his university thesis in which he deals with the impression of colors on the retina, the combination of moving mathematical curves, the observation of the deformation of moving figures and the reconstruction of deformed images (anorthoscopes). These investigations lead to the publication of another paper in 1832, on "a new genre of optical illusions." Plateau describes the persistence of the image as being linked to the retina, the common view in the nineteenth century. Plateau was not the first to describe the persistence of the image, but the first to measure the phenomenon in a reproducible way, and gave it the value of 0.34 seconds. The instrument used to demonstrate this, he called the phenakistiscope, but his London publisher who began to sell the rotating discs commercially a year later, decided for the first edition on "phantasmascope" and for the second edition "fantascope." Plateau distinguished himself from fellow researchers such as Simon Stampfer (who around the same time came up with a very similar apparatus, coined the stroboscope) by the often macabre iconography he applied to his discs. A little devil breathing into a fire, a young maiden turning into an old witch, a ghostly appearance in a monastery corridor: not exactly a typical repertoire for a positivist.

Étienne-Jules Marey
Fréquence des battements de l'aile…, undated
Plate of original photographs
Courtesy Cinémathèque Française, Paris

Ever since the first magic lanterns appeared, the ambivalence between the epistemological and the illusory, magic and science, entertainment or education was an essential part of the fascination. The very term "illusion" obviously implies that there exists the opposite, true vision, real perception. Ever since Athanasius Kircher published his famous description of a magic lantern in the second edition of his *Arts Magna lucis et umbrae* (1671) the image of a skeleton or the grim reaper, appears time and again as the key signifier for the process of animating (moving, resurrecting) still images. The drawings Christiaan Huygens made in his 1659 notes, the first one seriously describing the projection of moving lantern images, are of a skeleton that toys with

25 Laurent Mannoni, Donata Pesenti Campagnoni, and David Robinson, *Light and Mouvement: incunabula of the Motion Picture 1420–1896*, (Le Giornate del Cinema Muto, Cinémathèque Française, 1995), 54.

its own skull, based on Holbein's *Dance of Death*.[25] The lantern only received its epithet "magic" in 1668 from the Italian Jesuit Eschinardi. In the case of Kircher, and even Plateau, we could relate this canonical image of death at work to the religious background they all share. If these optical instruments were also called "philosophical toys," then the skeleton is the most appropriate motif, a *memento mori* in motion. The skeleton played a central role in the fantasmagoric shows (an expanded media show orchestrated around a hidden magic lantern) that were a great commercial success when promoted by Étienne-Gaspard Robertson shortly after the bloodbaths of the French Revolution. The skeleton juggling with his head recurs as the standard image we see whenever a choreutoscope is demonstrated, an invention from 1866 by L.S. Beale and the first application of the Maltese Cross for transporting film (in this case a glass plate), thirty years before the Lumières would gratefully apply the same principle to their cinématographe.[26] 1895 was also the year of Röntgen's discovery, and soon people started collecting X-ray photographs as namecards.

26 Although their proto-documentary cinema established photorealism as the norm for moving images, there are some exceptions to this approach; in the catalogue of their first thousand films, we find under number 831: *The Happy Skeleton*. See: Auguste et Louis Lumière, *Les 1000 premiers films* (Paris: Philippe Sers éditeur, 1990), 56.

The popularization of science through toys and entertainment meant speaking to the imagination as much as to the rational mind. Another contemporary of Plateau, the Czech anatomist and physiologist Jan Evangelista Purkyně, around the same time also conceived his version of the phenakistiscope. However, he was more interested in non-retinal perception. Purkyně published on subjective vision and the effects of several drugs (camphor, opium, belladonna) on human perception as from 1819 onwards. He even electrocuted his eyeballs to observe the effect, and later on he gave his name to the reflection of objects from structures in the eye, the Purkyně images, and also explained the change of brightness of red and blue colors at dusk, coined the Purkyně shift.[27] The distinction between hallucination and illusion, between perception with or without an external object, was clearly defined in 1832 by Esquirol, who used hallucination as a medical term for purely mental manifestations, not related to actual sensations.[28] A parallel distinction could be made between the photographic and the graphic image, and between analog film and drawn animation. Marey's research activities comprised both lens-based and purely graphic systems. But even when applying the photographic procedure, Marey often stylized his recordings in such a way as to retain only a sequence of graphic lines, exoskeletons in action. From his initial work on cardiac hemographics, he concentrated his efforts on dynamic processes invisible to the naked eye. Marey first used the zoetrope to study seagulls in slow motion. However "universal" his language of visual recordings collected on paper, Lumière glass plates or film, it meant nothing without a trained eye to interpret this ontological data.

27 Purkyně also introduced the scientific terms plasma and protoplasm (which Eisenstein would rely on heavily in his theories on animation), and he created the world's first department of physiology, in 1839. See http://en.wikipedia.org/wiki/Jan_Evangelista_Purkyně.

28 Tony James, "Les hallucinés: 'rêveurs tout éveillés' – ou à moitié endormis," in Donata Pesenti Campagnoni and Paolo Tortonese, *Les arts de la hallucination* (Paris: Presses de la Sorbonne Nouvelle, 2001), 16.

Method and Metaphor

29 See Mannoni et al. "Lanterne magique et film peint."

Although cinema can be considered to be at least four hundred years old if one includes the practice of the magic lantern,[29] it is generally accepted that the first animator started his professional career only in 1908. Cohl was still a baby when Marey had already perfected the spymograph to record traces of life, which could then be reversed into living traces. In the hands of Émile Cohl, the technology for graphically

tracing the inner world would no longer reach for physical but mental life. He would be more interested in registering thoughts than heartbeats, inventing the encephalogram rather than the cardiogram. At the time Cohl entered the film industry, he already had several careers behind him, as a graphic artist, an editor, a theater writer and actor, a photographer, among other activities. Starting at Gaumont at the age of fifty-three, Cohl directed over three hundred films in thirteen years.

With the title of his first film *Fantasmagorie* he clearly inscribes himself into the tradition of Robertson, Plateau and many others, who used the prefix "fanta-" to allude to the ghostly aspect of the animations they produced. But his artificial appearances are more a kind of drunken hallucination than a horror movie. Despite a duration of less than two minutes, the plot of *Fantasmagorie* is hard to summarize, given the constant shift of the scenes. The protagonist, merely a stick figure, gets involved in several skirmishes and all the objects he encounters are caught in a free flow of associative, rapidly transforming images. The stunning pace and bizarre accumulation of rudimentary pictograms might have been the consequence of a certain lack of control over his first film, but the consecutive works show that there clearly was a method behind the madness. A familiar face in the bohemian world around Montmartre, Émile Cohl was a leading member of the *Incohérents*, a shortly lived anarchic proto-Dadaist movement (1883–1887), which mocked all academic art, in particular Symbolism and Impressionism.

Applying his incoherent strategies to film, Cohl first of all caricatures the paradigm of cinema. He even simulates the destruction of the film screen itself with his protagonist attacking it with a knife.[30] By way of signing his work, the rapid succession of animated sketches is halted by the animator to mend his broken protagonist with a pot of glue. Pronounced in French, "Cohl," the pseudonym of Émile Courtet, is homophonic to the word glue (*"colle"*). Collage aesthetics abound in his often stunningly hybrid films where a clash of techniques is the main attraction. In titles such as *Les Locataires d'à-côté (1909)*, *Transfigurations (1909)*, *Moderne Ecole (1909)*, *Les générations comiques (1909)*, *L'Enfance de l'art (1910)* or *Les Beaux-Arts mystérieux(1910)*, Cohl is combining drawn animation with cut-outs, object animation, puppet animation, split screen, hand tinting etc. Several effects, notably the stop motion trick with moving objects, were already familiar to earlier filmmakers, and even drawings that moved on their own were not entirely new.[31]

Yet Cohl deserves his claims to being the first animator, as he was the first to devote a film entirely to these techniques (thus moving from special effect to standard practice), and to develop a recurring character over several films (*Fantoche*). Some of the technical innovations, like the vertical animation stand, were actually first conceived by Cohl. Like Méliès, Cohl was essentially a craftsman, and much less a business entrepreneur. Despite their transatlantic efforts both would be overrun by American efficiency in producing, promoting and distributing his type of work internationally. Also like Méliès, Cohl's stylistic originality actually was a way of keeping up older cultural formats. If Méliès can be understood as the last stage magician, then Cohl might be deemed the final lightning sketcher, with his automatization of performative drawing.[32]

30 As a surviving still frame suggests, Émile Cohl was apparently also the first animator to scratch directly on film for his *La Revenge des Esprits* (1911) thus preceding by nearly fifty years the scratch experiments of Len Lye for his *Free Radicals* (1958) and following works.

31 Stuart Blackton made his similarly drawn film *Humorous Phases of Funny Faces* already in 1906, and in 1907 he created *The Haunted Hotel*, with the object animations that notoriously intrigued the French Gaumont studio, allowing Cohl to step in and demonstrate his understanding of the technique. See: Donald Crafton, *Emile Cohl, caricature, and film* (Princeton, N.J.: Princeton Unversity Press, 1990), 128. In 1908 Cohl made *L'Hotel du Silence*, and so did many other filmmakers like Méliès, Segundo de Chomon; later even Disney varied on this same theme of a spookily animated hotel.

32 An idea first formulated by the film historian Jacques Deslandes, cited in André Gaudreault, "From 'Primitive Cinema' to 'Kine-Attractography'" in *The Cinema of Attractions Reloaded*, ed. Wanda Strauven, (Amsterdam: UVA Press, 2006), 91. The lightning sketch motif would still recur regularly as a motif in the work of several early American animators, such as Winsor McCay, The Fleischer Brothers' *Out of the Inkwell* series, among others.

In his work, Émile Cohl entertained a lively dialogue with the cinema of his period. He also directed many live action shorts himself, and frequently parodied both social and academic institutions with his nonsensical (non-)narratives, particularly of the pre-American period. A recurring trope to motivate the insertion of animations in his live action farces, is the foregrounding of an interface, an existing or imaginary optical instrument that confronts the protagonists with their inner workings. In one of his earliest works, *Le Cerceau Magique* (1908), a hoop becomes a gateway to a fantastic animated world; in *Les Joyeux Microbes* (1909) a microscope reveals the pathologies of modern life; in *Les Lunettes Féeriques* (1909) spectacles change their qualities depending on the person who wears them and in *Le Retappeur de Cervelles* (1910) a grotesque trepanation follows the cranial inspection of a delirious character.

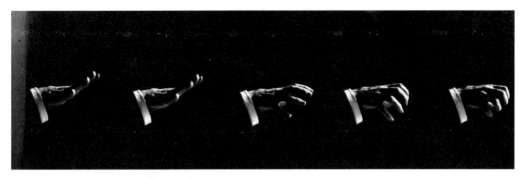

Étienne-Jules Marey
Mouvement de main, 1892
Chronophotograph on celluloid
Image courtesy Cinémathèque Française

More than even live action cinema, animated film from the start functioned like an antibody, both a symptom of and a reaction to modernity and all its expectations, restrictions, machinations. Film comedy proved a healthy response to the pathologies of the industrial age, consoling the viewer with merry caricature such as the slapstick genre. The cinema manifested itself of course as one of the most emblematic and profitable machines of the industrial economy,[33] a rigorously constructed form of entertainment. Dream therapy for the masses, as Eisenstein understood early on, an antidote to all those other imposed time regimes at work, at school etc. This innervation by the cinema, a medium that regulates while at the same time offering a deregulation of the senses, becomes an even greater paradox when applied to animation, where there is no contingency in the image, every moment calculated and controlled by the animator. And yet looming anarchy and revolt against the laws of nature is the main attraction.

If cinema creates illusions—where there is still a reference to real world—animation produces hallucinations. It consists of a fantasy universe with no necessary connections to reality, apart from the reality of the projection machine, and the physiological capacity of the viewer to recognize and respond to mimetic motion on a screen.

The optical unconscious of animation lies in its movement, not in the image information. As Marey stressed time and again, motion is

33 "Cinema is the Last Machine. It is probably the last art that will reach the mind through the senses," is a citation from Hollis Frampton's *For a metahistory of film*, quoted in Ian Christie, *The Last Machine* (London: British Film Institute, 1994), 7.

the most apparent characteristic of life. Movement equals life, it can only exist in time. Cinema reproduces movement, animation creates time. It is graphic cinema that invented the morph and the warp, the impossible transformation of form and the inversion of space.[34] In a similar way to how Max Ernst perverted the rules of the optical toy of the zoetrope, animation perverts the scopic regime of the camera. But it's the looks that count: we used quantified motions to trigger emotions. From determining the interval that deceives the brain, to measuring the heart's pulse, to the biometric organization of bodies in front of the camera and in the movie theater or the theme park: orchestrated desire through regulated behavior is still, more than ever, present in our daily interactions with technology. Modernized by the industry, animation keeps on transforming modernity in newer, more attractive configurations.

34 On the cultural history of morphing, see: Vivian Sobchack, ed., *Meta-morphing: visual transformation and the culture of the quick change* (London: University of Minnesota Press, 2000).

Execution of Czolgosz, with Panorama of Auburn Prison (1901)

Avery F. Gordon

What happens if the term animism is no longer used primarily as an ethnographic category, but is turned onto Western modernity itself? The concept then opens up a very different set of problems, at the core of which lies not subjectivity of perception but perception of the subjectivity of the so-called object. —Anselm Franke

Auburn New York Prison Card for Leon Czolgosz. 1901. Source: L. Vernon Briggs. *The Manner of Man that Kills* (1921). Da Capo Press, 1983. Retrieved from: http://en.wikipedia.org/wiki/File:Czol_execution_card.jpg.

1 See Avery F. Gordon, "On Education During Wartime," *Keeping Good Time: Reflections on Knowledge, Power, and People* (Boulder CO: Paradigm Press, 2004), 18–26.

2 Emma Goldman, "The Tragedy at Buffalo," *Free Society: A Journal of Anarchist Communism*, (October 1901). http://en.wikisource.org/wiki/The_Tragedy_at_Buffalo.

Leon F. Czolgosz, a 28 year old anarchist and steel worker who often used his mother's maiden name "Nieman," shot President William McKinley on September 6, 1901 in the Temple of Music at the Pan American Exposition in Buffalo, New York. McKinley, who died eight days later, is best known for having been assassinated and for starting the Spanish American War, presumed to be the first US imperialist war.[1]

Very little is known about "the young man with the girlish face."[2] One of seven children of Polish immigrants, Czolgosz was born in Michigan and lived and worked in Pennsylvania, Ohio and Illinois. It was said he was estranged from his family and solitary, spending his free time reading socialist and anarchist newspapers. He was accused by the editors of *Free Society: A Journal of Anarchist Commu-*

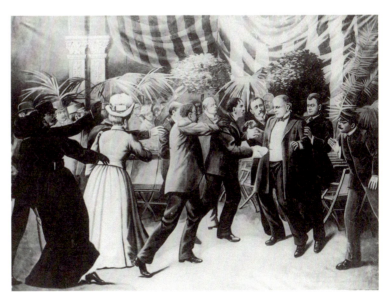

T. Dart Walker
Wash drawing of assassination of President William McKinley by Leon Czolgosz at Pan-American Exposition reception, ca. 1905
Source: Library of Congress Print and Photograph Division (cph.3a08686)

nism of being a government provocateur, but Emma Goldman, who inspired him, and who Czolgosz met very briefly, dismissed the charge and wrote eloquently about the young man who killed the "president of the money kings and trust magnates."[3]

Leon Czolgosz moved to Buffalo in August and on that September day waited in the receiving line to greet McKinley. Rather than shaking the President's hand, he shot him twice at point blank range with a .32 caliber revolver. He was immediately captured by the secret service agents and military police present and beaten almost to death by them. Between the angry crowds, the police and the prison guards, by the time Czolgosz arrived at Auburn Prison (via the Erie County Women's Penitentiary) on September 27 to be executed by electric chair as punishment for his crime, he was barely alive himself, unable to stand, moaning in pain. Czolgosz said nothing at his trial and refused to cooperate with his assigned lawyers, but moments before his death on October 29, strapped into the large electric chair, he was reported to have shouted out: "I killed the President because he was the enemy of the good people! I did it for the help of the good people, the working men of all countries!"[4]

Czolgosz's brother Waldek and brother-in-law Frank Bandowski were witnesses to the execution, but they were not permitted to take away Leon's body. After his brain was autopsied (no doubt to confirm the noted criminologist Cesare Lombroso's theory that "there were a greater number of 'lunatics' and 'indirect suicides'... among anarchists than among ordinary criminals"), sulfuric acid was placed into his coffin to destroy the body, his letters and clothes were burned, and his remains were buried on the prison grounds.[5] McKinley's assassination ignited another violent wave of anti-anarchist and anti-radical hysteria against those heard or known to be critical of McKinley and especially of his war that included the arrest of Emma Goldman, the tarring and feathering of Reverend Joseph A. Wildman by his own congregation, several near-lynchings, and numerous mob attacks that forced individuals and families to flee their homes. With the desecration and burial of Czolgosz, the vigilantism momentarily quieted, but "America's ongoing anti-radical bloodlust" persisted in various forms, aided and activated by Edwin S. Porter's widely viewed film of Czolgosz's execution and others such as D. W. Griffith's *The Voice of the Violin* (1909).[6]

Leon Czolgosz was the fiftieth person to die in the electric chair in the state of New York. Edwin S. Porter's reenactment of his execution for Thomas A. Edison Inc. marked the culmination of Edison's opportunistic involvement in electrocution. The first electric chair was built by Harold Brown, then secretly employed by Thomas Edison, and introduced at Auburn prison in 1890, replacing hanging as the principal form of capital punishment. Although Edison claimed to oppose capital punishment, his desire to crush his competitor George Westinghouse was stronger. The War of the Currents was aggressively prosecuted by Edison who ran a smear campaign against Westinghouse and his AC current, which included setting up a 1000 volt Westinghouse AC generator in New Jersey and publicly executing a dozen animals, the better to discredit it, which garnered considerable press coverage and lead to the new term "electrocution" to describe death by electricity. A skilled political operator, Edison not only lobbied the New York legislature to select AC for use in electrocution but managed to get Fred Peterson,

3 "Leon Czolgosz." http://en.wikipedia.org/wiki/Leon_czolgosz; Emma Goldman, "The Tragedy at Buffalo."

4 The Buffalo History Works, "The Trial and Execution of Leon Czolgosz." http://www.buffalo-historyworks.com/panamex/assassination/executon.htm. "Buffalo Men at the Execution. Sheriff Caldwell and Charles R. Huntley Saw Czolgosz Die. Their Impressions," *Buffalo Commercial,* (October 29, 1901). http://en.wikisource.org/wiki/Buffalo_Commercial/Buffalo_Men_at_the_Execution.

First photograph of Leon Czolgosz in jail. 1901.
Source: *Leslie's Weekly.* September 9, 1901, Cover. Library of Congress Print and Photograph Division (cph.3b46778).

5 Gina Lombroso-Ferrero, *Criminal Man: According to the Classifications of Cesare Lombroso* (Montclair NJ: Paterson Smith, 1972), 305.

Detail of Sing Sing Prison Principal Keeper James Connaughton's Execution Log Book. 1896-1897. Source: Sing Sing Prison Documents, 1893-1928. Westchester County, NY.

6 See Byron R. Bryant, "When Czolgosz Shot McKinley: a Study in anti-Anarchist Hysteria," *Resistance,* vol. 8, no. 3 (December 1949): 5–7; Richard Porton, *Film and the Anarchist Imagination,* (London and New York: Verso, 1999), 16; and Chris Vials, "The Despotism of the Popular: Anarchy and Leon Czolgosz at the Turn of the Century," *Americana: The Journal of American Popular Culture,* vol. 3, no. 2 (Fall 2004).

7 *Electrocuting an Elephant (1903).* http://en.wikipedia.org/wiki/File:Topsy.ogg.

8 Both Gustave Baumont and Alexis de Tocqueville (in *On the Penitentiary System in the United States and its Application in France,* 1833) and Charles Dickens (in *American Notes,* 1842) offered a very different impression of that panorama, finding the Auburn system of silence and hard labor inhumane.

9 "Jacksonian editor Francis Preston Blair rises from his coffin, revived by a primitive galvanic battery, as two demons look on. A man on the right throws up his hands as he is drawn toward Blair, saying: Had I not been born insensible to fear, now should I be most horribly afraid. Hence! horrible shadow! unreal mockery. Hence! And yet it stays: can it be real. How it grows! How malignity and venom are 'blended in cadaverous union' in its countenance! It must surely be a 'galvanized corpse.' But what do I feel? The thing begins to draw me... I can't withstand it. I shall hug it!" *Galvanism* (from the exhibition *Frankenstein: Penetrating the Secrets of Nature*). United States National Library of Medicine. National Institutes of Health. http://www.nlm.nih.gov/exhibition/frankenstein/galvanism.html.

10 Edward W. Byrn quoted in Jurgen Martschukat, "'The Art of Killing by Electricity': The Sublime and the Electric Chair" *The Journal of American History,* vol. 89, no. 3 (December 2002): 906, 908–9 (on Henry Adams).

a doctor hired by Edison to build him an AC chair, appointed to the committee, which unsurprisingly selected the AC voltage electric chair. Despite the fact that for years people referred to the process of being electrocuted as being "Westinghoused," Westinghouse did not support capital punishment, refused to sell his generators to prison authorities, and funded the legal appeals of the first prisoners sentenced to death by electricity. In the end, Thomas Edison lost the War of the Currents, but the battle confirmed his great talent for maximizing profits and monopolizing intellectual property. The sober representation of Czolgosz's execution—swift, seemingly without pain or bodily mutilation, a model of rational efficiency—was in sharp contrast to the reality of electrocution and to the far more graphic 1903 Edison depiction of its use to kill Topsy the elephant.[7] But, then, *Execution of Czolgosz*, with its touted panorama of Auburn prison was less an argument for or against electrocution than it was an example of electricity in the service of the restoration of a social order momentarily disrupted by the death of the President of Progress, Industry and Empire by a self-proclaimed anarchist.[8]

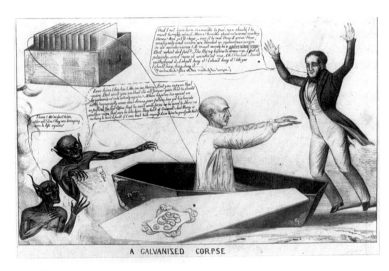

H.R. Robinson. *A Galvanized Corpse*, 1836.[9]
Source: Library of Congress Prints and Photographs Division (LC-USZ62-11916).

By the late nineteenth and early twentieth century, Mary Shelley's Dr. Frankenstein, grievously troubled over his usurpation of the divine powers of creation, has been replaced by Edison's Tower of Light, blinding in its scientific harnessing of what Henry Adams called electricity's "occult mechanism" to capitalist expansion and social order. As one nineteenth-century observer remarked, "The old world of creation is, that God breathed into the clay the breath of life. In the new world of invention mind has breathed into matter, and a new and expanding creation unfolds itself…. He [man] has touched it [matter] with the divine breath of thought and made a new world."[10] This new world was conspicuously displayed first in 1893 at the World's Columbian Exposition in Chicago and then at the 1901 Pan-American Exposition in Buffalo New York, both important industrial cities, each

fair designed to celebrate a phase in the conquest of the Americas. Chicago, in commemoration of the 400th anniversary of Columbus's arrival, debuted the installation of the 82 foot tall Edison Tower of Light, its 10,000 light bulbs flashing in concert with the 90,000 bulbs and 5,000 arc lambs lighting the grounds, which was built to 391 feet in Buffalo. This dazzling display of invention illuminated its automachinic wonders—the first electric chair among them—and the appropriate instruction to be made of them. Inspired by the living ethnological villages French anthropologists helped design to represent the colonized peoples of Africa and Asia at the 1889 Universal Exposition in Paris, Chicago hired Harvard's Frederic Ward Putnam to design the Midway Plaisance. Set at an angle to the White City, the Midway's living museum of "primitive" peoples was conceived to enable visitors to measure progress toward the electrified idea of civilization displayed in the White City.[11] That electricity was a key technological and symbolic medium by which modernity's presumptive progress was articulated was reiterated at the Pan American Exposition where it was explicitly tied to service in justifying the Monroe Doctrine, the Spanish American War, and US global expansion. As President McKinley said in the final speech he made before being shot by Czolgosz: "The Pan-American Exposition has done its work thoroughly… illustrating the progress of the human family in the Western Hemisphere…. The expansion of our trade and commerce is the pressing problem."[12]

By 1901, "American capital was no longer a middling mercantile player in a global economy commanded by imperial European powers. Now it was a robust industrial society voraciously appropriating a vast but disparate labor force which required cultural discipline, social

11 It's worth noting that the segregationist schooling faltered on at least two fronts. First, the Midway became the amusement center of the fair—George Ferris's great wheel was there and because the ethnological villages were also concessionary businesses, they offered more exotic and enticing entertainment than the more "civilized" and Victorian White City. Second, despite Frederick Douglass's participation as Haiti's representative, there was organized opposition (including a boycott) by African Americans to their racist exclusion, led by the great anti-lynching agitator, Ida B. Wells. Black radicalism and cultural hybridity (even if consistently disavowed) remained two key modalities by which white supremacy and segregationism have been continuously challenged and sometimes even undone.

12 "The Last Speech of William McKinley," Buffalo, New York, September 5, 1901. http://www.pbs.org/wgbh/amex/1900/filmmore/reference/primary/lastspeech.html. Silent film of the president's last speech is online at: http://www.youtube.com/watch?v=OtaGGG2uP7A.

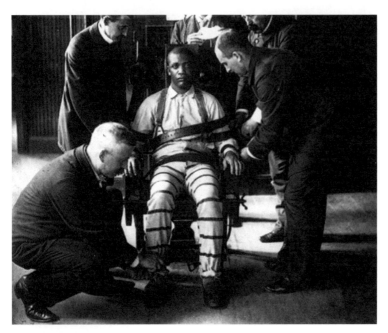

An African-American prisoner is prepared for execution in "Old Sparky," Sing-Sing Prison's electric chair. c1900. William M. Van der Weyde. (Library of Congress). Retrieved from: http://civilliberty.about.com/od/capitalpunishment/ig/Types-of-Executions/The-Electric-Chair.htm.

13 Cedric J. Robinson, *Forgeries of Memory and Meaning: Blacks and the Regimes of Race in American Theater and Film Before World War II* (Chapel Hill: University of North Carolina Press, 2007), 92.

14 See Robinson, *Forgeries of Memory and Meaning* and Jonathan Auerbach, "McKinley at Home: How Early American Cinema Made News," *American Quarterly,* vol. 51, no. 4 (December 1999). The most comprehensive collection of Edison source materials is available from the Library of Congress: http://memory.loc.gov/ammem/edhtml/edbiohm.html.

habituation, and political regulation."[13] The social and human terms of this advanced society were deadly: a finance-controlled monopoly capitalism rooted in patriarchal militarism and white supremacy. The US nation state will also, in time, be secured by regimes of punishment and imprisonment whose origins in the aftermath of the Civil War determined its trajectory and the particular fate of Black Americans who today remain the disproportionate object of state violence and its legal sovereignty in matters of life and death. Cinema played an important role justifying and normalizing this way of life. Thomas A. Edison Inc.'s propaganda films for the Spanish American War made by William Paley, for the Pan American Exposition, and for McKinley's presidential authority (his inauguration, death, and funeral) are only the most literal examples of Edison's particular contribution to this cinematic project.[14] Certainly too, it's arguably the case, that, in all these films, what's notably absent and repressed is just as significant: Black soldier resistance and desertion and the ongoing guerilla insurgency in the Philippines; the courageous movement to stop the lynching epidemic that terrorized black men, women and children from 1892–1902; or the organizing by workers against the degradations of capitalism and the founding of the US Socialist Party (1901) and the IWW (1905).

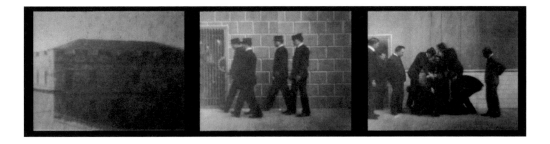

15 Edison film company catalog. http://memory.loc.gov/cgi-bin/query/r?ammem/papr:@filreq(@field(NUMBER+@band(lcmp001+m1b38298))+@field(COLLID+mckin)).

ELECTROCUTION OF CZOLGOSZ. Unhonored. [code for telegraphic orders]. A detailed reproduction of the execution of the assassin of President McKinley faithfully carried out from the description of an eye witness. The picture is in three scenes. First: Panoramic view of Auburn Prison taken the morning of the electrocution. The picture then dissolves into the corridor of murderer's row. The keepers are seen taking Czolgosz from his cell to the death chamber, and shows State Electrician, Wardens and Doctors making a final test of the chair. Czolgosz is then brought in by the guard and is quickly strapped into the chair. The current is turned on at a signal from the Warden, and the assassin heaves heavily as though the straps would break. He drops prone after the current is turned off. The doctors examine the body and report to the Warden that he is dead, and he in turn officially announces the death to the witness.[15]

A perception of the subjectivity of the so-called object is exactly what *Execution of Czolgosz* does not animate or conjure. Only the object and something of the forces that made it are there. Not because "passing from life to death, the figure on the screen… revers[es] the normal animating process by which cinema works its magic."[16] It's not a question of cinematic form *per se*, whose effectivity and residual melancholy is precisely that it can pass in both directions—from death to life and life to death—simultaneously, in time and across time. It's a question of whether there is to be found even a trace of sympathy for "the young man with the girlish face, about to be put to death by the coarse, brutal hands of the law, walking up and down the narrow cell, with cold, cruel eyes following him, 'who watch him when he tries to weep.'" It is a question of whether we are invited to contemplate, touch even, the animating force that "induces… a man to strike a blow at organized power."[17] This is the force the state tried unsuccessfully to kill and which, notwithstanding the objectification of Leon Czolgosz, the solitary anarchist with a girlish face, remains still, barely, a trace reaching across time to me, to us, today.

Portrait of Leon Czolgosz
Source: *Harper's Weekly.*
September 21, 1901.

16 Auberbach, "McKinley at Home," 824.

17 Emma Goldman, "The Tragedy at Buffalo," quoting Oscar Wilde's meditation on the death penalty, *The Ballad of Reading Gaol,* written after he was released from Reading prison on May 19, 1897.

Chasing Shadows

Santu Mofokeng

Many South Africans believed in apartheid as in inyanga (traditional healer), as in the sjambok (whip), as they believed in everything which made it unnecessary for them to forge their own destiny; they loved their fear, it reconciled them with themselves, it suspended the faculties of the spirit like a sneeze. Apartheid was a roof. And under this roof life was difficult; many aspects of life were concealed, proscribed. People tried to live their lives in dignity but their joy was tainted with guilt and defiance.

In South Africa, many black people spend their lives chasing shadows. While the expression "chasing shadows" has quixotic connotations in English, in indigenous languages the expression represents the pursuit of something real, something capable of action, of causing effects—a chase perhaps joined in order to forestall a threat or danger. Seriti in Sesotho (my mother tongue) does not readily translate. The word is often translated only as "shadow," unwittingly combining the meanings of moriti and seriti. The word "seriti" overlaps the word meaning "shadow," but the absence of light is not all there is to seriti. In everyday usage seriti can mean anything from aura, presence, dignity, confidence, spirit, essence, status, wellbeing and power—power to attract good fortune and to ward off bad luck and disease.

The demise of apartheid has brought to the fore a crisis of spiritual insecurity for the many who believe in the spiritual dimensions of life. Today, this consciousness of spiritual forces, which helped people cope with the burdens of apartheid, is being undermined by mutations in nature. If apartheid was a scourge the new threat is a virus; invisible perils both.

Nothing forces a backward glance like a threat. The Chinese say that our body is the memory of our ancestors. This is an ominous proposition since apartheid is an impossible ancestor, inappropriate and unsuitable. Whenever we come under threat we remember who we are and where we come from and we respond accordingly. The word "remember" needs elaboration. Re/member is a process by which we restore to the body forgotten memories. The body in this case is the landscape—on whose skin and belly histories and myths are projected—which is central to forging national identity.

One can't travel far within this country before coming upon shadowed ground of negative remembrances of violence and tragedy. This partly explains my peregrinations here and in foreign lands. This journey which began at home in Soweto took me to places invested with spiritual meaning in the Free State—concentration camps, burial grounds in Middleburg, Greylingstad and Brandfort—in my effort to embody the SA landscape.

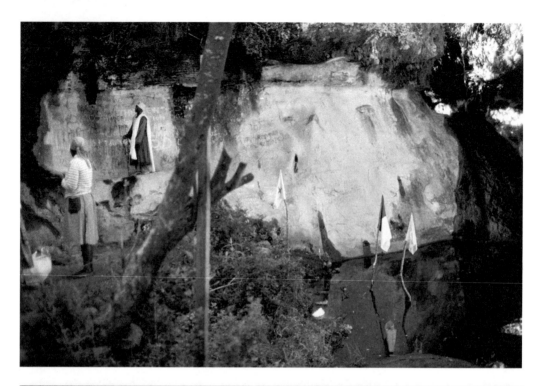

Santu Mofokeng
Chasing Shadows
above: *Christmas Church Service, Mautse Cave—Free State*, 2000
below: *Offertory/Shrine, Motouleng Cave—Free State*, 1996
Lambda prints
Courtesy the artist

Animism 82

Santu Mofokeng
Chasing Shadows
above: *Kgoro/Enclosure with Washing Line, Motouleng Cave—Free State*, 1996
below: *Inside Motouleng Cave—Free State*, 1996
Lambda prints
Courtesy the artist

In 1997 I started to visit the shadow grounds in Europe and Asia. I wanted to see how other countries were dealing with places associated with negative memories. In South Africa we were still discussing the fates of Robben Island, Vlakplaas and similarly affected sites at the time. Suffice to say, my forays into the metropoles of Europe have since convinced me of the futility of this enquiry. There is no universal model to follow. My efforts at this point are tantamount to chasing shadows.

For his project *Primitive*, filmmaker Apichatpong Weerasethakul travelled to the northeast of Thailand— an area where inhabitants' lives are characterized by the migration of souls between people, plants, animals and ghosts. *Primitive* is a multi-part project dealing with the history of Nabua, a village near the border with Laos. It was one of the places the Thai army occupied from the 1960s to the early 1980s in order to curb the communist insurgents. In 1965, it earned a nationwide reputation when the first battle between farmer communists and the totalitarian government broke out. Heavily occupied and controlled by the military for two decades, Nabua was the scene of fierce oppression, fighting and violence. In the *Primitive* project, Apichatpong Weerasethakul worked with the teenagers of the village, among others, exploring the presence and absence of a cosmography that has been destroyed.

Apichatpong Weerasethakul
Phantoms of Nabua, 2009
Digital video projection, 10 min 56 sec
© Kick the Machine Films, 2009

Angels Without Wings

A conversation between
Bruno Latour and Anselm Franke

Anselm Franke: Having your book *We Have Never Been Modern* in mind, I was wondering whether one could think of the institution of the museum, or the institution of the exhibition, within the diagram of the "modern constitution" you set up. I was trying to find a place for the museum and the exhibition within that diagram. Art institutions and museums of all kinds always had a license to officially represent hybrids, which is something that you otherwise describe as non-exist-ent in the setting of the modern constitution. Hybrids are everywhere and above all, proliferating, but not represented. They appear as mere intermediaries, but not in their full right as mediators. I was wondering what happens, for example, with such an interesting hybrid, like a trac-tor, when it's out of use? It either goes to the museum or to the dump, *chora,* where objects or things disintegrate. But what exactly happens when it goes to the museum?

Bruno Latour: Museums have never been modern, either. No one has ever been modern, so the museums have always maintained an ex-traordinary diversity of approach, always mixing art and science and antiquity in some way. There is a recent book on the invention of the Louvre. The Louvre has nothing modern about it; it is an extraordi-nary *Wunderkammer* that was built after the Revolution. And as for the scientific museum, a good example is the CNAM, the Conserva-toire National des Arts et des Métiers, which is one of the most beauti-ful museums in Paris, despite its own "modernizing" discourse about progress. It's a beautiful museum; the modernizing ideology remains, except where things stopped in the 70s or 60s with the computer. Eve-rything there is like a beautiful art object, despite the fact that they once were steam engines and so on. Technical museums are very in-teresting places to show how little we have been modern, so to speak. Even though it's not explicitly their message, it takes just a little twist to make different labels in the same museum. And there are actually a few technical museums that do that. CNAM is a good example, even though it is in France, which is a "modernist" country par excellence. It presents a very different narrative, which is more about drawings, than about aesthetics; it's about dreams, especially compared to the Science Museum in London and the Munich Technical Museum, which remain very technical– a technically grounded technical museum. The defense of technical cultures is quite modern. Museums are a place where hybrids have lived. Where would hybrids *not* live?

AF: But what is the contract, the political conditions that allow them to do it officially? One of the main narratives of modern art since the

late nineteenth century has been the discontent with "art," in the widest sense, being excluded from political consequentiality. So couldn't one say, yes, hybrids were allowed to be represented in museums, but on the condition that they remained politically inconsequential–which, of course, they never quite did. But the basic contract around the autonomy and freedom of art is a "yes but": You're free to deal with hybrids and expose them, but you pay that price of being rendered inconsequential. Then all the avant-gardes immediately start contesting that border again. They want to reconcile across the registers of the grand dualisms, move into everyday life; become political agents. One of the main drives in modernist progressive art history is to undo that very border, that circle of exemption drawn around the museum, which allowed it to do what it does.

BL: Well, we touch upon some of what was in "Iconoclash," but this was actually Peter Weibel's view in the last part of the *Iconoclash* catalogue around what happened to modernist art history. But the constitution is not something you can live; it is an idea. It's very easy to find counter examples of a distinction and, because the problem of being modern is that there's no way you can live being modern, it would mean that you would distinguish precisely what your daily practice always mixed, so what you say is very true of the museum. Hybrids are everywhere, but the question is how do you tame them, or do you explicitly recognize their strengths, which is part of the animist power of objects? So it is true that there is a sort of boundary around the museum; there is a denigration of their political impact. Thus art historians have done for the museum what historians of science have done for science; that is, they have shown that of course it is impossible to do that, and that they always have political dimensions. And they have renewed the question of what it means to be political, not just having a political dimension, which was the old way of approaching the question.

AF: But when you say that the constitution can't be lived, it nevertheless translates into border-making practice; that is, a political practice above all.

BL: Which is immediately covered and undermined–

AF: But I am thinking, for example, how the possibility to inscribe people into the continuum of nature has made their extinction possible, which is what happened to many so-called "animist" societies. And that was made possible with the help of a certain imaginary of animism, in which the "proper" distinctions that stem from the official constitution are conflated, and which regards the animation of objects, the treatment of non-humans as persons, as an epistemological mistake. In making an exhibition on animism, one encounters different registers whose relations are problematic; for example, the relation between the compensatory, symptomatic "animism" and animism as a practice that deals in particular ways with imagery. Recently, animism can be discussed again outside the specific twists and knots that the modern constitution produced, simply as a question of organizing associations.

BL: You cannot escape the official, officious distinction, because you can say, "Modernism is the mode of life that finds the soul with which matter would be endowed, the animation, shocking." Except, of course, it doesn't work very well, because it's also where these most extraordinary features of the things, of the facts speaking by themselves, which is an extraordinary invention of the modern, are invented. So simultaneously, while you would say that the "official" version is that you should be shocked every time you have an "animistic" argument because it's impossible for things to have souls, they have speech. And not only that, but they speak by themselves. So even to say—this is my dispute with Descola—what is modern or naturalist, to use his terms, is already an immense leap of imagination, because a naturalism that invents facts speaking by themselves looks to me a lot like a very, very intensely engaged definition of animism. So just by having speaking entities, which are nonetheless "devoided" of souls, we have already a hybrid, a fetish, a "factish" of such intensity. But it's not impossible to analyze it very clearly by saying: Officially it is separated, yet it's immediately denegated, and it's crisscrossed in multiple ways, and made into something entirely different, which is the most bizarre relation between non-souls speaking matters of fact, which is an odd piece of animism.

AF: The crossing-out of the soul allows for a different kind of speaking object, in your understanding? Why does the soul have to be crossed-out in the first place?

BL: Just one example: Simon Schaffer has a beautiful paper in which he shows that the carrier of gravitational force for Newton had been angels for many, many years. So it's first of all angels, which will transfer gravitational force at a distance, because acting at a distance was one of the avatars of animism in the seventeenth century; I don't mean animism in the anthropological sense, but in the sense that things have agency. If animism is about things having agency, then one thing modernists have done has been to multiply the amount of agencies in the world to an extraordinary degree. But we have silenced it. As Schaffer shows in his paper, the angels that are behind gravitational waves or gravitational forces have no wings. The wings are not visible. It's a very beautiful case. If you ask what it is to be modern, is it to have angels carrying gravity? Is it angels losing their wings so we now believe that gravity is a purely material force? And what would it mean if it were only a material force? It would be a really strange thing, indeed. What is it to have agency? Now take the scientists who believe that things have agency–and who doesn't say that? Everybody says it. So the problem with this modernist argument about what modernism has been is that it never can withstand one minute of analysis or history because modernists have never been modern. They always lived in history. And the great puzzle is how they can believe that animism is a problem, as if they were living in a world where no one has it, no one speaks, no one has a soul, and suddenly there are these strange guys from far away, or these odd, who believe that things have agency. It is very odd, and very surprising! The whole scene where this is surprising is what has to be explained. So you see, it's not the same question. Explaining why people are surprised by animism is not the same thing as saying... Well,

of course, in the official constitution, animism is not allowed, because, again, it is unsustainable.

AF: In this official version, with all the slippery ground it stands on, it is nevertheless a permanent transgression?

BL: Yes, that is part of being modern. What you describe is the opacity of being modern. You make a distinction, and immediately you erase it. That is what makes this an anthropological puzzle. And when they encounter animists, I mean in the anthropological sense, I mean people who build this sort of thing [*pointing to an African sculpture*], then they are completely twisted–they don't know how to react. It's not that they are not animists and the others are; it's that they are animists to a denegated degree, and they see others who are animists.

AF: And you have described this as also a sort of fetishism of a second, higher order.

BL: Yes, that is a form of fetishism that has been very well worked out by Viveiros de Castro.

AF: One genealogy of animism would be found in insanity, in madness, where it is delegated to this fantasy space of the unreal, full of symptoms, desires, strange mirror effects.

BL: Right. Mad people, artists, Others–all of these guys might be animists, but not us. Except that we immediately begin to do all these sorts of things.

AF: So what you described with the "modern constitution" is a scenography that exists and is dismantled at the same time? It was never functional in the sense that it didn't do what it said it did; but as a scenography it existed and produced realities. Was it a regime of justification?

BL: It is complicated to know what it was, I understand the question.

AF: The trace the question of animism left in the history of modern imagery and Western art history is very much implicated in that paradoxical scenography. There are the modern distinctions, the modern boundaries and dualisms, and art transgresses and simultaneously confirms them all the time. The drive to animate and mobilize; and the drive to conserve, to fix, and so forth, are mutually constitutive for modern imagery and media, from the idea of the museum to cinema; and they perform a strange dialectics. The problem one faces in making an exhibition is to find a way out of that logic, not to confirm that scenography of imaginary opposites, not to affirm the twisted logic–

BL: It is the same problem we had with "Iconoclash"– how to do a non-iconoclastic exhibition on iconoclasm, and it was very difficult.

AF: And what was the solution that you found?

BL: Well, to do an *Iconoclash,* and not an iconoclastic exhibition; and

very few people understood this, actually, because in part, the art world is completely sold on the idea of being iconoclastic—as a positive term. They call it critique, but it's exactly the same thing. So the sudden idea that you could turn iconoclasm from a resource into a topic is difficult. If you want to turn animism from a resource into a topic, it's probably similar. That is, it's a resource that people use to say, "You are an animist, and I am" –what would you say?–"a positivist." I believe in the distinction between souls and matter, let's say. And you are mad, so it's OK, because mad people or kids, mad people or artists, or savages; in those cases animism is a resource, a critical resource. Now, when you say, "I am making it a topic and not a resource. I'm not going to use animism as a resource, I'm going to use it as a topic"; what you see immediately arriving in the middle of your field of inquiry is agency. Now, you are anti-animist. Does that mean that there is no agency in the world? At all? Your interlocutor would say, yes, of course, there is agency. Atoms have agency, cells have agency, stars have agency, psyches have agency; and then you begin to look at the specificity and the specification of all these agencies, and you realize that you begin to jump from one field to the other, like Newton's angels, shifting from the very, very odd and unorthodox angelology of Newton to physics— are we still there, with the angels without their wings? So we begin to have a whole series of transports, of agencies from one domain to the other. Biology would be full of it. The whole question of agencies in biology is the gene. What is the action of the gene? What does it do and where does it come from? So suddenly, when animism becomes a topic instead of a resource, you can no longer use it as a term of a metalanguage. I'm not talking about the anthropological question, which is the Descola/Vivieros De Castro question of perspectivism. You see, in all of this discussion in anthropology, the moderns are the ones who are supposed to be understood by the official philosophy. Now, when you study the others, the Amazonian people, the Chinese, and so forth, they never say, "Well, just let us look at their philosophy." They look at their practices. So there is a complete disconnect when they deal with the modern, and only in this case do they deal with the official version. They deal with John Searle and they say, "I interviewed John Searle, and John Searle would say, 'Yes of course [*pounding on the table*] this has no agency, and you have agency; or you don't have agency, because you are full of little networks and genes and manipulators, and so you have no agency. This has no agency, agency is nothing.'" But, of course, just the same, no anthropologist should take John Searle's idea as a description of the "modern" culture in which he lives. We have a proliferation of agencies with a very, very strange mixed and hybrid history. We'll just jump. Do you see what I mean?

AF: I am thinking through some of your beautiful diagrams, and I am thinking of whether they have a common denominator, like exemplifying a particular operation that repeatedly occurs in most of them. It seems to be the paradox you have mentioned earlier: You erect a border and immediately undermine it; you cross out one thing to establish a short-cut, and on the blind spot you established, you make many other things possible.

BL: Yes, the fact that people believed they were modern had the same

effect as people believing they were revolutionary. But even the effect is difficult to describe, because it has negative and positive aspects. One of the negative effects is, if you believe the others are animists you are allowed more exploitations, because there is very little precaution to take, as we said at the beginning. In the idea of matter, in the idea of the non-animated, there is clearly license to go to much greater lengths in the same way as when you believe that animals are animal-machines you can be more cruel; and it's true also of humans. And so, negatively, it certainly has an effect. And positively. It is very difficult to differentiate the two, because you are free to go much further in many activities. Viveiros de Castro has this beautiful argument that, in our society, the big problem is solipsism, and the big problem with "East Indians" is cannibalism. It is a great anxiety to meet someone's own meat, if I can say it that way, whereas in "our" society (with even more of a quotation mark around "our"), solipsism is a bigger question, and you don't know if you are going to reach an alterity of any sort. So it has an effect, but the description of the effect is very difficult. In the case of science, the biggest effect, in my experience, is the doubt it casts on the impossibility of thinking about your own activity as a constructive activity. I mean, the disappearance of efficacy, that is clearly something—you accuse the one of being animistic and then you deprive yourself of any sort of tools to act. You are constantly deprived of efficacy, of the ability to "*faire faire*" as we say in French, to "make do." So you enter into a very strange, specifically modern madness about "making do," which is the source, if we are right in our catalogue of "Iconoclash," of many of the iconoclastic adventures, because you are constantly trying to break your own tools to act, so to speak. So the modernist "avant-garde" history of art has been doing that for most of the twentieth century; I mean, constantly trying to destroy what makes you able to do. That's why the twentieth century seems so far away, why it seems like it was the Middle Ages, because we can't relate to it any more.

AF: There are several points where you describe this, also in the *Iconoclash* introduction, where you literally speak of the double madness of the iconoclasts, a specific psychopathology of the moderns, shifting between omnipotence and the deprivation of any possibility to act. I wonder what this psychopathology does at that negotiating table to which the moderns, once the scenography of the constitution has disappeared, finally return, which you describe in *War of the Worlds: What about Peace?* as a second "first contact" of the moderns with everyone else.

BL: This is part of my discussion with Viveiros de Castro. He says no one from my people will ever want to be at your negotiating table. Descola says that, too. When I organized a meeting in Venice somewhere, Descola was very clear. He says, if any one of "our" Indians were sitting at the negotiating table, they would flee from it, because having a negotiating table is a typically modernist way of assembling. So this is our way of gathering—I mean, "our way" of gathering dissenters. But the thing is slightly more complicated than that. There are lots of other ways of composing than the negotiating table. Isabelle Stengers uses the word "diplomacy," which is slightly better, because it doesn't even predetermine if there will be a negotiating table; so it's

even more open. Will there be a negotiating table? Maybe, maybe not. If the moderns recover their "factischism," when they first realize that they have never been modern, and then suddenly realize that the negotiation is slightly more complicated, and then realize that they have been the enemies themselves all along, except they had strange souls and attributed even stranger souls to the others, or so we are supposed to believe, then we will see what happens! Would it be a negotiating table? I don't know, because we have very little idea about what the modernists will inherit when they abandon their idea of having been the bearer of rationality. We have very few inklings, and the reason why is that, in the meantimes, which was unexpected when I wrote this book, all of the others are modernizing in the most blatantly modernist unrepentant way: the Chinese, the Indians, the Indonesians. So actually, it's interesting that you are doing an exhibition on animism, because it's the spirit of the time, the Zeitgeist. It's like "Iconoclash." Suddenly, the Europeans realize that, wait a minute, maybe we made a big mistake in attributing animism to the others. What happens if we have been animists, and in what way were we? Since we have agencies everywhere, we mix the agencies, we made a whole series of transformations about the agent, we added wings, and we took the souls out, and sometimes the opposite. We did all sorts of very, very strange things, and we turned to the others, who are no longer others, and what did they do? Well they modernized without any worry.

AF: But if the moderns animated without knowing it, or they did magic all the time without knowing magic–

BL: Animation isn't magic, it's science. You cannot do magic.

AF: You cannot do magic?

BL: Magic is not magic. Magic is not magical. Magic is something else. But for agency and the transformation of agencies, you cannot do without it if you are a scientist. That's why when people say Newton is simultaneously an alchemist and a physicist, it doesn't mean much, because, on the contrary, he is doing good physics because he is doing alchemy. It's not that he is divided; he is not a divided soul, half-modern and half-archaic. He is doing transformations of agencies, which is exactly what science is doing. And that's what scientists have always done. Now, of course, you will say the official registration of that is something very different. Yes, and it makes a difference. It makes a difference in teaching, it makes a difference in exploitation, and it makes a difference in property, appropriation of matters, and so on. But then, when you ask what difference it makes, what effect it has, it's much more complicated, because the effects are like the effects of all denegated concepts about what you do. It drifts. So even to describe the effects of the belief in "inanimates" is complicated. What has to be explained in my view is the belief in "inanimates". It is an odd belief, because of course, again, it never worked. So it is this belief in the inanimate that is the big mystery—animism is very easy to explain, but inanimism is very strange. Especially when it's inanimates speaking by themselves, so they are inanimated but speak, able to close an argument, because they are undisputable. So when you add up all these things that inani-

mate things do, they are quite full of interesting agencies and animation as well. Now, of course, to believe that this set of capacities is completely different from what animist people do is very important. And it has effects, but it doesn't have effects that can be foreseen without being studied, because the effect might be very, very odd, and the effect might be madness. It might be a very strange hubris. Maybe the whole hubris argument is coming from that. You just become twisted in your head when you believe that the others are animist, and that you yourself are not, when you produce the most bizarre set of capacities out of your agencies. You see what I mean?

AF: I see what you mean. Do you have a hypothesis about the roots of this particular concept of the inanimate, the thing that has agency but no soul in this hubris condition?

BL: Well, the history of that has begun to be well known now, because there is a whole history that shows how matter has a very idealistic definition; the generation of it is complex. But for me, the locus is technical drawing; I think that's where this very strange idea of technical drawing printed, in perspective, with shades, gets confused with *res extensa*. Or at least the place where you have a piece of machinery, which is usually very beautiful (which is why the Musée des Arts et des Métiers is such an interesting place), because there is nothing more beautiful than a technical drawing done in the seventeenth, eighteenth, or nineteenth century, with shades and colors—the assembly drawing, where the agency of the agents assembling has, of course, been taken away, and is nowhere in the drawing. If you say that, and you say you took the agency out completely, and then imagine that the world outside is made of that, you have an approximation of the "inanimate." Except, of course, it is a highly skilled competence to draw technical drawings, and the whole piecing together of all these elements itself requires an agency.

AF: So you are saying that the conflation of *res extensa* into technical drawing, where the model and the supposed inanimate object are there and these two conflate, is what creates that disenchantment?

BL: I'd say more. I'd say that what we mean by *res extensa* is a technical drawing. It's drawing on paper. *Res extensa* is the extension of drawing in the same way as the territory is an extension of the map. The power of those tools, of these visualizing technologies, has been so strong that the temptation to say "well, that's what the world is really like" is very great, especially when your foreground is all of the engineering talents and engineering skills that are necessary to assemble. This is why I am so interested in the Columbia disaster. It was very clear during the Columbia disaster (you recall, this shuttle that was supposed to be assembled by nobody in particular, suddenly exploded). Then, suddenly, people go everywhere, and do inquiries and say that there must be lots of agencies there, first NASA as an agency in the legal sense, then a mistake made by this office and that office, and suddenly you have a population of people and of agencies that is supposed to gather all of these pieces together. This means that there always was—in the definition of agents and agencies and Columbia as an agency before it exploded—an animated entity. So Columbia was

an animated entity, and, of course, every engineer at NASA knew that beforehand, except this was only registered collectively after its explosion. And then forgotten immediately, because the agents inside the technique are never visible.

AF: They are enclosed in a "black box," as you say.

BL: It's black boxing. But more precisely, because black boxing is part of that, there is a very important possibility of moving one's fingers in space without changing their properties, which is the quality of technical drawing (which is a great invention by another compatriot, by the way, Gaspard Monge, from the same city, Beaune, as Étienne-Jules Marey and myself), and this idea that you could make whatever moves in space without anyone moving it: from one drawing, you can imagine all its positions in space. So, if there is a native locus for "inanimate," an origin—I don't know what the history of art and perspective would say, but I have some proof of this, it's not invented out of my head completely, but I don't have it proved all the way—I think it will be there. Actually, it's a contribution of art to the philosophy of science. Of that I am convinced; there is a connection in this way. I once said that the invention of *res extensa* was the result of Descartes and Locke being in Amsterdam for too long and seeing all of these beautiful mimetic paintings, *natures mortes*—Descartes and Locke saw too many of them. You see it when you look at Dutch painting, *natures mortes*—but of course, you forget the whole history of art and all the necessary skill, but you have decided that the space in which you see these things is the same in which you live, which of course exists only when you contemplate this very, very specific period of art history. In science, and at no other moment in art history, you never have that situation, except at the very brief moment, which is the *Wunderkammer*, the moment of exquisite drawing skills, inventories, all of these natural history moments, which are actually not framed as an "inanimate," but as the extraordinary discovery by art of a multiplicity of agencies, and for a very long time of God's power on Earth and the wonder of nature, and so on and so forth. So even that is not always framed as an "inanimate." But then you have Descartes, and the *res extensa* argument, which is probably as close as you can get to the official constitution of "inanimate"—constantly denegated, constantly transformed. Even Leibniz, just a few years after, says that this *res extensa* argument is absolutely absurd, and reanimates the whole thing with monads. Westerners are quite interesting people!

AF: Is there a particular place for the mimetic in your theory? In *Iconoclash*, you refer to Michael Taussig's work. He is most known for his study of the economy of mimesis in colonial situations. Animism has also been brought into association with ways of mimetic knowing, a form of mental and bodily mimesis by which one enters into relations with the environment. Taussig speaks of mimesis as aping, as the ability to copy and to take over the powers of the model, departing from James Frazer's description of sympathetic magic. These forms of mimesis are officially excluded from modern rationality. But if I think of Gabriel Tarde–

BL: Imitation is a word Tarde might use. I don't think Tarde would say "aping," actually. That's a whole theme of art history that is quite interesting, the themes of apes in painting, because apes don't ape. Apes do all sorts of things. I think of mimetic in a very simple sense, which is that, in one period of art history, there was the idea of a copy and a model. This was only for a very, very short period, which is basically the moment Svetlana Alpers describes in Dutch painting in Antwerp and elsewhere. In all other cases, there were many more than two (that is, more than a copy and model), which is the case of science, which is why I say that science is not mimetic, but not in the same sense; that it is precisely a long, long chain of transformations, none of them reasonable, and resemblance actually is the enemy, because if it resembles, then there is no longer any new information, so the whole series of scientific reference chains is precisely based on the non-resembling resemblance, because resemblance would be a sort of loss of information. Alternatively, you would play on the multiplicity of differences between the copy and the model, and that is basically what all art has done, except this very strange moment in *natures mortes*. It started long before with prehistoric art; and immediately after the Dutch, it started again. It would be difficult to say what mimetic is, but it is not in science, that much is sure. Taussig interested me for other reasons, on account of *Iconoclash,* because he points out that it is very difficult to be iconoclastic. As for magic, I never believe anything I read about magic anyway, because magic is itself a term that is completely under the shadow of the idea that there would be something else which is not magic. Which would be what? No transformation of agency, no hybrid, no gestural engagement with the matters at hand? I mean, it would be very odd if there were something non-magical in that sense. So the difference must be somewhere else, but this is not my field.

AF: Can we talk about immaterial non-humans, and the question of belief and spirituality?

BL: Spirituality is a word I will not use—it is too loaded with the idea that the world would be material and we would be missing something important and that spirit should be added to the world. Because spirituality would be a word that already accepts the idea that there is somewhere in the history of the Western world where "inanimate" actually reigned, where there would have been a "realm" of "inanimate," and people would get worried (actually, I have worked a lot on religion and precisely in a non-spirituality version). That's why it's like magic—it's modes of existence, as I call them.

AF: The non-humans that are of that other kind, like angels let's say—those that we previously put purely in the realm of the social representation—do they play a role in these modes?

BL: They have room in ontology, yes; not only those, but lots of other entities that were always there. It's not that they are new; they are always there, with very, very different types of specifications. But the question you are asking is: "When the belief (which was never worked out practically in any case) in inanimate objects started, what other souls were silenced and why?" This is a very important question. Be-

cause, I now have this idea that the moderns never looked at the future; they always looked at the past that they were afraid of. Now the moderns are actually turned toward the future, always aware of what is behind them. They always have "ruptures" at their backs, and they are continuously moving forward. They flee backwards. So they flee from something that is in front of them, and the future is behind them. They don't look at the future. And now the moderns are doing this [*indicating an about-face towards the future*] and they are horrified, and that's why you are doing your exhibition. Because while you have your back to the future, you flee animism. And you turn around, and suddenly you realize that, first, you have destroyed the whole planet—I mean, this is cause for a little hesitation—and suddenly you realize that something else entirely different has happened. I think that the moderns are looking for the first time now at the future.

Machinic Animism

Angela Melitopoulos and Maurizio Lazzarato

There has been a sort of de-centering of subjectivity. Today, it seems interesting to me to go back to what I would call an animist conception of subjectivity, to rethink the Object, the Other as a potential bearer of dimensions of partial subjectivity, if need be through neurotic phenomena, religious rituals, or aesthetic phenomena, for example. I do not recommend a simple return to irrationalism. But it seems essential to understand how subjectivity can participate in the invariants of scale. In other words, how can it be simultaneously singular, singularizing an individual, a group of individuals, but also supported by the assemblages of space, architectural and plastic assemblages, and all other cosmic assemblages? How then does subjectivity locate itself both on the side of the subject and on the side of the object? It has always been this way, of course. But the conditions are different due to the exponential development of technico-scientific dimensions of the environment of the cosmos.

I am more inclined [...] to propose a model of the unconscious akin to that of a Mexican curandero or of a Bororo, starting with the idea that spirits populate things, landscapes, groups, and that there are all sorts of becomings, of haecceities everywhere and thus, a sort of objective subjectivity, if I may, which finds itself bundled together, broken apart, and shuffled at the whims of assemblages. The best unveiling among them would be found, obviously, in archaic thought.
—Félix Guattari

We do not know, we have no idea what a society without a state and against the state would be. Animism is an ontology of societies without a state and against the state.
—Eduardo Viveiros de Castro

Guattari brings about a de-centering of subjectivity in separating it simultaneously not only from the subject, from the person, but also from the human. His challenge is to escape from subject/object and nature/culture oppositions, which makes man the measure and the center of the universe, in making out of subjectivity and culture-specific diversions (differences) between man and animals, plants, rocks, but also machines and mechanics. Capitalist societies produce both a hyper-valorization of the subject and a homogenization and impoverishing of the components of its subjectivity (parceled out into modular faculties such as Reason, Understanding, Will, Affectivity, governed by norms).

It is within this framework of a search for a new definition of subjectivity, one that could escape the capitalist enterprise, that the reference to animism is often made. In Guattari's work, and in the same manner as in animist societies, subjectivity loses the transcendent and transcendental status that characterizes the Western paradigm. Guattari's thought and that of animist societies can find common ground in this understanding of subjectivity.

I very much enjoyed a passage in which Guattari speaks of a subject/object in such a way that subjectivity is just an object among objects and not in a position of transcendence above the world of objects. The subject, on the contrary, is the most common thing in the world. That is animism: the core of the real is the soul, but it is not an immaterial soul in opposition or in contradiction with matter. On the contrary, it is matter itself that is infused with soul. Subjectivity is not an exclusively human property, but the basis of the real and not an exceptional form that once arose in the history of the Cosmos.[1]

1 Eduardo Viveiros de Castro, our interview, Rio de Janero, 2009.

It is not subjectivity that separates man from "nature," because there is nothing "natural" about it. It is not a given; but it is, on the contrary, both an epistemological and a political operation. There is, indeed, something before the subject/object opposition, and it is necessary to start from their fusion point. Guattari prefers to speak about "objectity" and "subjectity" to mark their non-separation and their reciprocal overlapping.

Guattari does not make a specific anthropological category out of animism, nor does he focus on a particular historical phase, since he does not limit himself to non-literate, non-governmental societies. Aspects of polysemic, trans-individual, and animist subjectivity also characterize the world of childhood, of psychosis, of amorous or political passion, and of artistic creation. Guattari's attachment to the La Borde clinic is surely linked, as Peter Pelbart suggests,[2] to the radical alterity in which psychosis plunges us with regards to the subject and its modalities of "human" (linguistic, social, individuated) expression.

2 Peter Pelbart, our interview, Sao Paolo, 2009.

And it is true that among psychotic people, and notably among schizophrenics, this practically daily commerce with particles of self or perhaps with corpses, outside the self, does not pose a problem [...] There is a certain very particular "animist" sensibility that one could call delirium. Of course it is a delirium by our standard; it is something that cuts psychotics off from the social reality that is completely dominated by language, social relations, thus effectively separating him from the world. But this brings him closer to the other world from which we are totally cut off. It is for this reason that Félix maintained this laudatory view of animism, a praise of animism.[3]

3 Jean Claude Polack, our interview, Paris, 2009.

Guattari's summoning of animism (he goes so far as to say that it would be necessary to temporarily pass through animist thought in order to rid oneself of the ontological dualisms of modern thought) does not signify in any way a return to some form irrationalism. On the contrary, for the anthropologist Eduardo Viveiros de Castro, expert on Ama-

zon indigenous people, this conception of subjectivity is completely materialist, even permitting a renewal of materialism. "I just read the passages that you sent me on animism in Guattari's work, which I was not familiar with, in fact. I find this artificial alliance between animism and materialism incredibly interesting, since it allows one to separate animism from any other form of idealism [...]. To reintroduce a subject's thought that is not idealist, a materialist theory of the subject, goes along with the thought of the Amazon peoples who think that the basis of humans and non-humans is humanity. This goes against the Western paradigm, which maintains that that which humans and non-humans have in common is 'nature.'"[4]

4 Eduardo Viveiros de Castro, our interview, Rio de Janero, 2009.

The "animism" that Guattari claims to represent is not at all anthropomorphic, nor is it anthropocentric. The central concern is one of "animism" which one could define as "machinic," to recycle the terms of a discussion that we had with Eric Alliez. In Western philosophy, there are traditions of thought (Neo-Platonic, monadological, from the infinitely small to the infinitely large—Leibniz, Tarde, and so forth), which can coincide with the cosmologies of animist societies in certain places.

> Animism is present in the work of Deleuze before he meets Guattari. And it is a horizon, a totally expressionist category which participates in that which one could call, more globally, a universal vitalism. There, according to the Neo-Platonic tradition, everything breathes, and everything conspires in a global breath. This vitalism is visible in authors like Leibniz, but also in Spinoza across the general category of expression and expressionism [...]. To my mind, what is going on in his collaboration with Guattari is that animism is no longer invested from an expressionist or vitalist point of view, but from a machinist point of view. And this changes everything, because it is necessary to understand once and for all 'how it works,' and how it works in our capitalist world whose primary production is that of subjectivity.[5]

5 Eric Alliez, our interview, Paris, 2009.

What are we to understand by machinist animism? The concept of a machine (and later of assemblage), which allows Guattari and Deleuze to free themselves from the structuralist trap, is not a subgroup of technique. The machine, on the contrary, is a prerequisite of technique. In Guattari's "cosmology" there are all sorts of machines: social machines, technological, aesthetic, biological, crystalline, and so forth.

To clarify the nature of the machine, he refers to the work of the biologist Francisco Varela, who distinguishes two types of machines: *allopoïétique* machines, which produce things other than themselves, and *autopoïétique* machines which continuously engender and specify their own assemblage. Varela reserves the *autopoïétique* for the biological domain, for reproducing the distinction between living and non-living which is at the foundations of the Western paradigm; whereas Guattari extends the term to social machines, technical machines, aesthetic machines, crystalline machines, and so forth.

In the universe there exist everywhere, with no distinction between living and non-living, "non-discursive *autopoïétique* kernels which engender their own development and their own rules and mechanics. The *autopoïétique* machinic asserts itself as one-for-self and one-for-oth-

Angela Melitopoulos / Maurizio Lazzarato
Assemblages
above: *Tree associated to a Orisha divinity, Salvador de Bahia*, 2009
below: *Salvador de Bahia*, 2009
Courtesy the artist

Angela Melitopoulos / Maurizio Lazzarato
Assemblages
above: *Tree, Salvador de Bahia*, 2009
below: *Tree associated to a Orisha divinity, Salvador de Bahia*, 2009
Courtesy the artist

ers—non-human others. The for self and the for others cease to be the privilege of humanity. They crystallize wherever assemblages or machines engender differences, alterities, and singularities.

All over the cosmos there exist becomings, haecceities, and singularities. If they are not the expression of "souls," or of "minds," they are the expression of machinic assemblages. The disparities they create in variations have their own capacity for action and enunciation.

"For every type of machine we will question not only its vital autonomy, which is not an animal, but [also] its singular power of enunciation." Every machinic assemblage (technical, biological, social, etc.), once contained enunciative facilities, if only at the embryonic stage. They thus possessed a proto-subjectivity. There, too, like subjectivity, it is necessary to separate the singular power of the enunciation of the subject from the person and the human. This goes against our philosophical and political tradition, which, since Aristotle, has made language and speech a unique and exclusive characteristic of man, the only animal that possesses language and speech.

Guattari, detaching himself completely from structuralism, goes on to elaborate an "enlarged conception of enunciation," which permits the integration of an infinite number of substances of non-human expression like biological, technological, or aesthetic coding, or forms of assemblage unique to the socius.

The problem of assembling enunciation would no longer be specific to a semiotic register, but would cross over into expressive heterogeneous matter (extra-linguistic, non-human, biological, technological, aesthetic, etc.). Thus, in "machinic animism," there is not a unique subjectivity embodied by the Western man—male and white—but one of "heterogeneous ontological modes of subjectivity." These partial subjectivities (human and non-human) assume the position of partial enunciators.

Additionally and most importantly, the expansion of enunciation and expression concerns artistic materials, which the artist transforms into vectors of subjectivization, in "animist" *autopoïétiques* facilities.

The artist and more generally, aesthetic perception, detaches and de-territorializes a segment of the real in order to make it play the role of partial enunciator. The art confers meaning and alterity to a subgroup of the perceived world. This quasi-animist speaking out on the part of the artwork consequently redrafts subjectivity both of the artist and of his consumer.[6]

6 Félix Guattari, *Chaosmose* (Paris: Galilée, 1992).

Guattari's great friend and accomplice, artist Jean-Jacques Lebel, on whom Jean Rouch's *Mad Masters* (*Les maîtres fous*), filmed in Cameroon on the occasion of a society of witch doctors' trance ritual, "left an indelible impact," was one of the first to emphasize the filiation between the thought of non-Western "savages" and the "savage" artists of the East.

Guattari was not only in the friendly company of anthropologists, who included Pierre Clastres of *Societies Without State and Against the State*, but also artists who solicited the "wild libertarian flux" of the unconscious and its intensities.

"[This leads us,] above all to the savage; to savage thought. Permanent and major influence. Thanks to Artaud and his Tarahumaras,

thanks to the surrealist gaze resting on magic art, and thanks to my father who turned me on (starting in childhood) to the art of primitive peoples, with respect to art that is radically different from that which is considered classic; I never considered Paris or New York, Rome or Berlin to be the center of the world. The intensity that comes from primitive art at its peak is the standard against which I judge what I like or what I do not like in Western art."[7]

7 Jean Jacques Lebel, our interview, Paris, 2009.

On its end, Lebel's "Direct Poetry" provides a critique of the "imperialism of the signifier" by "blowing up language," and by carrying out an a-grammatical poetry that is "beyond and beneath the verbal." This is another theme that runs throughout Guattari's work: that of a-signifying, a-grammatical, or a-syntactical semiotics, to borrow Lebel's terms. The privilege of speech has a profound political meaning. Not only have signifying and linguistic semiotics served as an instrument of division between human and non-human, but of hierarchization, subordination, and domination inside the human as well. All of the non-linguistic semiotics such as those of archaic societies, the mentally ill, children, artists, and minorities, were considered for a long time to be minor and inferior.

It was only in the 1960s and 70s that these non-linguistic modes of expression began to be appreciated for their major political role and for making up an experimental field of psychiatry, like at La Borde or as in the work of Deligny with the autistic "savage children" and their a-signifying modes of expression.

It was an obsession in all of the history of Western thought to define what was natural and what was not, to the point where people thought that if there was no spoken language, it was necessarily animal. Thus they forbade the "savage children" who grew up among animals and without speech to express themselves with signs. People behaved in a similar fashion towards deaf people. For one hundred years the Vatican forbade the use of sign language, though it is a language par excellence.[8]

8 Barbara Glowczewski, our interview, Paris, 2009.

Polysemic trans-individual animist subjectivity does not constitute a "vestige," or even a simple "renaissance" of ritual ancestral practices in capitalist societies. It is also updated and activated as both a micro and macro-political force, which fuels the resistance and creativity of the "dominated," as Suely Rolnick and Rosangela Araujo explain.

"Trans-individual polysemic animist" subjectivity uncovers the possibility of producing and enriching itself in societies such as those in Brazil (and, according to Guattari, in another way, in Japan) by means of updated "animist" rituals. This fascinated Guattari. The Capoeira and the Candomblé, as described by Janja (Rosangela Araujo),[9] a master of Capoeira Angola, are mechanisms of production and singularization of subjectivity that renew themselves and use "semiotic symbols" of the body, dance, postures, and gestures to speak the language of Guattari, as well as "a-signifying semiotics" such as rhythms, music, and so on.

9 Salvador de Bahia, our interview, 2009.

Capoeira Angola, Nzinga Group, Salvador de Bahia, 2009

The function of speech is not discursive, but existential. With other semiotics and with no privileged role, it helps bring about the "mise en existence" or the production of existential territories. In these practices, the fluctuations of signs act upon real fluctuations without the mediation of representation, of the individual subject and its conscious-

ness. In a remark by Guattari on the subject of ritual, we find, as if in a mirror, his entire concept of the collective (or machinic) assemblage of enunciation, and of the power of the non-metaphorical use of signs and words: "Primitive 'magic' is illusory. This is how ethnologists see it. Primitive peoples are *realistic*, not mystical. The imaginary and the symbolic are real. No backworld. Everything extends into everything. No break—separation. Bambara does not imitate, does not use metaphors, does not index. Its dance and its mask are wholly rich signs which are at the same time representation and production. One does not watch the performance, powerless. It is itself, collectively, the show, the spectator, the stage, the dog, etc. It transforms by means of expression, as a sign that is connected to reality. Or rather a sign such that there is no break between a reality, an imaginary mediated by a symbolic order. No break between gesture, speech, writing, music, dance, war, men, gods, the sexes, etc."

Thus there are possible echoes and crossovers between updated ancestral rituals in contemporary capitalism and machinic assemblages, as was discussed by anthropologist Barbara Glowczewski who worked with Guattari. Rituals like collective enunciation mechanisms produce the body as they manufacture an enunciation. But in one case as in others, it is not a question of anthropomorphic productions. The "collectivity," as Barbara Glowczewski reminds us, is irreducible to a human grouping; it is other than belonging to inter-subjectivity or simply to the social: "If people are interested in Félix today, it is precisely because he defines subjectivity by assemblages, according to which humans are just as soon with other humans as with collectivities, with concepts, with animals, objects, as with machines."[10]

The ritual, like assemblage, is a "machine" that concomitantly determines the action of the cosmic and molecular fluctuations, of real and virtual forces, of sensible affects and corporal affects, and of incorporeal entities such as myths and universes of references.

These rituals and these cultural practices produce a subjectivity not based in identity that is becoming, since "the process is more important than the result."[11] This is reminiscent of the process-driven concept of the assemblage of activity in Guattari's work.

Through art as Guattari understands it (and which constitutes, for Eduardo Viveiros de Castro, an authorized reserve for "savage thought," providing that it does not transgress assigned boundaries), ritual pierces the chaosmosis, bringing us back to the point of subjectivity's emergence, to the condition of the creation of the new. "Art is, for Guattari, the most powerful means of putting into practice some aspect of the chaosmosis" (Jean Claude Polack), to plunge beneath the subject/object division and to reload the real with "possibles." These indigenous cultures of the Americas do not represent a simple survival of ancestral practices that are doomed to extinction. They do not constitute a simple quest for the improbable "African" identity in the face of the reality of slavery and the social inequalities in Brazil. These processes of subjectivization are actualized through the use of the myth (and, for Guattari, mythograms—from Leninism to Maoism—are indispensable in any process of subjectivization) of an Africa that never existed.

"It is a reinvented Africa, an Africa before slavery, where men and women are free, in order to be propelled into a future of liberty and

Previous pages:
left: Min Tanaka dancing in the clinic of La Borde
Still from the video by François Pain and Joséphine Guattari, 1986
right: Stills from the film *Le moindre geste* (1971) by Fernand Deligny, co-directed with Josée Manenti

10 Barbara Glowczewski, our interview, Paris, 2009.

11 Rosalgela Araujo, our interview, Salvador de Bahia, 2009.

12 Rosalgela Araujo, our interview, Salvador de Bahia, 2009.

autonomy for all."[12] What fascinated and intrigued Guattari during his numerous voyages to Brazil and Japan was not only the power of practices like the Candomblé ("an unbelievable factor in the production of subjectivity which contaminates not only its initiates, but [also] the entire population"), but also the meaning and the political function of these modes of subjectivization.

13 Suely Rolnik, our interview, Sao Paolo, 2009.

For Suely Rolnik,[13] these practices contain a "popular knowledge of the unconscious, which is very strong and very effective." If they play a major role in the elaboration of the trauma of slavery in a "beyond post-colonial" situation, they can and should play a major political role.

If there are hierarchical class divisions at the macro-political level in Brazil, which seem insurmountable, this "questioning of" and "this other politics of subjectivization" cross the same divisions and class hierarchies, and circulate and diffuse into the population as a whole, through bodies.

According to Rolnik, the richness of the micro-political dimension expresses all of its power when it assembles with the macro dimension, as it has occurred at certain moments in Brazilian history (1968, the beginning of the 1980s, etc.). The valorization of this "production of other subjectivity" has a long history in Brazil, since the "anthropophagic" manifesto of the 1920s had already legitimized it.

Guattari was particularly attentive to all of the modes of production of subjectivity that recharge themselves in non-Western traditions, since the primary production in contemporary capitalism is the production of subjectivity, and since the crisis that we have been experiencing for the last forty years, "before being economic, it is precisely the fact that there is no intermediary for subjectivization. There is a settling of modes of subjectivizations, and no one knows what to cling to, subjectively speaking, anymore."

The production of subjectivity, having never been "natural," means we have things to learn about these practices if we are to be capable of updating them for contemporary capitalism: "Archaic societies are better armed than white, male capitalist subjectivities in charting the multivalence and the heterogeneity of components and of semiotics that help bring about the process of subjectivization."

For a reversal of history, science will force us deeper and deeper into an animist world: "Every time science discovers new things, the world of the living gets bigger [...] It is obviously a thought problem. The certitude of knowing what is living and what is not continues to shift [...]

14 Jean Claude Polack, our interview, Paris, 2009.

we are in an animist problematic, of the soul, of animation."[14]

It is not only the evolution of science, but the development of capitalism itself which forces us to an "animist" thinking and politics.

That which appears natural to us—springs, rocks—are loaded with history for the aboriginal peoples, who practice forms of totemism, and are thus cultural and non-natural [...] There are those here among us who function this way even more today than in the past, because we have less and less apprehension regarding what is natural, while the category that philosophy contributed to setting up opposes humans to untouched nature. And the greater the desire was to leave it untouched, the more it was developed. This sort of opposition no longer really makes any

sense. The nature/culture opposition nevertheless constricts our thinking a great deal. It is still our paradigm, since we continue to fantasize about natural peoples, natural environments, about the fact that we must preserve nature. And as much as we think this way, I think we are wrong when it comes to the solutions to be found for the different problems. For example, the question of the environment is not really about protecting nature by stopping pollution. On the contrary, it is necessary to invest it with new forms of assemblages and cultural mechanisms.[15]

15 Barbara Glowczewski, our interview, Paris, 2009.

But, as in archaic societies, one cannot imagine an ecology of nature without simultaneously considering an ecology of the mind and of the social. One must then update a cosmic thinking, where "soul" and "machine" exist everywhere concurrently—in the infinitely small as in the infinitely large. The three ecologies of Guattari, leaving behind the parceling of reality and subjectivity, reacquaint us with the conditions of possibility of a cosmic thinking and politics.

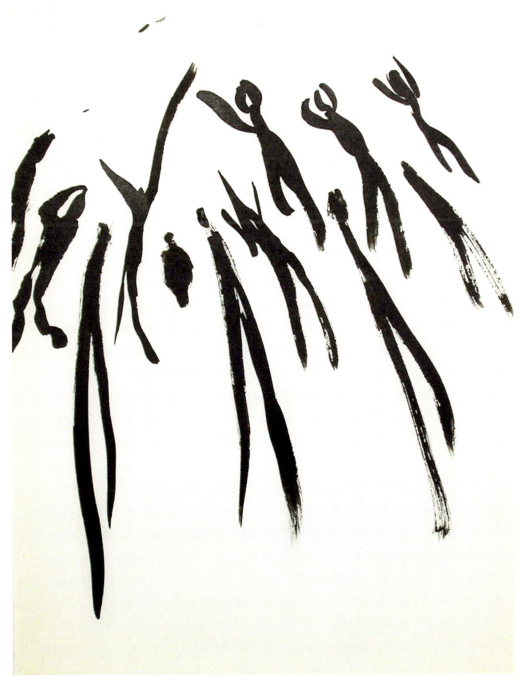

Henri Michaux
Movements, 1950–1951
Chinese ink on paper
Courtesy private collection

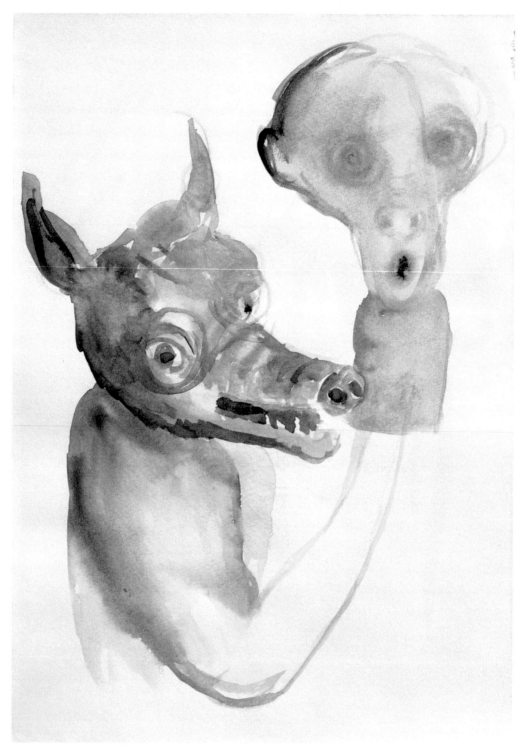

Rosemarie Trockel
Untitled, 1992
Watercolour and ink, scumbled, on paper
Courtesy of Commune du Landeron, Switzerland

On Wanting to be an Animal: Human-Animal Metamorphoses in Nietzsche and Canetti

Gertrud Koch

We admire, fear and envy animals because of certain qualities which we ascribe to them. I am not talking here about the efforts of zoologists and anthropologists to determine the difference between animals and other living beings and things, using various biological, psychological and biochemical methods. What I mean is the relation of humans to animals based on a certain human image of animals, an image to which humans then want to conform.

The image of happiness. A long-established thesis holds that animals are happy because they have no consciousness of time and thus have no consciousness of their own finitude. They do not, as Heidegger put it, live in "anticipatory disclosedness unto death." Instead, they exist in the moment. As Friedrich Nietzsche explained in *On the Uses and Disadvantages of History for Life*: "Consider the cattle, grazing as they pass you by: they do not know what is meant by yesterday or today, they leap about, eat, rest, digest, leap about again, and so from morn till night and from day to day, fettered to the moment and its pleasure or displeasure, and thus neither melancholy nor bored. This is a hard sight for man to see; for, though he thinks himself better than the animals because he is human, he cannot help envying them their happiness—what they have, a life neither bored nor painful, is precisely what he wants, yet he cannot have it because he refuses to be like an animal."[1] Humans are condemned to historicity, conscious of their own mortality; animals are forgetful, existing obliviously in the pastless Now of pain and desire. The unbounded temporality of this life assigns the animal to a cyclical model of time, in which birth and death are transitory stages.

The capacity of some animals for metamorphosis serves as a concrete depiction of this relation to time. The larvae of the frog, the snake's shedding of its skin, the pupation of the butterfly can all be used to represent the possibility of becoming something else, of passing smoothly from one state to the next. A film like *The Silence of the Lambs* takes up this image of metamorphosis. Here, the male hero's transformation into a woman is carried out organically, transmitted through the murdered women's skins, in the way beautiful butterflies flutter out from their pupae. The two images from the organic life of animals here merge in a horrifying fantasy of self-creation through metamorphosis, which imagines organic life within a cycle of becoming and passing away.

The image of beauty. Seen through human eyes, many animals represent aspects of perfect beauty—the panther's silky fur, the hummingbird's shimmering plumage, the delicate head of the gazelle, the colors of the parrot, the swift's sweeping flight. "I read about the leaps of a

1 Friedrich Nietzsche, "On the Uses and Disadvantages of History for Life," [1874] in *Untimely Meditations*, ed. Daniel Breazdale, trans. R.J. Hollingdale (Cambridge: Cambridge University Press, 1997), 57–124; 60.

gazelle-child in that oasis, a child which could spring four meters at a bound, like the gazelles to which it belonged. As I read, I asked myself if this is what I meant by *metamorphosis*? And I have asked myself ever since."[2] The indistinction at the centre of this short narrative derives from its reference to a leaping "gazelle-child," rather than a "young gazelle." We cannot tell if this is a child who leaps like a gazelle, or a young gazelle which is like a human child in spite of belonging to gazelles. Canetti's literary version of "metamorphosis"—for Kafka, it was a man turning into a beetle—is a metaphor for a certain untouchable kind of beauty, untouchable because while it emerges from nature, it does not return to it. Natural beauty here becomes an imaginary hybrid creature in the eye of the beholder. The beauty of the human body can only be thought in connection with the animal; beauty in the animal lies in the human gaze which conjures up this metamorphosis. This gaze is materialized in description and in narration—here the animal becomes the medium of aestheticization. In films like Jacques Tourneur's *Cat People*, legends of metamorphosis are still being told, they are endlessly retold, just as Canetti tells them. I read about and saw a panther's leap between woman and animal. In Paul Schrader's remake a zoo director dreams that the beautiful panthers are enchanted women who have fallen in love with him.

2 Elias Canetti, *The Agony of Flies: Notes and Notations* (New York: Farrar, Strauss and Giroux, 1994), 185. Translation modified.

The image of another life. "I would give years of my life to be an animal for just a short time."[3] In his film *Grizzly Man*, Werner Herzog assembles interviews about and footage shot by a man who imagined he could live with grizzly bears in the wild. He thought the bears would accept him as one of their own; he thought so right up to the moment when they ate him. It was the madness of love: a man who believed himself transformed, imagining the bears would recognize him, just as he recognized his significant Others in them. The longing which drove him into the voracious mouths of wild animals was a longing for a totally other life, for a life removed from all things human, for the life of the bears. And so he thought that the bears would recognize him, that they would sense that he loved them, that they would know it was for love that he wanted to live among them and share their life. But Herzog is like Canetti. He knows that *metamorphosis* is an aesthetic device for expressing a desire, an affect. He also knows that bears cannot see the visions and metamorphoses which our human gaze has them perform. Herzog knows how to *separate*, and he keeps his own camera at a distance. Natural beauty and the sublime is the horror of indifference and unapproachability. Nature and the aura of natural beauty are always distant. The lovestruck fool doesn't get that, and gets eaten. "Is everything prey? Is everything feed? There is a good reason for taking it out on the animals. The more seriously one takes them, the more determined one is to help them to assert their rights, the more the world proves itself a feeding network. No escape. Despair by way of compassion."[4]

3 Elias Canetti, *Über Tiere* (Munich: Carl Hanser Verlag, 2002), 96.

4 Elias Canetti, *The Agony of Flies*, 41.

1 A translation of Henri Michaux, *Encore des Changements* (Paris: Editions Gallimard, 1935) by John Tittensor. © Editions Gallimard, Paris, 1935.

Still More Changes[1]

Henri Michaux

Because of the constant pain I lost control of my size and grew ungovernably.

I was all things: but above all ants, an interminable line, industrious yet somehow hesitant. Frenzied activity. Calling for my undivided attention. I soon realized I was not only the ants, I was their path too. Crumbly and dusty at first, then hardening up until the pain became unendurable. I kept expecting the path to explode and be hurled into space at any moment. But it held firm.

I rested as best I could on another, softer part of me. It was a forest, ruffled gently by the wind. But then a storm blew up, and to withstand the rising gale the roots bored into me; you can put up with that, but then they hooked in so deep it was worse than dying.

Suddenly the ground collapsed, pushing a beach into me, a pebble beach. It began ruminating inside me and summoning the sea, the sea.

Often I turned into a boa, and although the length bothered me a bit, I would get ready to sleep, or I was a bison and I would get ready to graze, but soon a terrible typhoon burst out of my shoulder and the small boats were sent flying through the air and the steamers wondered if they would make it into port and all you could hear was SOS.

I was sorry not to be a boa or a bison any more. A little later I had to shrink to fit on a saucer. Endless sudden changes, everything had to be done all over again, and it wasn't worth the trouble, it was only going to last a few moments, and yet you had to adapt, and there were always these sudden changes. It's not so bad going from a rhombohedron into a cropped pyramid, but it's really tough going from a cropped pyramid into a whale: straight off you have to know how to dive and breathe, and the water's cold and then you're face to face with the harpooners, but in my case, as soon as I saw one, I took off. But it could happen that without warning I was turned into a harpooner, and that meant much more ground to cover. When I managed to overhaul the whale I launched a harpoon quick-smart (after checking I'd made the line fast), good and sharp and strong it was, and away it went, driving deep into the flesh and opening up an enormous wound. Then I realized I was the whale, I had become the whale again, with a brand new opportunity for suffering, and suffering's something I just can't get used to.

After a mad chase I gave up the ghost, then turned into a boat, and you better believe it, when I'm the boat I ship water everywhere, and once things get really bad you can bet on it, I become the captain, and I try to look cool, calm and collected, but in fact I'm desperate and if we manage to get help in spite of everything, then I change into a hawser and the hawser snaps, and when a lifeboat breaks up, naturally I was all its planks and so I started to sink in the form of an echinoderm and

none of this lasted more than a second, me being at sixes and sevens amid nameless foes who fell on me at once, consuming me alive, with those white, ferocious eyes you only find under water, under the salt water of the ocean, which whets all wounds. Ah, will no one leave me in peace for a little while? No chance, if I don't keep moving I rot on the spot, and when I do move I lay myself open to my enemies. I don't dare budge. I fall to pieces and at once I'm part of a baroque ensemble with a stability problem that's apparent all too soon and all too clearly.

If it was always an animal I changed into maybe I could cope, since the behavior's always more or less the same, following the same principle of action and reaction, but I become objects as well (and if it were only objects that would be okay), not to mention all kinds of totally factitious combinations and impalpable stuff. And let's not talk about the time I changed into a bolt of lightning—the kind of situation where you really have to move fast, and I'm always so slow and can't make up my mind.

Ah, if I could just die once and for all. But that's out of the question, I always turn out to be ready for a new life, even if I just make blunder after blunder and promptly bring it to an end.

No matter though, straight away I'm given another life and once again my inordinate incompetence surges to the fore.

Sometimes it happens that I'm reborn angry... "Eh? What? This place needs trashing? Buttoned-up bastards! Parasites! Rabble! Scum! Harridans! Ball-breakers!" But when I'm hot to trot like this nobody ever shows and pretty soon there I am transformed into some different, ineffectual creature.

Always and always, and over and over.

There are so many animals, so many plants, so many minerals. And I've already been all of them, and so often. But I never learn from experience. Turned into ammonium hydrochlorate for the umpteenth time, I'm still apt to behave like arsenic, and when I'm back to being a dog my old nightbird ways keep on showing through.

Once in a while I see something without having that odd feeling of *Oh yes, I've been THAT*. I don't exactly remember it, I feel it. (This is why I'm so fond of illustrated encyclopedias. I go through them page by page and often I get a kick out of them because there are photos of things that I haven't been yet. It's deliciously relaxing. I say to myself, "I could have been that too, and I was spared." I give a sigh of relief. Oh, the ease of it!)

Henri Michaux
above left: *Untitled (mescaline pencil drawing)*, 1956
above right: *Untitled (mescaline pencil drawing)*, 1956
Pencil drawings on paper
below left: *Untitled (mescaline ink drawing)*, 1954
below right: *Untitled (post-mescaline ink drawing)*, 1966–69
Chinese ink on paper
Courtesy private collection

Disney as a Utopian Dreamer

Oksana Bulgakowa

Eisenstein's essay on Walt Disney forms part of his unfinished book
Method, which examines the connection between the practice of art
and archaic forms of thought.[1] With his interest in archaic struc-
tures, Eisenstein followed the same path as T.S. Eliot, D.H. Lawrence,
Ezra Pound, Aby Warburg. He began the book in Mexico in 1932
and worked on it until his death. The formalized structures of archa-
ic thinking were regarded as a reservoir for the artistic devices: *pars
pro toto*—and the close-up; sympathetic magic—the function of the
landscape; participation—actors' experience; the reading of tracks by
a hunter—constructing the plot of a detective story. Shakespeare, Bach,
Dostoevsky, Joyce and Disney were analyzed according to his mod-
el. Nobody before had placed the creator of Mickey Mouse in such
"heavy" context.

Eisenstein's starting point is neither Disney's synaesthesia nor his
perfect rhythm. Rather, Eisenstein begins with eloquent descriptions
of the unstable stability achieved by Disney in his creation of plastic
form. This property of unstable stability, which Eisenstein admired for
its irresistible attractiveness, is paradoxical because of the way Dis-
ney's forms seem to exist in a continuous state of self-dissolution. In
an analysis of Disney's animated drawings, Eisenstein shows how this
plasmatic property (one shared by the elements of origins—water, fire,
air and sand) functions within a form strictly delineated by a line's con-
tour. The line is the form's limit, but in Disney's work this line is con-
stantly in motion: stretching, extending itself, dancing. This continu-
ous movement animates the line-drawing, lending it a certain plasticity.
As a result, Disney's work does not take metamorphoses as a topic or
even as an object of representation, rather, metamorphosis is a proper-
ty of his form, which embodies the essence of art, here understood as a
deeply mythological activity. The "animated cartoon" is traced back to
anima and *animation*, the life and the movement of things, i.e. bringing
things to life by making them move. In this respect, constructivists are
no less archaic than symbolists.

Disney's ducks and mice create a modern animal epic, leading
Eisenstein towards animistic beliefs, totems and myths of origin. This
strengthened his conviction that relations between humans and nature
still followed an archaic model, one deeply rooted in ritual. Thus, when
fighting or hunting, man devours the animal or is devoured by him, he
copulates with the animal or he disguises himself as an animal. In all of
these forms, there is a palpable sense of an original unity of opposites,
a unity which creates the ecstatic moments experienced in the passage
from one state to another. This passage can instill horror or can bring
about laughter. Disney's comic bestiary confronts the uncanny ani-

1 Eisenstein's essay on
Disney was published in
abridged form in 1985. In Rus-
sian, see *Problemy sinteza v
khudozhestvennoi kul'ture*, eds.
Alexander Prochorow and Boris
Rauschenbach (Moskow: Nauka,
1985), 209-284; in English, see
Eisenstein on Disney, ed. Jay
Leyda, trans. Alan Y. Upchurch
(Calcutta: Seagull, 1986). A new
German translation (forthcom-
ing, Berlin, 2010) is based on the
text published in 2009 by Po-
temkinPress (*Metod*, ed. Oksana
Bulgakowa. vol. 3, 769–888).
This is based on manuscripts
(September 21, 1940–June 16,
1946) held in the Russian State
Archive for Literature and Art,
Moscow (RGALI, fond 1923, opis
2, ediniza chranenija), 321, 322,
323, 256.

mals of Edgar Allen Poe, Comte de Lautréamont and D.H. Lawrence, but also Eisenstein's own ecstatic cows and oxen, which copulate like mythical beings. The bulls of the corrida, which both die and kill, take the place of Jesus in Eisenstein's Mexican drawings, his film-bull resurrected as the God of the seasons' return. Thanks to Disney, Eisenstein became aware of his own bestiary, which he now saw as revealing modernity's mythological monstrosity. His battleship now seemed like a mechanical man-fish, the fleet a mythological whale threatening to swallow the Potemkin, the bull appearing in the form of a tractor. Eisenstein believed that he could draw borders between horror, ecstasy and laughter, separating the mythological from the rational—in life as well as in art.

Where the pre-logical meets the rational, past and present collide and the archetypes of an archaic, classless society meet modernity's fantastic visions. It is precisely at this point that utopias appear. Eisenstein regarded nineteenth-century utopias as an archive of collective dreams, in which technical progress and social development coincide. Socialism draws on these dreams, which Eisenstein wanted to analyze using the examples of Campanella, More, Cabet, Jules Verne, Fourier, Sue and Disney. One of the reasons for the resonance of Disney's work Eisenstein saw in the promise of freedom within the relationship of people to nature; this provides Eisenstein with the transition to Fourier. Fourier conceived labor according to the model of children's games that was not oriented on value production, but rather on "improved nature." His utopian vision—with humanity and nature in alliance, with humans neither themselves exploited nor exploiting the environment—is a countermovement to industrialization, which subordinated nature to humans and humans to machines.

Eisenstein placed his text on Disney in the anthropological section of his extensive book. Here the body is presented as a direct source for art but also as its material, with the skin seen as a surface for painting, tattoos as the first self-portraits, and the abdomen presented as the original form for architecture and ceramics. Bodily fluids and excretions (blood, urine, excrement) are the basis of the color scale. As a model for structure, Eisenstein suggests this fluid body rather than the skeleton; form is analyzed for its plasmatic, polymorphous qualities. Disney emerges as the central object of analysis because his work unites animism and totemism with plasmatic qualities of form, synaesthetic perceptions of sound and color, and perfect visual rhythm. Eisenstein ultimately explains the impact of Disney's work by its utopian promise of liberation from ossified form, the way it offered the possibility of a state of eternal becoming. Here Eisenstein discovered a deep longing for freedom, which would allow a fresh reimagining of relations between human and nature, and even perhaps their reformation.

Disney

Sergei Eisenstein[1]

1 From: Sergei Eisenstein, *Disney*, ed. Oksana Bulgakowa, trans. Dustin Condren (Berlin: PotemkinPress, 2010).

I

The animals in *"Merbabies"* substitute for other animals: fish become mammals.

In Disney's opus in general, animals substitute for humans.

The tendency is the same: displacement, combination, an idiosyncratic protest against metaphysical inertness established once and for all.

It's interesting that such a "flight" into animal skins and the anthropomorphic qualities of animals seem to be characteristic of many different epochs. This is most sharply visible in the very inhumanness of the systems of social government or philosophy, be it during the epoch of American-style mechanization of daily life and behavior or during the epoch... of mathematical abstraction and metaphysics in philosophy.

It's interesting that one of the brightest examples of such a rebirth of the animal epic is, as a matter of fact, the century in which metaphysics was first systematized...the nineteenth century. Or more accurately, the eighteenth century which moved under the banner of overcoming the seventeenth.

...

> That which Rousseau had fought for, with open polemic and slogans, had been spoken of before him by the artistic images and form of La Fontaine's works.
>
> "He defended his animals from Descartes, who had made them into machines. He does not allow himself to philosophize like the educated doctors, but humbly asks permission and in the manner of a meek recommendation he tries to devise a soul to be used by (*à l'usage*) rats and hares..."
>
> And that's not all:
>
> "Like Virgil he feels for the trees and does not exclude them from the general picture of life. 'Plants breathe,' he said. At the very time when artificial civilization sheared the trees of Versailles into cones and geometric bodies, he wanted to preserve freedom for their greenery and their sprouts..."[2]

2 Hippolyte Adolphe Taine, *La Fontaine et ses faibles* [1853] (Paris: Libraries Hachette, 1870), 179–180. Eisenstein translated this text into Russian.

Soulless geometrism and metaphysics engender here, as an antithesis, a sudden rebirth of universal animism.

Animism, wherein thoughts and feelings for the interconnectedness of all elements and kingdoms of nature wandered blindly, long before science solved the puzzle of this configuration with its sequences and stages. Objective examination of the surrounding world took hold.

Before this, mankind knew no path other than projecting its own soul onto its surroundings and making judgment by analogy with the personal.

The Animal Epic.
Man in the image—the form of an animal.

The most literal expression of everything poetic, of every form: the difference in levels between form and content!

The animal "form" is a step backward in evolution with respect to the "content"—man!

In psychology: "don't awaken the beast inside me"—i.e., the earlier complex—it always retains a place.

Here it's brought up to the surface, for tactile perception as well!

Totemism and Darwinism—the descent from animals.

The very idea, if you will, of an **animated cartoon** [animation: literally, a drawing brought to life] is practically a direct manifestation of the method of animism. Whether the momentary endowment of life and soul of an inanimate object, which we retain from the past, for example, when we bump into a chair and swear at it as if it were a living thing, or the prolonged endowment with life that primitive man confers upon inanimate nature.

In this way, what Disney does is connected with one of the deepest features of the early human psyche.

NB. Provide here an illustration from Atasheva's book—where there are *animated* English safety pins and so on.[3]

3 Pera Atasheva (1900–1965), Soviet journalist, Eisenstein's lawful wife (he married her in 1934, but they never lived together), was editing a volume on American animated cartoon for the series of the publishing house "Iskusstvo" on American film directors. The volumes on D.W. Griffith (1944) and Chaplin (1945)—with Eisenstein's contributions—were published but this one never appeared.

Webster:
Animal – L fr. *anima* breath, soul.
Animate – L animatus p.p. of animare, fr. *anima*, breath, soul, akin to *animus* soul, mind.
Greek ἄνεμος wind.
Sanskrit *an* to breath, live.
L to give natural life to, to make alive, to quicken, as the soul *animates* the body.
Animated picture.

Animism L *anima* soul... the belief that all objects possess natural life or vitality or that they are endowed with indwelling souls. The term is usually employed to denote the most primitive and superstitious forms of religion...

In *Snow White*, the villainess looks into the *fire* and *a face from the fire* speaks to her, giving her information about Snow White (cf. Moses, Buddha and Zoroaster).

But what is all this if not a regression to a "stage"?

The impossible is tragic in life—but when it is shown to be possible, it is as funny as an old man in diapers. Hyperion throws himself into the fire.[4]

[D.H.] Lawrence and his animals.

But further on, T[aine] does more: in his book he confirms in the form of theses that which everyone experiences emotionally.

A lyrical digression.

Revenons à la nature [Let's return to nature]. Quote. Note that it is

4 Marked nearby and deleted: Endymion (the embodiment of sunset and sleep). In Greek mythology Hyperion—a titan, the son of Gaia and Uranus, a "shining" god, often identified with Helios, although he does not throw himself into the fire. It is possible that Eisenstein is conflating the heroes of two different works by Hölderlin, Hyperion and Empedokles. The hero of the tragedy *The Death of Empedokles* (existing in three versions, 1798, 1800, 1826) throws himself into the crater of an active volcano in order to determine whether or not he is immortal.

also not accidental that this is what arises—the magic of enchantment as it resonates with Disney—*zusammenfassen* (summarize).

... A drawing brought to life, the most direct realization of... animism! A knowingly lifeless thing—a graphic drawing—is *animated*.

The drawing as such—outside of the object of representation!—made living!

But, besides that—inseparably—the subject-object of representation—is also animated: dead objects from daily life, plants, animals—they are all brought to life and made human.

The process of mythological personification of natural phenomena (forest—wood demon, home—the house sprite, etc.) in the image and likeness of... man.

Because of an unexpected shock—a man bumps into a chair in the darkness—you regress to the stage of sensuous thinking, and curse at the chair as if it were a living being.

Here, seeing the chair as a living being, a dog as a man, your mind flies into a state of psychological displacement—shock, into the "blissful" condition of the stage of sensory experience!

Audio-visual synesthesia is obvious and speaks for itself.

II Animism

I take Veselovskii's definition from the article "*Psychological Parallelism and its Forms as Expressed in Poetic Style.*" (NB. The polemic about "parallelism" in which I engage A.N. Veselovskii is elsewhere. Here I am using only the factual material of the provided illustrations and the general, indisputable conditions):

> "Man assimilates the images of the external world in the forms of his own consciousness; particularly, primitive man, who has not yet worked out the habits of abstract, non-figurative thought, although the latter cannot really operate without certain accompanying imagery. We unwittingly project onto nature our own feeling for life, which expresses itself in movement, in manifestations of power directed by will; once upon a time, those phenomena or objects in which movement could be observed, they were suspected of containing energy, will or life. We call this outlook animistic..."
> ("*Istoricheskaia poetika,*" p. 125)

(I prefer Levy-Brühl's definition—a participatory one—and other definitions that spring from the condition of undifferentiated consciousness, expressing an undifferentiated social environment. Cite these.)

This outlook "rests on the juxtaposition of subject and object by their category of movement..." (NB. There is no "juxtaposition" Yet. For there is not yet the differentiation of the subjective and the objective. And the "animation" of nature emanates from here: nature and the I are *one and the same*, further along they are *identical*, even further they are *similar*. Up to the stage where the difference is sensed, they all work on the animation of nature, on animism. This has to be sharply emphasized and conceptually polished.)

"...according to the category of motion, action as a sign of willed vital activity. Animals, naturally, appeared to be objects; more than anything else they resembled man: hence the distant psychological foundations of animal apologists; but plans also pointed to such a similarity: they also were born and bloomed, turned green and bowed under the strength of the wind. The sun, it seemed, also moved, rose, and set; the wind chased the clouds around; lightning sped; fire enveloped, devoured, twisting and so on. The non-organic, unmoving world was unwittingly dragged into this line of thought... it also lived..." (p. 126).

In English, the moving drawings of Disney are called... an animated cartoon.

In this term both concepts are bound together: both "animation" (*anima*—the soul), and "liveliness" (*animation*—liveliness, mobility).

And surely, the drawing is "animated through mobility."

Even this condition of indissolubility—of unity—of animation and mobility is already deeply "atavistic" and completely in accordance with the structure of primitive thought.

I've had occasion to write about this before on the basis of materials from Norse mythology—about this unity as it is found in connection with the divine functions which the Nordic world attributed to the father of the gods, to Odin/ Wotan, to this product of the "animization" of the forces of nature.

In my article, "*The Incarnation of Myth*" in connection with the production of "*Die Walküre*" in the Bolshoi Theater of the USSR, I wrote ("*Teatr,*" No 10, October 1940):

[Wotan was given the element of Air… But since this element can only be perceived when it is in motion, Wotan also personifies *movement in general*. Movement in all its variety—from the mildest breath of a breeze, to the tempestuous rage of a storm.
But the consciousness that created and bore myths was not able to distinguish between direct and figurative understanding. Wotan, who personified movement in general and primarily the movement of the forces of nature, at the same time embodied the whole compass of *spiritual movements*: the tender emotions of those in love; the lyrical inspiration of a singer and a poet, or, equally, the warlike passions of soldiers and the courageous fury of the heroes of yore.[5]]

5 "The Incarnation of Myth," in Eisenstein, *Selected Works, vol. 3*: *Writings 1934–1947*, ed. Richard Taylor, trans. William Powell (London: BFI, 1996), 145.

The following condition comes entirely from this same principle: *if* it moves, *then* it is animated, i.e., it moves by means of an internal, independent, impulse of will.

To what degree, outside of logical consciousness but within the sphere of sense perception, even we are constantly subject to this very phenomenon is apparent from our reception of Disney's "living" drawings.

We *know* that these are drawings, and not living beings.

We *know* that this is a projection of drawings onto a screen.

We *know* that they are "miracles" and tricks of technology and that such beings don't actually exist in the world.

And at the very same time:

We *sense* them as living,

we *sense* them as active, acting,

we *sense* them as existing and we assume that they are even sentient!

But this is all from the same stage of thought where "animization" of nature's unmoving objects occurs, objects from everyday life, lines from the landscape etc.

The eye of the observer (the subject) "runs over" the observed (the object). In this term itself—"runs over"—the previously existing stage has survived: when the "capture" of the object was done by hand, the "running over" of it happened... on legs which moved around the object that could not be caught by hand. After this, the process became concentrated in the capacity of the "capture" by means of the gaze that "ran over" the subject.

The difference with the previous instance is that here, the subject (the eye) is the one moving along the outline of the object, and not the actual object itself, which would travel in space.

But, as it is well known, at this stage of development, there is still no differentiation between the subjective and the objective. And the movement of the eyes, as they run along the contoured line of a mountain range can be read just as successfully as the running of the line itself.

The eye moves outward with the gaze in the direction of the road and that can be successfully read as the road itself running off into the distance.

Thus, with linguistic metaphor—which is born by this process and which exists as a deposit in the fabric of language from this earlier stage of thought—the process is based on a series of events in the action of an individual gaze (the already figuratively transferred action of the person, the person as a whole, onto himself, onto one of his parts) "animistically" attributed to the object of observation.

I'll give a series of examples from Veselovskii, which I happen to have at hand ("*Istoricheskaia poetika,*" p. 127):

(At the same time, I am sharply opposed to his formulation and interpretation of "parallelism." I'll undertake a polemic on this point—on the building of a process image—in a separate appendix.)

"...Un parc immense *grimpait* la côte."
[An enormous park *clambered* up the slope.]
(Daudet, *L'Évangéliste*, ch. VI)

"*Behaglich streckte* dort das Land *sich*
In Eb'nen aus, weit, endlos weit...
...
Hier *stieg* es *plötzlich* und *entschlossen*
Empor, stets *kühner* himmelan..."
[There the earth *unfolded itself* in cozy valleys, wide, endlessly wide... here it unexpectedly and decisively *lifted itself upwards*, bravely to heaven."
(Lenau. *Wanderung im Gebirge*)

"*Sprang* über's ganze Heideland
Der *junge* Regenbogen..."
[The young rainbow *jumped over* the entire steppe.]
(Id. *Die Heideschänke*)

"Doch es dunkelt tiefer immer
Ein Gewitter in der Schlucht
Nur zuweilen übers Tal weg
Setzt ein Blitz in wieder feucht"
[The storm *darkens* in the ravine, only seldom does the humid
lightning *illuminate* the valley.]
(Id. *Johannes Ziska*)

"Fernhin *schlich das hagre Gebirg*, wie ein wandelnd Gerippe,
Streckt das Dörflein *vergnügt* über die Wiese sich aus..."
[In the distance *hides* a *gaunt* mountain range just like a walking
skeleton, the village *stretches out*, *satisfied*, among the meadows.]
(Hölderlin)

"Der Himmel glänzt vom reinen Frühlingslichte,
Ihm schwillt der Hügel sehnsuchtsvoll entgegen..."
[The sky sparkles in the purest color, a hill *rises up* to meet it, full
of desire.]
(Möricke. *Zu viel*)

The process of the formation of these figures is perfectly obvious.

The eye "leaps around," "spreads out," and "skips over." By the
characteristics of this one feature of motion, by its schema, its rhythm,
its drawing—in accordance with the law of *pars pro toto*—a *complete
act* of "leaping around," "spreading out" and "skipping over" is con-
structed for the person as a whole.

Based on the identification of the subject and object—and more
accurately, based on the indivisibility of the one from the other in this
stage—all of these actions and steps are attributed to the landscape it-
self, to the hill, to the village, the mountain chain, and so on.

Such a mobile metaphor (to "carry over" is a more advanced proc-
ess that is only capable of existing and, more importantly, acting thanks
to this earlier foregoing condition—affective identification—identifica-
tion in affect) is the earliest most ancient type of metaphor, it is *directly*
mobile. (Thus the father of the gods—Wotan—is Movement).

It is "verbal"—*active*—process-based, not object-based.

It is not objectively *visible*, even less "something comparable to
something else" (two objective phenomena between themselves, this
appears at a later stage) it is most likely a mobile, subjective, *thing-to-
be-felt par excellence*.

This is true to such a degree that Chamberlain (on Goethe[6]), for
example, *übersieht* [overlooks] this type of comparison! He consid-
ers, for example, that for Goethe and his realistic greatness there is a
characteristic avoidance of metaphorical comparisons. As support he
quotes "*Still ruht der See*" ["Quietly rests the Lake"] and juxtaposes
his non-metaphorical rigor with the revelry of metaphorical compari-
sons in one of Wieland's sunsets.

While doing so, he entirely misses the point that Goethe is particu-
larly full of verbal metaphors. The most primary, deepest, and there-
fore most sensuously captivating metaphors. Moreover, the least objec-
tively "visible" ones, but more likely felt in the musculature, through
reproduction of figures that are "past" [*mimo*] the visually graspable
(both "*mimo*" as *vorbei* [past] and "*mimo*" as *mimisch* [mimic]). The

6 Houston Stewart Chamber-
lain (1855–1927), English political
philosopher, son-in-law of Rich-
ard Wagner, he took on German
citizenship in 1916. His book,
Goethe (München: F. Bruck-
mann, 1912), was purchased by
Eisenstein on September 8, 1937.

fogs "*schleichen*" [crawl], the lake "*ruht*" [rests], etc.

It is this very process that Disney perceptibly and specifically presents in drawings.

These are not only waves that are actually "boxing" with the sides of the steamboat. (And by a well-known comic formula, for this they gather all their outlines together into one boxing glove!)

This is also Disney's amazing elastic game of the outlines of his creations.

When amazed, their necks grow longer.

When running in a panic, their legs get stretched out.

When frightened, not only does the character shake, but a shuddering line runs along the entire outline of his shape.

Here, namely in this aspect of the drawing, the very thing that we have just presented so many examples and excerpts from comes into being.

Here is a very curious phenomenon.

Because if horror stretches out the necks of horses or cows, then the representation of their skin stretches out, and not... the line of the drawing of their skin, as if it were an independent element!

In that elongation of the neck there cannot yet be any of that which we discussed with the "running" mountain range or the "jumping" outline of the mountain range.

And only from the moment when the *line of the neck* elongates beyond the limits of possibility for *necks* to elongate does it begin to be a comical incarnation of that which takes place as a sensuous process in the previously discussed metaphors.

The comical here occurs because every representation exists dually: as a collection of lines and as an image which grows out of them.

Sergei M. Eisenstein
drawings of the series *Iosif and Potifar's wife*, 1931
Ink on paper
Courtesy Russian State Archives of Literature and
Art in Moscow (RGALI), Moscow

Rosemarie Trockel
Replace Me, 2009
Digital print
Courtesy Sprüth Magers Berlin/London

Rosemarie Trockel
Door, 2006
Digital print behind plexiglass, painted frame
Courtesy Sprüth Magers Berlin/London

Animism

126

Animated Origins, Origins of Animation

Brigid Doherty

Duras, a 2008 book by Marcus Steinweg and Rosemarie Trockel, proceeds from a question concerning its eponymous subject. A question—"Why Marguerite Duras?"—to which the book provides some twenty-five answers, in the form of brief chapters written by Steinweg, most of which contain at least one full-page black-and-white reproduction of a work made by Trockel. Why Marguerite Duras? Answer number one: "Because in every moment of her writing Duras circles around the question of the 'origin' of the origin." About halfway through the book appears a photographic image (a video still) that shows Trockel in a blur of movement suggesting a state of fervor, bare arms aloft, mouth open as if crying out. *Ontologisches Fieber*, the picture is called. Why? Because "the question of the 'origin' of the origin," and the question of the relation of the origin to our being in the present, animates Trockel's art with an intensity to rival the urgent circling of Duras's writing.

L'Origine du monde (1866) is not among the works shown on the postcards from Trockel's mother's collection reproduced in the book *Mutter* (2006), the artist's first collaboration with the Berlin-based philosopher Steinweg. A reproduction of Courbet's painting does make an appearance, however, in Trockel's photographic montage work, *Replace me* (2006), in which the prominent pubic hair of Courbet's model appears to have metamorphosed into a spider. Courbet's picture makes plain its nomination of the female sex as the origin of the world and presents the astonishing coloristic verisimilitude of its painted flesh—which effects a seeming rush of blood in ruddy labia, an as-if actual stiffening of a pink nipple, and the virtual pulsation of blue veins in splayed thighs—as not only a tribute to the site of human procreativity and its erotics, but also a claim on behalf of human creativity (painting in particular) and its capacity for animation. *Replace me* suggests instead a gray-scale mortification of human flesh for which the metamorphosis of the pubic hair into a spider perhaps figures at once a cause and a potential antidote. As if for Trockel's digitally altered photographic reproduction of Courbet's painting the spider might be seen as possessing a capacity not only for lethal contamination but also for animation, a capacity, in this instance, to arouse the human body sexually and thereby bring it back to life, restoring it to a state in which it could be seen as the origin of the world by those who might behold its reanimated appearance.

With typical canniness, even as it evokes an animistic fantasy of what the lively black spider might be doing to the gone-gray deathly flesh of the human body, Trockel's work does not offer any hint that a moment of revivification might ever come. Instead, *Replace me* leaves us looking at an exposed female pudenda that seems to have given rise

to a spider, and figures by means of that digitally generated transformation something like an imperative replacement of the painter as animator by the spider as seducer. It is as if we're looking at a frame from someone else's nightmare, a frame whose powers of fascination keep us from displacing it with figures from our own imagination. *Replace me* alludes at once to animism, and to something like its inversion, as described by the British psychoanalyst Wilfred Bion in his account of how a human capacity for "learning from experience," including experiences of dreaming, and of having nightmares in particular, can come to be disabled by an incapacity to relegate thoughts to the unconscious, which destroys the possibility of a person's making "conscious contact with himself or another as live objects." "This state," writes Bion, "contrasts with animism in that live objects are endowed with the qualities of death."[1]

If a mother embodies an origin, flesh materializes its threshold. Trockel's *Door* (2006) presents a threshold of flesh in the form of a photographic montage composed of pictures of a pair of antique wood-and-metal hinges mounted on a reproduction of a ceramic work from a series of pieces that each bore the name *Shutter* (2006). Made using a mold cast from meat that had been shaped by Trockel, the original ceramic works call up associations between the slats and bindings of a window blind and the flesh-covered ribcage of a flayed human torso. The glaze on the ceramic *Shutter* glistens as if slick with viscous blood and thus invokes a relation not only to the real, dead animal flesh from which its mold was made but also to flesh rendered in paint in still-life pictures of slaughtered animals. Digital reproduction intensifies this effect in a color version of *Door* to the extent that the object in the composition appears as if about to drip with blood. A black-and-white version of *Door* appears opposite the first chapter of *Duras*, the chapter that begins with the line "Because in every moment of her writing Duras circles around the question of the 'origin' of the origin," while a photograph of a window blind serves as a frontispiece to the book as a whole, each as if marking at once a threshold and an obstacle to an inquiry into the significance of Duras's writing and of "the question of the 'origin' of origin" around which it circles. And, in the case of *Door*, a threshold to a recognition of the presence of flesh as a materialization of the threshold of human origin.

And not just Duras. In *Die Aufzeichnungen des Malte Laurids Brigge* (1910), Rainer Maria Rilke links a recognition of a mother as an embodiment of origin and of being, and as an animating presence, to a figuration of windows and doors as elements of the scenography of the revelation of that embodiment and that presence in a way that illuminates (I think) the scenographies, embodiments, and presences of Trockel's art.

1 Wilfred Bion, *Learning from Experience* [1962] (New York: Jason Aronson, 2004), 9.

> *O night without objects. O dim outward-facing window, o carefully shut doors; arrangements from long ago, taken over, authenticated, never quite understood. O silence on the staircase, silence from adjoining rooms, silence high up on the ceiling. O mother: o you the only one, who displaced all this silence, long ago in childhood. Who took it upon yourself, said: don't be afraid; it is I. Who had the courage, in the middle of the night, to be this silence*

for one who was frightened, who was falling apart with fear. You strike a match, and already the noise is you. And you hold the lamp in front of you and say: it is I, don't be afraid. And you put it down, slowly, and there is no doubt; it is you, you are the light around the familiar intimate things, which are there without any surplus of meaning, good, simple, unambiguous.[2]

2 Rainer Maria Rilke, *The Notebooks of Malte Laurids Brigge*, trans. Stephen Mitchell (New York: Vintage, 1985), 75; translation modified. For the German see Rilke, *Die Aufzeichnungen des Malte Laurids Brigge*, ed. Manfred Engel (Stuttgart: Reclam, 1997), 66–67.

Rilke's night without objects, his dim outward-facing windows and carefully shut doors, are figures that might come from the thinking of a person who has lost the capacity to make "conscious contact with himself or another as live objects," a state from which, for Bion as for Rilke, a mother has the capacity to rescue a child. The mother's presentation of her being (*ich bin es*, says the mother in the scene from *The Notebooks of Malte Laurids Brigge*, enabling Malte eventually himself to recognize, and to say, *du bist es*) and her demonstration of a capacity for animation (*Du zündest ein Licht an, und schon das Geräusch bist du* [...] *du bist es, du bist das Licht um die gewohnten herzlichen Dinge, die ohne Hintersinn da sind, gut, einfältig, eindeutig*) effects such a rescue, providing a cure, as it were, for the child's *ontologisches Fieber*—a fever, with accompanying terror, manifested in the passage's opening lines by the repetition of the child's "O", presented on the page as if in imitation of a mouth forming a cry, a cry that subsides as Malte takes in the mother's admonition, *erschrick nicht, ich bin es*.

Rosemarie Trockel's art reminds us that we can lose our capacity to make conscious contact with ourselves and others as "live objects," that we can end up instead as practitioners of a kind of counter-animism, in which "live objects are endowed with the qualities of death." At the same time it confronts us with objects embodying thresholds to experiences from which we might again come to learn.

Rosemarie Trockel
Cologne Nightingale, 1991
Acrylic and pencil on paper
Courtesy Sprüth Magers Berlin/London

Rosemarie Trockel
Cologne Nightingale, 1991
Acrylic and pencil on paper
Courtesy Sprüth Magers Berlin/London

The Uprising of Things

Vivian Liska

Death is the price we pay for being alive. In order to justify our transience and console ourselves about our mortality we insist on the lifelessness of things. We take our revenge on their permanence and make them subservient to us by weaving them into our activities. Henceforth their function binds them to us and subordinates their duration to our temporality. We have thereby secured our compensation. Nothing can harm us anymore, now that we have given meaning to our impotence in the face of death. We can explain our dying as deterioration caused by our active life and contrast our vitality with the inertness of things, which meekly occupy the place we have assigned to them. We have domesticated them and they no longer remind us of the scandal of our finitude in comparison to their duration. But the foreignness of things continues to haunt us. We therefore repress their autonomy and believe that in this way we solve the equation whose denominators we are. In order to ensure our mastery, we try to get a grip on things. It is through language that we apprehend and grasp them. By naming them, we assign them a role and make them submissive. Words are our tools of mastery. They are mighty, and habit is on their side. They are out to catch the apostates who pursue their own aims or no aim at all. Words lead them back to their proper place in the paternal house.

There are literary works of art in which objects practice their insurrection and come to life. They resist appropriation and ally themselves with uncommon words that refuse to be enlisted in the game of naming, of signifying and of framing. These words bear their own aims in mind, or at least know how to avoid servility and make themselves unusable as means of mediation. With the help of these allies, rebellious things can become small and agile, hiding in hallways, in crevices and storerooms, hanging about in stairways and in attics. Unnoticed and clandestine, they can wrest leeway from furnished homes and stuffy houses. There they cause unrest and are a source of worry.

The worry of the *Hausvater* in Kafka's eponymous story is based on the possibility that Odradek, a useless thing that lurks in the dark corners of the house and "looks like a flat star-shaped spool of thread" covered with "old, broken-off bits of thread, knotted and tangled together, of the most varied sorts and colours," cannot die, for "anything that dies has had some kind of aim in life, some kind of activity, which has worn him out; but this does not apply to Odradek." Hence the father's "almost painful idea" that Odradek will still be "rolling down the stairs, with ends of thread trailing after him, right before the feet" of his "children, and children's children," and that he could outlive him. The father's logic, which Odradek eludes, is imperative. In its inversion, it amounts to this: we must die, but at least we have

lived. Things outlast us, but at least they never were alive. The father keeps the account books of death: The debit side is assiduous activity, purpose and goal, the credit side a meaningful death, a causal nexus, a deserved erosion. "Worn out by activity": this pride derived from the bourgeois work ethic reconciles with death. The end is then not meaningless and void, not an offensive scandal but a logical consequence. The chains of causality are maintained and the house is secure—if it were not for Odradek.

For none of this applies to Odradek. Odradek, we read, cannot be grasped. Not as the character of a story, which has been subject to myriad interpretations, not as a word, since neither of the explanations of the name proposed in the first sentences of Kafka's story is valid and can provide it with a meaning; not as a thing, whose shape sheds no light onto a possible origin or earlier purpose, not as an unruly, childlike creature with "no fixed abode" and a sinister smile "without lungs." Odradek's elusiveness is well-known. He—or it—was identified by Kafka's readers as "alienated junk," as commodity, as a symbol of universal being, as messenger from another world, at any rate as something that cannot be classified by the father's rationality and ordering speech. Odradek has also been viewed as a perfect aesthetic object that eludes unequivocal designation, and turns the thing into an event. This event is described as the failure of the attempted appropriation of Odradek by the father, who, in this defeat, recognizes his own limitations and thereby encounters himself. But has he also encountered Odradek?

For Walter Benjamin, Odradek has "the form things assume in oblivion. They are distorted." Odradek is a relative of the hunchback, the "prototype of distortion" who bears the repressed on his back. "Quite palpably," Benjamin says, "being loaded down is here equated with forgetting." Benjamin associates this forgetting, which has led to the hump, with the guilt of mistaking the world as it is presents itself to us for the only possible reality. This forgetting of "the Best"—the possibility that things could be otherwise—and the distorted life that this oblivion engenders, will, according to Benjamin, only disappear "with the coming of the Messiah who (a great rabbi once said) will not wish to change the world by force but will merely make a slight adjustment in it." But how would this trifle of a change affect the being of things?

All that is lacking from the father's worry is a trifle of change. His redemptive unsettlement is indeed not complete. After all, why is the idea that Odradek may outlive him, only *almost* painful? Will the father have vanquished Odradek after all, be it by enlisting him in his final thoughts about his own death or simply by making Odradek speak his, the father's, language? In the course of Odradek's transformation from word to living thing, Odradek mutates from an "it," made up of a feminine spool (*die Spule*) and a masculine star (*der Stern*), to a "he," a small male creature, which—given the worry that he causes the father—can also be seen as a rebellious son reminding the father of the impermanence of his rule. However, since Odradek, who, while a mere thing, remained defiantly silent, has learned the language of the father and has engaged in conversations with him, the risk prevails that he will, one day, forget his former existence as a thing and, at long last, become a worthy inhabitant of the house. He may then be called upon to put the world in order and end up as the new son of man, the *Hausvater* of tomorrow.

The Dangers of Petrification, or "The Work of Art and the Ages of Mineral Reproduction"

Richard William Hill

No form of Nature is inferior to Art; for the arts merely imitate natural forms.
—*Marcus Aurelius*, Meditations. xi. 10.

Here are three objects described, with varying degrees of credibility, as being: 1) a petrified apple slice; 2) a petrified bonbon and; 3) a petrified cloud. Petrification is the process by which an organic object, preserved under the right conditions for the necessary centuries, gradually has its organic material replaced by minerals, until none of the original organic material remains and the object has been literally turned to stone. Under the right circumstances this process of reproduction can be precise to the level of cellular detail. Despite their mimetic aspect, petrified items are no less authentically stone than other types of sedimentary rock, such as limestone, sandstone and shale, which are also created by the accretion of minerals over time.

The petrified apple slice, a wedge of luminously translucent stone with the suggestion of an opaque skin around its outer edge, is the most visually convincing of the petrified objects. Surely it *might* just be what the artist claims? Its appearance of relative authenticity perhaps explains why it requires no additional text for ontological support. The petrified bonbon is a small rectangular stone with a smooth surface and striated bands of various shades of black, brown, yellow and ochre. This "combination of flavors," the text informs us in deadpan museumese, is thought "by scientists" to have "contributed to the downfall" of the civilization that produced the bonbon. This petrified candy, despite its endearing name, is the heaviest of heavy little stones, loaded as it is, layer upon layer, with the imagined tragic history of a civilization's collapse. We are relieved only by the charming absurdity of the claim itself. Even more charming and more absurd

is the thought of a petrified cloud, a surrealistic conjunction if ever there was one. Although the stone on display is puffy looking and white we cannot believe in petrified clouds. And yet the accompanying text provides a convincing explanation of how some clouds do become saturated with minerals and, therefore, in effect, petrified.

This investigation of mimetic stoniness relates to Durham's wider interest in architecture. Since returning to Europe in 1994, he has investigated and critiqued the ways in which architecture structures our experience and particularly the support it gives to state narratives and belief. A key deconstructive strategy in this ongoing project has been to encourage ways of thinking about stone beyond its conventional uses in architecture. Among other things, the process of petrification emphasizes the enduring quality of stone in relation to organic material, such as ourselves. The supposed permanence of buildings and their institutions is often set against us in this way. In Christian mythology, Jesus "petrified" his disciple Simon with a pun, changing his name to Peter (stone), and telling him he would be the "rock" upon which the Christian church would be built. These works begin with that assumption and take us to the beautiful image of the petrified cloud.

The original meaning of petrify was literally to turn to stone. Not long afterwards the term took on two additional metaphorical connotations: to be frozen with fear and to be emotionally hardened. Each of these meanings say a great deal about how we think about stones: permanent, immobile and insensate. They carry out their stealthy, human-imposed agendas in architecture behind the cover of this mistaken identity. They are just things after all, and Western culture has a long history of convincing itself that things are "just things," harmless

Jimmie Durham
The Dangers of Petrification I + II, 2007
Stones, paper, knife and ceramic object
Courtesy the artist and Jutta Nixdorf Art, Zurich

nouns, never verbs. It is true that one can "get stoned" or have their heart "turn to stone," but once "stoniness" is achieved the action is over and we are back in the realm of timeless, static indifference. Cree and Cherokee and a number of other indigenous languages are often described as verb-based. They leave few things just sitting around being objects. Similarly, stone clouds might fall from the sky or improbably drift away, but they are unlikely to be co-opted into architecture.

The process of petrification also bears a strange relationship to art insofar as it is a process of representation and reproduction. In many cases petrification achieves a remarkably high level of mimetic accuracy, which, since antiquity, has been one of the highest (and most suspect) values in Western art. For thousands of years, stone, particularly marble, has been Western art's primary material for three-dimensional mimesis. As Durham has noted, the supposed mimetic veracity of statues in the Greco-Roman tradition depends enormously on our willingness to ignore that human bodies are not, for example, the pearly white of marble. It is in the gap between mimesis and its object that meaning is actively made.

The issue of reproduction also raises interesting questions about the continuity of the identity of objects over time. A petrified object is a copy in which the original cannot, by definition, survive the process of reproduction. Yet an object that has become petrified achieves a qualified form of immortality. If we look closely at our own existence as bodies, we find that we too become reproductions of ourselves over time. DNA provides the blueprint for new cells, which replace old cells and, at an even smaller scale, molecules and atoms come and go from our bodies.

Durham's attitude toward mimesis is also evident in the use of labels and "didactic" texts that are themselves mimetically appropriative of the science museum's techniques of display. They are labels and didactic panels, but with a difference—Durham's texts are written by hand. Imitation with a purposeful difference is one definition of satire. Contemporary science (and other) museums no longer write labels by hand, but primarily for rhetorical rather than scientific reasons: type is professional and convincing, handwriting is not. The implication is that museum expertise is special and distinct from ordinary knowledge. Perhaps, then, we can read the appearance of amateurism evoked by handwriting as, after all, a sign of Durham's commitment to empiricism and its democratization, despite certain practices of institutional science. With the covert appeal to authority of the museum display evaded we are again invited not to believe, but to engage with the objects before us speculatively.

It is helpful to consider these three petrified objects in relation to a display of petrified objects first shown in the exhibition "Indoor" in 1998 at the Centro Civico per l'arte Contemporanea la Grancia, Serre di Rapolano. This was a bountiful display of stone foodstuffs, a petrified *nature morte* of bread, meat and fruit, half covered by a real napkin turned enticingly back to reveal the tempting items. The small knife was a further invitation to, perhaps, slice off a bit of petrified salami. This creates a double layer of mimesis—stones representing petrified objects, which are themselves the stone representations of organic objects. We might call the medium "found mimesis." The effect of tempting us with stone can go in several directions. Our desire for these stones as food, releases them from the hold of architecture. They have another sort of agency as well. Stone food is an invitation to break one's teeth. Given this, what is a human body made from stone an invitation to?

"Les lettres du blanc sur les bandes du vieux pillard": Raymond Roussel's Animism of Language

Irene Albers

My favorite anecdote from the bizarre life of Raymond Roussel (1877–1933) was told in 1928 by Roger Vitrac.[1] Vitrac reports how Roussel, when he left for India on one of his many journeys, was asked by Charlotte Dufrène, his "girlfriend" (in fact: housekeeper and alibi for his homosexuality), to bring her back a "rare" souvenir. Whereupon Roussel had a heating stove shipped to her in Paris. (Her reaction, unfortunately, is not recorded.) What at first glance may seem a rather absurd choice of gift is in fact a precise material instantiation of the phonetic coincidence between the two first syllables of "rare" and "radiator [radiateur]." As well as fulfilling his friend's wish, Roussel here brings out the linguistic logic of the two words, tracing the "desire" of "rare" to be connected with the word "radiator." The separation of language and reality is here abolished; laws of language take the place of causal or psychological logic. "Rare" and "radiator" also rhyme with "Raymond" and "rays"—the rays Roussel claimed to receive and transmit while writing—and with the idea of "Gloire" [fame]. Obsessive neurosis (Starobinski)? Or schizophrenia (Deleuze)? "C'est un pauvre petit malade" ("He's just a poor sick man") is how psychiatrist Pierre Janet described Roussel, whom he treated, and to whose "profane ecstasies" he devoted a whole chapter of his book *De l'angoisse à l'extase*.[2]

There are close connections between this ecstatic experience and Roussel's very modern search for a "pure aesthetic beauty"[3] which would lend the artwork its own reality. Janet cites how Roussel perceived the act of writing: "What I wrote was surrounded with radiance. I closed the curtains because I was worried that the slightest crack between them would allow luminous rays from my pen to escape, when what I ultimately wanted was to pull back the screen in one go and thus illuminate the world."[4] The author's internal light, in other words, should flow out of his pen onto paper, in works to illuminate the world and make the writer immortal. Language becomes a medium for this "radiance." Not coincidentally, Roussel venerated the astronomer and spiritualist Camille Flammarion ("spiritism is not a religion but a science."). Roussel took part in the annual celebrations of the summer solstice which Flammarion organized on the Eiffel Tower, beginning in 1904. He also carried a locket containing a kind of relic: a star-shaped cookie from a meal organized by Flammarion in 1923. After Roussel's death, this "curious object" (Bataille) first ended up in a flea market, and then passed in turn from Bataille—it lay in a drawer in his house—to Dora Maar, before finally coming into the possession of Pierre Leroy. On June 27, 2007, it was auctioned at Sotheby's for €26,000. Roussel's inheritance shines on.

1 Roger Vitrac, "Raymond Roussel," in *Bizarre*, 34/35, (1964), numéro spécial Raymond Roussel, 79–84, 82; (reprint of an article from the *Nouvelle Revue française*, 1928).

2 Pierre Janet, *De l'angoisse à l'extase*, 2 vols., vol. I, (Paris: L'Harmattan, 1926), 132–138.

3 Janet, 136.

4 Janet, 134.

J. Stall
Le Sorcier, advertisement, 1928
Courtesy of the Bibliothèque Forney, Paris
Source: Brett A. Berliner, *Ambivalent Desire:*
The Exotic Black Other in Jazz-Age France.
Amherst: University of Massachusetts Press, 2000

Outside Surrealist circles, where he was revered as "the greatest magnetizer of modern times" (Breton), Roussel was generally seen as a "lunatic" or a "naïf." Even today, his eccentric lifestyle, his vast wealth, his journeys in his *roulotte* (a luxurious motorized caravan he had built and patented), and his mysterious death are all better known than the works themselves. Only a few specialists can claim first-hand knowledge of *Impressions d'Afrique* (1910),[5] *Locus Solus* (1914), *Nouvelles Impressions d'Afrique* (1932) or his last work and testament *Comment j'ai écrit certains de mes livres* (1934). And yet this final work in particular—in which Roussel explains his "procédé" and presents his novels as the product of a game of linguistic equivalences—can be seen as epitomizing his modernism. Thanks to this ludic procedure, Roussel freed language from all reference to reality or psychology. No wonder authors such as Julio Cortázar and Italo Calvino cited him as an influence; he was also an inspiration for the *nouveau roman* and the Oulipo writers. A new writing also meant a new kind of reading: in 1954, the Argentinian Juan Estabio Fassio invented a "machine for reading Roussel."[6] Fassio was responding in particular to *Nouvelles Impressions d'Afrique*, a text no longer readable in linear fashion, whose complicated parenthetical system amounted to a kind of hypertext *avant-la-lettre*. For *Rayuela*, Cortázar wanted to build a similar machine.[7]

The famous "procédé" was based on homophony and polysemy:[8] here, narrative is a device whereby two sentences, acoustically equivalent but semantically different, can pass through one another. Thus in "Parmi les noirs" ("Among the Blacks"), the early predecessor text of *Impressions d'Afrique*, the narration has the sole function of transforming the sentence "les lettres du blanc sur les bandes du vieux billard" (i.e. "the white letters on the cushions of the old billiard table") into "les lettres du blanc sur les bandes du vieux pillard" ("the white man's letters about the old plunderer's band.") Here, the basic opposition between "blacks" and "whites," and between Africa and Europe, is simply a result of the semantically-contingent homonymy between the two sentences. Many of the most fantastical inventions in *Impressions d'Afrique* are generated by this kind of word-play. (For example, the central figure of the "métier à aubes," a huge water-powered loom built over the river contains dense allusions, where "métier" refers to "vocation" but also to "loom," and "à aubes" contains "at sunrise" as well as "with paddles.") "Reality" is here ordered by language, not the other way round. Words create their objects. Jean Ricardou, high priest of the 1970s theory of "autonomous productivity of the text," even proudly traced Roussel's 1933 suicide back to textual play,[9] emphasizing the assonances and homonymy between "suicide," "Sicily" and "Switzerland." (Roussel had intended to go to Binswanger's clinic in Kreuzlingen for a detoxification program.) Others pointed to the feast of Santa Rosalia, celebrated in Palermo on July 14, suggesting that the true word-play lay in parallels between the writer's name and that of the city's patron saint, hinting that Roussel experienced the ecstatic scenery of processions and fireworks as the carnival and metamorphosis of his own person. His death in a hotel room in the city—never fully explained—thus becomes an *effet du texte*. In this reading, death takes the writer-text relation beyond the "bleeding for every sentence":[10] Roussel's death becomes a mystificatory self-sacrifice to the semantic machinery of his own linguistic reality-production, making both him

5 Raymond Roussel, *Impressions d'Afrique* (Paris: J.-J. Pauvert, 1963).

6 François Caradec, "La machine à lire Roussel ou La machine à lire les *Nouvelles Impressions d'Afrique* d'après les notes et les croquis de Juan Esteban Fassio," in *Bizarre*, 1964, 61–66.

7 Julio Cortázar, "De otra máquina célibe," in Julio Cortázar, *La vuelta al día en ochenta mundos* (México: Siglo XXI editores, 1969), 79–88.

8 See Roussel's explanations in *Comment j'ai écrit certains de mes livres* (Paris: J.-J. Pauvert, 1963).

9 Jean Ricardou, "Disparition elocutoire," in Leonardo Sciascia, *Actes relatifs à la mort de Raymond Roussel* (Paris: L'Herne, 1972), 7–19.

10 Claimed by Leiris in his *Roussel & Co*, ed. Jean Jamin (Paris: Fata Morgana, Fayard, 1998).

Fig. 9 : Une carte du chant I.

Fig. 10 : Emplacement des illustrations.

Source: François Caradec, "La machine à lire Roussel ou la machine à lire les *Nouvelles Impressions d'Afrique* d'après les notes et les croquis de Juan Esteban Fassio." *Bizarre*, no. 34/35 (1964): 63–66.

Fig. 11 : La Machine à Lire Roussel terminée (fonctionnement manuel et sélection digitale).

Fig. 12 : La Machine à Lire Roussel : photo parue pour la première fois dans la revue *Letra y Linea*, n° 4, Buenos-Aires, juillet 1954.

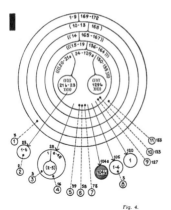

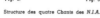

Fig. 4. Fig. 5.

Structure des quatre Chants des *N.I.A.*

Fig. 6. Fig. 7.

Schema of the four chants of the *Nouvelles Impressions d'Afrique* after Caradec, "La machine à lire Roussel ou la machine à lire les *Nouvelles Impressions d'Afrique* d'après les notes et les croquis de Juan Esteban Fassio." *Bizarre*, no. 34/35 (1964): 63–66.

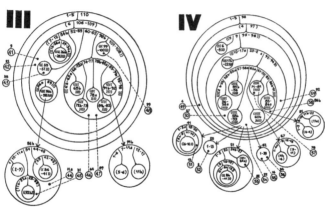

11 Lucien Lévy Bruhl, *Les Fonctions mentales dans les sociétés inférieures* (Paris: F. Alcan, 1910), 196–203.

12 Charles Blondel, *La Mentalité primitive* (Paris: Stock, 1926), 64f.

13 Michel Foucault, *Raymond Roussel* (Paris: Gallimard, 1963). Published in English as: *Death and the Labyrinth: The World of Raymond Roussel* (New York: Continuum, 2003).

14 Monika Schmitz-Emans, "Gespenstische Rede," in *Gespenster: Erscheinungen, Medien, Theorien*, ed. Moritz Baßler, Bettina Gruber and Martina Wagner-Egelhaaf (Würzburg: Königshausen & Neumann, 2005), 229–251.

15 Stéphane Mallarmé, "Le démon de l'analogie," in *Œuvres complètes*, ed. Henri Mondor and G. Jean-Aubry (Paris: Gallimard, 1945), 272f.

16 "Eine Monographie," in Hofmannsthal, *Reden und Aufsätze*, vol. I, 480, quoted in Schmitz-Emans, 243.

17 Hofmannsthal, "Ein Brief," in *Gesammelte Werke*, ed. Bernd Schoeller (Frankfurt am Main: Fischer, 1979), 461–472; ("The Chandos Letter"), 466f., quoted in Schmitz-Emans, 243.

and it immortal. (This bears a certain similarity to the death of the narrating "I" of Bioy Casares's fantastic tale *La invención de Morel*, who must kill himself to enter the virtual eternity of Morel's three-dimensional projections.) Man does not have words at his disposal. Instead, words dispose of *him*. However, this has nothing to do with modern appropriations of "the magic of language." Rather, what come into play here are ideas of a life and of the power of language. Modernity appeared to have no concept for this power, apart from ethnological speculations on the confusion of sign and object and on the "puissance mystique des mots" ("the mystical power of words"[11]) in "primitive" or pre-modern cultures. In his *La Mentalité primitive* (1926), Charles Blondel wrote: "For him [the "primitive"], a name is not a simple label, nor does it only signify a collection of objective properties. It also signifies a set of mystical properties and, in signifying them, it takes possession of them. The name is, like the being or thing it designates, a centre of participation and it thus merges with this being or thing. To pronounce a name is always an important act, both for the namer and the one named. To pronounce the name is to touch the person, the being or the thing, it is to assault them, to invoke them and force them to appear—something which of course can at times be rather inconvenient...."[12] What is here presented as the linguistic belief of "primitives" in fact describes that of modern man. The "lunacy" in Roussel's work can be read as the complement to the modern search for *poésie pure*—the absolute autonomy and artificiality of the literary text. Writing in 1963, Foucault thus saw "our own madness" in the supposed "madness" of Roussel. Literature too has "never been modern." Precisely here, in places like Roussel's "language machines,"[13] where the idea of literature finds its purest realization, where the rule of the subject over language seems at its strongest—it is here that the inner life of language manifests itself in disturbing ways. Language is made a subject only to the extent that it is allowed to become autonomous. One can speak here of an animism of language, an animism which accompanies the whole history of the modern search for *poésie pure*, from its earliest appearance up until Jeff Noon's computer-generated *Cobralingus: a Metamorphiction* (2001).[14] Take the example of Mallarmé's prose-poem "Le démon de l'analogie,"[15] in which the narrator is pursued, not by a ghost or a *Doppelgänger* but by a mysterious sentence ("La Pénultième est morte") which brings him to a point where his own metaphors appear before him in reality. Think of Hofmannsthal, who wrote: "Words are not ordinarily in the power of human beings, but humans in the power of words."[16] Words, he felt, were actually *staring* at him: "The individual words swam around me, they congealed into eyes which stared at me and into which I had to stare back."[17]

Roussel was not simply mad, nor was he childishly naïve. We can see this most clearly by looking at Roussel through the eyes of Michel Leiris, who analyzed him with an ethnological gaze formed by his own experiences in Africa. Leiris's fascination with Roussel (whose immense fortune was managed by Leiris's father) went back to an evening at the theater in 1912, an occasion which would pass into avant-garde legend. On May 11, 1912, the Théâtre Antoine in Paris presented a play by a little-known author, its title reminiscent of adventure stories: Roussel's *Impressions d'Afrique*. A ship carrying a variety of Europeans—a circus troupe, an inventor, an historian, a ballet dancer, a hypnotizer, an

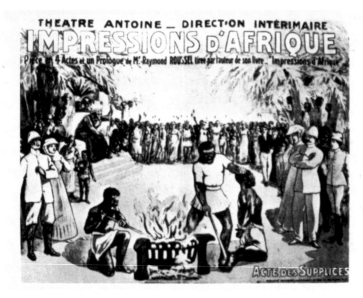

Poster for the staging of *Impressions d'Afrique* in the Théâtre Antoine, 1912
Source: Caradec, François, *Vie de Raymond Roussel (1877–1933)*,
édition Jean-Jacques Pauvert, Paris: 1972, (image coll. Mme Duard)

architect, a pyrotechnician, a sculptor, a banker, actors, opera singers,
etc.—is stranded on the West African coast and its passengers taken as
the hostages of King Talou. While they wait for their ransom money to
be delivered, they found an "Incomparables Club" and stage, as part
of Talou's coronation celebrations, an absurd gala of ludicrous inven-
tions and performances. Roussel had adapted the play from his 1910
novel, which was published at his own expense—its title plays on "im-
pression" ("printing") and "à fric" ("the author's costs.") He was also
among the performers, dressed up in a sailor suit. The play's audience,
scandalized, responded with noisy demonstrations of anger. However,
some present were more enthusiastic, among them Marcel Duchamp,
Francis Picabia, André Breton, Robert Desnos, Guillaume Apollinaire
and the 11 year-old Michel Leiris.[18] For this group, the play's advertiz-
ing posters were hilarious, promising the appearance of a "statue made
of corset stays, rolling on a track of calves' lungs." This statue would
be the forerunner of many later avant-garde objects and inventions
produced by word play: fantastic hybrids of nature and technology,
bodies and machines; machines which produce living beings and living
things; organic matter integrated into machines. Duchamp was fasci-
nated by Louise Montalescot, half doll and half human, inventor of a
painting machine powered by photoactive plants and a special tropical
oil, which produces hyperreal landscapes. The fascination for painting
machines in the work of Duchamp and others (e.g. Tinguely's "Méta-
matics") has thus frequently been traced back to Roussel.

For Leiris, however, it was the surreal image of Africa which had
a lasting effect. Had he not spent an evening at the Théâtre Antoine,
perhaps Leiris would never have become an Africanist—a surrealist Af-
ricanist who brought Roussel to the Dogon people of West Africa, who
used Roussel to decode their secret language, and used, in turn, that se-
cret language to read Roussel. Leiris's fascination with the Dogon has

18 On the circumstances see
Francois Caradec, *Raymond
Roussel* (Paris: Fayard, 1997),
135–139 and 149–157.

Stage photograph (enlarged detail of Roussel in a sailor's costume as an extra at the premiere of *Impressions d'Afrique*

« A la première d'*Impressions d'Afrique*, à un entracte, Raymond Roussel demanda à mon père et à ma mère :
« Avez-vous bien ri ? », s'inquiétant surtout de savoir comment les enfants avaient réagi » (p. 92-93).
Representation d'*Impressions d'Afrique* sur la scène du théâtre de l'apogée de l'œuvre
Non daté, page non datée. B.N.F.

Impressions d'Afrique, stage photograph
Source: *Leiris, Roussel & Co.*, ed. Jean Jamin. Paris: Editions Fata Morgana/Fayard, 1998.

Rousselian overtones, traceable not only in the fact that "Dogon" was a perfect anagram of his wife's maiden name (Louise Godon), but also in his pursuit of the expression "mère du masque." Having heard the term shortly after his arrival among the Dogon, he sought out the object to which it could refer, seeking a material instantiation of the alliterative connection between "mother" and "mask," as if it were a Rousselian word-play according to the "procédé." Leiris's scholarship on the secret Dogon language began here on the 1931–33 Dakar-Djibouti expedition. In his famous diary he summed it up thus: "The secret language is a language of formulae, made of enigmas, *non sequiturs* and elaborate puns [*coq-à l'âne et calembours*], cascading phonemes and interpenetrating symbols."[19] While here Leiris makes the texts of the Dogon seem analogous to works by Roussel (and by himself), in his 1948 monograph *La Langue secrète des Dogons de Sanga*,[20] he describes this "secret language" as both the "language of the bush" and the "language of another world"—ultimately, as the voice of the dead in the midst of the living. The image is reminiscent of Hofmannsthal's *Chandos Letter*: "When we open our mouths, we speak with the voices of ten thousand dead." Otherness permeates one's own speech, ghosts lurk there. Words live. Language is thought of as a subject.

Leiris's vision of Roussel transcends the "great divide" between them and us. Roussel becomes a "Dogon in a gondola," and his "language machines" for the production of "pure poetry" are transformed into animistic figures. Where Janet saw only his patient's psychotic ecstasies, Leiris sees in Roussel's texts a mythopoetic "magic nominalism" at work, through which words cause things to come forth and thus replace the "real" world. In his 1977 book *Le Ruban au cou d'Olympia*, Leiris published a short text entitled "The Dogon in a Gondola," a description of a fictional painting whose punning title—in the spirit of Roussel's famous "procédé"—motivates its strange visual construction. The painting shows a black African in a Venetian gondola at sun-

19 Michel Leiris, *L'Afrique fantôme* [1934] (Paris: Gallimard, 1981), 136 (Diary entry dated: October 11, 1931).

20 Michel Leiris, *La Langue secrète des Dogons de Sanga* [1942] (Paris: Éditions Jean-Michel Place, 1992).

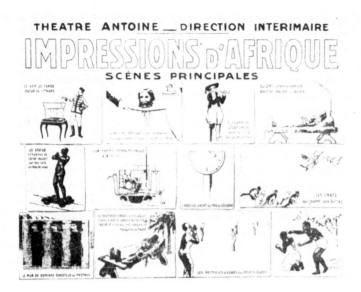

Poster for the staging of *Impressions d'Afrique* in the Théâtre Antoine (les scènes principales), 1912
Source: Caradec, François, *Vie de Raymond Roussel (1877–1933)*,
édition Jean-Jacques Pauvert, Paris: 1972, (image coll. Mme Duard)

set on the Grand Canal. In his arms, he carries a Dogon mask "…of the kind known as the 'tall building,' unquestionably the most spectacular of their masks, used for the dance of the dead." This kind of mask, five meters tall and made of painted wood, resembles the snake-like "great mask" (the "grand awa" or "mère du masque.") It is primarily worn for the masked dances of the "dama," the celebration at the end of a period of mourning, when the dead soul passes over from the "society of the living" to the "society of the dead." According to Leiris, both the secret language and the masked dances serve here as a medium for this passage. With the help of the masks, participants in the ritual communicate with the dead—a hint that Leiris, in this "Hommage à Raymond Roussel," wanted not only to pay off a debt, as he said, but to perform a ritual celebration of the dead. His "mère du masque" is the text about the strange painting, an encrypted text in the style of Roussel himself. The gondolier appears as "Nocher,"[21] ferryman of the underworld, with Venice alluding to Palermo, where Roussel appears to have committed suicide on July 14, 1933. Moreover, the day on which Leiris (supposedly) conceived the image, March 11, 1977, also makes an explicit—if not unironic—numerological reference to Roussel's biography, as this day exactly falls on the hundredth anniversary of Roussel's birth.[22] Pure "objective coincidence"? Although unlike Leiris, André Breton never studied the "initiatory language of the Dogon," he did recognize the originality of Roussel's *Impressions d'Afrique*.[23] The strange logic of the sentence puts Roussel's work on the same level as the Dogon secret language and turns the readers of Roussel into "initiates," able not so much to read a common language, as to *decipher* it. Leiris uses one of these procedures of deciphering and double-encoding in his own text, speaking of "my Dogon," referring in this way both to Roussel and also to his Dogon informant, Ambara Dolo, whom he met in Paris shortly before the text was written. "Mon ami Ambara"

21 Michel Leiris, *Le Ruban au cou d'Olympia* (Paris: Gallimard, 1977), 182.

22 Leiris, *Le Ruban*, 181f.

23 Leiris, *Le Ruban*, 182.

was one of his teachers and an initiate in the secret language. The red headcovering of the "Dogon in the gondola" is also ambiguous. It alludes to the characteristic head coverings of the male Dogons and to the red color in many of their masks, but also to the famous French Revolutionary "Phyrgian bonnet," and thus further connotes Roussel's death on Bastille Day. In this way Leiris creates a connection between the "sigi so," the secret Dogon language, and the word-plays and *calembours* which are the basis of Roussel's (and Leiris's) texts. One of the few readers of Leiris and Roussel who has a sense for this animistic relation to language is Yoko Tawada, the Japanese writer who resides in Germany and whose doctoral dissertation addressed *Spielzeug und Sprachmagie* ("Toys and Language-Magic.") In her "Tübingen Lectures on Poetics," Tawada writes: "Every letter is a person's back. They can turn around at any time. An author who believes his own text should be familiar down to the last letter is fooling himself. Whenever a letter turns around, an unfamiliar face is made visible."[24] It is not the modern fascination with the magic of language which we see here, but the animism of language in the literature of modernity.

24 Yoko Tawada, *Verwandlungen: Tübinger Poetik-Vorlesungen* [2001], 42, quoted in Schmitz-Emans, 251.

E. Blumenfeld,
Michel Leiris in the Musée de l'Homme with a statue of Gu, the god of iron and war, ca. 1947.
Private collection.
Source: *Leiris, Roussel & Co.,* ed. Jean Jamin, Paris: Editions Fata Morgana/Fayard, 1998

Raymond Roussel à 17 ans, costumé en marquis Louis XV.
Courtesy of Collection Laetitia Ney
Source: Caradec, François, *Vie de Raymond Roussel (1877–1933).* Paris: édition Jean-Jacques Pauvert, 1972

Marcel Griaule
Leiris's Informant Ambara Dolo
Source: Marcel Griaule, *Masques dogons.* (Paris: Institut d'Ethnologie), 1938

Irene Albers 145

CHOSES / DINGE / DINGEN / THINGS

000889

001226

000782

001227

001252

000869

000770

001241

001087

000885

000810

Assembly *(Animism)*

Agency is the generic name of an agency that was founded in 1992 by Kobe Matthys and is located in Brussels.

Agency constitutes an ongoing list of things that witness hesitation in terms of the bifurcation of nature in the classifications "nature" and "culture". This list of things is derived from judicial processes, lawsuits, cases, controversies, affairs, etc... where the bifurcation of nature was discussed.

Agency invokes these things in varying assemblies. On the occasion of Animism, Agency calls things forth from its list speculating around the question: Can non-humans be considered as authors?
Agency calls forth:

– thing 000770 (Zwischen Zirkuskuppel und Manege)
– thing 000782 (Bruits de la Nature nr2)
– thing 000810 (Thierry Mugler Photograher)
– thing 000868 (TTDL–42)
– thing 000869 (TTDL–46)
– thing 000870 (BR–1005)
– thing 000871 (BR–1020)
– thing 000885 (Daley Bicentennial Plaza)
– thing 000889 (Compliments of Enrich Bros. 8th Ave. & 24th St.)
– **thing 001087 (Unveiled Mysteries)**
– thing 001226 (Bingo!)
– thing 001227 (Scramble 2)
– thing 001241 (Blue Boy)
– thing 001252 (repertoire Hank Williams)
...

EDITOR'S NOTE

AT THE request of the Ascended Master, Saint Germain, and Victory, the Tall Master from Venus, the material in this book is written in a plain, direct manner with no attempt to conform to artificial literary standards, or outer world authority.

They said: "This series of books must go forth in a simple modern style which the layman can easily understand."

Therefore, the Inner Light and Feeling have been held as of the first importance in presenting this Truth; and the words used to express that Light and Feeling are those which are most direct and of easiest comprehension for the reader.

The Ascended Masters never use involved terminology regardless of any human opinion, for the nearer one comes to Eternal Truth, the more direct and concise is the language in which it is clothed.

In presenting this book to our readers, we have kept the Light and Feeling first and the literary form entirely secondary.

The material in the first two books is simply a record of the author's experiences in the order in which the events occurred, stated as clearly as possible and in words that convey to the reader the feeling of the experiences.

If the reader will bear this in mind, he too will be able to receive the Outpouring of Light which will open opportunities for similar transcendent experiences to come to him in a perfectly, normal, safe, harmonious manner for his permanent blessing and Illumination.

In loving service to the Light,
LOTUS RAY KING

Figure 1: *Unveiled Mysteries*, p. iv

AMANUENSIS' PREFACE

By permission of the Author, whose letter addressed to me follows as his preface herein, and to meet the natural inquiry and satisfy, so far as any personal statement from me will, any honest inquiring mind, I humbly appear in order briefly to give the major facts concerning the writing of this, even to me, very remarkable book.

I am an only child of Dr. and Mrs. Oliver, who for many years have resided in the State of California.

I was born in Washington, D. C., in 1866, and brought to this State by my parents two years later. Prior to commencing the writing of this book, in 1884, my education had been comparatively limited, and consequently very slight knowledge of the subjects here——

My father, a well-known physician, died a few years ago, my mother surviving him. Both were daily witnesses of most of the circumstances and facts surrounding the writing of this book. But further than to state this, I do not think myself called upon to introduce my family into the work, nor, in fact, myself, except insofar as it is meet for me to stand forth and do my personal part as the amanuensis.

I feel that I am mentally and spiritually but a figure beside the Author of the great, deep-searching, far-reaching and transcendent questions presented in the following pages; and I read and study them with as much interest and profit, I imagine, as will any reader. At the same time I feel with no sense of the natural pride of an Author of such a book, that it is a work of unselfish love, and will help to the betterment of an upward-struggling world, searching ever for more light, and feed the hungry for knowledge of the great mystery of life and of the ever evolving soul, through Him who said—— "I AM THE WAY; FOLLOW ME."

In these days of doubt, materialism, and even rank atheism, it requires all the courage I possess to assert, in clear unequivocal terms, that the following book, "A DWELLER ON TWO PLANETS," is absolute revelation; that I do not believe myself its Author, but that one of those mysterious persons, if my readers choose to so consider him, an adept of the arcane and occult in the universe, better understood from reading this book, is the Author. Such is the fact. The book was revealed to me, a boy, and a boy, too, whose parents were mistakenly lenient to such a degree that he was allowed to do as he chose in most things. Not lacking in inclination to study, but very lacking in will-power, continuity and energy, I gained little in educational triumphs, and was pointedly criticized by my teacher as "lackadaisical, even lazy." Hence, when a little past seventeen years of age, "Phylos, the Esoterist," took me actively in charge, designing to make me his instrument to the world, that profound adept showed what seems to me a rare faith, for his pupil without any solid education, as generally so considered, was minus any special religious trend, and for my sole commendation had willingness, love of the remarkable, and an uncolored mind.

For a year my occult preceptor educated me by means of "mental talks," and to such a point was my mind occupied by the many new thoughts with which he inspired me, that I paid no heed to my environment, worked automatically, if at all, studied and read not, and scarcely heard those who addressed my exterior senses. Then it was that my father determined to stop my "approaching imbecility," as he called it; for I had avoided explanations, and had said nothing of the talks with my mystic preceptor, whom even I had never seen but a few times. To parental pressure I yielded, and told my, to me, divine secret. To my relief it was not scouted, but after a long narration to both parents, they expressed a desire to hear the mysterious stranger also. This he would not grant, but permitted me to quote his words, talks and addresses, and at length I became so proficient that I could repeat what he said almost as fast as he spoke to me.

A circle was formed at home, consisting at first of my parents, W. S. Mallory (now of Cleveland, Ohio), and myself, as hearers, and Phylos as teacher. Later Mrs. S. M. Pritchard and Mrs. Julia P. Churchill were present. This was in Yreka, Siskiyou County, California, early in the eighties, where the MS. was commenced in A. D. 1883-4, but was finished in Santa Barbara County, California, A. D. 1886, where it has ever since remained in the manuscript, at the command of the author.

It will have added interest to many who love, or have become interested in CALIFORNIA, to know that within full view of Shasta, one of her loftiest mountain peaks, this book was begun and almost finished under the inspiration of that spirit of nature which speaks ever to those who, listening, understand.

How the Author differs from us common mortals, and how, by his occult methods, he possesses the power to dictate—— "reveal"—as he has done and still does, may be better known by perusal of his remarkable record set forth in this book, his personal history.

In 1883-4, A. D., in sight of the inspiring peak of Mount Shasta, the Author began to have me write what he told me, and, curiously enough, he dictated the initial chapter of "Book Second" first of all. Other chapters, both preceding and succeeding, were given at intervals of a few weeks, or even months, sometimes only a sheet or two, at others as high as eighty letter-size sheets being covered in a few hours. I would be awakened at night by my mentor and write by lamplight, or sometimes with no light, but in darkness. In 1886, the main work, as I remember it, was done. Then he had me revise it, under his supervision; and this work was as erratic as the other. In fact, the whole thing was as if he had the MS. already prepared when first he began dictation, and was indifferent as to what portions were written first, so only all were written. Had I been a medium in the sense usually understood by the believers in spiritualism, as I understand it, the writing would have been automatic, and I would not have been forced to clothe his converse so largely

Figure 2–3: *A Dweller On Two Planets*, p. ix–xi

Thing 001087 *(Unveiled mysteries)*

In 1934, Guy Ballard wrote a book called *Unveiled mysteries: Secrets of The Comte Saint Germain* under the pseudonym Godfré Ray King. *Unveiled Mysteries* contains revelations by the "Ascended Master Saint Germain." This book was the first volume in a series of fourteen books which teach the Ascended Master Saint Germain's "Great Laws of Life" and the use of the "Great Creative Words: I AM." In *Unveiled Mysteries* Godfré Ray King describes a series of encounters with Saint Germain which took place at Mount Shasta between August and October 1930. During these encounters with this "Powerful Cosmic Being" Godfré Ray King confronted several of his past lives. He also recorded in this book a trip with Saint Germain to the inside of Mount Shasta, where he met remaining members of the lost civilizations of Atlantis and Lemuria. Godfré Ray King stated in *Unveiled Mysteries* that all his experiences with Saint Germain "were as real and true as any human experience on earth." Guy Warren Ballard lived between 1878 and 1939. He worked as a mining engineer at Mount Shasta. He was also a student of theosophy and founder of the *I AM* activity of the spiritual organization Saint Germain Foundation.

Between 1883 and 1886 Frederick Spencer Oliver wrote a book entitled *Phylos the Thibetan: A Dweller on Two Planets*, also known as *The Dividing of the Way*. Oliver claimed that a disembodied spirit by the name of *Phylos the Thibetan* had revealed text to him. He found himself writing uncontrollably in his notebook and let his hand write. These automatic writings continued for several years; he would write a few pages at a time. Oliver claimed that the manuscript was dictated to him out of sequence and much of it backwards. He completed writing this book in 1886. The book is a collection of the different past lives of Phylos as Ouardl, Zo Lahm, Zailm and Walter Pierson. The book contains detailed descriptions of the lost continents Atlantis and Lemuria. The book claims that the survivors of the sunken continent of Atlantis and Lemuria live inside Mount Shasta in a secret city. A copyright was taken on the manuscript in 1894. *A Dweller on Two Planets* was finally published in 1905, by his mother Mary Elizabeth Manley-Oliver. It was republished in 1921 by his son Leslie Robert Oliver and in 1940 by Borden Publishing Company. The copyrights were each time renewed. Frederick Spencer Oliver was born in 1866 and died in 1899 at the age of 33. He lived most of his life near Mount Shasta in North California.

in my own language, and in that case no revision would have been necessary. But I was always conscious of every surrounding, quite similar, in fact, to any stenographer, with this lack of equality to such an amanuensis, that I was not then a shorthand reporter. Realizing how useful in taking my preceptor's teachings the possession of this art on my part would be, I learned to write stenographically, although never an expert.

Twice was the work revised; twice he had me go over this erratically written MS., which, as I have said, was mainly written backward. So strangely was it given that I had almost no idea of what it was, or with what it dealt. On one occasion, when I had written over two hundred sheets, mostly backwards, i. e., the sentences rightly last coming first, so fast and mixed that I had no idea of its sense, he bade me burn it without even reading it. This I did; to this day I have little idea of what those sheets contained, or why he had me destroy them; nor will he tell me. The book was finished in A. D. 1886, though for the purpose of publication the MS. has been thoroughly edited by a literary expert, that any errors therein due to my own limitations and mistakes in transmission as amanuensis, should be eliminated.

In the year 1894 the manuscript as finished in 1886 was typewritten in duplicate by Mrs. M. E. Moore of Louisville, Kentucky, and she has had possession of one of said copies ever since up to midsummer, 1899. The Moore copy has never been changed by even a letter since it was written, evidence whereof has been judiciously preserved. Said manuscript was copyrighted by me in 1894, and owing to an addition to the title, again in this, the year 1899.

During all this time I have not been permitted, nor able, to have it published. In the interval many of the things spoken of in the shape of scientific and mechanical rediscoveries, **spoken of in the book,** have been brought to pass. The high attainments of the Atlanteans, lost for thousands of years, following as the result of the engulfment of their great conti-

nent, have been and are rapidly being brought to light and utility, bearing out the prediction of the Author.

Witness the discovery recently of the Roentgen or "X-ray," not even dreamed of in 1886, yet in the book you will find a long treatise concerning "Cathodicity," and the amazing powers of the "Night Side of Nature," of such practical use to and so well understood by the people of that wonderful age. Also note wireless telegraphy; it, too, is herein, scattered all through and referred to in this book, precluding the possibility of interpolation. Again, regarding there being but "One Energy" and but "One Substance," now beginning to find able champions and general scientific acceptance, in place of passing it by as a chimera for the elementary hypothesis so long held by chemists. This also is an integral part of this book; though it is not more than two years since an article appeared in Harper's Magazine seriously advancing this belief of fin-de-siecle science as a novelty, but major examples of what was set forth in "DWELLER ON TWO PLANETS" in 1886, together with many more predictions of the immediate oncoming of what the Author terms rediscovery of the secrets buried with Atlantis; and it is promised that we, as Atlanteans returning, are going beyond her fallen greatness, and that by slow, synthetic steps, we are coming up to surpass even those wonderful attainments, as the ever expanding and growing mind and soul of man climbs ever higher in the rounds of his evolution.

To all earnest, though perhaps skeptical, inquirers, I may say that the evidence as to this book being finished in 1886, and before the latter-day discoveries became known, abundantly exists and can be clearly established, to clear away any cobwebs that might otherwise find lodgment in their minds and prevent them from accepting the book for what its Author claims, the truth.

Upon the ability of the perusers to so accept this book as history and not fiction, much depends, in lighting up the Path for their souls. I am rather in expectation of another work,

but whether I will have it, or some other amanuensis will get it, I do not know. If it comes as promised, it will be one for the inner eyes of those who profit by this work, and seek yet more of the counsel which will place their feet firmly on the "Narrow Way of Attainment".

In writing as such amanuensis, I am always conscious of the presence calling himself Phylos, whenever he chooses to come to me, and sometimes I see as well as hear and speak with him, though vision is rare. Clairvoyance and clairaudience would account for this. I hear, and speak or write, what is said as I am directed. Often, after being shown the mental picture, I am left largely to express it in my own language. At such times I am as fully conscious of my surroundings as at any other time, though I feel lifted as into a Master's presence, and gladly do for him the work of an amanuensis. If the good counsel and loving care I have personally received from my wise friend had been faithfully and persistently remembered and followed, instead of so largely slighted or forgotten as often to almost fade from my memory during his absence, I should undoubtedly have been a better example than I feel that I am of the grand lessons he sets forth in this book.

I have never represented myself to any person nor to the public as possessing mediumistic or any other quality, nor have I ever used the same at any person's request, for love or money. Whatever my talents or qualities in these things may be, they have only been used as a sacred gift. With such influences as have surrounded me in this work, I can gratefully and truly say that I have never been tempted to do otherwise, if I could, and have ever received exceedingly more good than I feel that my services have returned.

Now the question arises, do I believe this Book? Unhesitatingly, Yes. There may be points that I can accept only on faith, like any other reader, feeling that a day will come when, if I shall be faithful, I will be instructed by the Spirit to which he testifies. There certainly will be criticisms from some as to the manner of the writing of this MS., and as to the truth of

my statements regarding it, as there has so often been by those who prefer to believe that all such claims are but author's fictions. I have come personally to know the truth of some of the things mentioned in this book, in the course of the fifteen years that I have had in this connection. I have had many experiences, mentally confirmatory at least, either of the direct statements of the author, or tending to strengthen the absolute confidence which I feel in him I reverence so deeply. I have often, even as "Christian" in "Pilgrim's Progress," fallen. But the Path is there. Does the sun cease to shine because fogs obscure it? Then is it not for us to follow the Path, forgetting persons, and looking to the spirit, as we read Phylos' Book? F. S. OLIVER.

LETTER FROM PHYLOS, AUTHOR OF THIS HISTORY

January, 1886

To-day, my brother, the masses of humanity on this planet are awakened to the fact that their knowledge of life, the Great Mystery, is insufficient for the needs of the soul. Hence a school of advanced thought has arisen, whose members, ignorant of the mysterious truth, yet know their ignorance and ask for light. I make no pretenses when I say that I, Theochristian student and Occult Adept, am one of a class of men who **do know** and can explain these mysteries. I, with other Christian Adepts, influence the inspirational writers and speakers through an ability to exert the control of our trained, and therefore more powerful, minds over theirs, which are enormously less so. Hence, when the people ask for bread, our media give it to them. Who are these, our media? They are all men or women, in churches or out, who bear witness of the Fatherhood of God, the Sonship of Man, and the Brotherhood of Jesus with all souls, irrespective of creeds or ecclesiastical forms. Because these, our writers and speakers, have wrought for human good, so shall, and so does, good come to themselves, bread from the waters. It is proper that the

Figure 4–5: *A Dweller On Two Planets*, p. xii–xv

In 1940 an action was taken by Leslie Robert Oliver, the son of Frederick Oliver, and Borden Publishing Company against the Saint Germain Foundation for injunction against infringement of a copyright in *A Dweller on Two Planets*. The Saint Germain Foundation argued that the copyright was invalid because the author of the book was not human.

On September 16, 1941 the court case *Oliver v. Saint Germain Foundation* took place at the District court of California. Judge Dawkins stated that:

"This motion alleges invalidity of the copyright in that (a) Frederick Spencer Oliver, to whom the original was issued, did not pretend to be the author of the book *A Dweller on Two Planets*, but stated plainly that it was dictated to him by the spirit of a previously deceased person; (b) the copyright was issued to him not as author but as proprietor; and (c) that this necessarily implied an assignment which could not be made by the spirit of a dead man. ... It appears from the record in this case that Frederick Spencer Oliver did not claim to be the author of the book as ideas and thoughts of his own, but he describes himself as the 'amanuensis' to whom it was dictated by Phylos, the Thibetan, a spirit. ... More than six pages of the book are consumed in emphasizing that it is a true revelation by Phylos through Oliver, the 'amanuensis', and the latter appends to his preface what he solemnly asserts are letters from Phylos, the author of this history. ... It is perfectly clear, therefore, that Oliver wished to impress in the strongest terms possible, his sincere belief in the truthfulness of his statement that he, a mortal being, was not the author, and to induce those who might read to believe that it was dictated by a superior spiritual being, whose motive was to uplift and benefit the human race spiritually, religiously and morally. In other words, he sought to give the book an origin similar to that claimed by the followers of Joseph Smith in the *Book of Mormons*, the *Koran* by the followers of Mohammed, and to some extent the *Bible*, although it affirms the teachings of much of the *New Testament*. ... In this situation, if we accept Oliver's statement as true and not fiction, how can we say that King, who wrote defendants' book, was any less truthful and sincere, even though there be some similarity as to the methods of spiritual communication, incidents, etc., between the two? Who can say that the spirit of the Master or Masters, whether called by one name or another, might not see fit to use both men as instrumentalities or amanuenses for communicating their messages of guidance and direction to humanity? The law deals with realities and does not recognize communication with and the conveyances of

leaders of the mental van should receive generous remuneration. And they do. But at this point enters a different phase. Observing the cry for more light, more truth, observing also how great is the recompense, up springs the imitator, who has no light of inspiration, no conception of the real truth, none of the laws of the Eternal. What does he? Watch! With a pen whose shaft is imitation, and whose point is not of the gold of fact, but of the perishable metal of selfish greed, this person writes. He dips his pen into the ink of more or less thrilling sensationalism, muddy with the dirt of immorality and nastiness, and he draws a pen picture illuminated by the tallow-dip of lust and corruption. There is in his work no lofty aim to inspire his readers; he deals with the lowest aspects of life, and, ignorant of the inexorable penalty for sin, has no expiation to demand of his characters. While a little allured by brilliant word-painting, the reader goes to the end, he is conscious ever that the cry of his soul for the bread of infinity has been answered not even by a crust, but by a handful of mud! No good purpose has been served; nothing taught of the real laws or philosophies of life; it drags down, but never elevates. Whoso shall utter thus, upon them shall come retribution, and they shall be judges upon themselves, and executioners also, out in the open sea of the soul, where their own spirit will have no mercy for the misdeeds of the soul. Other imitators there may be, who, fired with a genuine desire to do good, will mimic intuitional utterances, and, however poor the work, yet if the animus has been to do good, in the measure of that resolve shall the Most High judge that whatever is for good is not for evil. But let them beware who, for money or profit, are tempted to give stones or mud!

And now, my brother, I have another subject to speak upon. Readers of my book, "Two Planets," may consider awhile over those passages concerning the sin of the Princess Lolix and of Zailm, the legal nephew of the Emperor Gwauxln. They may say that the mention of this fact, though liable to occur as one of the varied experiences of life, is nevertheless out of place in a book whose aim is highly moral. But I

ask those who know my work, is it? Is it inexcusable to speak of those grave but common crimes, if the author can treat them as examples of broken law, and can place the working of such law so clearly before this unthinking world that men and women will be afraid to break it, fearful of the penalty, which can in no wise be evaded? I think it unjustifiable to keep silence under such circumstances. I have, so far from overdrawing the estimate of the penalty of crime, not given the entire expiatory picture. I know whereof I speak, for this, my brother, is my own life history, and words have no power to depict the utter misery which the exaction of the punishment has caused me! If but one soul shall be saved like misery, and similar or equal sin, or less or more error, then I am content. I have sought to explain the great mystery of life, illustrating it with part of my own life history, extracts which cover years reaching into many thousands; and the greatest of all Books has been my text. I add not thereto nor take away, but explain*. Peace be with thee.

 PHYLOS.

Addendum: I feel myself vastly indebted to many bright writers and authors for numerous quotations of which I have availed myself, without making credit at the time; it is impossible to render this award to every individual by name, hence I must do so concretely, just as the world finds itself forced to express its aggregate gratitude, not by words of laudation, but by shaping its life in conformity to the noble precepts in poetry and in prose, devised to humanity as the legacy of all the ages. As the world is helped, so has my work been; I hope I have returned help for help.

 Sincerely, PHYLOS.

*Revelations, XXII, 18-19; also I Tim. VI. 3-12

A MARVELOUS PREDICTION

The preface is mine to say what may properly please me. It was so given me by the Author.

A subject not specifically treated by Phylos in his book, but not forbidden me by him, I feel it almost due the public to give here, most especially as it was told me by him while I was summering in Reno, Nevada, in the year 1886. I at that time embodied it in a short story, which I dated but, more to the point, read to a young lady friend, Miss S. This fact she can testify as being fact, for it was partly written under her eyes, was criticized by herself, sister and mother, and, climax, was written upon paper bought for the purpose from her father's drug and book store.

Phylos stated to me that inside of fifty years, considerably inside, he thought, mundane scientists would have discovered and applied electric forces to the astronomical telescope. Just how, he did not state, although he did give ample enough details so that one familiar with those subjects probably would have been able to seize upon and work out the idea to a successful issue. He said that electric currents unimpressed with vibrations such as produce sound, heat and light, until resisted, would be superadded to the light vibrations constituting the image beheld through the telescope. This would be accomplished through the media of well-known so-called chemical elements, whose then unrecognized higher powers remained to be discovered.

The result was described to me as awe-inspiring and marvelous past earthly dreams. Thus he stated that upon suns and stellar bodies so distant that hundreds of them only (even in this A. D. 1899) seem as a faint speck through the most powerful modern telescopes, to this electrostellarscope would, by proper amplification of the electro-luminous waves, be made so plain to earthly vision that objects not visible to the unaided earthly sight would be easily perceptible on the most distant stellar body, however remote from the mundane beholder.

Further, Phylos says that he did not embody this subject in his book, because Atlantis did not know of it, despite her marvelous scientific attainments. Hence it will be no "rediscovery," but a distinct step in advance of anything that Earth has known—Solomon at last outreached, so far as his time-honored saying applies to our planet, at least.

 Respectfully,

 THE AMANUENSIS, FREDERICK S. OLIVER

Los Angeles, October 11, 1899

Figure 6–7: *A Dweller On Two Planets*, p. xvi–xix

legal rights by the spiritual world as the basis for its judgment. Nevertheless, equity and good morals will not permit one who asserts something as a fact which he insists his readers believe as the real foundation for its appeal to those who may buy and read his work, to change that position for profit in a law suit. ... One who narrates matters of fact may be protected by copyright as to his arrangement, manner and style, but not as to material or ideas therein set forth. ... There is no charge of infringement here based upon style or arrangement, but it is upon the subject matter or stories of two earthly creatures receiving from the spiritual world messages for recordation and use by the living. There is no plagiarism or copying of words and phrases as such, but only slight similarity of experiences in that the parties became agencies for communicating between the spiritual and material worlds, of things which happened in other ages. In final analysis, the object of both is to impress what is said to be one of the chief attractions of the theosophical movement, belief in the reincarnation of the soul."

The court refused to ascribe copyright protection to a spiritual being, notwithstanding the revelation originating from a spiritual being.

"The three Fox sisters of Rochester, originators of the
spirit-rapping movement" (caption by Edward Tylor)
Source: Edward Tylor's diary
PRM2009.148.2
Image courtesy the Pitt Rivers Museum, Oxford

Animism meets Spiritualism:
Edward Tylor's "Spirit Attack," London 1872

Erhard Schüttpelz

1.

Recent research has subdivided the phenomenon known as "spiritualism" into a variety of local practices and motivations. However, this does not mean we are finished with the broader picture of "spiritualism" as an international movement closely associated with a single founding event (the Fox Sisters and their "rappings"), and transmitted primarily by travelling mediums, which appealed to both autodidact and academic audiences. In fact, the latest research into regional and variant practices only throws the international movement into sharper relief. What is now clearer is how spiritualism served as an international lingua franca, a sort of international pidgin differently creolized in various locations. Seen in this light, transatlantic spiritualism consists of the transposition of local necromantic practices into the vocabulary of a highly mobile international lingua franca, and vice versa.

There were several kinds of "translation" at work. First, as very early observers like Frank Podmore grasped, the appearance of the rapping spirits in provincial upstate New York became the founding event of spiritualism thanks to its transatlantic transfer, itself part of a broader transmission via mass media and media tours.[1] Mesmerist techniques of "induced trance," long widespread in continental Europe, were now discovered in the Anglo-Saxon countries as a necromantic technique. They became the subject of public discussion there, but now associated with events that would previously have been classified as a kind of poltergeist. Moreover, via Great Britain these techniques now returned to Europe, where they emerged as a sensation and a novelty in the fashion for "table tapping" and the public appearances of mediums. This view of international spiritualism will doubtless be modified in the light of recent work, but even the most up-to-date accounts of spiritualism's emergence retain this figure of its transatlantic transfer, spanning the "Spiritual Atlantic," an area also connected with the colonies, and, thanks to Kardecism, with South America.

Second, new practices centered on the translation of spirit messages. Since the Fox Sisters, this translation had repeatedly been conceived in terms of recoding, and, more broadly, of communications technologies. "Tapping" and unsemantic "rumbling" became comprehensible when understood as an alphabetic sequence corresponding to an arithmetic code. From this point, it was only a short step to comparisons with telegraphy and Morse code: the American idea of the "spiritual telegraph."[2] Until the end of the nineteenth century, transatlantic spiritualism was marked by high expectations regarding the place of new information technologies in spirit communication. This

1 Frank Podmore, *Modern Spiritualism: A History and a Criticism*, 2 vols., (London: Methuen, 1902).

2 Werner Sollors, "Dr. Benjamin Franklin's Celestial Telegraph, or Indian Blessings to Gaslit American Drawing Rooms," *American Quarterly*, no. 35 (1983): 459–480.

belief was seen as both verified and falsified in the development of what were then "new media" (for example, photography, the invention of radio transmission). It further manifested itself in the ongoing concern with the recoding of messages received from spirits. The first translation took place in the gap between the human medium and the technical apparatus, but it depended on the inseparability of the two. "No spirit messages without a personal medium," remained spiritualism's fundamental axiom, even when an automatic technical apparatus seemed to render the human medium superfluous. No matter how elaborate spiritualism's cosmology became, its minimum requirements remained, first, a commitment to the inseparability of human mediums and technical media, and, second, to new technologies and techniques that would maintain their association.

Third, the foundation of transatlantic spiritualism did not consist of the discovery of new kinds of spirits or messages. Rather, its styling as a founding event was the result of a widespread debate, which amounted to a permanent work of translation between competing versions of the Fox Sisters' story. This debate—between the versions of believers and opponents, between faithful adherents and skeptical demystifiers—was further marked by defections and conversions. Having begun with the first publications on spiritualism, the debate made the Fox Sisters the prisoners of a lifelong regime of apparitions and unmaskings, a process that ended late in their lives with their self-revelation and subsequent recantation. With regard to transatlantic spiritualism, it thus makes little sense to attempt to isolate an uncontroversial or essential practice. The controversy around spiritualism, the debate on the possibilities of telecommunication—in a sense, this is what spiritualism actually *was*. More precisely, we might give this mode a deliberately modernist name: the debate is the "International Style" of spiritualism. As the debate came to a close towards the end of the nineteenth century, its self-appointed historians emerged from both camps—adherents[3] and skeptics.[4]

In this spiritualist International Style, no practices or mediums could escape the tension between revelation and unmasking. Neither were any completely removed from mass media: ever since the Fox Sisters had climbed the podium, the movement was fundamentally concerned with the publicizability of spirit communications. As the historian Michael Hochgeschwender has shown, the mass marketing of religious revelation was already a significant phenomenon in the USA, even before the public appearance of spiritualism.[5] Hence the international debate around spiritualism constantly oscillated between private spaces and mass media, between skepticism and persuasion, between self-marketing and journalistic campaigns of unmasking. Even at this point, private spaces could count on a level of regular reportage, already with its own generic rules.

3 Alexander N. Aksákow, *Animismus und Spiritismus* (Leipzig: Oswald Mutze, 1890).

4 Podmore.

5 Michael Hochgeschwender, "Geister des Fortschritts: Der US-amerikanische Spiritualismus und seine mediale Vermittlung im 19. Jahrhundert," in *Trancemedien und Neue Medien um 1900*, ed. Marcus Hahn and Erhard Schüttpelz, (Bielefeld: Transcript, 2009), 79–96.

"Spirit-photograph of William Howitt (in the flesh) and granddaughter (in the spirit)" (caption by Edward Tylor)
Source: Edward Tylor's diary PRM2009.148.3
Courtesy the Pitt Rivers Museum.

2.

For a public debate to be launched and for it to persist over time, there must be a certain common ground between opposed participants. Only when these points in common are no longer self-evident do debates dissipate, disappear, or transform into something else. However, in retrospect, this kind of common ground is often the most difficult aspect to properly comprehend. Spiritualism was marked by this structure between about 1850 and 1890, until the gradual waning of the debate's intensity around the later date. To sum up: What spiritualists and their opponents shared was an uncontroversial belief in the existence of a Beyond, and of a life after death. Precisely because it was shared and uncontroversial, however, this common belief remained largely unthematized in the controversy itself. Where it *was* addressed, it did not become an issue for debate. The crucial point is that the desire to prove and to concretely stage the communication of the spirits of the dead did not—in ideological terms—come from the margins of religion or of science. Instead, it emerged from the broad consensus of progressive-minded belief in the hereafter, a consensus spanning the late eighteenth and the whole of the nineteenth century. As Lang and McDannell have pointed out,[6] the idealizing "anthropocentric heaven" of progressive afterlife theories had succeeded in assimilating the hereafter with earthly life. Heaven was no longer centered on God, it was instead focused on mankind's mutual sympathy and ever-increasing cooperation, a process that incorporated both the living on earth and the dead in heaven. From this viewpoint, life beyond became a continuation of earthly life under more ideal conditions. There was "a new Heaven and a new Earth," requiring a belief that progress would be realized through communication, active cooperation, and practical mutual sympathy. In this way, earthly life and the hereafter not only came to

6 Bernhard Lang and Colleen McDannell, *Heaven: A History* (New Haven: Yale University Press, 1988).

resemble each other; they, in fact, also approached each other. Moreover, the spiritualist heaven was the *modern* heaven, dominating, in the course of the nineteenth century, both Protestant and Catholic notions of the afterlife. So the battle lines between spiritualism's adherents and its opponents did not run through the imagination of the afterlife itself. Rather, the dispute lay with the controversial assertion—both practical and theoretical—that the convergence of the living and the dead should result in their *actual* communication. Hitherto, this convergence had been understood only in terms of progressive knowledge and mutual improvement through cooperation, sympathy, and communication.

Therefore, at the center of the debate between spiritualism and anti-spiritualism, we find an axiom that would not have made sense in other spirit-communication contexts, in Europe or elsewhere. This axiom posited that an anxiety-free and sentimental sympathy between the living and the dead was provable in practical terms, and that such a sympathy was the precondition of all communication between the living and the dead. Both the Beyond and its individual constituent spirit souls were actually constituted in this "sympathetic" fashion. In strong contrast with many—in fact, all—other European and non-European visitations of the dead, these were remarkably pacified spirits, which came both to assert and to perform a peaceful, amicable, fond communication.

3.

If we take into account this fundamental consensus between adherents and opponents of spirit communication, we can better understand the technical consensus reigning between the two groups. Opponents of spiritualism wanted to prove that communication with the dead was impossible, or impossible in this particular way. Every fresh claim had to be refuted anew, and a decisive refutation lay solely in the revelation of deception and of self-deception. General suspicion could be focused through individual acts of exposure, aimed at each human medium and for each technology used, incorporating the establishment of a Tribunal of Reference for the spirit summoned and leading to a decisive weakening of the credibility of a medium or a technique. Among spiritualism's opponents, the Tribunal of Reference was understood above all, as a means of identifying the tricks used to bring about an apparition. Spiritualism's adherents, by contrast, did not need to deny the possibility of tricks, deception, and self-deception—the broad existence of such things was readily admitted in spiritualist texts. Adherents could so easily make this admission because they were solely concerned with the real possibility of communication with the dead. This possibility, it was felt, could persist even in the face of unmaskings and refutations; it was identifiable in the remainder left unexplained by these revelations, their shadow side. Proofs of deception could thus even be seen as an ongoing refinement of spiritualism, a process by which intentional action and possible deceptions would be progressively dissociated from spiritual effects and their proofs, allowing a deepening and clarifying of the gap between human action and the realm of spirit communications. For the skeptic, proving the impossibility of spirit communications was as a zero-sum game: the spiritualist would

lose and the skeptic would win. By contrast, the adherents' idea of the proof of spiritualist communication was *not* as a zero-sum game. In this case, *both* parties would win; in fact, each would benefit from the gain of the other. This constellation—combining, on the one hand, the assertion of a possibility, and, on the other, the attempt to prove an impossibility—underlies the striking informality and calm in relations between adherents and opponents investigating dubious cases, with both parties secure in their respective positions.

In addition, as in any debate, there was always a hope of bringing the opponent over to one's own side: the hope of incorporating skeptics' efforts into a more successful summoning of the spirits, or, on the other side, the hope of turning the conjuring-up of spirits into a decisive disproof against itself. More generally, there was a wish to make mediums and their technical media into devices of skepticism and disenchantment (this was at stake in the Fox Sisters' defections at the end of their career), and—on the other side—to turn skeptics and disenchanters into spiritualist adherents, and perhaps even into mediums. There is a rich set of examples of these conversions in the spiritualist debate. But what are the general rules of this game?

A conversion experience seems to include within it the sense of a previously known situation "turning" or "tipping" into something else, possibly into its opposite. A conversion could simply be a disillusionment. This was precisely the aim of spiritualism's opponents, who attempted to weaken the credibility of mediums, adherents, arguments, and practices to such an extent that individual spiritualists would simply become disillusioned. The historical record amply documents the skeptics' criminalistic patience and cunning in pursuing mediums and their performances and apparatuses.[7] On the face of it, these efforts at revelation and refutation seem convincing and straightforward, until we begin to consider instances in which declared opponents of spiritualism were unable to resist a séance's force. Or rather, they were unable to resist its *lack* of force, the amicable sympathy of the situation. On the side of the spiritualists, there was thus no "arms race" of tricks, no constant development of new ruses to out-do the skeptic in cunning and connivance.

In response to skeptics' "unveiling" attacks, adherents of spiritualism turned to another kind of attack—what I.M. Lewis called the "spirit attack."[8] This was a friendly and sympathetic attack by spirits, taking the form—quite unexpectedly for the skeptic—of a pronounced and unexpected sympathy and a relatively open encounter with an unknown. This ultimately took the form of an unknown (dead) individual, of whom the medium took possession in a trance, or by some kind of signal transmission, and who then addressed those present via the medium. The skeptic, in other words, was answered with a message of love. As the spiritualist Alexander Aksákow put it: "In fact, if we grant at all the existence of something beyond death, then this is most likely to be love, pity, our investment in those close to us, our desire to tell them that we continue to exist. And it is precisely these sentiments which most commonly 'motivate' spirit or soul interventions."[9]



7 Podmore.

8 I.M. Lewis, *Ecstatic Religion* (Harmondsworth: Penguin, 1970).

9 I.M. Lewis, *Ecstatic Religion* (Harmondsworth: Penguin, 1970).



"Spirit-photograph of Mr John Jones, & a spirit supposed
to be a deceased daughter" (caption by Edward Tylor)
Source: Edward Tylor's diary
PRM2009.148.4
Courtesy of the Pitt Rivers Museum.

4.

10 Claude Lévi-Strauss, "The Sorcerer and His Magic," [1949] in *Magic, Witchcraft, and Curing*, ed. George Middleton, (New York: Natural History Press, 1967), 23–41.

11 Edward Tylor, *Primitive Culture*, (New York: J.P. Putnam's Sons, 1871).

12 George Stocking, "Animism in Theory and Practice. E.B. Tylor's unpublished 'Notes on Spiritualism,'" in *Man* (n.s.), no. 6 (1971): 90.

13 Edward Tylor, "Notes on 'Spiritualism,'" in George Stocking, 92–100.

An 1872 journal written by a founder of cultural anthropology contains two of the most interesting descriptions of precisely this kind of "spirit attack." However, even the existence of the text is itself something of a sensation: it is as if Lévi-Strauss, at the high point of his work, had reentered psychoanalytic treatment in order to reveal its charlatanry. (In fact, Lévi-Strauss would have no need of this—by the time he had decried psychoanalysis as a modern form of magic, he was already an intimate friend of Jacques Lacan.)[10] To extend the comparison: Edward Tylor had at this point already published his main theoretical book, *Primitive Culture* (1871), the founding document of cultural anthropology. Contemporary spiritualism was at the very center of this book, sometimes implicitly, sometimes acknowledged explicitly. However, at the same time, Tylor's text excluded spiritualism from the contemporary world, characterizing it as both a contemporary "animism" and an untimely "survival."[11] In fact, had the spiritualist movement not existed, "spiritualism" is probably the term Tylor would have used to refer to "animism" as a more precise expression for the spirit-inhabited religious world of primitive peoples. As George Stocking observed of Tylor's early writings: "[Tylor] offered a number of examples to show how 'man in his lowest known state of culture is a wonderfully ignorant, consistent, and natural spiritualist,' how the 'effects of his early spiritualism may be traced through the development of more cultured races,' and how his early 'all-pervading spiritualism' forms 'a basis upon which higher intellectual stages have been reared.'"[12] From this point of view, contemporary spiritualism was merely the untimely expression of an archaic form of thought and of its ritual practices, a residual "survival" from another time. In 1869, Tylor made this explicit: "Modern spiritualism is a survival and a revival of savage thought, which the general tendency of civilization and science has been to discard."[13]

The impact of Tylor's dismissal of contemporary spiritualism as allochronic—something from another era—and his scholarly rejection of its own loudly proclaimed claims to modernity and progressivism can be felt even in the present day, probably more influential than all the scandals and the skeptics' campaigns of revelation. There is probably no more difficult fate than that of a modernizing movement that has the legitimacy of its modernity denied. And it was explicitly as a modernizing movement that transatlantic spiritualism made its appearance, and, as shown above with regard to its beliefs in the afterlife, it was undoubtedly correct in this self-description. Spiritualism is one of the few genuinely modern movements to have experienced a thoroughgoing delegitimation, to be banished from the history of modernity and of modernization. Tylor's visits to London séances can thus be read as a journey made in order to encounter the phenomena underlying his two great terminological coinages: first, "animism" in a non-authentic or at least questionable form, namely as "spiritualism," and second, the "survival" of older and still potent customs. He would meet there, so to speak, the dis-simultaneity of the simultaneous, the asynchronicity of the synchronous. His journal begins with just such an intention: "In November 1872, I went up to London to look into the alleged manifestations. My previous connexion with the subject had been mostly by

way of tracing its ethnology, & I had commented somewhat severely on the absurdities shown by examining the published evidence."[14]

14 Tylor (1971), 91.

For Tylor, the spirits he would encounter would represent a non-authentic form of "animism," and their agents would be a kind of "living dead," untimely members of a modern era that had left animism long behind. We might expect that these central motifs of *Primitive Culture* would be reflected in Tylor's protocol. However, his participant observation of "animism" and of "survivals" quickly reached its limits. While Tylor did leave the journal in publishable form, giving it the unmistakeable title "Notes on 'Spiritualism'" and providing it with a literary ending unarguably clear and memorable, the text remained unpublished for a hundred years. Since George Stocking's publication of the journal, however, the text has prompted the revision both of the history of ethnology and the history of spiritualism.[15] As I will show, the journal amounts to a highly revealing ethnographic investigation, a pioneering work of "domestic ethnology," which also amply documents the interplay between a researcher's anxiety and his research methodology.[16]

15 Peter Pels, "Spirits of Modernity: Alfred Wallace, Edward Tylor and the Visual Politics of Facts," in Magic and Modernity. Interfaces of Revelation and Concealment, ed. Birgit Meyer and Peter Pels, (Amsterdam: 2000), 302–340.

16 Georges Devereux, From Anxiety to Method in the Behavioral Sciences, (The Hague: Mouton, 1967)

The séances attended by Tylor featured two "oldtimers or believers" for every one "newcomer or sceptic."[17] Among these skeptics and novices were a strikingly high number of anthropologically-minded academic observers, including the co-founder of evolution theory, Alfred Wallace,[18] the museum founder Pitt Rivers (whose museum would later be led by Tylor), members of the Howitt family, early ethnographers of Australia, as well as several physicians. On September 4, 1872, Tylor visited his first séance, which featured Mrs. Jennie Holmes, "a stout pasty-faced half-educated American with a black bush of curls."[19] Pasted into Tylor's journal for this date is a clipping of a newspaper advertisement that explicitly invites skeptical researchers—like Edward Tylor—to the séance: "*Mrs Jennie Holmes* (late of New Orleans, La., U.S.A.) SEANCES, for Musical, Physical, Trance, Inspirational, and Materialisation Manifestations, will be held every MONDAY, TUESDAY, WEDNESDAY, and THURSDAY Evenings, at her reception rooms, No. 16, Old Quebec Street (two doors from Oxford Street), Marble Arch, W., at Eight o'clock; fee, 5 s. Private Sittings, for Business and Medical Consultations, from One to Four o'clock p.m. same days; fee, One Guinea. Strangers, investigators, and non-believers especially, are invited to attend, to 'prove all things and hold fast to that which is good'. – Her powers as a Medium have been the subject of wonder and comment throughout the United States, Canada, and Central America. Her endorsements are from some of the most prominent gentlemen of the States."[20]

17 Tylor (1971), 92.

18 Malcolm Jay Kotter, "Alfred Russell Wallace, the Origin of Man, and Spiritualism," *Isis*, no. 65 (1974): 145–192.

19 Tylor (1971), 93.

20 Edward Tylor, "Notes on 'Spiritualism,'" [1872], Manuscript copy, Pitt-Rivers Museum, Manuscript Collections, Oxford.

One prominent feature of Jennie Holmes's repertoire was a summoning of the spirits of the Indian dead, not an unusual phenomenon in 1870s America. "The medium was then possessed by a little Indian girl-spirit named Rosie, who talked a kind of negro jargon, speaking of Mrs. Holmes as my squaw, my medy (short for medium), etc. A favourite joke was to say 'you stand under me' for you understand, etc."[21] In his journal, Tylor noted with satisfaction his reaction to the dead girl's mixture of impertinence and strangeness, and her blurring of the social boundaries of North America. (Supposedly an Indian, she performed black folklore ["nigger melodies"] and a variety of other songs.) He thumbed his nose at the medium in the dark, noting how Jenny Hol-

21 Tylor (1971), 93.

mes "reproved me for keeping one leg crossed over the other, which she declared she saw in the dark [...] She did not, however, appear to see the free hand which I occupied in making the long nose for a good time in her direction."[22] Even today, thanks to Tylor's protocol, the comedy of this scene remains informative. The spirits appear, but they do so in an impossible, childish, ridiculous way; the expert defends himself with a mocking gesture, just as childish, directed at the medium. Only towards the end of the journal entry do we find anything amounting to a scientific assessment of the spirit claims. Here, too, the encounter begins with an attack, but a "spirit attack" in which the dead Indian girl "Rosie" declares Tylor to be a suitable medium: "Rosie declared that she saw light about my face and that I was highly mediumistic. She did not mind my being what she called a skepatic, because this does not interfere with truth. Rosie talked what she called Ojibwy Indian and I call gibberish. I asked her the word for stone, which was nothing like the real word."[23]

In this way, Tylor's account of his meeting with "Rosie" is organized as a series of attacks and counter-attacks. At the beginning of the séance, he is warned not to cross his legs, probably because this would break the circle with a point of "resistance." And in fact, he reinforces his resistance—if only in retrospect in his protocol—by means of his aggressive gesture. Ascribed with mediumistic gifts, including the visibility of a medium's light around the face, he counters with a professional counter-attack, attempting to show Rosie's revelations to be self-contradictory. This is a Tribunal of Reference: the spirit claims to be an Ojibway Indian, but doesn't even know the word for "stone." The logic of the encounter is obvious. Tylor understands the exchange as a zero-sum game, and plays it in this manner. His opponent, however, does not. Instead, she emphasizes the possibility of changing sides and the existence of shared values: "She did not mind my being what she called a skepatic, because this does not interfere with truth."[24] Tylor chalks up the encounter as a victory. Together with an artist and a lawyer, he makes his way home. All are agreed on the results of the investigation, marking it down as a successful tribunal: "Our verdict was simply imposture. I should say the most shameful and shameless I ever came across."[25]

22 Tylor (1971), 93.

23 Tylor (1971), 94.

24 Tylor (1971), 94.

25 Tylor (1971), 94.

26 These photographs were apparently shown to Edward Tylor by Stainton Moses on November 24, 1872. Tylor reports: "The next morning we spent about the grounds & I had a long smoke & talk with Moses in the afternoon, on the question of the spirit photographs, of which on the whole his talk though professing scepticism tended to confirm the reality of in certain instances. He showed us photos, taken with blurs of white, behind, which he suggested however might have been made by waving a white handkerchief."

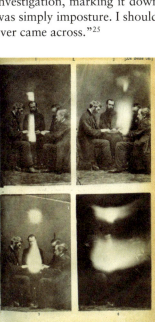

John Beattie
Three series of chronophotographs, 1872
Source: Alexander N. Aksákow,
Animismus und Spiritismus.[26]

5.

Visits to four further séances, including an appearance by Kate Fox, one of modern spiritualism's most prominent mediums, presented no particular challenge to Tylor. Only the last of the séance series turned into an unexpected test. This encounter amounted to a kind of summit meeting between British cultural anthropology and British scholarly spiritualism, represented respectively by Tylor and by Stainton Moses (whose pseudonym in global spiritualist publications was "M.A. Oxon.") The particular significance of the meeting for Tylor may also have lain, first, in the fact that this was a European meeting, entirely without reference to non-European customs, groups, or religions, and, second, because, here, the mediumistic trance appears in a very English context, amidst the best social circles.[27] A clergyman and private tutor, who only converted to spiritualism in 1872, William Stainton Moses was in later years the only widely-known British medium not to be subjected to a campaign of unmasking. This may have been due to his astute deployment of both his clerical expertise and his biographical background: "At our first talk he jumped at the idea of experimental tests [...] On Nov. 15 I saw him again at the school & he told me about his life, how he was a sickly boy & sleepwalker, did an essay in his sleep which had weighed on his mind when awake, & got prize for it. He would have got honours at Oxford, for he was always at head of class, but broke down with brain fever just before examinations. He described himself as sensitive in the extreme, only sleeps 4 hours, has mysterious senses of future things."[28]

Moses's "spirit attack" on Tylor—in Tylor's account—parallels "Rosie's" friendly attack, but with a different outcome. The medium's higher credibility, his social proximity and his particular sensibility to illness seem to have played a key role here. The long "warm-up" to the séance may also have had an impact. This consisted of a close inspection of spirit photographs "with blurs of white," which had a strong effect on Tylor. Tylor's protocol of the evening of November 23, 1872 thus records the paradoxical capacity of the medium and his circle to bring the séance to a tipping point, which reinterprets the skeptical observer's resistance as mediumistic sensitivity. To counter this accusation of his own sensitivity (albeit not during the séance itself), Tylor turned to modern topoi of demystification, seeking in this way to subsume the spiritualist "proofs" into his own discourse: "One characteristic of the evening was that it came to be gradually opined that my presence was injurious, & when I absented myself for a while I was informed on returning that more moving & noise had happened than the whole time of my presence. In fact the manifestations had been violent. Moses expressed strong belief that as similar followed on his early sittings with Herne and Williams whose manifesting force he almost neutralised, so I, being a powerful but undeveloped medium, was absorbing all the force. In the course of the evening Moses 'became entranced,' yawning gasping & twitching & falling into a comatose state. Then his hand twitched violently, & a pencil and paper being put into it he wrote rapidly in large letters, 'We cannot manifest through the medium' or something of the kind. I think it was genuine, & afterwards, I myself became drowsy & seemed to the others about to go off likewise. To myself I seemed partly under a drowsy influence, and partly consciously sham-

27 Stocking, 102.

28 Tylor (1971), 99.

ming, a curious state of mind which I have felt before & which is very likely the incipient stage of hysterical simulation. It was a kind of tendency to affect more than I actually felt."[29]

29 Tylor (1971), 100.

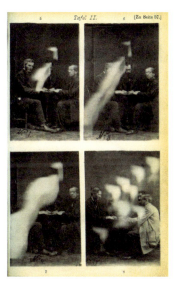

John Beattie
Three series of chronophotographs (the second), 1872
Source: Alexander N. Aksákow, *Animismus und Spiritismus.*

These lines form the paradoxical climax of Tylor's séances: not long after, he broke off the visits, concluding his observations with a labored expression of disbelief, cast in biblical style: "Blessed are they that have seen, and *yet* have believed."[30] The protocol clearly shows how the resistance of the skeptical observer could, in the context of the séance, be given new significance, altering the situation and creating a new psychic and psychosomatic disposition. The form of a logical paradox explicitly appears here, with its manifestation the precise tipping point: the spirits cannot manifest themselves through the medium, but their non-appearance itself becomes a kind of appearance. The spirits communicate that "we will not communicate," or, as in the protocol, "we cannot manifest through the medium." The written message directed at Tylor indicates that he is absorbing all energies, be it through his own mediumistic capacity or by virtue of his resistance. Moses then alludes to a similar experience he had had as a novice, at the joint appearance of two well-known British mediums. By means of this kind of story, the observer himself is put in the position of a novice, made to feel—through the latent public opinion in the room—that a change of roles has already taken place: "It was gradually opined that my presence was injurious." We can assume that this emphasis at the very least made Tylor (and any skeptical observer) aware of his own obstruction, while additionally making him the centre of attention. It was now he who was under scrutiny. A reversal of the initial situation—now obvious to all—had taken place, without Tylor being able to do much about it; even a temporary absence on his part counted against him. From this point on, rather than simply observing the medium, he himself was under observation for his potential mediumistic capacity. Opinion in the room already had him down as a potential novice medium.

30 Tylor (1971), 100.

Indeed, it is striking how it is precisely at the most explicit and intensified moment of his resistance—his paradoxical objectification into a communication from the spirits—at which Tylor's resistance begins to break. He reacts to the mediumistic trance, and its paradoxical messages, by beginning himself to drift off into a kind of trance—the first and only time this would occur: "I myself became drowsy and seemed to the others to go off likewise." The observer-observed situation is reversed. The power of attribution too seems to shift—for the other participants, it seems reasonable to interpret Tylor's behavior as the behavior of a spiritualist medium, and to begin to inquire as to the messages he might be communicating. Bearing in mind the nature of the participant audience, this reversal—which could even amount to a possible conversion—arose spontaneously and empirically from the situation and from Tyler's own reactions.

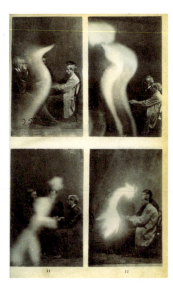

John Beattie
Three series of chronophoto-graphs (the third), 1872
Source: Alexander N. Aksákow,
Animismus und Spiritismus.

6.

If Tylor did not want to concede defeat to this incipient consensus in the room, he was left to deploy *against himself* various topoi that depicted skeptical unmasking as a kind of deception or self-deception. He had used these familiar topoi before, against ideas of mediumistic sensitivity, and more generally, against magic. In *Primitive Culture*, he says of the magician: "The sorcerer generally learns his time-honoured profession in good faith, and retains his belief in it more or less from first to last; at once dupe and cheat, he combines the energy of a believer with the cunning of a hypocrite."[31] Analogous to this, Tylor here performs a kind of self-exposure, as someone who is "at once dupe and cheat." On the one hand, he suggests that his mood of incipient trance was based on a *suspension* of consciousness, manifested in his "drowsiness." On the other, the trance also functioned by virtue of his "conscious shamming," his decision to "affect more than I actually felt." If the clichés of spiritualist capacity are based on a widespread diffusion of eighteenth-century literary sensibility, then here we see the process

31 Tylor (1871), vol.1, 134.

in reverse, as Tylor recalls the inauthentic aspects of this earlier literary sensibility. He perceives not a true affect, but rather an affectedness: "The incipient stage of hysterical simulation" —that combination of hysteria, theatrical inauthenticity, and affective self-stimulation that, in the eighteenth century, was above all associated with women.[32] While this combination may have opened the way to pathological states, it could be normalized by means of self-observation, as here with Tylor, who calls it "a curious state of mind which I have felt before."

32 Ursula Geitner, "Passio Hysterica: Die alltägliche Sorge um das Selbst," in *Frauen, Weiblichkeit, Schrift*, ed. Renate Berger (Berlin: Argument, 1985), 130–144.

In this way, Tylor retrospectively succeeds in translating (through introspection: "To myself I seemed...") his séance experience into the language of intentionality, in order to conceive of it in terms of a *self-induced* simulation. Reading Tylor's account, the question arises whether we should continue to accept his interpretation. More precisely, we can ask what exactly the simulation here is. Did this experience actually take the form of a (self-) simulation? Or was it rather that Tylor retrospectively gave it the simulated form of a (self-) simulation? Either way, the protocol records an elementary process whereby the trance-experience appears to be transmitted to Tylor, observed by the medium and the others in the room ("I... seemed to the others to be about to go off likewise"). In this moment, in spite of his own intentional, directed opposition, Tylor succumbs.

Tylor's protocol of his own tipping point, momentarily indistinguishable from a spirit apparition, reveals better than any theory the relation of translation and transposition between the séance and its debunking. (Is this a moment of initiation into a medium's world? Is the psychological self-unmasking convincing? Who is fooling whom?) We can see, moreover, the precise ways in which this translatability reveals itself at the center of the séance, in the spirits' address. The demystifiers aimed to reveal the *intentions* of the spiritualists by their actions: actions of trickery and deception to be revealed by a self-induced self-deception. For the spiritualists, by contrast, the séance would make manifest the gap between, on the one hand, the world of human actions, and on the other, the world of mediumistic sensibility and workings of the spirit. This particular (minimal) sensibility could pass over from one participant into others. It could be experienced, for example, within the séance's human circle, whose movements could be startling, and which also served as feedback effects. The sensibility could also be passed on through the interpretation of certain effects (and nonactions) as "signals", and their recoding (not as actions but as further effects). The preparation and intensification of a séance, but also of any other spiritualist medium-practice, served at the very least to intensify this sensibility, allowing the world of human actions and the world of spirit effects and influences to palpably diverge. Tylor's protocol records how during a séance this divergence could be experienced even—or especially—by skeptics, their sensibility paradoxically heightened by their own resistance.

33 Godfrey Lienhardt, "Modes of Thought," in *The Institutions of Primitive Society*, ed. E.E. Evans-Pritchard et al. (Oxford: Basil Blackwell, 1954), 95–107.

What was experienced here, to use Godfrey Lienhardt's precise terms, was the experience of the difference "between the self as subject of experience, and what is not the self as the object of experience."[33] The séance was an empirical manifestation of the gap between, on the one hand, action and intention, and on the other, the passive experience of effects, whether of a trivial, painful, or simply absent-minded kind. The séance deepened the chasm between the two modes of expe-

rience. Into this gap came the spirits, to whose presence was then ascribed this process of deepening, and its subsequent experiential consequences.

If we accept the above reconstruction, then the encounter between adherents and opponents of spiritualism—the encounter underlying the spiritualist "International Style"—becomes more plausible. We can understand better the difficulties that skeptics had as soon as they tried to thematize this experiential "gap" for a spiritualist audience. We can better comprehend how spiritualist adherents could put their hopes in new technologies and even in techniques of demystification (including the development of laboratory techniques). It becomes clearer, moreover, that every spiritualist medial practice involved both human mediums and technical media, insisted on the inseparability of the two, and was performed in the hope of a successful "spirit attack." Adherents hoped that a spiritualist sphere of medial passivity could be isolated and distilled from a broader zone, including fraud, and of mediums' self-induced utterances, the existence of which was freely acknowledged. There was no reason to exclude fraudulent practices from spiritualism's investigation. However, it was recognized that the required sensitivity could be passed from the medium to other participants: In fact, this possibility formed the core of spiritualist social relations (of mediums and clients). In this way, both sides could share a common interest in the invention of radio,[34] insomuch as this involved testing a new technical sensitivity; in other words, the intensification of both human sensibility and technical sensitivity. But the sides necessarily came into conflict as soon as the sensibility of the human medium was denigrated or disallowed.

It can also be suggested that, in the key area of psychological and psychosomatic statements, the claims of skeptics necessarily remained implausible for spiritualists and other séance participants. The world of action and the world of reception (that is, the world of experienced effects and sensibilities) strongly diverged here in a way that could be empirically experienced and could be further intensified by specific practices. Therefore, opposed skeptics not only had to disprove that this gap was caused by spirits, they had also to close this gap with effective concepts. This meant convincingly identifying the "self as subject of experience" with the "not the self as object of experience." The demystifiers succeeded in doing so in response to certain tricks, but they had more difficulty with the central trance-experience itself. Very few concepts seemed capable of closing, once and for all, the gap experienced by the subject between individual conscious action and effects from outside the self. One such concept was Tylor's idea of mediums' "self-deception" as "at once dupe and cheat." Tylor's account might stigmatize the spiritualist mediums in social terms, but ultimately, the experience-memory of the transmissibility of a "psychic force" could not simply be written off: "So that our talk ended with more reference to simulating hysteria, & the way in which even occasional fraud spoils the evidence of psychic force, tho' in wonder at Moses's spiritual gifts."[35]

34 Peter Rowlands and J. Patrick Wilson, (eds.), *Oliver Lodge and the Invention of Radio* (Liverpool: PD Publications, 1994).

35 Tylor (1971), 100.

7.

Perhaps the reason Tylor's journal remained unpublished was because its labored ascription of "self-deception" was ultimately an unconvincing exposure of fraudulent practice. The witness who acknowledges his own skillful "self-deception" undermines his own credibility and provokes others to recategorize *him*. The kinds of inauthenticity that Tylor expected to find in spiritualism—the underlying deception and its untimeliness—proved, in the end, to undermine his *own* authenticity, doing so, moreover, by the induction of a kind of male hysteria. For these reasons, however, Tylor's journal is today all the more revealing and authentic as an ethnographic protocol, made during a participant observation of spiritualism. It includes intentionally parodic aspects— as an account of an expedition, part-success and part-failure, to the heart of transatlantic spiritualism. Edward Tylor sought a confrontation with something he, in *Primitive Culture*, had characterized as the relation between "animism" and "spiritualism." He did experience— in his own body as well as through his observation of others—a fundamental aspect of what he called "animism." This was a temporary disturbance in his consciousness, which went beyond everyday mental experience, and which, then and now, posed difficult questions about consciousness and agency. Tylor could not, and would not, attribute this animating experience to the undead ghosts of spiritualism; but his labored self-description remained marked by a contradiction in a failed attempt to prove his own dissembling. Beyond this, however, what survives is a protocol of anxiety and of method: "Blessed are they that have seen, and met their experience with disbelief."

Bibliography

Dillinger, Johannes and Nicole Longen. "Die gesellschaftliche Konstruktion des Totengeisterglaubens: Amerikanischer Spiritismus und deutscher Geisterkult im Vergleich." In *Trancemedien und Neue Medien um 1900*, eds. Marcus Hahn and Erhard Schüttpelz. Bielefeld: Transcript, 2009, 57–78.

Fischer, Andreas. "'A Photographer of Marvels.' Frederick Hudson and the Beginnings of Spirit Photography in Europe." In *The Perfect Medium: Photography and the Occult*, ed. Clément Chéroux. New Haven: Yale University Press, 2005, 29–43.

Sawicki, Diethard. *"Leben mit den Toten": Geisterglauben und die Entstehung des Spiritismus*. Paderborn: Ferdinand Schöningh Verlag, 2002.

Stolow, Jeremy. "Techno-Religious Imaginaries: On the Spiritual Telegraph and the Circum-Atlantic World of the 19th Century." 2006. Accessed 2007. Available from http://www.globalautonomy.ca/global1/servlet/Xml2pdf?fn=RA_Stolow_Imaginaries

Zander, Helmut. "Höhere Erkenntnis: Die Erfindung des Fernrohrs und die Konstruktion erweiterter Wahrnehmungsfähigkeiten zwischen dem 17. und dem 20. Jahrhundert." In *Trancemedien und Neue Medien um 1900*, eds. Marcus Hahn and Erhard Schüttpelz. Bielefeld: Transcript, 2009, 17–56.

Joachim Koester
*To navigate, in a genuine way, in the unknown necessitates
an attitude of daring, but not one of recklessness (movements
generated from the magical passes of Carlos Castaneda)*, 2009
16mm film, 3'14"
Courtesy Jan Mot, Brussels

To Navigate, in a Genuine Way, in the Unknown Necessitates an Attitude of Daring, but not one of Recklessness (Movements Generated from the Magical Passes of Carlos Castaneda)

Joachim Koester

In the summer of 1960, the anthropology student Carlos Castaneda was introduced by a friend to an old Yaqui Indian in a Greyhound bus station on the border of Arizona and Mexico. The Indian's name was don Juan Matus. He was a sorcerer, a *brujo*, who knew about the preparation and use of peyote, mushrooms and other psychedelic plants, a topic Castaneda was excited to get information about for his research. Their conversation was brief and awkward, but shortly after, Castaneda traveled to the desert of Sonora, Mexico to meet don Juan again. Many more visits would follow. Eventually don Juan agreed to take in Castaneda as an apprentice and teach him about medicine plants and the sorcerer's way.

The story of Castaneda's remarkable apprenticeship that included several experiences with peyote and the notorious hallucinogenic plant *Datura*, speaking with lizards and a near fatal meeting with a malicious witch, were later chronicled in his book *The Teachings of Don Juan: A Yaqui Way of Knowledge* (1968). The book proved to be enormously successful. Not only was it favorably reviewed and widely read, it was also considered a breakthrough in anthropology and Castaneda was later awarded a PhD for his research. As readers all over the world devoured Castaneda's "field notes"—some even hunted the Sonora desert for don Juan to be taken in as apprentices themselves—Castaneda responded to his newfound fame by following the advice of the old *brujo*: he veiled his personal history in a web of secrecy.

The Teachings of Don Juan ends by Castaneda giving up his apprenticeship and leaving the world of sorcery behind. Yet over the next two decades he wrote many new titles expanding on his magical journey. These were extended shamanic instructions on how to see, dream, master non-ordinary reality and ultimately become a woman or man of power taught by the enigmatic and patient don Juan. The tales were captivating, terrifying and occasionally beautiful. Just as often they were incomprehensible and tedious, featuring a perpetually hardheaded Castaneda struggling to understand the sorcerer's world.

Castaneda revealed the final lesson of don Juan in his book *Magical Passes*. It was a secret system of exercises deployed for "navigating the dark sea of awareness." According to don Juan, sorcerers had practiced these movements for centuries in order to enhance their perception of non-ordinary reality. Curiously, also in the book, don Juan speaks for the first time about *his* mentor, a sorcerer and mime named Julian Osorio living in Mexico at the beginning of the nineteenth century. Julian Osorio was a professional actor who would pour all his efforts into creating what he named "the shamanistic theater." Don Juan recalls: "every movement of his characters was imbued to the gills with the magical passes. Not only that, but he turned the theater into a new avenue for teaching them."

Magical Passes was published in 1998 the same year that Carlos Castaneda died. By then the contradictions and inconsistencies in his life and books had become so pronounced that few believed don Juan ever existed. Castaneda always claimed that the magical world found him—at that chance encounter in the Greyhound bus station—but his wife, Margaret Runyan, writes in her memoir that at the time magic was already his obsession. Despite that, or maybe because of it, Castaneda's fictitious apprenticeship and his transformation into a mystic master were in fact magical.

"Uncle Snookum's Astral Odditorium & Psychic Haberdashery": Sun Ra & The Occult

Darius James

To perform spiritual-cosmic-intergalactic-infinity research works relative to worlds-dimensions-planes in galaxies and universes beyond the present now-known used imagination of mankind, beyond the intergalactic central sun and works relative to spiritual and spiritual advancement of our presently known world. To awaken the spiritual conscious of mankind putting him back in contact with his "Creator." To make mankind aware that there are superior beings (gods) on other planets in other galaxies. To make mankind aware that the "Creator" (God) is here now and that he is present in other world-galaxies. To help stamp out (destroy) ignorance destroying its major purpose changing ignorance to constructive creative progress. To use these spiritual-cosmic values for the greater advancement of all people on Earth and creative live beings of this galaxy and galaxies beyond the intergalactic central sun. To establish spiritual energy refilling houses (churches) where people can come to refill themselves with spiritual energy and to seek their "natural Creator" (God). To perform works as the "Creator" (God) wills us, "Infinity," to perform. Sun Ra, the second charter for "Ihnfinity, Inc."

Some called him the original brother from another planet. Others said he was a crank driven into bizarre realms of psychic otherworldliness by the exploitation and oppressive consequences of the black diaspora. He himself claimed he was an angelic expression of the Egyptian god of enlightenment. To his nieces and nephews, he was "Uncle Snookums." By any available measure, he was a genius of rare order. His music mystified. His pronouncements puzzled. And his name was "Mister *Re.*"

Sun Ra baffled. Le Sony'r Ra is known by most, if at all, as an eccentric twentieth-century African-American composer who claimed his true home was based on the second largest planet in the Milky Way (which meant, when he vacated the confinements of this one, he was roughly two and a half Saturnian years in age), and insisted throughout his forty-year career as the leader of the Solar-Myth Arkestra "Space was the Place." To his devotees, however, he was a respected visionary of multi-planed and inter-dimensional Afro-futures, who was an amalgam of mathematician, composer, mystic, poet, ritualist, and world teacher. As an artist "melding art, poetry, music, theater, (and) esoteric philosophy" (resulting in a formidable unifying force of magic that many confuse with the spectacle of entertainment), Sun Ra is also the point of origin for rethinking how the spiritual practices of the African diaspora are now conducted in the Western world's post-modern era.

Sun Ra was an initiate of the mystery schools. His recording label, El Saturn Records, partnered with Alton Abrahams, not only served

as the production and distribution network for his ensemble's musical output; it also functioned as a center for esoteric research and study. Sun Ra's aim for such an operation is clearly stated in the charter of "Ihnfinity, Inc":

To awaken the spiritual conscious of mankind.

His recordings, then, are sonic cartographs to transcendent planes of being: Logos without text.

Sun Ra's fascination with the arcane began in late childhood. By age seven, he had already begun to question the veracity of the Christian bible: "If Jesus died to save people, why [did] people have to die?"

If a so-called earth-bound deity died so all of humanity might live, he reasoned, why did death still exist on earth? Why didn't Death die with the mortal body of Jesus? According to the promise of this logic, the whole of human life should be immortal. Should we not all exist as gods? Angels of divine substance? Christ's ultimate self-sacrifice simply made no sense to Sun Ra.

Sun Ra continued to ask what the higher truths ordinary existence did not provide were. And probed into the mysteries of death. After his encounter with *The Egyptian Book of the Dead*, (and, perhaps, a visit to the underworld), he realized our perception of death in the Christianized consumer-zones of the West was a mediocrity; an ingrained mental construct freighted with fear and *inconsequential* cultural baggage. At ten years of age, due to an affiliation with the Knights of Pythias Temple, a black Masonic lodge in Birmingham, Alabama, he explored its library, devouring all its volumes of esoteric wisdom; thus, embarking on a life-long quest toward union with the *Absolute*.

Along the way, he encountered intelligent entities and airborne vehicles of strange geometries. What were the true origins of these manifestations? Were they plumbed from the depths of his deepest inner worlds through ancient technologies such as trance meditation, Dervish dancing, and the holy sound of the cosmos, AUM? Or were they indeed vessels from the uncharted regions of space manned by inhabitants of planets *blacker* than themselves?

As his forebear, Fats Waller, once said after a portentous vision of a yet unborn George Clinton debarking from a Motherplane in *Afrofari* feather-gear:

"If you don't know what it is, don't mess with it."

Let's look at some details of biography Sun Ra repeatedly disavowed.

He was christened "Herman Poole Blount." His forename paid tribute to a popular early American twentieth-century illusionist and former medicine show huckster greatly admired by his mother. This conjurer and proponent of the early "black arts" movement headlined in the great theaters of Harlem, and toured a tent show through the Jim Crow South under the stage name of "Black Herman." He would tell his audience he was a member of the Zulu Nation and then have the crowd tie him up. "If the slave traders tried to take any of my people captive," he said, after escaping his binds, "we would release ourselves using our secret knowledge."

Curiously, the character of "Black Herman" is featured in Ishmael Reed's novel *Mumbo Jumbo*. The novel itself is inspired by the intellectual tumult of the Lower East Side Umbra group of poets and writers. Sun Ra was very much an influential part of this artistic community.

The story grows with increasing interest with the addition of his middle name "Poole." His mother actually appears dismissive in offering her explanation why. According to John Szwed's *Space is the Place: The Life and Times of Sun Ra*, "His mother said Mr. Poole was a man [she knew] who wanted a child named after him" Mr. Poole was a railroad worker she had met early in her employment at the Terminal Station restaurant in Birmingham, Alabama.

Gossip attended Sun Ra's arrival. But there is no conclusive proof his landing was out of Christian wedlock. However, an early twentieth-century black community in the southern clime of Alabama wouldn't necessarily need evidence to fuel fevered speculation on the nature of his origins, earthly or otherwise. Brutalized into accepting the Christian faith upon setting foot on these alien shores, they seemed to have no difficulty in believing a white-feathered pigeon impregnated the mother of the man whip-wielding traffickers of human flesh claimed was their "Savoir." So, if their speculations regarding his mother's off-hour activities were so, there was a very distinct (and not unlikely) possibility that Sun Ra was a paternal blood relative of the founder of the lost/found "Nation of Islam" (a.k.a. The Black Muslims)—Elijah "Poole" Muhammad.

Sun Ra often joked the two men were related. They were friends and talked a great deal by phone. He also claimed he was the source for much of the Nation of Islam's bizarre mythology (a mythology, I might add, which rivals the best fiction of Philip K. Dick.) Further evidence of Sun Ra's sympathetic allegiance to the N.O.I. is his musical contribution to Amiri Baraka's play *Black Mass;* a surreal slice of pageantry inspired by the N.O.I.'s legend of the evil big-headed scientist Mr. Yacoub.

But, as I said, there is no evidence of a direct blood tie between the two men. There is only gossip. And absolutely none confirming Sun Ra as the source for the N.O.I.'s astonishing belief that the white race is a result of the Frankensteinian procedure of grafting together the slaughtered parts of rats, cats, pigs, and dogs (however, among cognoscenti, it's generally acknowledged that "Sonny wasn't feelin' white folks too tough").

Lastly, "Blount" is the surname of the man to whom his mother was married at the time of his birth. This man, however, was gone by the time little Herman had reached the age of three.

With the absence of men he could not identify as father, both of whom associated with a name he disavowed throughout his public career (names further complicated by the impact of American slavery on the solidity of black family structures nearly fifty years after its abolishment, and its implications for the N.O.I.), it's apparent, despite his vast intellectual gifts and the warm supportive love of the matriarchs who nurtured him, Sun Ra was painfully conflicted by questions left open in his childhood.

"I came from somewhere else [...] the Creator separated me from my family [...] And from then on, I was under his guidance. I was there but I wasn't there [...] I never felt like I was a part of this planet. I felt that all this was a dream, that it wasn't real [...] I wasn't just born... I

am not a human. I never called anybody 'mother.' The woman who's supposed to be my mother I called 'other momma.' I never called anybody 'mother.' I never called anybody 'father' [...] I really believe my father was not a man [...] He was another kind of spirit, a dark one [...] I have separated myself from everything in general you call life."

"Henry Poole Blount" was haunted by questions of identity; the purpose of family; his paternity; the true nature of life, "reality," God, and the universe. In the end, he collapsed under the burden of these unanswered (and unanswerable) questions, and was rendered invisible.

Ostensibly, he was a cipher. A *void*.

Unlike the Ralph Ellison's ectoplasmic *Invisible Man*, "Henry Poole Blount" was not invisible due to "a peculiar disposition of the eyes" of the persons with whom he came in contact. No. The blindness of the segregated South did not effect him until much later, he claims. "Them troubles peoples got, prejudices and all that, I didn't know a thing about it, until I got to be about fourte en years old. It was as if I was somewhere else that imprinted this purity on my mind, another kind of world [...] a pure solar world."

He was supported and recognized by a self-sufficient black community. His invisibility was a consequence of something all together different—the "peculiar disposition" of his own "inner eyes." Without answers, he was a man hidden to himself. Unless he surrendered to the unexamined life of Earth's mindless human population, its cattle, dwelling in the darkness of ignorance, Sun Ra had no choice but to accept he had become an *occult* man.

Occult: knowledge that is hidden, out of view.

Wait a minute. Isn't *deliberately* hiding something out of view to *deceive*? A *deception*? To believe in that which is not true or of factual existence? I may have been born, raised, and educated in the United States, but that doesn't mean I'm completely stupid. We all concede truth is "good." Or *God*. So again: "What is occult"?

Hmmm, God is not in open view.

Or is she?

Ein Freudenklang ist Erleuchtung
Die Weltraum-Feuer-Wahrheit ist Erleuchtung
Weltraum Feuer
Manchmal ist es Musik
Seltsame Mathematik
Rhythmische Gleichung"
–Sun Ra, "Enlightenment"

Two Tales

I.

Sun Ra: "These spacemen wanted me to go to outerspace; so that's what I did. A giant spotlight shined down and changed my body into something else. I wasn't in human form. I could see through myself. I went up through many times zones and landed on the planet Saturn. I saw a rail like the long rail of a railroad track coming out of the sky. It landed in a vacant lot. I sat in the last row of a huge stadium in the

dark. I was alone. The spacemen were down there on stage. It looked something like a boxing ring. They had one little antenna over each ear and one little antenna over each eye. Four antenniantennae. They called my name. I didn't move. They called again and I still didn't answer. Then all of a sudden I was teleported to the stage. There was going to be trouble in every part of life, they said. That's what they wanted to talk to me about. There was going to be great trouble in the schools, and they told me to stop training in teacher's college. They would teach me things when it looked like the world was going into complete chaos, when there was no hope for nothing; then I could speak, but not until then.

II.

Tenor saxophonist Red Holloway recounts his time with Sun Ra in 1950s Chicago in the free jazz history, *As Serious As Your Life.* to author Valerie Wilmer. Sun Ra once told him he was going to New York to pick up some books. When Red saw Ra next and asked about the trip, Ra replied, "It wasn't necessary. I found a way to get to there without a car, bus, train, or plane." "He said he just sent his body" Red reported, referring to the outer body experience of astral projection. "And got the information he needed."

Occult: Take Two

Occult is from the Latin: occultus [hidden; concealed; secret]. The Greek word is esoteric. The contemporary meaning refers to knowledge unobtainable through any visible or scientific means of measure. It is knowledge that is "hidden" or "concealed" from the five normal senses of sight, sound, taste, smell and touch. The five senses allow the physical body to operate and survive in the material or "outer" world. The "esoteric" knowledge of the major and minor religions throughout time say the physical body also has a second, yet "hidden body" of subtle energies. Or "inner" body. This subtle inner body is commonly called "the soul."

> *"What is soul?"*
> *"I don't know"*
> *"Soul is a joint rolled in toilet paper"*
> –Mommy,

What is a Funkadelic?

Our soul, or "subtle" body, mirrors the physical body. And this subtle body has a secondary set of senses: "inner sight," "inner sound," "inner taste," "inner smell," and "inner touch." Evidence for the existence of these "inner senses" is found in the arts. The painter is gifted with "inner sight." The musician expresses "inner sound." The great chef has "inner taste." The perfumer, "inner smell."

And the "harlot," of course, has the gift of the *healing* "inner touch."

The occult also refers to that which is "veiled." This is perfectly represented by the third symbol of the Tarot's major arcana. *The High Priestess*. She signifies "mysteries veiled." The occultist unveils. Art is occult practice. The artist becomes occultist by dint of the inner senses' expression unveiling what is *perceived* (or, as the silly Tom Robbins said it in *Another Roadside Attraction*, providing "what life does not.") Picasso came to Cubism through his recognition of the spiritual function of African art. (This was Picasso's "Negro Period." If it had been the eighteenth century, he would have been accused of "Hottentotism." Later, Spike Lee would say he had "jungle fever." Now, they'd just call him a "whigger.") It was more than decorative. These works of "imagination" are inhabited by gods.

Sleep

Sun Ra was a man hidden to himself. He was an *Occult Man*.

Sun Ra found the Christian bible fraught with deception. He also felt the book accessible to the general population was a bowdlerized version of a greater, far more enlightening book. These are factors that would cause a man to be blind to his "true self." Yet he continued to study it.

"[A]s he went deeper in the Bible," Szwed writes, "he began to understand the meaning of 'revised': it had been edited, and some books removed [...] some of the most critical passages appeared either suspiciously transparent or hopelessly impenetrable [...] nonetheless, clues to a correct reading seemed to [be] buried in the Bible itself."

He collected concordances, studied ancient languages and histories, and sought out arcane texts to unravel the mystery of the Bible's clues. Key, too, was the fact he saw "The roles played by black people in the Bible [as] confused, distorted, ignored: Nimrod, Melchizedek, and all the sons of Cush and Ham [...] were treated disrespectfully." Eventually, his readings would lead him to the Land of Pharaohs: Ancient Egypt.

Awakening

The Africans' traditional worldview, according to Janheinz Jahn in *Muntu*, is one of "extraordinary harmony." It has unity of purpose. As James Brown said, it's "on the one."

The numinous flowing force infused through all mortal beings, throughout all of nature and the cosmos, is an expression of the Creator's radiance. The ego dissolves in a warm oceanic wave of ecstatic light more brilliant than the sun.

On Atmosphere and a Capital A

Bart De Baere

Wer sich aber auf den Weg macht und Fremde vermehrt, der setzt auf eine andere Macht der Worte. —Vivian Liska

In her magisterial post-Second World War book on the human condition, Hannah Arendt, articulates the notion of work—which can be seen as encompassing the whole of civilization: the man-made world—in relation to a Marxist notion of labor. After having qualified "work," she goes on to focus on the notion of "action," which she envisages as the space of the political. At the very end of her chapter on work, however, she deals with philosophy and art as part of work, yet possessing characteristics of their own, like a hidden intermediate chapter. It is like a valley in between the two other notions. Art and philosophy share in the longevity of artifacts that are made—as opposed to merely produced—and they are a prefiguration of action, of the political. The image of this landscape in between both dimensions nowadays cannot but assume an Arcadian quality. The ardent belief in civilization that motivates European thinking from the Enlightenment onwards up till the Second World War, and the secluded valley of a specific interest in the arts and philosophy that rested within it, are no more. Let us look at how frenetically we find ourselves thinking and rethinking, acting and reacting, making and remaking.

Two years ago, we formulated, from Antwerp, a program that was to connect the cities and biennials of Istanbul, Athens and Venice. We drafted topics for the first two venues. In Istanbul, we wanted to interrogate the relation between "understanding" and "change" as that which may constitute the magic at the heart of the Enlightenment. What kind of understanding would be needed to necessitate change? What kind of involvement can understanding produce and in which setting does that come about? In Athens, we wanted to discuss the heritage of the Enlightenment and its rationality, also by exploring the hidden power relations it implies. In both cities we organized well-attended events. In Venice, finally, we decided not to organize an event—the environment being saturated in any case—but to stick to our core question.

"Can the language of events and locations be translated into the language of speaking-positions, and even further, into empathy-positions, so that we can see the conditions under which we can actually share?" we asked. We pretended this was a discussion about the weather. It was when and where we got our notion of an atmospheric politics: *"Because what is up in the sky above has long been understood as a model or mirror to the human inner life. Only recently have we*

changed the ways in which we speak about the sky and the stars, and now we dream like children about populating the moon and suddenly fear, our urban body becoming feverish. But we never stopped speaking about the immediate sky, the weather, the atmosphere. In taking the poetics of the weather as literal metaphors, what is at stake now is no longer the engineering of the depths of the soul, as in the age of metaphysics, but the social atmospheres, which, as we know, determine not what can be said, but the effects it can have."

Since M HKA supported the project "Clinic – A Pathology of Gesture" at HAU Berlin, organized by Anselm Franke and Hila Peleg in November 2006, and the discussion on what was to become "Animism" began in earnest, a lot has happened among us.

Anselm subsequently organized the group exhibition "No Matter How Bright the Light, the Crossing Occurs at Night," the title based on a quote taken from the introduction of an American book on responsibility in relation to deconstruction, which identifies the need for a continued engagement with the emancipatory tradition of the Enlightenment to focus on its shadows, stating that this is where all the changes and transformations occur. He went on to organize "Mimétisme," a group exhibition reflecting on what Walter Benjamin, his most revered writer has referred to as the "mimetic faculty": the mind's ability to detect and appropriate similarities, to mirror others, to imitate, to immerse and to become something else. For Manifesta Anselm Franke then worked under the title "The Soul (or, Much Trouble in the Transportation of Souls,)" a project that proposed to examine today's Europe in relation to the engineering of its psyche. It understood the soul as a cultural object, an allegory for social relations shaped by ideas and techniques of power, in which the production, mobilization, and representation of the inner self became a final frontier, a last outside.

M HKA, from its side, had started a project in 2004 which it described as an "essay in reconstructive thinking," informed by the teachings of deconstruction yet once again searching for its own foundations to work from. In its so-called "Metaforum" project it tried to "salvage" notions that had been discarded, and relaunch them independent from the grand récits, the master narratives of late modernity that had come to subdue them. In "Vreugde" (Joy), for example, my colleague Dieter Roelstraete described the joy of participating in the total conversation of reality, transcending the categorical contradictions and the conceptual abysses inbetween, that form the condition of all self-centered critical thinking. Parallel to this, M HKA sought to recast its collection in a performative mode and developed a series of presentations that were often a solo *and* group effort simultaneously. In the 2009 project "All That Is Solid Melts into Air" it reflected on the problematics of the spiritual status of art in our post-secular society. It did so through five exhibitions with divergent approaches, each of which could be seen as a perspective on art but also on life at large, a "materialist spirituality" that may express itself through a focus on the thing, the work, the quest, man or the void.

Just as "Animism" could not be conceived at the moment when "Clinic – A Pathology of Gesture" was developed, none of these aforementioned projects would have been possible a decade earlier. It is as if we are not only carrying our own personal horizon with us—

as an immense hoop circling around us, with limits that remain neatly out of reach—but as if we are likewise moving along all together in a bubble we share, losing ground on one side and gaining it in the opposite direction, imagining ourselves to be perfectly autonomous from all and everything while we are merely acting out the possibilities of the space we cohabitate with our companions. Our moment is so perfectly tightened around us that we can barely imagine ourselves acting and existing otherwise, even if the smallest excursion—say, as little as ten years into the past—would suffice to make us understand that we were doing different things differently back then, with different twists to them, different tics and different tones. While we want to imagine ourselves as solid "selves," we are continuously reshaped by the ideas, objects and people around us. Both in individual and in collective terms this tightness only grows, and with it the hardship to get a feeling of sense. As soon as we succeed to move a bit beyond our present moment, even if only a mere ten years away, our activities become hilariously relative. It is through some particular, private insistence that we may carry some sentiments with us for a longer period, or that we stay acquainted with certain topics. These "hobbies," even if they may make up our charm, are rarely decisive for the effectiveness of our survival.

Our survival depends—and does so ever more explicitly—on the degree to which we become a function of our own bio-energy. Life has come to be enacted as a continuous "creating world" in productive mirror-relations which leave no time to their participants, who forget both past and future in this amazingly intense copulation between themselves and their world. The individual, for so long immersed in its inner reflections, is at this moment projected outwards, put into full capacity for the production of both "self" and "world." How then is it possible to regain the space to reflect about our joint or disjointed future?

Worse. Any system, any rethoric that believes in its construction rather than in its resonances, is bound to become yet another extension of the hegemonic dimension of our society, which is the one we call the economic one, which is the one that makes things exchangeable. If we name it *the systemic one*, it is easier to see how all the efforts from the cultural field to develop and maintain an autonomy from it, have proven to offer major possibilities for its extension. They have allowed it to spread itself over terrains that used to be unlikely ones, and even to use these border discoveries, negotiations and subsequent extensions as the main resource of energy for the system at large, as the many facetted reflections on the creative economy of the last years show so splendidly. The tactics and strategies of the cultural field are not only tolerated but seamlessly and effectively incorporated, and with that ever larger fields are swallowed up. Indeed, the avant-garde remained the avant-garde, only it becomes aware of the fact that even an avant-garde doesn't decide about the course of events or the army or its battles. Society did accept the offer of these irregulars and of course did so on its own terms. The avant-garde has been levied and trained and is now intimately coached.

How then to respond and how to regain space? Perhaps thought itself already opens up this space. If it is truly so that we have come to continuously create self and world, we are free to open up this

world. It must be sufficient then to see in the depth of our mirror a very thin line, of a color that does not resemble any other color, as an Argentinian writer once wrote. It must be sufficient to undo the relational network with its continuous production of both ourselves and this place we inhabit. For a long time I felt that the weakness of Actor-network theory was its failure to grant the gravitas of their own uncommunicated, lonely complexity to its actors, because it inevitably sees them as tautological to the networks that render them visible. Only recently did I come to intuit that its true weakness may lie in its other half, in the way in which it replaces space by the vectors of its habitation. These vectors obviously load it, articulate it, express it, but they don't initiate it. Instead of extending the objectification and complementary subjectification, of extending and refining thereby our possibility to manipulate all and everything, we may aspire once again to qualify the space that allows becoming. It is not so obvious to find a way to focus on this space on its own behalf, since, as we have seen, any system at present is bound to attach itself to the immense and suffocating mass of social structuring.

Perhaps a useful image for this may be offered by a discarded modern notion, one that was only discarded only after the special theory of relativity became hegemonic. It is the notion of the lumniferous aether, which was recently visualized by the artists Nina Canell and Robin Watkins. Its haunting presence demands from us to be aware that every couple of seconds immense electromagnetic loads are echoing back and forth from pole to pole around the earth, while it is at the same time present in the walls around us, in our bodies and in the air we breathe.

The aether, the version of which held by the political philosopher Thomas Hobbes was discarded by the gentleman scientist Robert Boyle in one of the classic examples of Actor-network theory—with the vacuum pump in a lead role—the visions of which have proliferated in so many variations throughout most of modernity; the aether is a magnificent notion. It expresses the intuition that there is a need for a medium of transmission. For gravitational, electric and magnetic phenomena it may offer elegant explanations. Up to now in the Dutch language a radio station is said to go *into the aether*, which is far more convincing than it going *into the void or whatever else*.

The true beauty of the aether is that it is like this line of the Argentinian writer, of a color that does not resemble any other color. The aether is undetectable, untouchable, invisible, weightless, frictionless, transparent. It is like God, all pervading.

In referring to it, we should, however, not necessarily speak about eternity and the universe, we may speak about ourselves to start with. Its grandeur is that this is what pervaded us, it is by that which we think, our sense of scale and perspective which allows us to do some things and to be repelled by others.

It may offer us a double awareness. To start with it is an awareness of the fact that we can't see it at all, and that we have to think this very fact as our main frame. Because of this, our togetherness with that which we can see, changes.

All the modes of formulating coexistence all of a sudden become relative possibilities rather than the fabric which allows us to survive

and hang in there. As if by magic the overriding power of the system evaporates, it is no longer the master narrative, it is merely economy. By the same twist we are liberated from that awkward position we have manoeuvred ourselves into, having to continuously weave a network of activity in order to survive, having to restlessly project ourselves into productive mirror-relations in order to continue to exist. The space the aether unfolds is that which can be inhabited, and thereby also that which can be inhabited by someone other and something else, and by other versions of ourselves.

A notion like the aether might then become profoundly luminiferous, light-bearing; it might enhance our lucidity as opposed to our efficiency. It might give us a sense of awareness that it is effectively the qualities of our notions of scale and perspective which allow us to do some things. It might empower us to change. By going into space with the lightning speed of electromagnetic impulses, we might come back to ourselves as speedily as we veered off. Or effect a little twist away from where we were, as Anselm sees it.

Hence a notion like this is not a maybe-god. It may be the altar for an unknown god such as that present in the Roman Pantheon besides the named spots. What it is then is undetectability, a basic awareness of the limits of our own social spheres, which is translated into openendedness and opensightness. For that sake alone it may be important that we assign the aether an uppercase A, for a power that may be even if it might not be. Through it we may find again a belief in the effectiveness of different chronotopes other than the one which so efficiently consumes all and everything we try to become.

Arriving here the atmospheric metaphor may be of help. It is a capital A, it is that which cannot be systemically described, which cannot be privatized. It is irreducible, however much it is manipulated, to the extent it is filled with privatized wavelengths; it essentially contains the forces beyond control. It is unified, yet differentiated. It is changeable, yet durable. And also, in contrast to the aether, it does not allow us the illusion that we are not really responsible for it. Until yesterday we might say, well, not really. We might tell ourselves that we were only responsible for the microclimate around the dinner table, and try to excel in managing our living room that way; or at best point to our responsibility for the climate during an event or in an organization, which might make us its director. The larger climate, the climate out there, seemed liked it would remain beyond our reach for ever. It only appeared so, however, as we are presently finding out, as mountains of ice and coral islands disappear overnight. Only recently have we become aware of the fact that the weather, even if it continues to contain forces beyond our control, is in fact not only our fate but also effectively our responsibility. We live a life that massively impacts the atmosphere, to the extent that we may be forced to rethink virtually all of the tools we have become accustomed to using. We slowly come to understand that we confused the "manageable" and the "engageable"—that which is so much vaster.

Animism in an Antwerp 2010-way, carefully reflects on its past in order to enable a future. Or so we hope. In doing so, it is not conclusive: too many of its actors are reaching out in too many directions, only vaguely organizing their actions in movements of enchantment and disenchantment. It is not a thematic show but the outcome of an

aspiration: to respect. It is an animism that seeks to let its space charge itself with the magic of affect.

Very much like this spatial ambition, not entirely equal to those floods of ideas, things and people that are our companions, we may start to change ourselves, not for the sake of change but for the sake of the atmosphere we have been losing sight of for far too long.

Anima's Silent Repatriation: Reconsidering Animism in the Contemporary World

Masato Fukushima

Introduction

Anima, the protagonist of the long-disputed notion of animism, has been at best somewhat a backseat player both in our everyday life and in the history of thought in recent years. Even though Western philosophers of antiquity and the medieval period occasionally paid serious attention to her role, she does not seem to be a hotter issue than, say, global warming or Islamic fundamentalism at present. Nowadays she is supposed to only inhabit African forests or oriental shrines; in short, she is still *there*, but not really here in the West.

Although anima is occasionally discussed in the academic circles of anthropologists or researchers of modern paganism, what happened to her *here*, is said to be the collapse of *der Zaubergarten* (the garden of magic) and the massive extinction of her species in modern society, as Max Weber sternly emphasized.[1] "The tidal waves of rationalization wiped her species away, and sooner or later the existing anima in other parts of the world will also suffer from a similar destiny"; such is the prediction of Weber's countless sympathizers, reciting the mantra of modernization without questioning its premises.

These scholars, legitimately emphasizing the notion of the iron cage of modernity,[2] seem to me to have failed in recognizing the various holes, large and small, bored by the intrinsic limitation of rationality. Computational theorists, for instance, have cogently suggested that in general the more a particular system becomes complex, the more impossible it becomes to carry out rational computation because the required time for doing so will be exponential.[3] In other words, rationality requires calculation, yet in many cases of complex systems, calculation cannot be properly exercised due to the time needed for it. The iron cage of modernity does not have the seamless walls of rationality, but countless holes of incomputability caused by its very complexity. And nobody knows what entities go in and out through these holes between modernity and its outside.

So it is not so illegitimate to reconsider the very premises of the idea of the collapse of *der Zaubergarten*. Anima may not really be extinct even in the West but may simply disguise herself, silently planning to return to the central stage. To visualize the various facets of her possible manifestation both in an explicit and implicit way through the holes of modernity, I invite readers to a brief round trip through the three scenes that follow—different in time, space and content—so as to provide cases to reconsider the possibility of her renewed role in the contemporary world.

1 Max Weber, *The Sociology of Religion*, trans. Ephraim Fischoff (London: Methuen, 1965).

2 Max Weber, *The Protestant Ethic and the Spirit of Capitalism*, trans. Talcott Parsons (London: George Allen & Unwin, 1978).

3 Yoshinori Shiozawa, *On the Order of Market: From Anti-equilibrium to Complexity* [in Japanese] (Tokyo: Chikuma-Shobo, 1990).

Scene 1: Villages of Java, Indonesia.

The scene starts in the tropical region of Java, Indonesia. My field research in the depth of Javanese villages in the 1980s revealed to me some classical examples of the liveliness of the works of anima in the forms of spirits and magical exercises.[4] The most impressive thing of all was the phenomenon of spirit possession in the village I stayed in, which I had previously seen only in an introductory ethnographic movie of anthropology for freshmen.

4 For the general background to the Javanese religion, see Clifford Geertz, *The Religion of Java* (Glencoe: Free Press, 1960).

One day my landlord, one of the leaders of the orthodox Muslim school of the village, noticed that I was interested in the phenomenon of spirit possession and he somewhat reluctantly agreed to let me meet one of the well-known spirit mediums in the village. At a glance, the man, in his mid-forties, looked like a born-tired peasant, scrawny, suntanned, and reticent. The landlord asked the medium to invite the spirits he was in contact with, and at first he grumbled, a bit reluctant to respond.

But after a brief exchange of words between the two, the medium became silent for a moment and then suddenly he exploded into laughter, the facial expression changed dramatically from that of a reticent peasant to that of an aggressive and excited person with glaring eyes, a person very hard to imagine as the same as the one a few minutes before. The landlord whispered to me that it was Mr X who usually possessed the medium, and the landlord also told me that his neighbors, mainly poor tenant farmers, occasionally asked the possessing spirit for all sorts of medical advice.

The fact is that the landlord, though being a member of the conservative school of Islam in Java, had a hidden but insuppressible sympathy for the reformist movement, so, basically, he held a negative opinion about this kind of phenomenon. He was embarrassed by witnessing such a dramatic transformation of the personality of the medium, but he appeared to me not to want to admit that such a phenomenon had just occurred in front of him. Then the second spirit possessed the medium. It was quite a silent one, called a dumb (*bisu*), followed by a third, a polite character mimicking the demeanor of the Javanese nobility. The landlord watched these events with a wry smile.

Irrespective of the landlord's obvious distaste, spirits are witnessed everywhere in Java; they are supposed to cause various effects, sometimes attacking people in the forms of misfortune or illness or sometimes giving advice to those who have trouble in their life. These spirits, they say, are to be controlled by the various specialists like magic doctors, spirit mediums, and so on. The constant need for ritual offerings is to soothe them so they do not cause damage to people. A brief stay in a Javanese village would easily lead you to a full encounter with such entities.

5 The Saminists use a sort of clandestine vocabulary hard to fathom by outsiders. For instance, when they were asked their name, they answered that their name was man (or woman). Their age: one for ever, and so on. Behind such tricky conversation lies their peculiar notion of language. On Saminism at large, see Harry Benda and Lance Castles, The Samin Movement, *Bijdragen tot de Taal-, Land-, en Volkenkunde* 125 (1968). Also see part three of Masato Fukushima, *Religion and Society of Java* [in Japanese] (Tokyo: Hituzi-Shobo, 2002).

Yet this was only half the story, as I soon realized. A few months later, a friend of mine, also a researcher on rural culture, came to see me to report that he had encountered legendary Saminists in a village of eastern Java. They were peasants who followed the teaching of Surontiko Samin, a well-known leader of a peasant revolt against the Dutch colonial government around the beginning of nineteenth century in central Java. Unlike other present revolts, however, the Saminists' behavior was mysterious[5] and the authorities did not really understand the motive and content of what they adhered to.

Some Saminists survived the persecution by the colonial government, and small numbers of their descendents were still living in various parts of the rural districts in Java. What my colleague happened to find was one such enclave.

The Saminists lived a very modest life, rarely attended to any other work than agriculture and were fond of wearing traditional clothes of village style. From their outward appearance they looked as if they were sticking to the traditional way of life in the village. Yet after tapping into their worldview, I was struck by the sheer rigor with which they excluded the traditional elements of otherworldliness. References to supernatural beings were completely erased; no offerings were made to deities. In short, the spiritual entities which are usually the invigorating addition to everyday life in Java, had utterly gone.

The appearance of the peasants' simple life was not due to their adherence to the traditional way of life, but rather, the result of them realizing their strict ideology, the religion of Adam, as they put it. Its basic idea is the belief in the dichotomy between "the way of man" (*tatane wong*) and "the way of material" (*sandang pangan*) as the fundamental principle that humans should abide by. "The way of man" is represented by the act of reproduction of the family, and "the way of material" is that of economy. So the essential requirement for man is to make love and to cultivate the fields.

From this basic tenet derives a dozen subsidiary rules, one of which is the very centrality of man, as it is man that names all the existence in the world. They emphasize that all the entities in the world are actually man-made or even part of the human. I was often ridiculed by them when I mentioned supernaturals. For them, what I called supernatural was caused by human utterance. The limited number of their rituals contained no references to supernaturals but was strictly confined to human action and conditions.

Metaphorically speaking, it was very much like observing the act of antibiotics on a Petri dish in a laboratory, when you cultivate bacteria on the plate. By putting antibiotics on the center of the plate, a clear circle is formed where the bacteria are killed. And the Saminist village reminded me of that. Despite its traditionalistic disguise, all the entities usually flourishing outside the village were massively eradicated, and the world around it became, amazingly, uninhabited.

Scene 2: A lecture room of cognitive science in London.

The scene now changes from tropical Java to a lecture room of cognitive science in London. In the 1960s and 70s, researchers of the human mind witnessed the massive advent of the gospel that the von Neumann type of computer architecture would become a pivotal tool for understanding the human psyche. Under the banner of emerging artificial intelligence and cognitive science, almost theatrical controversies were fought about ideas such as how the human mind can be simulated by a computer program, or how it represents outer reality by means of a "language of thought," a hypothetical mechanism in our brains inspired by the idea of a programming language like LISP.[6]

However, the general optimism in advancing such an ambitious program seemed to become almost lifeless twenty years later, which

6 Howard Gardner, *The Mind's New Science: A History of the Cognitive Revolution* (New York: Basic Books, 1985).

was what I witnessed during my stay in London in the 1990s. The very belief in the similarity (or even identity) between the computer and human mind just, somewhat awkwardly, corroded, and even the invention of parallel distributed processing and the neural network model, which in fact expanded the very notion of computation significantly, fell short of reviving the enthusiasm that we witnessed at the initial stage of its development.

While the heated controversy about the relation between computation and the human mind were gradually subdued, another attempt began to take shape, namely artificial life, or alife, as is called at present. Rather than talking about the working of the human mind, researchers tried more audaciously to define what life is, by means of computer simulation based on cellular automata. These automata proliferate like a unit of life, such as genes or germs, and you can observe how they grow or evolve in number on a display, following a couple of simple rules in relation to the neighboring cells. Some insisted that this could simulate the very evolution of living things through thousands of generations *in silico*, and others went further, insisting that these cellular automata were actually *alive*.

In a lecture held in a small office in Tokyo, presenting the general map of controversies around the status of alife philosophically in the 1990s, mainly for the purpose of introducing the original idea of C.G.Langton and his followers,[7] I remember I had a very acute sense of *déjà-vu* about the way the very status of such simulation was discussed. It was something quite similar to the way the nature of human mind was debated in the frame of representation and computation. Naturally, as in the case of artificial intelligence, there were those for and against these ideas.

Yet at the same time, I also remember that I was also struck by the fact that there were some, as far as I observed the lecture-room, who, if somewhat hesitantly, agreed with the idea that these cellular automata *in silico* could be defined as alive. It was an eye-opener to me, in a sense, as there are a variety of ways to define life. And the essential function of these automata was self-multiplication in relation to others, and some seemed to believe the essence of life was reducible to such a simple operation.

Of course, like in the case of artificial intelligence, there is a huge gap between mimicking certain aspects of a living thing and insisting that these automata are actually living, yet I found it not easy to exclude the validity of the idea of life-as-it-could-be for describing alife.

Scene 3: A field museum of architecture in Tokyo.

The third scene is at the western outskirts of the expanding capital of Tokyo. There lies a large park where you find a field museum of traditional and modern buildings, some of which are traditional farmhouses equipped with a couple of well-known items for traditional Japanese houses, such as earth floors, *tatami*, and sliding paper doors. Western visitors that I have accompanied there usually marvel at witnessing the actual openness of the structure of these houses, as well as at the thinness of these sliding doors. Once I met a Finnish student of contemporary architecture there, and later I wondered if he noticed the historical

7 Claus Emmeche, *The Garden in the Machine: The Emerging Science of Artificial Life* (Princeton: Princeton University Press, 1994).

genealogy from these peasant houses to some world-renowned contemporary works by Japanese architects, such as Toyo Ito or SANAA, whose architectures are famous for their transparency and structural airiness.

There is, however, an item which time-pressed visitors often overlook: a small shrine on the wall, close to the ceiling in the innermost room, the darkest part of the house. Traditional houses are usually furnished with this kind of miniature shrine, usually with a portion of various ritual foods provided as an offering to spirits or deities.[8] Foreign visitors may have regretted having failed to notice such exotic tradition there, yet they would soon be compensated by discovering countless numbers of shrines, here and there, large and small, only if they manage to wander through the forests of fancy modern skyscrapers in the center of Tokyo, or through the densely populated suburbs around the city.

Yet, the visitors might have also noticed that the miniature shrine in the farmhouse was empty. The caretakers of the museum, usually very attentive to the cleanliness of these houses, do not seem to be bothered by the lack of any ritual offerings. The prosperous look of these shrines in town does not automatically guarantee the great liveliness of anima's activity. Some shrines are simply deserted; others may be used occasionally for karaoke concerts on bank holidays. And nobody appears to even care if the shrine in the farmhouse is empty, for this is Tokyo, at the apex of the manifestation of modernity.

But are these shrines always vacant like this? The following case is a story about a bizarre, but deeply disturbing TV program broadcast decades ago on Japanese TV, which may be seen as a tiny piece of counter-evidence to the seemingly empty shrines. The intention of the program appeared to be to exhibit the mysterious world of spirits in Japan in the form of a TV show and documentary, and various examples were introduced, such as spirit possession, favorite haunts for spirits, traditional mediums, and mysterious traditional dolls in the shape of a girl which are supposed to have ominous power. Thus far, it was like an occult entertainment show to scare the credulous audience.

Yet what was distinctive about the program was that the producer invited two different types of specialists to the stage and to appear in the documentary, and their contrasting opinions were repeatedly referred to and compared. They were psychiatrists and traditional spiritualists, the latter mainly women. On the stage, they both observed how the above mentioned Japanese doll with its mysterious atmosphere affected the mood of the audience, some of whom started to get into trance, allegedly because of its power. And in the documentary part of the program, a woman who suddenly got ill, lost consciousness and spoke in tongues was taken care of by both a psychiatrist and a spiritualist.

The psychiatrists, naturally, "diagnosed" these abnormal events as symptoms of acute mental disorder. So the reaction of the audience to the mysterious doll was diagnosed as a sort of collective hysteria or autosuggestion, while the woman who lost consciousness was interpreted as suffering from acute dissociative personality disorder. The spiritualists, in turn, insisted that these were the acts of spirits, the spirit of the doll possessing the audience, or that an unknown spirit was affecting the woman in the documentary.

[8] For a classical introduction to the native religion of Japan, see Sokyo Ono, *Shinto: the Kami Way* (Tokyo: C.E. Tuttle, 1962) and Scott Littleton, *Shinto: Origins, Rituals, Festivals, Spirits, Sacred Places* (Oxford: Oxford University Press, 2002).

What impressed me, then, was not really the contrast between the two. Rather, it was the overwhelming self-confidence of the spiritualists vis-à-vis the cautious psychiatrists. The contrast was most apparent in the case of the documentary part mentioned above. The psychiatrist's diagnosis of dissociation of personality at the scene was not directly followed by any concrete way of treating the woman, while the spiritualist, asserting that it was caused by a spirit of unknown origin at a glance, quickly went on to identify who the possessing spirit was.

In the exchange of conversation between the woman and the spiritualist, the latter gradually revealed the identity of the spirit, which turned out to be that of her friend who had died in a car accident in the recent past. The spirit then revealed that it had possessed the woman because it missed her. When this process of identification was over, the woman came to herself again, in front of the psychiatrist, who looked somewhat embarrassed to witness the exchange between the two.[9]

Anima's repatriation to the contemporary cultural scene.

Our journey through the juxtaposition of these fragments of scenes, ranging from the villages of Java and alife to the Japanese shrines and the TV show, is intended for readers to come into contact with the various ways anima manifests itself in a contemporary context. Anima's liveliness cannot be easily confined to a particular place or culture.

Scene 1 shows that the very flourishing of spirit possession in one village is paralleled by the almost total negation of its existence in the next. In the Saminist village, anima's lively manifestation in the form of spirit changes into the abstract notion of "life" (*urip*) which they believe is eternal, inherited from generation to generation. And this variety of anima's ontology cannot be easily explicated by the limited notion of the unilinear progress of modernity. In Scene 3, the shrines are occasionally empty, but anima wanders the border between empty shrines and traditional healers, and also between spirit possession and dissociative personality disorder.

One of the lessons that we should learn from the tropical villages *out there*, is the remarkable richness of the activity of anima in the form of spirits or others. They are flying here and there. They may cause damage to people but may also carry fortunes. They may make people sick, but they also rescue them by possessing the human body in order to become an advisor. In short, they bridge the dispersed realms by building up an intricate network of relations. They are the embodiment of the nexus of cultural/natural relations.

Once this dense network of connectedness is understood in the form of spirit, anima's destiny can be foreseen through the observation of the shifting balance of culture/nature. One of the fallacies in diagnosing such an ever-changing condition is to reduce it to an intransigent dichotomy like tradition/modern. It is true, like in Scene 3, that in some areas, anima's habitat, represented by a particular type of holy space in a house, is seemingly empty. The small shrine has become simply a nostalgic and even somewhat exotic ornament for a traditional house. The modern theorists of architecture seem to have never reflect-

9 The same issue is treated more theoretically in Yuji Sasaki, *From Religion to Psychiatry* [in Japanese] (Tokyo: Kongo-Shuppan, 1986).

ed on the meaning of space represented by the small shrine of the Japanese farmhouse, when they compiled the theory of architecture based on the abstract and empty notion of functional space.

Here, however, the point is that the apparent dissolution of the work of anima is only half of the story. Scene 1 depicts the scattered distribution of anima's habitat through the rural area of Java. The disconnecting power of Saminism, a sort of revitalized traditionalism, actually wiped out the works of anima, while in the neighboring villages she was still active and busily connecting disparate realms of our living space. The point is that if anima is understood as the nexus of culture/nature, it will constantly appear and disappear from our view, in accordance with the shifting balance of cultural/natural conditions, so that in the very process of reappearance, anima might come into view in a very different shape from its traditional version, which would go beyond our ordinary imagination.

In Scene 2 we had a quick look at the notion of artificial life in the form of blinking cellular automata on a computer display. The very fragility of this candidate for a new form of anima, aside from its small number of supporters, is its very limited connectedness—almost close to nothing—in contrast to the shining richness of relations which the traditional anima spawns around her, as shown in Scene 1. The ontological status of the blinking automata is indeed ambiguous, so are the new chimera like products-to-be of the newly emerging synthetic biotechnology. These new entities may expand our fixed notion of life, yet the automata are far from causing illness or explaining our misfortune, or even incorporating into our body. The scope of their *work* is largely confined to the very limited area of activity in the computer display or in the test tube, in its extreme forms. For them to grow as a new form of anima, they would need to connect various elements in our daily zones of activity.

Conversely, once the prerequisite of anima as the nexus of connectedness is somewhat fulfilled, there is a chance for these new entities to grow as her new candidate. Here we should pay careful attention to the multifacetedness of the word "life." Viewing it from the non-Western linguistic tradition, it is hard to find a precise semantic counterpart in, say, Japanese language. Different terms in Japanese might be allocated to its derivatives, such as everyday life, life science, life world and so on. To put it concretely, *seimei* is for a biological term like life science (*seimei kagaku*), *seikatu* is for social life, and *sei* for philosophical life. The notion of life actually integrates these multiple aspects, and from this viewpoint, the notion of alife, for instance, only covers the very limited notion of life in the context of biology(*seimei*), but not the wider realm of the social and philosophical aspects of it (*seikatu*, and *sei*).

So if the new candidates for anima, ones not confined to computer simulation but any form of images and shapes, are ready to connect different realms of our "life" in the multifaceted meaning of the word, we are going to be eyewitnesses to the new form of anima emerging from our contemporary techno-scientific environment. Being still at the primitive level of development, there are in fact a profusion of candidates for the contemporary anima. And some of them in fact may audaciously challenge the border between life and non-life with their various strategies.

To acknowledge these as anima in the contemporary form, we have to scrutinize the connection she creates through her activity. Through such scrutiny, we can finally abandon all the negative and orientalistic connotations of the concept of animism, to create a new one for the future, totally in the affirmative voice, in accordance with our contemporary age of a superficially empty, spiritless world like the abstract space of modern architecture.

Vital Phantasy

Some fragments from a stitched story
between Animism, Evolutionism and More-Than-Human Earth...
By Didier Demorcy

First: exploring biological and cultural evolutionisms...

At the beginning of the nineteenth century, occidental scientists finally came to agree about the fact that Earth had indeed been subject to transformations in the course of ages...

Lamarck was the first to argue that if physical Earth experienced transformations, living beings also may have changed in order to survive...

The fossil forms that geologists brought to light were the ancestors of today's forms. It was only a matter of learning to see those gradual modifications.

Tylor, as cultural evolutionist, also proposed a theory of gradual modifications: animism (the faith in the individual soul or anima of all things and all natural manifestations) was the first step of human religion to be followed by polytheism and monotheism.

 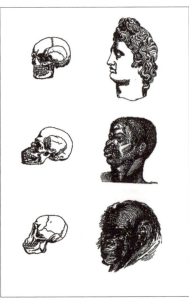

Tylor had also to refute the "theory of degeneration" that was popular at his time.

For its supporters if the new theory of biological evolution was truthful, it meant that mankind biological history was no longer an unitary process: some races had to be considered as degenerate.

Following a contemporary scientific expedition in a very strategic place in those times of climate warming: between a forest and a savannah...

And discovering that Western sciences meet the world only through a long succession of operations which shape and format it...

That there is no "external world" waiting to be discovered! In order for the scientific Western knowledge to be produced, the world first has to be: aligned, transformed, constructed!

"White man writes everything down in a book (so it will not be forgotten) but our ancestors married animals, learned all their ways, and passed on this knowledge from one generation to another"
– A Dakelh (Carrier) Indian of the Bulkley River, quoted by D. Jenness, 1943

HUMAN NATURE?
HUMANKIND – HUMANITY

Searching for paths in our past...

"I'm a lover of learning, and trees and open country won't teach me anything, whereas men in the town do." – Socrates / Plato, Phaedrus, around 370 BC

And discovering a very powerful animistic tool...

Vav	Hay	Daled	Gimmel	Vet	Bet	Aleph
Final Chaf	Chaf	Kaf	Yud	Tet	Chet	Zayin
Ayin	Samech	Final Nun	Nun	Final Mem	Mem	Lamed
Resh	Kuf	Final Tsadee	Tsadee	Final Fay	Fay	Pay
Taf	Taf	Sin	Shin			

A Alpha	K Kappa	T Tau
B Beta	Λ Lambda	Y Upsilon
Γ Gamma	M Mu	Φ Phi
Δ Delta	N Nu	X Chi
E Epsilon	Ξ Xi	Ψ Psi
Z Zeta	O Omicron	Ω Omega
H Eta	Π Pi	
⊙ Theta	P Rho	
I Iota	Σ Sigma	

With the advent of the "aleph-beth," a new distance opens between human culture and the rest of nature [...] the written character no longer refers us to any sensible phenomenon out in the world [...] but solely to a gesture to be made by the human mouth.
– David Abram, 1996

P... PS... PSY... PSYCHÊ

"Now that there are strong grounds to dispute Descartes' contention that animals lack the ability to think, we have to ask just how animals do think [...]
Animals' thoughts and emotions presumably concern matters of immediate importance to the animals themselves, rather than kinds of conscious thinking that are primarily relevant to human affairs."

– Donald R. Griffin, 1994

"Animals see in the same way as we do things that are different from the ones we see because their bodies are different from ours.
I do not mean physiological differences but affects, affections, powers that singularize each kind of body: what it eats, the way it moves, how it communicates, where it lives."

– Eduardo Viveiros de Castro, 1996

EDUARDO VIVEIROS
DE CASTRO
**MÉTAPHYSIQUES
CANNIBALES**

For finally glimpsing a new kind of universal?

Folkbiology

How to explain the fact, recognized by anthropologists since the sixties, that human beings, even when belonging to different populations, share the way they categorize animals (assembling and differentiating them into singular unities that we, in the West, call species)?

Maybe, as suggested by d'Arcy Thompson's work, all human brains (organs) would be able to follow the subtle twist and turns of forms... as produced by simple physical mechanisms.

And so reaching the end, maybe the most surprising: young mammals –whatever their morphology or habitat– have something in common and that's... play!

"To the cat playing, the paper or rubber ball isn't a dead object but something alive [...] Thanks to its 'vital phantasy' the animal sees all sorts of hidden properties and potentialities, inviting it to movements of investigation, and perhaps leading to play [...]"
– Frederik J. J. Buytendijk, 1928

Animism and the Philosophy of Everyday Life

Le Tour de Tiergarten

Michael Taussig

I am cycling through the Tiergarten in Berlin behind Britta and followed by Thomas. It is a cold and rainy day in November. Yellow leaves lie thick on the ground. The way we sit upright but relaxed, breathing easy with our hats of different colors and angles, we are more like machines than people, a collection of levers and joints like the bike itself. Where does the bike bit stop and the human bit begin? We are unified, this machine and I, like the Inca Indians in the Andes of South America were supposed to think of the Spaniards mounted on their horses: not as a man on a horse but as a man-horse.

I see some elegant cassowaries and then a zebra with its incredible stripes to one side of the path. I think: Well, we too are a zoo, me and Britta and Thomas and our bicycles. What might these wonderful beasts think of us and our bicycles as we ride past? Do they distinguish between animals and things? What is the bicycle to them as it spins along, the spokes of the wheels catching the fading light of the afternoon?

The wheels of the bike turn effortlessly, not like in New York where people hunch over the handlebars and with a grim look on their face push furiously at the pedals racing against time. The man-horse combination of bicycle-and-rider is different in Berlin to New York and if the zebra and the cassowaries were taken to New York I am sure they would see that difference too. So where does the bike bit end and the human bit begin? And what is this "racing against time"? Is time a

thing too, standing over and against us? Or is it part of an activity, like the wind on one's face while freewheeling over the yellow leaves in the Tiergarten?

Those stripes of the zebra dazzle me. The stripes are things in themselves that have come alive. It is impossible to domesticate zebras and use them like horses, Thomas tells me as we ride along. Might that have something to do with those dazzling stripes? I wonder, and then I think of the stripes on Genet's convicts in the opening pages of *The Thief's Journal*. Those stripes are the sign of a brutal domestication turning people into things.

Was there ever an animal more surreal than this zebra standing stock-still as we ride past? The stripes however do not stand still. Not at all.

But then aren't all animals surreal, from earthworms to the snail and the domestic dog. It's a question of how you look. Like the bicycles on the move, those stripes of the zebra hover between the thing world and the animate world. It is this hovering, neither one thing nor the other, that makes for what we call animism, just as it makes for surrealism.

It also makes for chemistry and for capitalism based on the factory production of the modern world. The big breakthrough was in mid-nineteenth-century Germany with August Kekulé inventing what is called "organic chemistry"—organic as opposed to "inorganic," organic as in a chemistry of life, the symbol and working tool of which was the hexagonal-shaped benzene ring derived from the carbon in coal.

Primo Levi ends his book, *The Periodic Table*, with this benzene ring. In that book he picks a small number of elements from the Periodic Table and writes a story about each one. The last element he chooses is carbon. "To carbon, the element of life," he writes, "my first literary dream was turned, insistently dreamed in an hour and a place when my life was not worth much: yes, I wanted to tell the story of an atom of carbon."

But the way this works it can seem like it is not him telling the story but that the elements themselves are telling their story. This seems to me a great achievement. Things speak on their own, so to speak. But when I think more about it I see this is not nature speaking to us but what could be called "second nature," meaning nature elaborated by human history such that, like the man-bike, the story comes from the join.

What makes organic chemistry the chemistry of "life"? Isn't all chemistry "organic"? What sort of word chemistry is involved when we talk of "biochemistry" and now of "biopower"? Surely all these constructions are vivid instances of animism, meaning a quality of being that is uncertainly alive with a mind and even a soul of its own when, from another point of view it is merely inert matter? And just as surely can't we say that the core of the modern world is therefore animistic? It is astonishing how we so easily encompass such confusion and contradiction in our everyday philosophy and get on with life as on this bicycle ride through the Tiergarten. Only now and again does the animism of it all confront us and make us laugh and wonder or feel frightened and wonder, as with those stripes and the easy movement of our bicycles through space and time as our legs move up and down and the spokes of the wheels catch the rays of the dying sun.

The stakes are pretty high. Without this organic chemistry there could be no modern world. Most of that which we live by and think by comes from it in one grand mimesis of nature, playing with the benzene ring. And now the stakes are really high, now that carbon fuels global warming and potentially the end of life. The domination of nature has turned full circle.

A little further along the path where we cross the winter-brown waters of the canal we come across an open field surrounded by pines. The field is full of mounds of earth, little mountains about fifteen centimeters high. These are made by moles, blind creatures that burrow deep in the earth, like the revolution coming into being, said Marx. The mole is certainly an animal. But what of these mounds? Are they animate or inanimate? And what of the revolution? Is it still animated or animating? Has the "old mole" lost its way?

The revolution would be surreal, too. And that means animistic. Neither thing nor nothing it would be a movement that took into account all these wonderful confusions that Western culture has created and upon which it depends—confusions between animate and inanimate, made all the more confusing because in the everyday philosophy of life we use these confusions as if they were not confusing at all. As long as I am on my bicycle cycling through the Tiergarten behind Britta and followed by Thomas, breathing easy with our hats of different colors and angles, more like machines than people, it really does not matter where the bike bit stops and the human bit begins. We are unified, this machine and I, not as a man on a horse but as a man-horse eyeing a zebra.

Lutz & Guggisberg
Entrance, 2000
Photographic lithograph
Courtesy the artists

Lutz & Guggisberg
Big Hare, 2000
Photographic lithograph
Courtesy the artists

Lutz & Guggisberg
Fireplace, 2000
Photographic lithograph
Courtesy the artists

Absentminded Wandering through an Indeterminate Maze of Intentionality

Philippe Pirotte

Desperate or Hopeful Relationships?

In the introduction to his book *Fetischismus und Kultur*, Hartmut Böhme recounts a joke about Niels Bohr. Apparently, the famous physician had horseshoes hanging above his door, an old superstitious habit in Germany.[1] A visiting friend, wondering why the professor would do this, asked Bohr if he believed, in this kind of superstition. Bohr replied that he did not believe it but that it worked for non-believers just the same, the power of the object being wholly independent of the convictions of the subject. We all know variations of this story. It is the fetishist or animist paradox we invoke in order to remain rational and modern in a Western way, and grant "dead" objects agency. Swiss artists Andres Lutz's and Anders Guggisberg's "Impressions from the Interior" comprises thirty photographs that have been taken over the past ten years. They offer a view of Switzerland that is rural, suburban, magical, mundane, quirky, and surreal. The black-and-white images contrast bricolage with tourist idyll, window displays with children's playgrounds, birds with crocodiles. The photo-litho prints, each highly detailed and in perfect focus, essential for a so-called scientific gaze, are at the same time characterized by an unexpected potential to reveal human eccentricity, though very few humans are actually shown. Mountainous landscapes contain odd foreground groups of birds, or stones that look animated. Musical instruments, second-hand bargains on display, animal skins, clocks, masks, bales of hay, crockery, dollhouses, and bird nests form hopeful relationships. Pre-modern forms and institutions of magic, myth, cult, religion, and ritual may have dissolved in our "modern" societies, but the energies contained in these pre-modern institutions and forms were certainly not eradicated. On the contrary, these energies were liberated from their institutions and now float as spectres through all system levels of modern society to rewrite themselves (uninvited) in its structures. In "Impressions from the Interior," jokes and especially puns crop up also. *Big Hare* (2008) for instance, shows a ridiculous, stuffed, long-eared comic creature, seated in a portable chair with a basket of flowers, a garden gnome, and a plaster duck. In *Tired Hut* (2008), a cleverly observed, tilted view shows the sad wooden shelter leaning precariously in the middle of a vast sloping field of flowers.[2] Nothing in these photographs seems to be more false than a disenchantment of the world. No theory of modernity seems therefore more false as the one that identifies modernizing with a growth of rationalism.[3]

Whereas Lutz's and Guggisberg's distanced, almost scientific documenting of chance situations suggesting animistic relationships, which

1 Hartmut Böhme, *Fetischismus und Kultur. Eine andere Theorie der Moderne* (Reinbek Bei Hamburg: Rowohlt Verlag, 2006), 13–16.

2 See Bob Dickinson, "Andres Lutz & Anders Guggisberg", in *Art Monthly*, (London, July–August, 2008).

3 Bruno Latour, *Nous n'avons jamais été modernes: essai d'anthropologie symétrique* (Paris: La Découverte, 1991).

Once upon a time, a rock was flung from a catapult at a boat... 2 weeks later, it was used as kettle stand for 5 seconds by a man who set it there after retrieving the kettle from the fire when he noticed his sandal was unstrapped...2000 years later, it is currently being used to prevent a blue tarp from blowing off of a pile of cedar logs. Today, it has been incorporated into a story being written by myself... something about garden casinos, prison canteen walls, yogurt cultures, homemade slot machines and lime fizz ices in the dark.

Adam Avikainen
THINGS CHANGE, 2009
Photo print
Courtesy the artist

The prisoners are playing doctor behind the smokehouse.

"I'm writing a pilot for a new television series called CSI:DNR...ya'know...crime scene investigators for the department of natural resources."

"Right."

"the detectives catch some juveniles smoking joints on a high fire risk day in summer and then find out one of the kids is the son of a super-big-poacher."

"oh, that reminds me, the menu tonight revolves around poached, peached pheasant."

"oh, that's good, the dude will be poaching waterfowl and cutting down smokable trees on private land and selling them to gourmet crooks by the docks for fast shipment overseas."

Adam Avikainen
CSI:DNR, 2009
Photo print
Courtesy the artist

A woman in her twenties walks into a restaurant serving Korean bbq dishes.

"Hello, I am going door-to-door exchanging recipes in the neighborhood"

"Oh?"

"Yes, I would like to trade you my recipe of lavender infused beef brisket for your kimchi recipe."

"Oh! Our kimchi is the best! It tastes like it was made from a cabbage grown in heaven."

"I...yes...I am sure it does...ummm....I suffer from anosmia...or I lack the sense of smell...I can't really taste anything...I think your kimchi is very beautiful to look at on a cold winter night...it reminds me of my childhood and ice fishing...when I was sadder...or was I happier then...I can't recall...you see my memory and emotions are sort of messed up too, because smells go directly to our limbic systems in our brains, or the part that handles memories and triggers emotions. As opposed to sight and sound which goes through the hypothalamus and then the cortex which controls primal desires like hunger...."

"Umm, could you excuse me, I have to prepare the bbq for the customers."

"Oh okay. I'll come back tomorrow."

"Um."

i am the headlight.
i am the deer.

Adam Avikainen
ANOSMIA, 2009
Photo print
Courtesy the artist

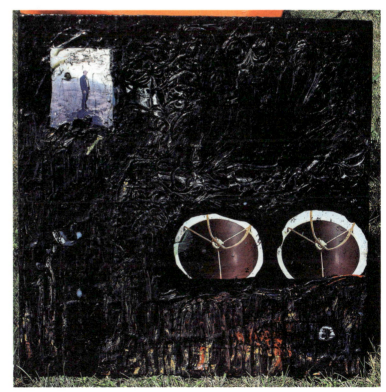

Adam Avikainen
I AM THE HEADLIGHT I AM THE DEER, 2009
Photo print
Courtesy the artist

Philippe Pirotte
205

are unconsciously persisting in contemporary daily life in the West, the Finnish-American artist Adam Avikainen really engages everything that meets his gaze, be it in Finland, the United States, or Japan (the three countries where he mostly resides). This literally takes the form of a dialogue with his so-called "fellow travellers," be they humans, plants, thoughts, or creatures from fables and myths.[4] From Adam Avikainen's point of view, every entity can easily slip into different states of being: a thought becomes a living creature, an object becomes a wise storyteller. His work constitutes an artistic biotope, in which natural cycles are mirrored. In this configuration, the artist himself is not so much a "creator" or "demiurge" of his world, but rather a part of it. He disappears and reappears in different guises. Consequently, Avikainen employs a host of different materials and media like film, photography, installation, painting, text, and sound. He often tells his stories in parallel, complementary strands of different media, which combine into a complete and unified project, his so-called *Storyboards*. For example, Avikainen's photographs—photography being the most sober and documentary medium by definition —are supplemented with texts that function as mythical narratives and bizarre parables, and that turn the images into transfiguration devices of an idiosyncratic, wondrous cosmos, where "things" are definitely subjects that determine the scenes themselves.

4 I would like to thank curator Elfriede Schalit for summarizing her correspondence with Adam Avikainen.

Mark Manders
Life-Size Scene with Revealed Figure, 2009
Brass, wood, iron, sand, hair, dust, apoxy, rope

Untitled Drawing, 2005
Pencil on paper

Drawing with Vanishing Point, 2007
Pencil on paper
All images courtesy Zeno X Gallery, Antwerp

With *Life-Size Scene with Revealed Figure*, Mark Manders may have tried to make such a fictitious "thing" exert power. An appliance rather than a piece of art, it seems a kind of musical instrument, but could also be the sculptural translation of a projection. To project is a ubiquitous way of transporting images in exhibitions today. The displacement of film in the field of visual arts stresses the power of the animated image and its potential to transport us to other places. The "projected" image in Manders's sculpture is assembled from different figures "precariously suspended from a bridle of taut string that pulls it forward in a careful balancing act, but that, in some animistic con-

5 Peter Eleey, "Mark Manders" in *The Quick and the Death* (exh. cat), (Walker Art Center, Minneapolis: Minnesota, 2009), 242.

6 Mark Manders in conversation with the author, December 9, 2009.

7 Mark Manders, "Inhabited for a Survey (First Floor Plan from Self-Portrait as a Building)," in *The Absence of Mark Manders*, eds. Christoph Becker, Stephan Berg, Solveig Ovstebo, and Philippe Van Cauteren, (exh. cat.), (Hatje Cantz, 2007), 16.

8 Aristotle, *De Anima*, 3rd Book, 7th Paragraph, 413a, 16–17: "To the thinking soul images serve as if they are contents of perception (and when it asserts or denies them to be good or bad it avoids or pursues them). That is why the soul never thinks without an image."

9 "Rien ne vient dans l'entendement sans une image," Voltaire, "Imagination," in *Encyclopédie méthodique: Grammaire et littérature*, Volume II (1784), 295.

10 "Sensualism" is an empirical philosophical doctrine, according to which sensations and perception are the basic and most important form of true cognition, which may oppose abstract ideas.

11 On this, see Martin Jay, *Downcast Eyes: The Denigration of Vision in Twentieth-Century French Thought* (Berkeley and Los Angeles: The University of California Press, 1993).

12 About this function of the image, see: Gunnar Schmidt, "The Peculiar Effect: Nathaniel Hawthornes Medien und Modernitätskritik," in *Das Unsichtbare Sehen*, eds. Sabine Haupt und Ulrich Stadler (Zürich: Edition Voldermeer, 2006), 199–212.

ception, might also illusorily cast it back, as if it were a shadow on the wall of a primeval cave."[5] The figure, vaguely reminiscent of those used in the Indonesian *Wayang Kulit*, or shadow play, seems to be made of sticky dust, sand, and hair, and appears very fragile. The artist recounts that he deliberately wanted to create the ultimate cannibalistic sculpture.[6] The sculpture is solely made out of referential elements from various cultures and existing artworks in order to become a quasi-religious tool that is no longer recognizable as belonging to a specific culture. Manders suggests it could have come from a culture that never existed. He used brass for the unfolding background surface not only because of its association with musical instruments, but also to hint at Christian relics or other items of value. The metal piece holding the strings is made using both medieval ironworking techniques and metal applications for pistols. As in most of his works, Manders deals with the relationship between the world of objects and the artist as first spectator. The observant self experiences this world not only as something that exists entirely independently from itself, but also as a constellation in which things shape the subject's intentions and thoughts. As Manders described in relation to an earlier work: "I could move over these objects, and they dictated my thoughts with their colour, language, form and indescribable physical coherence."[7] It is this physical coherence that seems a surprise to the artist himself, and opens an experience in the domain of the uncanny.

An Unpardonable Sin

In Aristotle's famous text *De Anima*, "Anima" does not think without images.[8] Centuries later, Aristotle's original idea still prevails. For philosophers like Voltaire, nothing could be conceived without an image,[9] and also Kant, in his *Reflexionen zur Anthropologie,* departs from the idea that all conception needs imagination. When one wanted to study and understand the human mind in the nineteenth century, one needed a methodical conception of mental images that would exceed the speculative intuition and introspection of rationalism, and even reach beyond the epistemological basis of empirical sensualism[10]. The progressive development of analytical philosophy in the beginning of the twentieth century, however, allowed for a degradation of the visual because thinking was understood to be a strictly verbal undertaking. Long considered "the noblest of the sense," vision increasingly suffered critical scrutiny at the hands of a wide range of thinkers who questioned its dominance in Western culture. These critics of vision, especially prominent in twentieth-century France, challenged its allegedly superior capacity to provide access to the world, and, in the same move, they warned of the dangers of its complicity with political and social oppression through the promulgation of spectacle and surveillance.[11]

Already in nineteenth-century fiction, the negative effects of the power of images were stressed, which allows us to presuppose a strongly entrenched disquiet for the mythic, described as a menace to modern rationality, as is the case in E. T. A. Hoffmann's *Der Sandmann*, Oscar Wilde's *The Picture of Dorian Gray*, Edgar Allan Poe's *Oval Portrait*, or Nathaniel Hawthorne's *The Scarlet Letter*.[12] The stories

describe a movement back and forth between fascination for the image and a basic iconoclastic desire. As much as the image in these novels––be it a painting, a sculpture, or an automaton—contains a promise, it also initiates a reversal, and damages our abilities to know. Supposedly "dead" things start to live, the beholder is subjected to a fatalistic influence, and reality succumbs to distortion. Time and again, they describe an ambiguous situation in which image and reality merge, and the borders dissolve between the iconic and the real. All the texts are connected through the topic of a crossing between reality and the imitation of life. The passing into the "unreal," into the illusion, the hallucination, or the dream, animates the novels and dramatizes the insecure position of the subject between wish and reality.

Most of Nathaniel Hawthorne's stories deal with this subject matter, but especially relevant in this context is his short story *Ethan Brand* (1850), which traces the domestication of the image imbued with life. The main character, Ethan Brand, returns to his village after an eighteen-year search for the "unpardonable sin." Brand oozes an uncanny coldness and is rather unapproachable. A raree-show in the village vainly seeks to entertain the youths with an antiquated device until a boy puts his head in the box and a lively image appears: "Viewed through the magnifying glasses, the boy's round, rosy visage assumed the strangest imaginable aspect of an immense Titanic child, the mouth grinning broadly, and the eyes and every other feature overflowing with fun at the joke."[13] Diverted from its intended use, the raree-show becomes fascinating again in an actualization of its function performed by the boy. Until a cold observer appears and fixates the boy: "Suddenly, however, that merry face turned pale, and its expression changed to horror, for this easily impressed and excitable child had become sensible that the eye of Ethan Brand was fixed upon him through the glass."[14] A lonely, intelligent, and heartless gaze pierces the boy whose expression freezes into an image: he changes from an actor into an observed object. He is exposed to the scientific gaze of Ethan Brand, the cold observer. In Hawthorne's critical stance towards a progressing modernity, it is this mean and inspecting gaze that is the unpardonable sin that Brand searched for: the gaze that disenchants the world.

David Gheron Tretiakoff's film *One God Passing* documents a real situation in which an opposite logic to the one in Hawthorne's story is unleashed in the streets of modern, urban Cairo. The huge granite statue of the ancient Egyptian pharaoh Ramses II was moved overnight from downtown Cairo to a place near the Great Pyramids, at a stately pace on two flatbed trucks. Tens of thousands of people came out to watch it go by in a valedictory mood to say goodbye to the god-like pharaoh sculpture, which used to be an evident part of their urbanity. The head of Ramses, protruding from protective steel to hold the statue steady, was wrapped in plastic and thick padding, but its face was visible to the crowds lining the streets. There were people chanting "Allahu Akbar," and waving "V" for Victory signs. There was clearly jubilation in the air. The people sensed that they were participating in an event, but there is discussion about its possible significance. In the by-and-large Muslim country, some fiercely denounced the excitement for the *Sanam* (false idol), while others emotionally pleaded that, since the pharaoh is part of their heritage, it cannot be a false idol—first carefully, but then more and more overtly denouncing their actual lead-

13 Nathaniel Hawthorne, "Ethan Brand," in *Tales and Sketches*, (New York: 1982), 1061.

14 Hawthorne, 1061.

- Tu parles à une statue !
- Qui dit que je parle à une statue, je suis musulman.

David G. Tretiakoff
A God Passing, 2007
Video, 22 min
Image courtesy the artist

15 "Creative Participation" is a term used in social science to describe the position of the observer towards the observed. Originally a Lucien Lévy-Bruhl term from the 1920s for analyzing social relations of cultural groupings, Creative Participation rewrites the traditional participant-observer approach in which dynamic movements can be captured by means of feelings.

16 See Victor I. Stoichita, *Brève Histoire de l'Ombre* (Genève: Librairie Droz, 2000), 20.

ers as the "real" false idols. Tretiakoff combines his own images with footage taken from Egyptian television, subtly shifting between official reporting and "creative participation"[15]: the camera heightens the natural sense for drama of some of the protagonists in the street, but at the same time, Tretiakoff himself becomes a medium of the multiplicity, of the agencies that traverse us even if we do not necessarily recognize them. What is important in the event, though, is that Ramses, the statue, the image, releases a hallucinatory mode of public perception. For ancient Egyptian culture, statues took the place of divinity and were necessarily considered animated. The famous *Ka* of the Egyptians was the soul of the statue in the form of its shadow. The statue is moved at night (obviously the time with the least traffic), which, in ancient belief, would provoke a "nocturnal shadow" differentiating itself from the natural way things go, in opposition to a shadow in daylight.[16] Although the crowd is supposed to know better, and the statue does not move, but is pulled forward, the onlookers negotiate an ancient belief that images of gods might become imbued with divine force and acquire movement, which, again, could be considered an unpardonable sin in a Muslim environment.

In both Hawthorne's story about Ethan Brand and Tretiakoff's documentary of the movement of Ramses II's statue, there is an unease with images that oppose one another: both the iconic and the optical are forbidden to be animated. The "uncontrollable," "uncontained" image is refused by both science and religion. Hawthorne diagnoses a crisis in the nineteenth century at the moment modernity breaks through, in which both art and science lose insofar as one does not in-

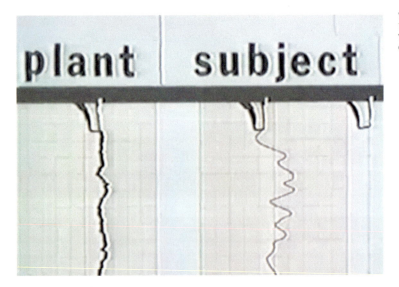

Walon Green
The Secret Life of Plants, 1979
Video, 96 min
Courtesy Paramount Pictures

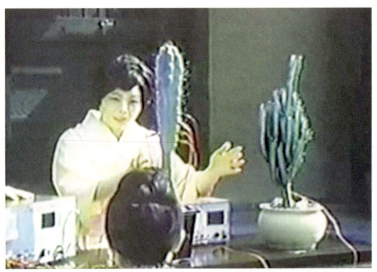

clude the other. In Hawthorne's pessimistic view, this provokes alienation: hallucination, disenchantment, and fear take hold of the subject. Tretiakoff's film suggests that, when dropping that fear for the unpardonable sin, the subject would no longer be an isolated, lonely individual who has to provide the world with meaning, but would be part of what Félix Guattari called an *agencement collectif d'énonciation*, a disposition of subjectivity, interacting with an environment and a group in permanent evolution.

From Disenchantment to Reciprocity

17 Peter Tompkins and Christopher Bird, *The Secret Life of Plants* (San Francisco: Harper & Row, 1973).

Through controlled experiments investigating floral intelligence, the 1970s cult book *The Secret Life of Plants*[17] demonstrated ways in which humans and plants might communicate. It suggested not only that all things have a life force—plants, rocks, metal—but also that all things experience a certain level of sentience and awareness. It proposes that, even though not all existing things have a neurological presence (one will hardly find a brain stem in a rod of iron), there is a certain form of awareness that all things possess. This communal "reciprocity with things and nature" suggests that, perhaps, humans are not exclusively sentient, and perhaps, our purpose here on Earth is not so much to be the masters over this domain, but rather, the servants and keepers of it. The ideas in Peter Tompkins's book are shared by the *new animists*,[18] who have been much inspired by the serious way in which some indigenous people placate and interact with animals, plants, and inanimate things through ritual, ceremony, and other practices.

18 This new use of the term "animism" applies to the religious worldviews and lifestyles of communities and cultures enthusiastically engaging with indigenous and environmentalist spiritualities in which people celebrate human relationships with significant other-than-human beings and for which it is important to inculcate and enhance appropriate ways to live respectfully within the wider community. See Graham Harvey, *Animism: Respecting the Living World*, (Kent Town, South Australia: Wakefield Press, 2005).

Reduced to an object strictly governed by natural laws, nature can, of course, be studied, known, and employed to our benefit. The progress in knowledge and material well-being may not be a bad thing in itself, where the consumption and control of nature is a necessary part of human life. George Washington Carver, a born slave, who revolutionized agriculture in the American South, appears in Walon Green's film version of *The Secret Life of Plants*. Much of Carver's fame is based on

Otobong Nkanga
Social Consequences II, 2009
Acrylic on paper
Courtesy the artist

his research into and promotion of alternative crops to cotton, such as peanuts and sweet potatoes. He wanted poor farmers to grow these alternative crops both as a source of their own food and as a source of other products to improve their quality of life. The most popular of his forty-four practical bulletins for farmers contained 105 food recipes

that used peanuts. He also created or disseminated about one hundred products made from peanuts that were useful for the house and farm, including cosmetics, dyes, paints, plastics, gasoline, and nitro-glycerine. The legend goes that Carver did not want any financial benefit of his findings because the peanut was not "created" in order to make God rich. The passage with Carver functions as an ideological statement connecting to ecological ideas introduced by neo-Marxists of the Frankfurt School. While classical Marxists regard nature as a resource to be transformed by human labor and merely utilized for human purposes, Horkheimer and Adorno saw Marx himself as a representative of the problem of "human alienation." Although George Washington Carver developed new vegetable possibilities in agriculture, he did not adhere to a narrow positivist conception of rationality as an instrument for pursuing progress, power, and technological control.

The positivistic disenchantment of natural things, through observation, measurement, and the application of purely quantitative methods, combining determinism with optimism for critical Marxists, in fact, disrupts our relationship with them, encouraging the undesirable attitude that they are nothing more than things to be probed, consumed, and dominated. The perversity lies in the idea that exploitation is fundamental to culture when it is defined as the adaptation of natural resources towards human ends. Otobong Nkanga's series of drawings "Delta Stories" hover between a personal and an abstracted account of the conflicts relating to the harsh oil-exploitation in the Nigerian delta, whereby the local population considers disenchantment of nature as a source of environmental problems and destruction. The crisis arose in the early 1990s over tensions between foreign oil corporations and a number of the Delta's minority ethnic groups. Competition for oil wealth as part of an ever-ongoing "scramble for Africa" has fuelled most of the violence, but the conflict is symptomatic of a clash of different worldviews. "Delta Stories" hints ex negativo at the corporate world, which achieved monopoly control of their business sectors, prohibiting locals or colonists by law from competing against the corporation extracting their resources or selling them goods. The corporation as a virtual entity mediates all lateral contact between people or small companies and businesses, and it redirects all created value to a select group of investors. Any creation or exchange of value runs through these default social principles of our age, in a system enforced by law, controlled by currency, and perpetuated through the erosion of all other connections between people and their world. According to Walead Beshty, corporations are "a multitude of voices congealed into a singular entity, a transcription of an ephemeral set of compromises and competing agendas given a unified voice."[19] Beshty further notes Gilles Deleuze's characterization of the corporation as a spirit, and wonders what it means for that ghost to speak. Like most innovations of the colonial era persisting in postcolonial times, this ghost extracts value from the so-called periphery, and brings it back to the so-called center. Covering the wide range of changes from human value creation to corporate value extraction, Nkanga's "Delta Stories" forms a meditation on the exploitation of natural resources in a poetic, allegorical way.

The positivism of science and technology not only removes our fear of nature by promising limitless knowledge and power, but also destroys our sense of awe and wonder towards it. In his later work,

19 Walead Beshty, "American Ingenuity (And the Failure of the Readymade)," in *Afterall Magazine* nr. 17, (Antwerp, London, Los Angeles, 2008), 23.

20 Adorno borrows the term "sensuous immediacy," which he considers the defining characteristic of art, from Hegel's *Aesthetics*. In his own *Aesthetic Theory*, he considers "the sensuous" as part of aesthetic understanding, which is considered a resistant quality against quantification, or a quality that remains after the violence of naming and categorizing. Aesthetic understanding makes note of the sensuous, the non-rational that is so often dismissed as merely irrational and that cannot be exhausted by irrational codification. (Theodor W. Adorno, *Aesthetic Theory* (first published in German, Frankfurt Am Main: Suhrkamp, 1970).

21 Some students of Adorno's work have recently argued that his account of the role of "sensuous immediacy" can be understood as an attempt to defend a "legitimate anthropomorphism" that comes close to a weak form of animism (Jay Bernstein, *Adorno: Disenchantment and Ethics* (Cambridge: Cambridge University Press, 2001), 196.

22 Simryn Gill was born in 1959 in Singapore, was raised in Malaysia, and currently lives in Sydney, Australia.

23 Eleanor Heartney, Press Communication about Simryn Gill's exhibition at ArtPace, San Antonio, Texas, 1999.

24 Heartney.

Theodor Adorno advocated a re-enchanting aesthetic attitude of "sensuous immediacy" towards nature.[20] This means an acknowledgement of the possibilities to be directly and spontaneously acquainted with nature without interventions of our rational faculties. Adorno refers to the "excess" in works of art, something more than their mere materiality and exchange value, which is akin to natural things, and should therefore be able to re-enchant the world through aesthetic experience, which would at the same time be a re-enchantment of lives and purposes.[21]

The project *Vegetation* (1999) by South-East Asian artist Simryn Gill[22] was inspired by her desire to be a plant in the American landscape. She enacted her fantasy in some of the wide, open spaces for which the American West is famous. A series of black-and-white photographs document the action. As Eleanor Heartney describes, "becoming a plant was not an easy process. On locating the appropriate sites, Gill gathered native plants and brought them back to her studio. There she transformed them into face-obscuring headdresses. Then Gill returned to the original site where she, and occasionally several other plant-spirited accomplices, posed for photographs wearing the headdresses within the rugged Texas landscape."[23] Although the project had a lot of political implications, questioning the philosophical, social, and political paradoxes surrounding questions of nature, land, and identity (what is delimited by borders, personal or political, for human beings does not count for plants), Gill, at the same time, raises questions about hierarchies in rational Western culture. In this view, the human relates to plants like the mind relates to the body. By covering their head, the seat of rationality and identity, she and her accomplices perform an act of becoming invisible, though their bodies are visible for all to see. In the photographs, we see Gill and her semi-camouflaged comrades "rise above prairie grass, stand in front of barbed wire fences and sit along the banks of the Rio Grande, the region's most powerful border. The absurdity of their half human-half plant personas is further evidence of the clash between the human artifice of boundaries and the mobility of vegetation."[24] Gill's project is also motivated by her awareness of the Western tradition to consider (Asian) "Others" as closer to nature, which would imply a judgment made out of a feeling of superiority. Using horticulture as a metaphor for a human situation in many of her works allows Gill to undermine the supposed dichotomy between nature and culture, and confuse the language that sustains such assumptions, for instance, the condescending way natural metaphors are imbedded in human consciousness, although even the most radical transformations of industry and modernity could not obliterate them. In *Vegetation*, we witness a wonderful, witty subtext of resistance about the (both alien and self-evident) plant people sprouting from the landscape, reminding us of the force of identifying matrixes imposed upon us by geography, politics, history, and biology.

Japanese artist Yutaka Sone undertook a similar gesture when he made a so-called *Magic Stick* to approach the jungle in a ritualistic act. In a video of the action, we see the artist trying to merge with the surrounding nature, carrying a weird transparent object that looks like a big, clumsily made walking stick. Specialized craftsman in Japan helped Sone make the stick in glass, which became plastic at 1,200 de-

Yutaka Sone
Magic Stick with Bolero, 1998
Stills from video, 17 min
Courtesy David Zwirner, New York

grees Celsius. He modeled its form for forty seconds with his hands, only protected by heat-resistant gloves. The cooling down of the object to room temperature took two weeks.[25] Subsequently, Sone filmed his wanderings as an alien in the jungle with his magic stick, trying to approach his surroundings, while at the same time performing an attempt to "re-enchant" nature. Whether Sone loses himself in the jungle with a magic stick, makes snow-crystals from natural crystal, carves landscapes in white marble, or sculpts the Himalayan Mountains out of snow, the work always deals with a strategy of self-denial. Sone admits he loves landscapes that evoke an intense experience, in which the time of his own presence and that of nature exist simultaneously.[26] Underlining in his work the experience of such an exalted moment, he crystallizes the tension of magic sensations in a person's relationship to the environment.[27] For the artist, his magic stick mediates this relation, as do roller coasters, bikes, or skis. Yutaka Sone does not consider the kicks of exploratory travel, adventure, sport, and speed necessary stimuli for modern man to compensate for a poverty of experience. For him, the kick, a kind of delightful shock experience, gives form. It provokes no "high" in which one loses oneself in an unreal world; but rather, it is an almost situationist approach to a reality that seems to be increasingly evicted from experience.

25 Yutaka Sone in conversation with the author, December 14, 2009.

26 Yutaka Sone, "Statement for Magic Stick," in *Yutaka Sone. Travel to Double River Island*, ed. Min Nishihara, (Toyota: Toyota Municipal Museum of Art, 2002), 11.

27 See Philippe Pirotte, "The Time of the Landscape," in *Yutaka Sone* (exh. cat.) (The Renaissance Society at the University of Chicago, Aspen Art Museum, Kunsthalle Bern: 2006), 33-44.

Passionate Choreographies Mediatized.
On Camels, Lions, and Their Domestication Among the 'Isāwa in Morocco

Martin Zillinger

The adepts of the 'Isāwa congregation convene in a village in the *ġarb,* the western plain of Morocco. All night long, they have celebrated a *līla*—a ritual—organized as a *ṣadaqa,* an offering to God and the public in order to share some of the good one has received. Religious passion has been on the rise throughout the night, brought about by the common dancing in time with the music of the brotherhood. Together, they mourned over those who died and about the hardship and sorrow they have endured during the last year. Time and again, the *muḥibbīn*—the followers of this particular Sufi path—fell into trance, dancing in ecstasies, enchanted by *baraka,* the divine blessing and power of the ritual.

Film 1a: *The Camel-Trance,* 20 min 30 sec Gharb, 1992 Courtesy of Muqaddim Muḥammad Ṭawīl

The Camel-Trance

Their passion culminates in the *ḥāl* (trance state) of the camels. Heat rises inside them; they "depart from the world as it exists," and in trance they leave the village; the trance "strikes them" and so they run frantically, shouting, growling and bellowing as camels do, in search of the *hindīa,* the savaged cactus pear (Opuntia ficus-indica) which can be found in many Mediterranean landscapes, and which covers wide areas of the Moroccan countryside. Along goes the cameraman, who records the scene, while attendees start weeping, overwhelmed by the powers that manifest around them and in their bodies. We see men mounting the cactus, numb to the pain of the thick, long thorns, some of which drive into their feet, their hands, their bodies. The "sheik" of the camels stands on the cactus bush and agitates the musicians and the dancers; and, in turn, he is empowered by the music and the crowd. Some fellow 'Isāwa try to calm him, to prevent him from being hurt, but the *ḥāl* asks for its tribute and the dancers reject any attempts to interfere. The *baraka* of the founding saint and therefore of God, the Beneficent and the Compassionate, protects and empowers those who are enchanted.

But is the man who climbs the cactus misguided by some mistaken belief, as modernists claim? What is it that moves the women into trance? For the 'Isāwa, it is the "state of the camel," a power, a wind, a spirit other than themselves, not unlike the *jinn,* spirits that God created from fire, and who inhabit the earth alongside man. It is these forces, which come to the fore and act in and through them. In time with the drums and the oboes, they perform the trance-dance, clinging to the pieces of the *hindīa,* pressing them close to their bodies while the spirits drive them deeper and deeper into trance. In order to "cool

down," they have to find their way into the course of the ritual. The *muqaddim*, the principal of the congregation and *sheik* of the "camels," supervises the ritual operations and directs them to form a circle. The women-camels perform the trance-dance side by side, carrying thick branches of the cactus in their arms, roaring at the men who dance around them.

A man in the trance state of the camel, agitating the crowd from a cactus (filmstill)

The crowd moves on, and the spectator of the film is immersed in what the camera shows, now among the men and women on their way out of and then back to the village. The procession stops, and we watch male and female camels in need of "playing with each other." Playing cools them down, and eases the tension between them. The women kneel down, encircled by the men, who walk, or rather stalk, around them, bouncing up and down, their arms folded behind their backs, snapping at the women, who snatch back at them. The music stops and the air is filled with the howling and shrieking of the animal-spirits. The men challenge each other, dancing in line with a choreography that has been handed down to them by their fathers and forefathers, driven by the forces of the wilderness. They rub shoulders and let each other go again, they snap at the women and pause time and again: They kiss each other's cheeks and ask for forgiveness; they are exasperated in trance, acting and moving beyond the ordinary social norms of everyday life. At the same time, they are grateful for the mutual assistance to act out their *ḥāl* of divine possession, "cooling down" the "heat" that "rose" in them along with the spirit of the camel.

Film 1b: *The Blessing*, 1 min 2 sec
Gharb, 1992
Courtesy Muqaddim
Muḥammad Ṭawīl

The Blessing

Finally, the ritual comes to a halt. Time and again, a *fatḥa* is spoken, intercessions for the participants, and through the camera we are becoming part of the crowd, among whom *baraka* is distributed, the blessing of God and the founding saint, evoked by the sacred ritual techniques. First, the host-family and the donor of the *ṣadaqa*—the arrangement of the *līla* as charity agreeable to God—receives the blessings of the brotherhood; later, other attending adepts step forward and make an offering while somebody calls out loud the specific concern of the solicitant, a concern to be verbalized by the intercessor—someone may be sick, somebody might migrate soon, or somebody got lost on his way over the sea. "*God may ease things for you; he may restore your health and smoothen the path ahead; he may watch over your beloved one and guard her return,*" says the intercessor, and, together, the congregation affirms each prayer by rhythmically reciting a collective "*amīn.*" The suppliant turns the palms of his hands upsidedown in order to receive the blessing. Afterwards, he or she rubs the hands over his or her face and breast to disperse it over the body, while the members of the brotherhood sing verses that evoke God and the Prophet. We may be acquainted with these small poetic verses sung at family gatherings and in sacred contexts, or listen to these "sweet words" for the first time:

> *This is the house of the prophet, from which comes this cure.*
> *Drink a glass of milk and taste these sweets. There is no God but*
> *God, oh Lord cure us.*

The *fatḥa* opens for the participants the doors of this world and the next; it establishes a sacred space for the exchange of *baraka*. Translating this Arabic term as "divine blessing" is somewhat reductionist, since it covers a whole range of linked ideas specifying and delimiting this basic meaning. It may best be described as a whole complex of forces constituting, governing, and affecting the world in positive ways, inhering in persons, places, actions, or things. Its force, however, can also turn into a destructive power. The saints' *baraka* (in Arabic: *walī/awliyā' allah*), for example, may strike the devotee if they fail to meet certain demands, not unlike the saints at the northern shore of the Mediterranean, who generally help, but may harm at times, striking the believer with their wrath, or simply by overpowering the devotee. *Baraka* is a force, but materializes in the body techniques of the trance dancers driven by their camel-spirits onto the cactus plants, and into the sacred play of male and female. Through mastering their affliction and the painful contact with the wilderness, they establish the divine power that brings about *al-khiyār*. This goodness can be distributed in intercessions and literally rubbed off through material contact, stretching out over all aspects of life, and turning into a blessing for all. In the course of the ritual it tames malevolent spirits, and domesticates the wilderness both outside and within the human realm.

*The ritual congregation is animated by an 'Isāwi imitating
the stalking moves of the camel-spirit*
Photo: Martin Zillinger, 2008

The Lion- and Jackal-Trance

Film 1c: *The Lion- and
Jackal-Trance*, 7 min 7 sec
Gharb, 1992
Courtesy Muqaddim
Muḥammad Ṭawīl

The congregation, however, is divided—whereas some adepts adhere
to the *ḥāl* of the camels, others enact the *ḥāl* of the lions. When the heat
rises, they do not go for the *hindīa*, but for a sheep, slaughtered and
immediately torn apart by the lions and lionesses. Even though both
engage in this *frīsa* (literally tearing apart), it is the male lion who en-
ters the body of the sheep first with his fingers, breaking through the
skin and tearing it apart. He then rips out the liver, where the power
resides, and hands it over to the women. Often, however, the sight of
blood and the slaughtered animal escalates the trance-states of the at-
tending lionesses, and some women try to get away with its body, the
heat inside them becoming paramount, driving them away from the
ritual assembly. Other members of the congregation take care of them
and try to calm them, and their *ḥāl*. Returning to the general crowd,
their tension is declining through contact with the sheep, and the taste
of its blood, liver, and the common trancing in time.

Upon return, male and female counterparts engage in a common
trance choreography. The women, their clothes still stained with blood,
kneel down, hiss, and bawl at the men, their hands crossed and their
arms ready to strike the approaching male counterparts. The lions line
up and approach the women with swaying steps. Suddenly, a jackal
approaches and kneels down in between them. The lions encircle him,
and tension rises. They have to get him down, but if they are not mas-
ters of their *ḥāl*, the jackal will bite them and will not let them go with-
out a violent battle. Therefore, one of the experienced dancers needs to
grasp his nose and bend him down. Now it is the jackal who fears the
confrontation. He lies down and feigns death. The lions pull back his
shirt and check if there is any "life" in him—if they feel his abdomen
move or any respiration, they will tear him apart as they tore apart the
sheep, or so it is said. Fitfully roaring and howling, they dance around
the jackal, who dares not to move. The female lions try to get hold of

the dancing men, but the latter are careful not to come too close. A second jackal mounts the first, and, head-to-toes, they embrace each other, protect each other from the lions' examination. They need to trick them and take the air at precisely those moments they are turned around by the searching hands of the lions. Then, quickly, they roll over to the lionesses for protection. The latter push the jackals through their legs and behind their backs, roaring at the lions, bringing them out of sight.

A jackal feigning death (filmstill)

The entire village seems to be on its feet watching the social drama unfold, and we, the viewers of the film, family members in places far away from their village in Morocco, the adepts of the brotherhood who could not take part in the ritual, or strangers encountering these ritual techniques and the unfamiliar experience of estrangement for the first time, join in via the camera.

Time and again, the women bystanders chant and praise the Prophet, the forefather of all Muslims, in whose sign they assemble and enact their social relations, taken over by spirits and forced into the heat of the trance. The sheik of the lions takes care of his followers, releases exhausted men and women from the course of the choreography, kissing his or her forehead, and entrusts them in the care of the assembly.

Time and again, the men line up, stamping the earth, and rushing towards the women, jumping, slapping the ground and trying to unveil them. The women, in turn, protect their respectability and defend themselves, trying to strike the lions, who, moreover, engage in mock-

fighting among themselves. Once every spirit is tamed and the heat of the trance cooled, the assembly returns to the homestead of the host, trying to rest, while tea is served for refreshment. The *hellāla* begin to lament the power of death, and to remember the beloved ones, those whose voices remain unheard, and whose bodies remain unmoved during this year's convention.

On Being a Jackal...

Film 2: *On Being a Jackal,* 7 min 46 sec
© Anja Dreschke, Erhard Schüttpelz, Martin Zillinger, 2010

Talking to the 'Isāwa about the jackal, the interlocutors usually start laughing and explain that he is always ready to play tricks, that he "does sketch." This French expression relates to his habit of stealing things from attendees and hosts, mocking them when they want to redeem what is theirs. He is long known to wear a hat full of electric bulbs during processions "to make the spectators laugh." But be aware, the jackal is feared for his ambiguous character. The well known *"horreur du noir,"* the aversion to everything black among the lions, which often results in attacks on black-vested bystanders, is developed furthest, it seems, among the jackals, who perform the most violent attacks and the fiercest beating against anybody who dares to show marks of blackness—be it on their clothes, their shoes, or their cameras.

A jackal performing "folklore" heads an urban congregation of the 'Isāwa. Procession in front of the king on the occasion of the Prophet's birthday, 2006 (filmstill). Note his hat with the electric bulbs. Courtesy Muqaddim Abdelhāq al-'Awād.

Somewhat a buffoon, however, the jackal even used to mimic Koranic teachers and seers who pretend to have special knowledge of the other world. Equipped with a pen, so we are informed from early reports, they used to offer their services to bystanders, speaking unintelligibly while examining their palms and uttering some religious formula. Whereas the adepts of the camel- and lion-trance build what observers called clans, the jackals used to be go-betweens. During public feasts, they visited the different 'Isāwa congregations while hiding from the li-

1 René Brunel, *Essai sur la Confrérie Religieuse des 'Aissaoua au Maroc* (Paris: Geuthner, 1926).

ons, who jealously guard their wards.[1] However, until today, the most striking feature of the jackal's action concerns the sacrifice.

A *voleur sacré*, it is the jackal who takes off to "steal" a sheep from the host of the *līla,* and to provide it to the lions for the *frīsa.* Even though the jackals may be furious enough to tear the sheep apart, they never partake in gorging its liver or swallowing its blood. And it is by watching the jackal mingling fearlessly with the powerful lions that his trickster-like character is revealed to the spectator. First of all, he allegorizes the act of domestication by serving the lion the sacrificial lamb, an important element in "cooling them down." Furthermore, he has the guts to present himself as a potential victim/sacrifice, and is ready to outwit the lions, who are eager to tear everything living apart. Feigning death, he overcomes the deadly danger, while the lioness tries to get hold of and save him. Finally, it is through them that the women, representing the domestic domain, dominate the scene in the end. Even though the lions may be successful in unveiling them—robbing them of the most visible sign of domesticated sexuality—they deprive them of their sacrifice, they fight for and finally save their common "child."

In classical anthropological terms, the trance-choreography of the 'Isāwa does evoke tensions and contradictions that lie at the heart of human socialization. The staging of the trance-states and their trans-formation into a ritual choreography aims at embodying processes of domestication. Animal spirits and forces of the wilderness are tamed; tensions between the male personas and between male and female are overcome. Within the manifold actions, several transgressions take place while the ritual unfolds: crossing the divide of culture (village/man) and nature (outside the village/animals), the mingling of male and female, the empowerment of the women vis-à-vis their male counter-parts when the lionesses go after the sacrificed sheep, or when they save the jackal, or the undermining of otherwise sanctified values and ordi-nary rules of behavior (the religious ban on ingesting blood, the veiling of women, the ideally self-determined behavior of men). The mimetic enactment of natural and social forces creates a reality that resembles social experiences, and makes them recognizable in what I like to call a public choreography. Even though the moves of the dancers and those possessed by spirits are far from being thoroughly predetermined, the spatial movements of the participants follow a certain pattern enacted in every ritual. Through them, the moving and unpredictable spiritual forces are transferred into a ritual order, and thus domesticated.

In many ways, the ritual is evocative of other sacred plays in Mo-rocco, during which the spectators on the spot—or the viewers of the film—encounter a kind of re-staging and re-framing of the Islamic sac-rifice, the al-'Id al-Aḍḥā. Every year, Muslims all over the world par-take in this major religious feast, during which—at least ideally—the head of every household ritually slaughters an animal. Only a little later, in some local plays, the values sanctified by the ritual are mocked and ordinary conventions transgressed. It seems as if the sanctifica-tion of power and gender relations—enforced during the staging of the "ideal" Abrahamic ritual during the 'Id—is paradoxically mediated and enacted in its transgression, or so a possible interpretation of the 'Isāwa-rituals might conclude along these lines.[2]

2 Cf. Hammoudi, Abdellah, *The Victim and Its Masks: An Es-say on Sacrifice and Masquerade in the Maghreb* (Chicago: Uni-versity of Chicago Press, 1993). [French orig., 1988]

...and the Experience of Otherness

But beyond every possible interpretation remains the experience of otherness. This "otherness" can be translated into and instrumental-ized as "Othering" by modernists, so-called religious fundamentalists, anthropologists or culturalists, all of whom may essentialize, disavow, and display these practices as archaic, heretic, or as "culture," be it one's own or another. However, the experience of trance is basical-ly an experience of estrangement. In the course of dissociation, the possessed person experiences the source of his or her perception and agency as something other than him or herself—an "other" that takes form in and through them. It would be misleading to discard the ac-tors' knowledge and to call this experience an erroneous belief or a misconception. The German anthropologist Fritz Kramer reconsiders the outmoded concept of *passiones* in order to grasp the modus of "be-ing acted."[3] Unlike the term "passion," *passiones* connotes the inver-sion of agency in relation to the human self. He considers the spirits to be the "images" of the *passiones* they invoke. The spirit, then, be-comes manifest during the experience of "being moved" or "captured" and it takes form, or becomes an image, in the body movement of the trance dancer. It is this so-perceived "other" that forces its medium into action—an action that generates resemblance. In a psychologized reading, this mimetic performance may enact subjective experiences of crisis and deviance; but far from being merely a subjective and idiosyn-cratic state, the *passiones* are established in and through an "image" brought about by a force in its own right: the spirit, wind, or *ḥāl*, or whatever you want to call it.

3 Fritz W Kramer, *The Red Fez: Art and Spirit Possession in Africa* (London: Verso, 1993). [German orig., 1987]

Migration, the Experience of Loss and Passionate Ritual Networks

Film 3: *The Lion-Trance in the City*, 8 min 58 sec, 2003 Courtesy Muqaddim Hāmid Buhlāl

Many people of the western plain live with and through migration. Since the times of the French "Protectorate," they have moved to the cities in order to make a living. They brought with them their rituals and closely-knit ritual networks, which provided help and a sense of intimacy—not only in the shanty-towns they have since built and re-built into urban districts. These ritual ties also secured enduring relations between their new place of settlement and their families in the countryside. Even though the ritual activities have diversified, the young generation of today especially has started to mingle with the rather fancy traditions of the urban brotherhoods; their common origin (*al-aṣl*) in the villages and homesteads of the western plain continues to provide them with enduring social ties and economic networks. The number of congregations may have di-minished, but the density of the ritual networks is still remarkable. For ritual occasions, guests are invited from the cities as much as from the villages and homesteads, and also the brotherhoods—that is, the musicians and particularly experienced trance dancers—are composed of members from the country and the city alike. How-ever, without doubt, the relationships of mutual indebtedness, char-acteristic of Moroccan social life, are overextending in the course of migration within and beyond Morocco. It is in the rituals of the

'Isāwa and at their sacred places that the social relations "re-contract" in many ways.

If at all possible, relatives in Europe are informed about ritual gatherings in advance and may try to join, if only by a telephone call. This way, adepts from all places continue "to meet" by means of the mobile phone at the rituals.

During a ritual, a hellāl recites verses for an 'Isāwi living abroad
Photo: Anja Dreschke, 2008

Often, family members or spiritual kin finance ritual gatherings, donate sacrificial animals, new banners for the congregation or the recording of the sacred play. The *hellāla* continue to sing about the experience of loss and alienation; loud and penetrating, they recite poetic verses that deal with individual sorrow and collective experiences. In most cases, they know their fellow mourners and their families, and how to put their feelings into words. Often, the attendees start to weep as soon as they hear the first verses, words they have shared with their beloved ones from early on, evoking the presence of those who left, and conceptualizing the grief of those who remain:

> *Come here, my brother Mūsa*
> *So I can tell you what hurts inside my heart*
> *Look up, oh Aiša, my mother*
> *And see what is happening to me*
> *Where shall I begin, with me or my children*
> *My children's fate torments me, who will carry it?*
> *This burden falls to me*

These lines are "called" out to the participants, who have a dead person to lament, but other participants may also find their emotions and losses expressed in them. Most importantly, these are words that speak directly to the body, in which everything is made to flow, wa-

ter from the eyes, nose, and mouth. A second caller stands up and starts to sing:

Baba, baba, Sīdī Baba [an invocation of the saint]
Let me weep and I will never stop
My heart is full, to whom can I turn to pour it out?
I am afraid to tell this; I will be reviled
My enemies are just waiting to see me in such a state

The singer lets his head hang and throws his body to and fro, people wail and cry out as the two *hellāla* continue to shout lamenting verses into the room. Some of the listeners are "beaten" by the *hāl*, and along with the lion's spirit, the heat rises in their bodies. The city dwellers watch the sacred practices unfold in their midst while the lion-dancers find their way into the trance choreography. The female lions help them to enact and satisfy their spirits by kneeling down, trancing, and also the jackal enters the scene and offers himself as sacrifice in the *salon* of the host.

The "lions" are about to "attack" the "lionesses" in a ritual celebrated among city-dwellers (filmstill).

Mediation and Mediatization

Mediation, of course, is what a trance-ritual is about. And it is the relation of (personal) mediums and (technical) media that is increasingly taken as the starting point by scholars of religion to think about religious mediation in the age of globalization, mass media, and the circulation of so-called small media.

Since the shooting of the rural ritual in 1992, the 'Isāwa and other Sufi congregations in Morocco have increasingly used cameras in their rituals. The recordings serve as memorabilia, and are integrated into

personal archives of the adepts. Moreover, through the recording, the trance dancers are able to consciously observe the spirits as they take form in their bodies. Especially remarkable events can be recalled, and the experience of "communitas" during the ritual reconstructed. Deceased and migrated members of the congregation are remembered, and social relations reconsidered.

The spectacular entry of an 'Isāwa congregation gets filmed at a ritual
Photo: Martin Zillinger, 2008

Among their various applications, technical media are especially used to maintain the transnational networks of the 'Isāwa. People who are absent are made present during the ritual by the use of mobile phones or the video cameras that tape the ritual for them. Secondly, the media-products, that is, CDs and DVDs, are circulated among the adepts of the brotherhood. Media, therefore, are used to establish and foster social networks that are expanding all over the globe. The digitalization and the inexpensive possibility of replicating CDs and DVDs have created an intense exchange of these films among the adepts, even though the trajectories of their circulation and the publicity of the ritual activities remains—vis-à-vis modernists and religious reformists—a matter of concern. The ritual gatherings are held within clearly confined ritual networks; the invoked images, however, have a life of their own and can be shared beyond the circles of initiates. The mediatization serves to integrate people inhabiting different social worlds and to extend the ritual networks and spaces of engagement for the brotherhoods.

To be sure, the event of "being moved" integrates all kinds of media. Among them, the body is man's first and most natural technical object that is adapted to its use, as we have learned from Marcel Mauss long ago.[4] Among all kinds of techniques and media, the 'Isāwa, too, make use of a whole ensemble of techniques of the body to mediate and integrate "other" forces and actors with different backgrounds and at different places.

These socio-technical operations translate and stabilize the reli-

4 Marcel Mauss, "Les techniques du corps," in *Journal de psychologie* 32: 271-93 (1935). Reprinted in English in Marcel Mauss, *Techniques, Technology, and Civilization*, ed. Nathan Schlanger (Oxford: Berghahn, 2006), 77–96.

gious contexts through time and space, and structure religious publics in transnational networks of cooperation. The ritual actions create "other spaces" in which the spirits are invoked, and their images enacted and banished. But while the participants mediatize, archive, and share them, they encapsulate the images to a certain extent from the very event of its creation. Like art, the repetitive character of these ritual performances creates and mediates experiences and perceptions that open up a space of interpretation and movement, beyond narrowly conceived and authoritative readings. What remains is an experience of alterity encoded in ritual operations and re-coded in films (and, sometimes, texts)—produced and circulated among the dancers, the spectators on the spot and the viewers of their recording.

Whereas Islamic reformists try to invoke their own media-technical superiority by reinventing "proper" Islam, and fighting local traditions through recourse to the sacred texts, some 'Isāwa have started to defend their practices by claiming the superiority of sensuous knowledge brought about and confirmed by the first and most natural medium, the body. As an interlocutor once put it: "They say there is no *baraka* in the Sufi path we follow. But can they climb the cactuses or eat their leaves?" With their body techniques, therefore, the 'Isāwa are conscious of disposing of the "necessarily biological means of entering into communication with God," to cite Marcel Mauss once more.

It is a wonderful gift of the two congregations of the 'Isāwa and their principals to partake in this exhibition, which reconsiders what colonial observers called animism. During the colonial conquest, this concept served to devalue other knowledge and other techniques of mediation as inferior. Through a secularized conceptualization of these techniques as supposedly superstitious "magic," the superiority of European strategies to cope with estrangement was claimed. Watching the 'Isāwa in their ritual activities, we come to understand that these enlightened discourses are just another means to banish, domesticate, and subjugate other forces, experienced, but only poorly understood as an experience of otherness made by others. By sharing the museum as one of the few spaces left for non-teleological thinking and acting in the West, the enduring claim to superiority must be—and indeed gets—inverted. Through their films, we, the viewers, partake in their ritual activities, which bring about, affirm and do justice to an aspect of human experience that has come under siege by modernizers and their work of purification. The rituals remind the adepts, spectators, and viewers of who we are—men and women subject to manifold experiences of estrangement, moved and acted upon throughout the course of our life.

Special Thanks to 'Abdelhāq al-'Awād, Aḥmad A'anūnī, Laḥcen Bu'atīya, Hajj Mahǧūb, Muqaddim Hāmid Buhlāl, Muqaddim Muḥammad Ṭawīl, and the 'Isāwa diel ġarb.

Exchanging Perspectives

The Transformation of Objects into Subjects in Amerindian Ontologies

Eduardo Viveiros de Castro[1]

1 Eduardo Viveiros de Castro, "Exchanging Perspectives: The Transformation of Objects into Subjects in Amerindian Ontologies," in *Common Knowledge*, vol. 10, no. 3, 463–484.

2 Hypotheses that I have offered previously ("Cosmological Deixis and Amerindian Perspectivism," *Journal of the Royal Anthropological Institute*, n.s., 4.3 [1998]: 469–88.) are rehearsed here since they ground the argument of this article. I gave an early version of the present paper, in English, at the Chicago meeting of the American Anthropological Association in November 1999, and that version was subsequently published in Italian as "La transformazione degli ogetti in sogetti nelle ontologie amerindiane," *Etnosistemi* 7.7 (2000): 47–58. The title of that paper (a version of which is the subtitle of this essay) pays homage to Nancy Munn, "The Transformation of Subjects into Objects in Walbiri and Pitjantjara Myth," in *Australian Aboriginal Anthropology*, ed. Ronald M. Berndt (Nedlands: University of Western Australia Press, 1970).

My subject is the cosmological setting of an indigenous Amazonian model of the self.[2] I will examine two major contexts, shamanism and warfare, in which "self" and "other" develop especially complex relations. Shamanism deals with the relation between humans and non-humans; and in warfare, a human other, an "enemy," is used to bring a "self" into existence. I will deliberately use a set of traditional dichotomies (I mean, in the tradition of modernity) as both heuristic instruments and foils: nature/culture, subject/object, production/exchange, and so forth. This very crude technique for setting off the distinctive features of Amazonian cosmologies carries the obvious risk of distortion, since it is unlikely that any non-modern cosmology can be adequately described either by means of such conceptual polarities or as a simple negation of them (as if the only point of a non-modern cosmology were to stand in opposition to our oppositions). But the technique does have the advantage of showing how unstable and problematic those polarities can be made to appear, once they have been forced to bear "unnatural" interpretations and unexpected rearrangements.

Perspectival Multinaturalism

If there is one virtually universal Amerindian notion, it is that of an original state of non-differentiation between humans and animals, as described in mythology. Myths are filled with beings whose form, name, and behavior inextricably mix human and animal attributes in a common context of intercommunicability, identical to that which defines the present-day intra-human world. Amerindian myths speak of a state of being where self and other interpenetrate, submerged in the same immanent, pre-subjective and pre-objective milieu, the end of which is precisely what the mythology sets out to tell. This end is, of course, the well-known separation of "culture" and "nature"—of human and nonhuman—that Claude Lévi-Strauss has shown to be the central theme of Amerindian mythology and which he deems to be a cultural universal.[3]

3 Claude Lévi-Strauss, *Mythologiques*, 4 vols., (Paris: Plon, 1964–71).

 In some respects, the Amerindian separation between humans and animals may be seen as an analogue of our "nature/culture" distinction; there is, however, at least one crucial difference between the Amerindian and modern, popular Western versions. In the former case, the separation was not brought about by a process of differentiating the human from the animal, as in our own evolutionist "scientific" mythology. For Amazonian peoples, the original common condition of both humans and animals is not animality but, rather, humanity. The

great separation reveals not so much culture distinguishing itself from nature as nature distancing itself from culture: the myths tell how animals lost the qualities inherited or retained by humans. Humans are those who continue as they have always been. Animals are ex-humans (rather than humans, ex-animals). In some cases, humankind is the substance of the primordial plenum or the original form of virtually everything, not just animals. As Gerald Weiss puts it:

> "Campa mythology is largely the story of how, one by one, the primal Campa became irreversibly transformed into the first representatives of various species of animals and plants, as well as astronomical bodies or features of the terrain. ... The development of the universe, then, has been primarily a process of diversification, with mankind as the primal substance out of which many if not all of the categories of beings and things in the universe arose, the Campa of today being the descendants of those ancestral Campa who escaped being transformed."[4]

4 Gerald Weiss, "Campa Cosmology," *Ethnology* 11.2 (April 1972): 169–70.

The fact that many "natural" species or entities were originally human has important consequences for the present-day state of the world. While our folk anthropology holds that humans have an original animal nature that must be coped with by culture—having been wholly animals, we remain animals "at bottom"—Amerindian thought holds that, having been human, animals must still be human, albeit in an unapparent way. Thus, many animal species, as well as sundry other types of non-human beings, are supposed to have a spiritual component that qualifies them as "people." Such a notion is often associated with the idea that the manifest bodily form of each species is an envelope (a "clothing") that conceals an internal humanoid form, usually visible to the eyes of only the particular species and of "transspecific" beings such as shamans. This internal form is the soul or spirit of the animal: an intentionality or subjectivity formally identical to human consciousness. If we conceive of humans as somehow composed of a cultural clothing that hides and controls an essentially animal nature, Amazonians have it the other way around: animals have a human, sociocultural inner aspect that is "disguised" by an ostensibly bestial bodily form.

Another important consequence of having animals and other types of non-humans conceived as people—as kinds of humans—is that the relations between the human species and most of what we would call "nature" take on the quality of what we would term "social relations." Thus, categories of relationship and modes of interaction prevailing in the intra-human world are also in force in most contexts in which humans and non-humans confront each other. Cultivated plants may be conceived as blood relatives of the women who tend them, game animals may be approached by hunters as affines, shamans may relate to animal and plant spirits as associates or enemies.

Having been people, animals and other species continue to be people behind their everyday appearance. This idea is part of an indigenous theory according to which the different sorts of persons—human and non-human (animals, spirits, the dead, denizens of other cosmic layers, plants, occasionally even objects and artifacts)—apprehend reality from distinct points of view. The way that humans perceive animals and other subjectivities that inhabit the world differs profoundly from

the way in which these beings see humans (and see themselves). Under normal conditions, humans see humans as humans; they see animals as animals, plants as plants. As for spirits, to see these usually invisible beings is a sure sign that conditions are not normal. On the other hand, animals (predators) and spirits see humans as animals (as game or prey) to the same extent that game animals see humans as spirits or as predator animals. By the same token, animals and spirits see themselves as humans: they perceive themselves as (or they become) anthropomorphic beings when they are in their own houses or villages; and, most important, they experience their own habits and characteristics in the form of culture. Animals see their food as human food (jaguars see blood as manioc beer, vultures see the maggots in rotting meat as grilled fish); they see their bodily attributes (fur, feathers, claws, beaks) as body decorations or cultural instruments; they see their social system as organized in the same way as human institutions are (with chiefs, shamans, ceremonies, exogamous moieties, and whatnot).

The contrast with our conceptions in the modern West is, again, only too clear. Such divergence invites us to imagine an ontology I have called "multinaturalist" so as to set it off from modern "multiculturalist" ontologies.[5] Where the latter are founded on the mutually implied unity of nature and multiplicity of cultures—the former guaranteed by the objective universality of body and substance, the latter generated by the subjective particularity of spirit and meaning—the Amerindian conception presumes a spiritual unity and a corporeal diversity. For them, culture or the subject is the form of the universal, while nature or the object is the form of the particular.

To say that humanity is the original common condition of humans and non-humans alike is tantamount to saying that the soul or spirit—the subjective aspect of being—is the universal, unconditioned given (since the souls of all non-humans are humanlike), while objective bodily nature takes on an a posteriori, particular, and conditioned quality. In this connection, it is also worth noticing that the notion of matter as a universal substrate seems wholly absent from Amazonian ontologies.[6] Reflexive selfhood, not material objectivity, is the potential common ground of being.

To say, then, that animals and spirits are people is to say that they are persons; and to personify them is to attribute to non-humans the capacities of conscious intentionality and social agency that define the position of the subject.[7] Such capacities are reified in the soul or spirit with which these non-humans are endowed. Whatever possesses a soul is capable of having a point of view, and every being to whom a point of view is attributed is a subject; or better, wherever there is a point of view, there is a "subject position." Our constructionist epistemology can be summed up in the Saussurean (and very Kantian) formula, "the point of view creates the object."[8] The subject, in other words, is the original, fixed condition whence the point of view emanates (the subject creates the point of view). Whereas Amerindian perspectival ontology proceeds as though *the point of view creates the subject*: whatever is activated or "agented" by the point of view will be a subject.

The attribution of humanlike consciousness and intentionality (to say nothing of human bodily form and cultural habits) to non-human beings has been indiscriminately termed "anthropocentrism" or "anthropomorphism." However, these two labels can be taken to denote

5 See Eduardo Viveiros de Castro, "Cosmological Deixis." For a generalization of the notion of "multinaturalism," see Bruno Latour, *Politiques de la nature* (Paris: La Découverte, 1999), and, of course, his contribution to this symposium.

6 But see Anne Osborn, "Comer y ser comido: Los animales en la tradicion oral U'wa (tunebo)," *Boletin del Museo del Oro* 26 (1990): 13–41.

7 Animals and other non-humans are subjects not because they are human (humans in disguise); rather, they are human because they are subjects (potential subjects).

8 Ferdinand de Saussure, *Cours de linguistique générale* [1916] (Paris: Payot, 1981), 23.

radically opposed cosmological perspectives. Western popular evolutionism, for instance, is thoroughly anthropocentric but not particularly anthropomorphic. On the other hand, animism may be characterized as anthropomorphic but definitely not as anthropocentric: if sundry other beings besides humans are "human," then we humans are not a special lot (so much for "primitive narcissism").

Karl Marx wrote of man, meaning *Homo sapiens*:

> "In creating an objective world by his practical activity, in working-up inorganic nature, man proves himself a conscious species being. ... Admittedly animals also produce. ... But an animal only produces what it immediately needs for itself or its young. It produces one-sidedly, while man produces universally... An animal produces only itself, whilst man reproduces the whole of nature. ... An animal forms things in accordance with the standard and the need of the species to which it belongs, whilst man knows how to produce in accordance to the standards of other species.[9]

9 Karl Marx, *Economic and Philosophic Manuscripts of 1844* (Moscow: Foreign Languages Publishing House, 1961), 75–76.

Talk about primitive narcissism. ... Whatever Marx meant by the proposition that man "produces universally," I fancy he was saying something to the effect that man is the universal animal: an intriguing idea. (If man is the universal animal, then perhaps each animal species would be a particular kind of humanity?) While apparently converging with the Amerindian notion that humanity is the universal form of the subject, Marx's is in fact an absolute inversion of the notion. Marx is saying that humans can be any animal (we have more "being" than any other species), while Amerindians say that any animal can be human (there is more "being" to an animal than meets the eye). Man is the universal animal in two entirely different senses, then: the universality is anthropocentric for Marx; anthropomorphic, for Amerindians.

The Subjectification of Objects

Much of the Amerindians' practical engagement with the world presupposes that present-day non-human beings have a spiritual, invisible, prosopomorphic side. That supposition is foregrounded in the context of shamanism. By shamanism, I mean the capacity evinced by some individuals to cross ontological boundaries deliberately and adopt the perspective of non-human subjectivities in order to administer the relations between humans and non-humans. Being able to see non-humans as they see themselves (they see themselves as humans), shamans are able to take on the role of active interlocutors in transspecific dialogues and are capable (unlike lay persons) of returning to tell the tale. If a human who is not a shaman happens to see a non-human (an animal, a dead human soul, a spirit) in human form, he or she runs the risk of being overpowered by the non-human subjectivity, of passing over to its side and being transformed into an animal, a dead human, a spirit. A meeting or exchange of perspectives is, in brief, a dangerous business.

Shamanism is a form of acting that presupposes a mode of knowing, a particular ideal of knowledge. That ideal is, in many respects, the exact opposite of the objectivist folk epistemology of our tradition. In

10 See especially Philippe Descola, "Constructing Natures: Symbolic Ecology and Social Practice," in *Nature and Society: Anthropological Perspectives*, ed. Descola and Gísli Pálsson (London: Routledge, 1996), 82–102; and Nurit Bird-David, "'Animism' Revisited: Personhood, Environment, and Relational Epistemology," *Current Anthropology* 40, supp. (February 1999): 67–91.

11 See Pascal Boyer, "What Makes Anthropomorphism Natural: Intuitive Ontology and Cultural Representations," *Journal of the Royal Anthropological Institute*, n.s., 2.1 (March 1996): 83–97; and Stewart Guthrie, *Faces in the Clouds: A New Theory of Religion* (New York: Oxford University Press, 1993).

12 "The same convention requires that the objects of interpretation—human or not—become understood as other persons; indeed, the very act of interpretation presupposes the personhood of what is being interpreted. ... What one thus encounters in making interpretations are always counter-interpretations." Marilyn Strathern, *Property, Substance, and Effect: Anthropological Essays on Persons and Things* (London: Athlone, 1999), 239.

13 Alfred Gell, *Art and Agency: An Anthropological Theory* (Oxford: Clarendon, 1998).

14 I am referring here to Daniel Dennett's idea of *n*-order intentional systems: a second-order intentional system is one to which the observer must ascribe not only beliefs, desires, and other intentions, but beliefs (etc.) *about* other beliefs (etc.). The standard cognitive thesis holds that only humans exhibit second or higher-order intentionality. My shamanistic "principle of abduction of a maximum of agency" runs afoul of the creed of physicalist psychology: "Psychologists have often appealed to a principle known as Lloyd Morgan's Canon of Parsimony, which can be viewed as a special case of Occam's Razor: it is the principle that one should attribute to an organism as little intelligence or consciousness or rationality or mind as will suffice to account for its behaviour." Daniel Dennett, *Brainstorms: Philosophical Essays on Mind and Psychology* (Harmondsworth, U.K.: Penguin, 1978), 274.

the latter, the category of the object supplies the telos: to know is to objectify—that is, to be able to distinguish what is inherent to the object from what belongs to the knowing subject and has been unduly (or inevitably) projected into the object. To know, then, is to *desubjectify*, to make explicit the subject's partial presence in the object so as to reduce it to an ideal minimum. In objectivist epistemology, subjects as much as objects are seen as the result of a process of objectification. The subject constitutes/recognizes itself in the objects it produces, and the subject knows itself objectively when it comes to see itself from the outside as an "it." Objectification is the name of our game; what is not objectified remains unreal and abstract. The form of the other is *the thing*.

Amerindian shamanism is guided by the opposite ideal. To know is to personify, to take on the point of view of that which must be known. Shamanic knowledge aims at something that is a someone—another subject. The form of the other is *the person*. What I am defining here is what anthropologists of yore used to call animism, an attitude that is far more than an idle metaphysical tenet, for the attribution of souls to animals and other so-called natural beings entails a specific way of dealing with them. Being conscious subjects able to communicate with humans, these natural beings are able fully to reciprocate the intentional stance that humans adopt with respect to them.

Recently, there has been a new surge of interest in animism.[10] Cognitive anthropologists and psychologists have been arguing that animism is an "innate" cognitive attitude that has been naturally selected for its attention-grabbing potential and its practical predictive value.[11] I have no quarrel with these hypotheses. Whatever the grounds of its naturalness, however, animism can also be very much cultural—that is, animism can be put to systematic and deliberate use. We must observe that Amerindians do not spontaneously see animals and other non-humans as persons; the personhood or subjectivity of the latter is considered a nonevident aspect of them. It is necessary *to know how* to personify nonhumans, and it is necessary to personify them in *order to know*.[12]

Personification or subjectification implies that the "intentional stance" adopted with respect to the world has been in some way universalized. Instead of reducing intentionality to obtain a perfectly objective picture of the world, animism makes the inverse epistemological bet. True (shamanic) knowledge aims to reveal a maximum of intentionality or abduct a maximum of agency (here I am using Alfred Gell's vocabulary).[13] A good interpretation, then, would be one able to understand every *event* as in truth an *action*, an expression of intentional states or predicates of some subject. Interpretive success is directly proportional to the ordinal magnitude of intentionality that the knower is able to attribute to the known.[14] A thing or a state of affairs that is not amenable to subjectification—to determination of its social relation to the knower—is shamanistically uninteresting. Our objectivist epistemology follows the opposite course: it considers our commonsense intentional stance as just a shorthand that we use when the behavior of a target-object is too complicated to be broken down into elementary physical processes. An exhaustive scientific interpretation of the world would for us be able ideally to reduce every action to a chain of causal events and to reduce these events to materially dense interactions (with no "action at a distance").[15]

If in the naturalist view a subject is an insufficiently analyzed object, in the Amerindian animist cosmology the converse holds: *an object is an incompletely interpreted subject.* The object must either be "expanded" to a full-fledged subject—a spirit; an animal in its human, reflexive form—or else understood as related to a subject (as existing, in Gell's terms, "in the neighbourhood" of an agent). But an important qualification must now be made: Amerindian cosmologies do not as a rule attribute personhood (or the same degree of personhood) to each type of entity in the world. In the case of animals, for instance, the emphasis seems to be on those species that perform key symbolic and practical roles, such as the great predators and the principal species of prey for humans. Personhood and "perspectivity"—the capacity to occupy a point of view—is a question of degree and context rather than an absolute, diacritical property of particular species.

Still, despite this qualification, what cannot be conceived as a primary agent or subject in its own right must be traced up to one:

"Social agents" can be drawn from categories which are as different as chalk and cheese . . . because "social agency" is not defined in terms of "basic" biological attributes (such as inanimate thing vs. incarnate person) but is relational—it does not matter, in ascribing "social agent" status, what a thing (or a person) "is" in itself; what matters is where it stands in a network of social relations. All that may be necessary for stocks and stones to become "social agents"... is that there should be actual human persons/agents "in the neighbourhood" of these inert objects.[16]

Though there are Amazonian cosmologies that deny to post-mythical non-human species any spiritual dimension, the notion (widespread, as is well known, throughout the continent) of animal or plant "spirit masters" supplies the missing agency. These spirit masters, equipped with an intentionality fully equivalent to that of humans, function as hypostases of the species with which they are associated, thereby creating an intersubjective field for human/non-human relations even where empirical non-human species are not spiritualized. Moreover, the idea that non-human agents experience themselves and their behavior in the forms of (human) culture plays a crucial role: translating culture into the terms of alien subjectivities transforms many natural objects and events into indices from which social agency is derivable. The commonest case is that of defining what to humans is a brute fact or object as an artifact or cultured behavior: what is blood to us is manioc beer to jaguars, a muddy waterhole is seen by tapirs as a great ceremonial house. Artifacts have this interestingly ambiguous ontology. They are objects that necessarily point to a subject; as congealed actions, they are material embodiments of nonmaterial intentionality. What is nature to us may well be culture to another species.

Perspectivism Is Not Relativism

The idea of a world comprising a multiplicity of subject positions looks very much like a form of relativism. Or rather, relativism under its various definitions is often implied in the ethnographic characterization of Amerindian cosmologies. Take, for instance, the work of Kaj Århem, the ethnographer of the Makuna. Having described the elaborate per-

15 Cf. Lévi-Strauss, *La pensée sauvage* (Paris: Plon, 1962), 355: "La pensée sauvage est logique, dans le même sens et de la même façon que la nôtre, mais comme l'est seulement la nôtre quand elle s'applique à la connaissance d'un univers auquel elle reconnaît simultanément des propriétés physiques et des propriétés sémantiques."

16 Gell, *Art and Agency*, 123.

17 Kaj Århem, "Ecosofía Makuna," in *La selva humanizada: Ecología alternativa en el trópico húmedo colombiano*, ed. François Correa (Bogotá: Instituto Colombiano de Antropología; Fondo FEN Colombia; Fondo Editorial CEREC, 1993), 124.

spectival universe of this Tukanoan people of northwestern Amazonia, Århem observes that the notion of multiple viewpoints on reality implies that, as far as the Makuna are concerned, "every perspective is equally valid and true" and that "a correct and true representation of the world does not exist."[17] Århem is right, of course; but only in a sense. For one can reasonably surmise that as far as humans are concerned, the Makuna would say that there is indeed only one correct and true representation of the world. If *you* start seeing, for instance, the maggots in rotten meat as grilled fish, you may be sure that you are in deep trouble, but grilled fish they are from the *vultures'* point of view. Perspectives should be kept separate. Only shamans, who are so to speak species-androgynous, can make perspectives communicate, and then only under special, controlled conditions.

My real point, however, is best put as a question: does the Amerindian perspectivist theory posit, as Århem maintains that it does, a multiplicity of *representations* of the same world? It is sufficient to consider ethnographic evidence to see that the opposite is the case: all beings perceive ("represent") the world *in the same way*. What varies is the *world* that they see. Animals impose the same categories and values on reality as humans do—their worlds, like ours, revolve around hunting and fishing, cooking and fermented drinks, cross-cousins and war, initiation rituals, shamans, chiefs, spirits, and so forth. Being people in their own sphere, non-humans see things just *as* people do. But the things *that* they see are different. Again, what to us is blood is maize beer to the jaguar; what to us is soaking manioc is, to the souls of the dead, a rotting corpse; what is a muddy waterhole to us is for the tapirs a great ceremonial house.

Another good discussion of Amazonian "relativism" can be found in a study of the Matsiguenga by France-Marie Renard-Casevitz. Commenting on a myth in which the human protagonists travel to villages inhabited by strange people who call the snakes, bats, and balls of fire that they eat by the names of foods ("fish," "agouti," "macaws") appropriate for human consumption, she realizes that indigenous perspectivism is quite different from relativism. Yet she sees no special problem:

> "This setting in perspective [*mise en perspective*] is just the application and transposition of universal social practices, such as the fact that a mother and a father of X are the parents-in-law of Y. . . . This variability of the denomination as a function of the place occupied explains how A can be both fish for X and snake for Y.[18]

18 France-Marie Renard-Casevitz, *Le banquet masqué: Une mythologie de l'étranger chez les indiens Matsiguenga* (Paris: Lierre and Coudrier, 1991), 29.

But applying the positional relativity that obtains in social and cultural terms to the difference between species has a paradoxical consequence: Matsiguenga preferences are universalized and made absolute. A human culture is thus rendered natural—everybody eats fish and nobody eats snake.

Be that as it may, Casevitz's analogy between kinship positions and what counts as fish or snake for different species remains intriguing. Kinship terms are relational pointers; they belong to the class of nouns that define something in terms of its relations to something else (linguists have special names for such nouns—"two-place predicates" and such like). Concepts like fish or tree, on the other hand, are prop-

er, self-contained substantives: they are applied to an object by virtue of its intrinsic properties. Now, what seems to be happening in Amerindian perspectivism is that substances named by substantives like *fish*, *snake*, *hammock*, or *beer* are somehow used as if they were relational pointers, something halfway between a noun and a pronoun, a substantive and a deictic. (There is supposedly a difference between "natural kind" terms such as *fish* and "artifact" terms such as *hammock*: a subject worth more discussion later.) You are a father only because there is another person whose father you are. Fatherhood is a relation, while fishiness is an intrinsic property of fish. In Amerindian perspectivism, however, something is a fish only by virtue of someone else whose fish it is.

But if saying that crickets are the fish of the dead or that mud is the hammock of tapirs is like saying that my sister Isabel's son, Miguel, is my nephew, then there is no relativism involved. Isabel is not a mother "for" Miguel, from Miguel's "point of view" in the usual, relativist-subjectivist sense of the expression. Isabel is the mother *of* Miguel, she is really and objectively Miguel's mother, just as I am really Miguel's uncle. This is a genitive, internal relation (my sister is the mother of someone, our cricket the fish of someone) and not a representational, external connection of the type "X is fish for someone," which implies that X is "represented" as fish, whatever X is "in itself." It would be absurd to say that, since Miguel is the son of Isabel but not mine, then Miguel is not a son "for me"—for indeed he is. He is my sister's son, precisely.

Now imagine that all Amerindian substances were of this sort. Suppose that, as siblings are those who have the same parents, conspecifics are those that have the same fish, the same snake, the same hammock, and so forth. No wonder, then, that animals are so often conceived, in Amazonia, as affinely related to humans. Blood is to humans as manioc beer is to jaguars in exactly the way that my sister is the wife of my brother-in-law. The many Amerindian myths featuring interspecific marriages and discussing the difficult relationships between the human (or animal) in-marrying affine and his or her animal (or human) parents-in-law, simply compound the two analogies into a single complex one. We begin to see how perspectivism may have a deep connection with exchange—not only how it may be a type of exchange, but how any exchange is by definition an exchange of perspectives.[19]

We would thus have a universe that is 100 percent relational—a universe in which there would be no distinctions between primary and secondary qualities of substances or between "brute facts" and "institutional facts." This distinction, championed by John Searle, opposes brute facts or objects, the reality of which is independent of human consciousness (gravity, mountains, trees, animals, and all "natural kinds") to institutional facts or objects (marriage, money, axes, and cars) that derive their existence, identity, and efficacy from the culturally specific meanings given them by humans.[20] In this overhauled version of the nature/culture dualism, the terms of cultural relativism apply only to cultural objects and are balanced by the terms of natural universalism, which apply to natural objects. Searle would argue, I suppose, that what I am saying is that for Amerindians all facts are of the institutional, mental variety, and that all objects, even trees and

19 See Strathern, *The Gender of the Gift: Problems with Women and Problems with Society in Melanesia* (Berkeley: University of California Press, 1988) and "Writing Societies, Writing Persons," *History of the Human Sciences* 5.1 (February 1992): 5–16.

20 John Searle, *The Construction of Social Reality* (London: Allen Lane, 1995).

fish, are like money or hammocks, in that their only reality (as money and hammocks, not as pieces of paper or of string) derives from the meanings and uses that subjects attribute to them. This would be nothing but relativism, Searle would observe—and an absolute form of relativism at that.

An implication of Amerindian perspectivist animism is, indeed, that there are no autonomous, natural facts, for what we see as nature is seen by other species as culture (as institutional facts). What humans see as blood, a natural substance, is seen by jaguars as manioc beer, an artifact. But such institutional facts are taken to be universal, culturally invariable (an impossibility according to Searle). Constructionist relativism defines all facts as institutional and thus culturally variable. We have here a case not of relativism but universalism—cultural universalism—that has as its complement what has been called "natural relativism."[21] And it is this inversion of our usual pairing of nature with the universal and culture with the particular that I have been terming "perspectivism."

21 See Latour, *Nous n'avons jamais été modernes* (Paris: LaDécouverte, 1991), 144.

Cultural (multicultural) relativism supposes a diversity of subjective and partial representations, each striving to grasp an external and unified nature, which remains perfectly indifferent to those representations. Amerindian thought proposes the opposite: a representational or phenomenological unity that is purely pronominal or deictic, indifferently applied to a radically objective diversity. One culture, multiple natures—one epistemology, multiple ontologies. Perspectivism implies multinaturalism, for a perspective is not a representation. A perspective is not a representation because representations are a property of the mind or spirit, whereas the point of view is located in the body. The ability to adopt a point of view is undoubtedly a power of the soul, and non-humans are subjects in so far as they have (or are) spirit; but the differences between viewpoints (and a viewpoint is nothing if not a difference) lies not in the soul. Since the soul is formally identical in all species, it can only perceive the same things everywhere. The difference is given in the specificity of bodies.

This formulation permits me to provide answers to a couple of questions that may have already occurred to my readers. If non-humans are persons and have souls, then what distinguishes them from humans? And why, being people, do they not regard us as people?

Animals see in the *same* way as we do *different* things because their bodies differ from ours. I am not referring to physiological differences—Amerindians recognize a basic uniformity of bodies—but rather to *affects*, in the old sense of dispositions or capacities that render the body of each species unique: what it eats, how it moves, how it communicates, where it lives, whether it is gregarious or solitary. The visible shape of the body is a powerful sign of these affectual differences, although the shape can be deceptive, since a human appearance could, for example, be concealing a jaguar affect. Thus, what I call "body" is not a synonym for distinctive substance or fixed shape; body is in this sense an assemblage of affects or ways of being that constitute a *habitus*. Between the formal subjectivity of souls and the substantial materiality of organisms, there is thus an intermediate plane occupied by the body as a bundle of affects and capacities. And the body is the origin of perspectives.

Solipsism or Cannibalism

The status of humans in modern thought is essentially ambiguous. On the one hand, humankind is an animal species among other such, and animality is a domain that includes humans; on the other hand, humanity is a moral condition that excludes animals.[22] These two statuses coexist in the problematic and disjunctive notion of "human nature." In other words, our cosmology postulates a physical continuity and a metaphysical discontinuity between humans and animals, the continuity making of humankind an object for the natural sciences and the discontinuity making of humanity an object for the humanities. Spirit or mind is the great differentiator: it raises us above animals and matter in general, it distinguishes cultures, it makes each person unique before his or her fellow beings. The body, in contrast, is the major integrator: it connects us to the rest of the living, united by a universal substrate (DNA, carbon chemistry) that, in turn, links up with the ultimate nature of all material bodies. Conversely, Amerindians postulate metaphysical continuity and physical discontinuity. The metaphysical continuity results in animism; the physical discontinuity (between the beings of the cosmos), in perspectivism. The spirit or soul (here, a reflexive form, not an immaterial inner substance) integrates. Whereas the body (here, a system of intensive affects, not an extended material organism) differentiates.[23]

This cosmological picture, which understands bodies as the great differentiators, at the same time posits their inherent transformability: interspecific metamorphosis is a fact of nature. Not only is metamorphosis the standard etiological process in myth, but it is still very much possible in present-day life (being either desirable or undesirable, inevitable or evitable, according to circumstances). Spirits, the dead, and shamans can assume animal form, beasts turn into other beasts, humans inadvertently turn into animals. No surprises here: our own cosmology presumes a singular distinctiveness of minds but not even for this reason does it hold communication to be impossible (albeit solipsism is a constant problem). Nor does our cosmology discredit the mental/spiritual transformations induced by such processes as education and religious conversion. Indeed, it is because the spiritual is the locus of difference that conversion becomes a necessary idea. Bodily metamorphosis is the Amerindian counterpart to the European theme of spiritual conversion. Shamans are transformers (and likewise, the mythical demiurges who transformed primal humans into animals are themselves shamans). Shamans can see animals in their inner human form because they don animal "clothing" and thus transform themselves into animals.

Solipsism and metamorphosis are related in the same way. Solipsism is the phantom that threatens our cosmology, raising the fear that we will not recognize ourselves in our "own kind" because, given the potentially absolute singularity of minds, our "own kind" are actually not like us. The possibility of metamorphosis expresses the fear—the opposite fear—of no longer being able to differentiate between human and animal, and above all the fear of seeing the human who lurks within the body of the animal that one eats. Our traditional problem in the West is how to connect and universalize: individual substances are given, while relations have to be made. The Amerindian problem is

22 See Tim Ingold, "Becoming Persons: Consciousness and Sociality in Human Evolution," *Cultural Dynamics* 4.3 (1991): 355–78; and Ingold, ed., *Companion Encyclopedia of Anthropology: Humanity, Culture, and Social Life*, s.v. "Humanity and Animality."

23 The counterproof of the singularity of the spirit in modern cosmologies lies in the fact that when we try to universalize it, we are obliged—now that supernature is out of bounds—to identify it with the structure and function of the brain. The spirit can only be universal (natural) if it is (in) the body. It is no accident, I believe, that this movement of inscription of the spirit in the brain-body or in matter in general—AI, Churchland's "eliminative materialism," Dennett-style "functionalism," Sperberian cognitivism, etc.—has been synchronically countered by its opposite, the neophenomenological appeal to the body as the site of subjective singularity. Thus, we have been witnessing two seemingly contradictory projects of "embodying" the spirit: one actually reducing it to the body as traditionally (i.e., biophysically) understood, the other upgrading the body to the traditional (i.e., culturaltheological) status of "spirit."

how to separate and particularize: relations are given, while substances must be defined.

Hence the importance, in Amazonia, of dietary rules linked to the spiritual potency of animals. The past humanity of animals is added to their present-day spirituality, and both are hidden by their visible form. The result is an extended set of food restrictions or precautions that declare inedible animals that were, in myth, originally consubstantial with humans—though some animals can be desubjectified by shamanic means and then consumed.[24] Violation of food restrictions exposes the violator to illness, conceived of as a cannibal counter-predation undertaken by the spirit of the prey (turned predator) in a lethal inversion of perspectives that transforms human into animal. Thus cannibalism is the Amerindian parallel to our own phantom—solipsism. The solipsist is uncertain whether the natural similarity of bodies guarantees a real community of spirit. Whereas the cannibal suspects that the similarity of souls prevails over real differences of body and thus that all animals eaten, despite efforts to desubjectivize them, remain human. To say that these uncertainties or suspicions are phantoms haunting their respective cultures does not mean, of course, that there are not solipsists among us (the more radical relativists, for instance), nor that there are not Amerindian societies that are purposefully and more or less literally cannibalistic.

Exchange as Transformation

The idea of creation ex nihilo is virtually absent from indigenous cosmogonies. Things and beings normally originate as a transformation of something else: animals, as I have noted, are transformations of a primordial, universal humanity. Where we find notions of creation at all—the fashioning of some prior substance into a new type of being—what is stressed is the imperfection of the end product. Amerindian demiurges always fail to deliver the goods. And just as nature is the result not of creation but of transformation, so culture is a product not of invention but of transference (and thus transmission, tradition). In Amerindian mythology, the origin of cultural implements or institutions is canonically explained as a borrowing—a transfer (violent or friendly, by stealing or by learning, as a trophy or as a gift) of prototypes already possessed by animals, spirits, or enemies. The origin and essence of culture is acculturation.

The idea of creation/invention belongs to the paradigm of production: production is a weak version of creation but, at the same time, is its model. Both are actions in—or rather, upon and against—the world. Production is the imposition of mental design on inert, formless matter. The idea of transformation/transfer belongs to the paradigm of exchange: an exchange event is always the transformation of a prior exchange event. There is no absolute beginning, no absolutely initial act of exchange. Every act is a response: that is, a transformation of an anterior token of the same type. *Poiesis*, creation/production/invention, is our archetypal model for action; *praxis*, which originally meant something like transformation/exchange/transfer, suits the Amerindian and other non-modern worlds better.[25] The exchange model of action supposes that the subject's "other" is another subject (not an object);

24 Desubjectification is accomplished by neutralizing the spirit, transubstantiating the meat into plant food, or semantically reducing the animal subject to a species less proximate to humans.

25 From the point of view of a hypothetical Amerindian philosopher, I would say that the Western obsession with production reveals it as the last avatar of the biblico-theological category of creation. Humans were not only created in the likeness of God, they create after His own image: they "produce." Ever since God "died," humans have produced themselves after *their* own image (and that is what culture is about, I suppose).

and subjectification is, of course, what perspectivism is all about.[26] In the creation paradigm, production is causally primary; and exchange, its encompassed consequence. Exchange is a "moment" of production (it "realizes" value) and the means of *re*production. In the transformation paradigm, exchange is the condition for production since, without the proper social relations with non-humans, no production is possible. Production is a type or mode of exchange, and the means of "reexchange" (a word we certainly do not need, for exchange is by definition reexchange). Production creates; exchange changes.

I would venture a further remark on this contrast: the idiom of material production, if applied outside the original domain of *poiesis*, is necessarily metaphorical. When we speak of the production of persons (social reproduction) or the production of "symbolic capital" as if we meant the production of subjects rather than simply of human organisms, we are being no less metaphorical than when we apply the idiom of *praxis* to engagements between humans and nonhumans. To speak of the production of social life makes as much, or as little, sense as to speak of an exchange between humans and animals. Metaphorical Marx is not necessarily better than metaphorical Mauss.

I would speculate, further, that the emphasis on transformation/exchange (over creation/production) is organically connected to the predominance of affinal relations (created by marriage alliance) over consanguineal ones (created by parenthood) in Amerindian mythology. The protagonists of the major Amerindian myths are related agonistically as siblings-in-law, parents-in-law, children-in-law. Our own Old World mythology (Greek, Near Eastern, or Freudian) seems haunted, on the other hand, by parenthood and especially fatherhood. Not to put too fine a point on it: we had to steal fire from a divine father; Amerindians had to steal it from an animal father-in-law. Mythology is a discourse on the given, the innate. Myths address what must be taken for granted, the initial conditions with which humanity must cope and against which humanity must define itself by means of its power of "convention."[27] If such is the case, then in the Amerindian world, affinity and alliance (exchange) rather than parenthood (creation/production) comprise the given—the unconditioned condition.

26 See Strathern, "Writing Societies," 9–10.

27 See Roy Wagner, *The Invention of Culture* (Chicago: University of Chicago Press, 1981).

The Cannibal Cogito

The analogy between shamans and warriors in Amerindian ethnographies has often been observed. Warriors are to the human world what shamans are to the universe at large: conductors or commutators of perspectives. That shamanism is warfare writ large has nothing to do with violence (though shamans often act as warriors in the literal sense). But indigenous warfare belongs to the same cosmological complex as shamanism, insofar as both involve the embodiment by the self of the enemy's point of view.[28] Accordingly, in Amazonia, what is intended in ritual exocannibalism is incorporation of the subjecthood of a hypersubjectified enemy. The intent is not (as it is in hunting game animals) desubjectification.

The subjectification of human enemies is a complex ritual process. Suffice it to say, for our purposes here, that the process supposes a thorough identification of the killer with its victim, just as shamans be-

28 See Viveiros de Castro, *From the Enemy's Point of View: Humanity and Divinity in an Amazonian Society* (Chicago: University of Chicago Press, 1992).

come the animals whose bodies they procure for the rest of their group. Killers derive crucial aspects of their social and metaphysical identities from their victims—names, surplus souls, songs, trophies, ritual perogatives; but in order to do so, a killer must first *become* his enemy. A telling example is the Araweté war song in which a killer repeats words taught him by the spirit of the victim during the ritual seclusion that follows the deed: the killer speaks from the enemy's standpoint, saying "I" to refer to the enemy and "him" to refer to himself.[29] In order to become a full subject—for the killing of an enemy is often a precondition to adult male status—the killer must apprehend the enemy "from the inside" (as a subject). The analogy with the animist perspectival theory already discussed is clear: non-human subjectivities see humans as non-humans (and vice versa). Here, the killer must be able to see himself as the enemy sees him—as, precisely, an enemy—in order to become "himself" or, rather, a "myself." It is relevant in this connection to recall that the archetypal idiom of enmity, in Amazonia, is affinity. Enemies are conceptualized as "ideal" brothers-in-law, uncontaminated by the exchange of sisters (which would "consanguinize" them—make them cognates of one's children—and thus less than pure affines).

29 See Viveiros de Castro, "Le meurtrier et son double chez les Araweté: Un exemple de fusion rituelle," *Systèmes de Pensée en Afrique Noire* 14 (1996): 77–104.

In this idiom of enmity, then, neither party is an object. Enmity of this sort is a reciprocal subjectification: an exchange, a transfer, of points of view. It is a ritual transformation of the self (to use Simon Harrison's term) that belongs entirely to the "exchange" (not the "production") paradigm of action—though the exchange in this case is very extreme. Harrison describes the situation in a Melanesian context that closely resembles the Amazonian: "Just as a gift embodies the identity of its donor, so in Lowland warfare the killer acquires through homicide an aspect of his victim's identity. The killing is represented as either creating or expressing a social relationship, or else as the collapse of a social relation by the merging of two social alters into one."[30] The synthesis of the gift relates subjects who remain objectively separated—they are divided by the relation.[31] The killing of an enemy and its symbolic incorporation by the killer, on the other hand, produces a synthesis in which all distance is suppressed: the relation is created by abolishing one of its terms, which is then introjected by the other. The reciprocal dependence of exchange partners becomes inseparability here, a kind of fusion.

30 Simon Harrison, *The Mask of War: Violence, Ritual, and the Self in Melanesia* (Manchester, U.K.: Manchester University Press, 1993), 130.

31 See Strathern, *Gender of the Gift.*

Ontological predation appears to be the crucial idiom of subjectification in Amazonia. The relative and relational status of predator and prey is fundamental to the inversions in perspective that obtain between humans and non-humans. Again, the Melanesian context, as Harrison describes it, presents striking parallels to that of Amazonia: "Aggression is conceived as very much a communicative act directed against the subjectivity of others, and making war required the reduction of the enemy, not to the status of a non-person or thing but, quite the opposite, to an extreme state of subjectivity."[32] Which means, Harrison concludes, that enmity in these societies "is conceptualised not as a mere objective absence of a social relationship but as a definite social relationship like any other."[33] This remark brings to mind a well-known passage from Lévi-Strauss:

32 Harrison, *Mask of War,* 121.

33 Harrison, *Mask of War,* 128.

"Les observateurs ont été souvent frappés par l'impossibilité, pour les indigènes, de concevoir une relation neutre, ou plus exactement

une absence de relation . . . l'absence de relation familiale ne dé-
finit pas rien, elle définit l'hostilité . . . il n'est pas davantage possi-
ble de se tenir en deçà, ou au delà, du monde des relations.[34]

34 Lévi-Strauss, *Les structures élémentaires de la parenté*, (1949) 2nd ed., (La Haye: Mouton, 1967), 552–53.

"Pour les indigènes," no difference is indifferent and must immediately be invested with positivity. Enmity is a full-blown social relationship. Not, however, a relationship like any other: I would go a bit farther than Harrison and say that the overall schema of difference in Amazonia is cannibalistic predation. At the risk of falling into allegorical excess, I would even venture to say that, in Amazonian cosmologies, the generic attributive proposition is a cannibal proposition. The copula of all synthetic a priori judgments, in a universe articulated by a "logic of sensory qualities," is carnivorous copulation. Let me insist: these predatory relations are fully and immediately social relations. We are dealing here with a mode of subjectification, internal to the monde des relations to which Lévi-Strauss refers. That world has nothing to do with production and objectification, modes of action that suppose a neutral relationship in which an active and exclusively human subject confronts an inert and naturalized object. In the monde de relations, the self is the gift of the other.

Some Conclusions

Our current notions of the social are inevitably polarized by the oppositions I have been evoking: representation/reality, culture/nature, human/nonhuman, mind/body, and the rest. In particular, the social presupposes the non-social (the natural). It is impossible to rethink the social without rethinking the natural, for in our cosmological vulgate, nature (always in the singular) is the encompassing term, and society (often used in the plural) is the term encompassed.

The contrast between our basic naturalism and Amerindian cosmologies can be phrased in the terms of our own polarities. Animism could be defined as an ontology that postulates a social character to relations between humans and non-humans: the space between nature and society is itself social. Naturalism is founded on the inverse axiom: relations between society and nature are themselves natural. Indeed, if in the animic mode the distinction "nature/culture" is internal to the social world, humans and animals being immersed in the same sociocosmic medium (and in this sense, nature is a part of an encompassing sociality), then in naturalist ontology, the distinction "nature/culture" is internal to nature (and in this sense, human society is one natural phenomenon among others). Animism has society, and naturalism has nature, as its unmarked pole: these poles function, respectively and contrastingly, as the universal dimension of each mode. This phrasing of the contrast between animism and naturalism is not only reminiscent of, or analogous to, the famous (some would say notorious) contrast between gift and commodity—I take it to be the same contrast, expressed in more general, non-economic terms.[35] Likewise the distinction that I have made here between production/creation (naturalism) and exchange/transformation (animism).

In our naturalist ontology, the nature/society interface is natural: humans are organisms like all the rest—we are body-objects in eco-

35 "If in a commodity economy things and persons assume the social form of things, then in a gift economy they assume the social form of persons." Chris A. Gregory, *Gifts and Commodities* (London: Academic, 1982), 41; as cited in Strathern, *Gender of the Gift*, 134.

logical interaction with other bodies and forces, all of them ruled by the necessary laws of biology and physics. Productive forces harness, and thereby express, natural forces. Social relations—that is, contractual or instituted relations between subjects—can only exist internal to human society (there is no such thing as "relations of production" linking humans to animals or plants, let alone political relations). But how alien to nature—this is the problem of naturalism—are these social relations? Given the universality of nature, the status of the human and social world is unstable. Thus, Western thought oscillates, historically, between a naturalistic monism (sociobiology and evolutionary psychology being two of its current avatars) and an ontological dualism of nature and culture ("culturalism" and symbolic anthropology being two of its recent expressions).

Still, for all its being the polar opposite of naturalistic monism, the dualism "nature/culture" discloses the ultimate referential character of the notion of nature by revealing itself to be directly descended from the theological opposition between nature and the supernatural. Culture is the modern name for Spirit—I am thinking of the distinction between Naturwissenschaften and Geisteswissenschaften; or at least culture names the compromise between nature and grace. Of animism, I am tempted to say that the instability is of an opposite kind: there, the problem is how to administer the mixture of humanity and animality that constitutes animals, rather than, as is the case among ourselves, how to administer the combination of culture and nature that characterizes humans.

Amerindian perspectivism might be viewed as a radical polytheism (or rather, henotheism) applied to a universe that supports no dualism between created matter and Creator Spirit. I am led to ask whether our own naturalistic monism is not the last avatar of our monotheistic cosmology.[36] Our ontological dualisms derive ultimately from the fundamental difference between Creator and creature. Killing off the Creator, as some say we have done, has left us with a creature whose unity depends on the now-absent God. For God prepared science, and the transcendence of transcendence has created immanence.[37] This birthmark is visible on all modern efforts to dispose of dualisms. Our monistic ontologies are always derived from some prior duality—they consist essentially in the erasure of one of the terms or in the absorption (sometimes "dialectical") of the erased term by the remaining one. A genuine monism, anterior and exterior to the great divide between Creator and creature, seems beyond our reach. A lesson we can usefully draw from Amerindian perspectivism is that the relevant conceptual pair may be monism and pluralism: multiplicity, not mere duality, is the complement of the monism I am contemplating. Virtually all attacks on Cartesian and other dualisms consider that two is already too much—we need just one (one principle, one substance, one reality). As far as Amerindian cosmologies are concerned, it would appear that two is not enough.

My problem with the notion of relativism, or with the opposition between relativism and universalism, pertains to the concept that underwrites such categories and oppositions: the concept of representation. And my problem with representation is the ontological poverty it implies—a poverty characteristic of modern thought. The Cartesian break with medieval scholasticism produced a radical simplification

36 The question is also posed in Latour, *Nous n'avons jamais été modernes*, and in Marshall Sahlins, "The Sadness of Sweetness: The Native Anthropology of Western Cosmology," *Current Anthropology* 37.3 (June 1996), 395–428; to mention only two recent works of anthropology.

37 Amos Funkenstein, *Theology and the Scientific Imagination from the Middle Ages to the Seventeenth Century* (Princeton, NJ: Princeton University Press, 1986).

of European ontology by positing only two principles or substances: unextended thought and extended matter. Modern thought began with that simplification; and its massive conversion of ontological into epistemological questions (questions of representation) is still with us. Every mode of being not assimilable to obdurate matter has had to be swallowed up by mind. The simplification of ontology has led to the enormous complication of epistemology. Once objects or things have been pacified—retreating to the exterior, silent, and uniform world of nature—subjects begin to proliferate and chatter: transcendental egos, legislative understandings, philosophies of language, theories of mind, social representations, the logic of the signifier, webs of signification, discursive practices, politics of knowledge, and, yes, anthropology of course.

Anthropology is a discipline plagued since its inception by epistemological angst. The most Kantian of disciplines, anthropology is practiced as if its paramount task were to explain how it comes to know (to represent) its object—an object also defined as knowledge (or representation). Is it possible to know it? Is it decent to know it? Do we really know it, or do we see it (and ourselves) through a glass, darkly? There is no way out of this maze of mirrors, mire of guilt. Reification or fetishism is our major care and scare: we began by accusing savages of confusing representations with reality; now we accuse ourselves (or, rather, our colleagues).[38]

While philosophy has been obsessed with epistemology, ontology has been annexed by physics. We have left to quantum mechanics the task of making our most boring dualism, "representation/reality," ontologically dubious. (Though physics has questioned that dualism only in the confines of a quantum world inaccessible to intuition and representation.) Supernature has thus given way to sub-nature as our transcendent realm. On the macroscopic side, cognitive psychology has been striving to establish a purely representational ontology, a natural ontology of the human species inscribed in cognition, in our mode of representing things. The representational function is ontologized in the mind but in terms set by a simpleminded ontology of mind versus matter.

The tug of war goes endlessly on: one side reduces reality to representation (culturalism, relativism, textualism), the other reduces representation to reality (cognitivism, sociobiology, evolutionary psychology). Even phenomenology, new or old—and especially the phenomenology invoked these days by anthropologists—may be a surrender to epistemology. Is not "lived world" a euphemism for "known world," "represented world," "world real for a subject"? Real reality is the (still virtual) province of cosmologists, the theorists of quantum gravity and superstring theory. But listen to these custodians of real reality and it becomes obvious—it has been obvious, I might add, for more than seventy-five years—that at the heart of the matter, there is no stuff; only form, only relation.[39] There are "materialist ontologies" on offer as cures for epistemological hypochondria, but I do not know what to do with them. All I know is that we need richer ontologies and that it is high time to put epistemological questions to rest. No effort less strenuous and transformative and dangerously disorienting would make even disagreement with an animist warrior possible.

38 Polarities and other "othering" devices have had bad press lately. The place of the other, however, can never remain vacant for long. As far as contemporary anthropology is concerned, the most popular candidate for the position appears to be anthropology itself. In its formative phase (never completely outgrown), anthropology's main task was to explain how and why the primitive or traditional other was wrong: savages mistook ideal connections for real ones and animistically projected social relations onto nature. In the discipline's classical phase (which lingers on), the other is Western society/culture. Somewhere along the line—with the Greeks? Christianity? capitalism?—the West got everything wrong, positing substances, individuals, separations, and oppositions wherever all other societies/cultures rightly see relations, totalities, connections, and embeddings. Because it is both anthropologically anomalous and ontologically mistaken, it is the West, rather than "primitive" cultures, that requires explanation. In the post-positivist phase of anthropology, first Orientalism, then Occidentalism, is shunned: the West and the Rest are no longer seen as so different from each other. On the one hand, we have never been modern, and, on the other hand, no society has ever been primitive. Then who is wrong, what needs explanation? (Someone must be wrong, something has to be explained.) Our anthropological forebears, who made us believe in tradition and modernity, were wrong—and so the great polarity now is between anthropology and the real practical/ embodied life of everyone, Western or otherwise. In brief: formerly, savages mistook (their) representations for (our) reality; now, we mistake (our) representations for (other peoples') reality. Rumor has it we have even be mistaking (our) representations for (our) reality when we "Occidentalize."

39 See Alfred North Whitehead, *Science and the Modern World* [1925] (New York: Macmillan, 1948).

This thirteen-part television series brings to life the people, setting and continuing story of how Inuit in the Igloolik region of the Canadian Arctic lived on the land in the 1940s. Based on true stories of present-day elders, who still remember their early days growing up just before government and settlement life began, Nunavut recreates a nomadic lifestyle that no longer exists today. Following the lives of five fictional families played by contemporary Inuit, the series takes us through the different seasons of the years 1945 and 1946.

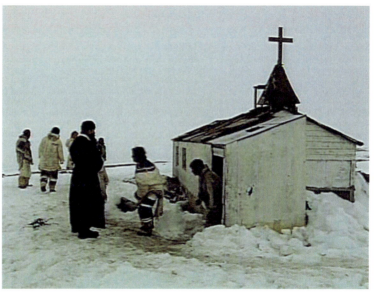

Zacharias Kunuk, Igloolik Isuma Productions
Nunavut–Our land series, 1995
Digital video projection, 6 h 30 min
Courtesy M HKA, Antwerp

Artists' Biographies

Agency

Agency is the generic name of an "agency" that was founded in 1992 by artist Kobe Matthys (born 1970) and is based in Brussels. Agency constitutes an ongoing list of things that witness hesitation in terms of the bifurcation of nature in the classifications "nature" and "culture." This list of things is derived from judicial processes, lawsuits, cases, controversies, affairs and so forth, where this bifurcation was discussed. Agency invokes these things during varying assemblies inside exhibitions. It has recently participated in "Un-Scene," Wiels, Brussels (Belgium); "When things cast no shadow," 5th Berlin Biennial, Berlin (Germany); "Mugatxoan," Fundaçao Serralves, Porto (Portugal); "Projekt Migration," Koelnischer Kunstverein, Koeln (Germany) and CASCO, Utrecht (The Netherlands).

Grigory Alexandrov

Born in Ekaterinburg, 1903, died in Moscow, 1983.

Grigory Alexandrov was a Soviet film director best known for his musical films. While still in his early twenties, Alexandrov met his contemporary Sergei Eisenstein, with whom he directed plays, before collaborating with Eisenstein as co-author, actor and co-director on his first feature films, including *Strike* (1925) and *The Battleship Potemkin* (1925). Alexandrov joined Eisenstein on a trip to Hollywood and Mexico in the 1930s, and put together Eisenstein's unrealized Mexico project *¡Qué viva México!* in 1979. Upon his return to the Soviet Union in 1930 Alexandrov made *Jolly Fellows* (1934) under the order of Joseph Stalin to make a musical comedy for the Soviet people. Throughout the 1930s and 1940s Alexandrov continued to make musical films, alongside more explicit Soviet propaganda films, and was designated People's Artist of the USSR.

Art & Language

Michael Baldwin: born 1945, Chipping Norton, UK, Mel Ramsden: born 1944, Ilkeston, UK, Charles Harrison: born 1942 Chesham, UK, died 2009

The name Art & Language was first adopted in 1968 to refer to a collaborative practice that had developed over the previous two years between Michael Baldwin and Terry Atkinson, in association with David Bainbridge and Harold Hurrell. Over the next several years it stood for a collaborative practice with a growing and changing membership associated with the journal *Art-Language*, first published in May 1969, and subsequently with a second journal *The Fox*, which was published in New York in 1975–6. Joseph Kosuth was invited to act as American editor of *Art-Language* in 1969. In the following year Mel Ramsden and Ian Burn merged their separate collaboration with Art & Language. Charles Harrison became editor of *Art-Language* in 1971. By the mid 1970s some 20 people were associated with the name, divided between England and New York. From 1976, however, the genealogical thread of Art & Language's artistic work was taken solely into the hands of Baldwin and Ramsden, with the theoretical and critical collaboration of Charles Harrison. Art & Language have been included in many international exhibitions including the *documenta* exhibitions of 1972, 1982 and 1997. They have also had several retrospectives in recent years at the Jeu de Paume, Paris (1993), P.S.1 Contemporary Art Center, New York (1999), Musée d'Art Moderne, Lille (2002), Centro de Arte Contemporaneo, Malaga (2004) and EMMA, Finland, 2009.

Adam Avikainen

Born in Shakopee, Minnesota, USA, 1978, lives and works in Japan.

Adam Avikainen started his artistic practice in the 1990s working with film, and referring to the avant-garde and experimental film of the 1960s and 70s. Today, he employs an array of different materials and media, from film, photography and installation to painting, text and sound. Avikainen conceives of his works as outlines or models for stories that are simultaneously told in several different media, thus complementing each other. Photographs, paintings, sketches, and text and sound fragments constitute an investigation of everything that grasps the artist's attention, be it human beings, plants, thoughts or mythical creatures smuggling spices into prisons. Avikainen studied at the University of Minnesota in Minneapolis and at the Finnish Academy of Fine Arts in Helsinki. He was awarded residencies in De Ateliers, Amsterdam, and the Center for Contemporary Art in Kitakyushu, Japan. Some of Avikainen's solo exhibitions include shows at the Monitor Gallery in Rome, the Galerie Martin van Zomeren in Amsterdam and in Kamiyama, Tokushima, Japan. He also participated in group shows in Assab One, Milano, the Stedelijk Museum in Amsterdam and PSWAR in Amsterdam.

Marcel Broodthaers

Born in Brussels, Belgium, in 1924. Died in Cologne, Germany, in 1976.

Marcel Broodthaers was only active in the visual and plastic arts for the last thirteen years of his life, but stands today as one of the most important conceptual artists of post-war Europe. Having failed to make a livelihood out of his first occupation—poetry—at the age of forty Broodthaers famously declared "the idea of creating something insincere finally crossed my mind and I set to work at once". The irony and critical energy of Broodthaers' poetry and prose carried into his visual works which spoke of the political reality around him, from the language rift between the Flemish ad French language communities of Belgium to the pan-European student revolts of the late 1960s. Through his four-year long itinerant endeavour, the *Musée d'Art Moderne. Department des Aigles*, Broodthaers engaged in conscious dialogue with the work of Marcel Duchamp and that of René Magritte, about the legitimising power of the art museum and semiotics.

Paul Chan

Born in Hong Kong in 1973. Lives and works in New York City, USA.

Tony Conrad

Born 1940 in Concord, New Hampshire, USA. Lives and works in Buffalo and Brooklyn, New York, USA.

Tony Conrad is an American artist, filmmaker, musician, composer, teacher and writer. Conrad graduated in mathematics from Harvard University in 1962 and has pursued an academic career alongside his artistic projects since the early 1970s. He was one of the founders of minimalist music and played a pioneering role in New York underground cinema in the 1960s. He was involved in the music ensemble The Theater of Eternal Music and was involved in the development of the band The Velvet Underground. His film *The Flicker* (1966), which consisted of only white and black frames, is a seminal structural film. In the past three decades Conrad's films, videos, music performances, and other works continue to be exhibited internationally. Some of his most radical films of the 1970s, including his *Yellow Movies* as well as his cooked and electrocuted film works, have recently been exhibited in galleries and museums in Europe and the US. Since 2006 he has been exhibiting at Galerie Daniel Buchholz in Cologne and Berlin and at Greene Naftali Gallery in New York. In 2008 Tony Conrad performed at the Tate Modern in London and at the Louvre, and his work was included in the Yokohama Triennale. 2009 he is included in the Venice Biennale.

Didier Demorcy

Born in Verviers, Belgium, 1965, lives and works in Brussels, Belgium.

Didier Demorcy is a Belgian film director, interested in questions relating to the production of knowledge, politics, perception and the animal sciences. Demorcy works with a variety of media, including video, radio, internet sites and installation. He has participated in numerous exhibitions, including "Laboratorium," Antwerpen Open and Roomade, Antwerp, in 1999 and "Making things public" at the ZKM, Karlsruhe, in 2005.

Walt Disney

Born in Chicago, 1901, died in Los Angeles, USA, 1966.

Walter Elias Disney was an American animator and film producer who attained world notoriety through the successes

of The Walt Disney Company. Raised in Missouri and Kansas City, Walt Disney developed an interest in drawing in adolescence and began making a living off cartoons at the age of eighteen. In 1923 he moved to Los Angeles where the first series of short films around the character of Mickey Mouse appeared. A series of technical and formal innovations in animation including the pairing of image and musical score and the development of cartoons into full-length feature films, the use of full Technicolor and the multiplane camera, notably in his films *Steamboat Willy* (1928) and the *Silly Symphonies* (1929–1939), turned the products of The Walt Disney Company into classics. The 1950s saw the development of his parallel involvement in the development of theme parks, which also broke boundaries in entrepreneurial industry and architecture.

Lili Dujourie
Born in 1941 in Roeselare, Belgium, lives and works in Lovendegem, Belgium.

Lili Dujourie is a Belgian artist known for her videos, sculptures and collages which address questions of feminism and engage with the history of art. Dujourie trained classically in both painting and sculpture at the Académie Royale in Brussels in the early 1960s. Both Abstract Expressionism and American minimalist and conceptual art provided strong models for Dujourie in the 1960s as she began to experiment with raw iron sheets and rods in her sculpture. Art history's genres and themes, which have remained an object of the artist's critique until today, informed her influential video series *Hommage à... I-V* (1972). In it, Dujourie commented on the tradition of the female nude painting by presenting moving images of herself naked in her bed in unruly contortion. More recent works include small abstract sculptures of steel wire and clay bearing such titles as *Filomène* (2001) and *Memories of Hands* (2007), suggesting the history of human experience.

Jimmie Durham
Born 1940 in Nevada Country, Arkansas, USA, lives in Rome.

Having been a poet and a political activist, Jimmie Durham is now an artist living in Europe. Of Cherokee origin, in the 1970s Jimmie Durham was involved in militant political activity in relation to the defense of Native Americans at the Central Committee of the American Indian Movement. Durham began as an auto-didact, and then went on to train at the Fine Arts Academy in Geneva from 1969 to 1972. From 1981 to 1983, he was Director of the Foundation for the Community of Artists in New York City and he returned to Europe in 1994. His drawing, sculptural works and installations frequently consist of assembled materials.

Eric Duvivier
Born in Lille, France, 1928, lives in Boulogne, France.

After studying medicine Eric Duvivier, the nephew of the film director Julien Duvivier, became interested in experimental

and medical film. In 1947 he created the Centre International du film médical under the patronage of the doyens of the medical faculty in Paris, with the collaboration of the pharmaceutical industry. The centre now has its seat in Geneva and produces numerous films. Duvivier himself has produced more than 500 short films, of which about a hundred are in the fields of psychopathology and psychiatry. Notable films include *Images of Madness* (1950) and an adaptation of Max Ernst's collage novel *La femme 100 têtes* (1968).

Thomas Alva Edison
Born in Milan, Ohio, USA, 1847, died 1931 in West Orange, New Jersey, USA.

During his lifetime, Thomas Alva Edison, who was trained initially as a telegraph operator, obtained 1,093 patents in the fields of telecommunications, electric power, sound recording, and motion pictures, among others. Among his best known inventions are the electric light bulb, the phonograph, the "kinetoscope" motion picture viewing device, and his improvements upon the telegraph and Alexander Graham Bell's telephone. Less famous, but influential nonetheless was Edison's patenting of the electric chair, which developed out of the war around direct versus alternating current, he waged against his market competitor, the industrialist George Westinghouse. Edison broadened the notion of invention to encompass research, development, and commercialization. In addition to his two major laboratories at Menlo Park and West Orange in New Jersey, more than 300 companies were formed worldwide to manufacture and market Edison's inventions.

Harun Farocki
Born Nový Jičín, Czech Republic, 1944, lives and works in Berlin.

Harun Farocki studied at the German Film and Television Academy in West Berlin from 1966 to 1968 and was the editor of the Munich based journal Filmkritik from 1974 to 1984. Since the mid-sixties he has produced over 100 films and has been making artistic installations since the early nineties. In all his works he tackles the role of images, the means of their making and the mechanisms of their distribution. His films do not present unfolding narratives, but are structured discursively around arguments. In his artistic installations Farocki confronts the new social deployment of images in the digital age. Farocki was visiting professor at the University of California at Berkeley from 1993 to 1999 and has been full professor at the Academy of Fine Arts in Vienna since 2006.

Léon Ferrari
Born 1920 in Buenos Aires, Argentina Lives and works in Buenos Aires, Argentina.

Léon Ferrari began making his first works of art as an auto-didact in the mid-fifties, starting with ceramic sculptures then moving on to wire sculptures, first interwoven, then welded, at the end

of the decade. In 1961 he made his first piece of abstract writing, consisting of unintelligible strings of ink suggestive of calligraphy, a form of drawing which he has turned to again and again. In 1965, his sculpture "Christian Western Civilisation", featuring a crucifix nailed onto an American fighter plane, marked the start of what was to become a life-long critical, and frequently provocative, engagement with atrocity in Christianity and contemporary politics. After a fifteen-year long period of exile in Brazil, during which he experimented with mail, photocopy and video-art, he returned to Argentina in 1991 and has since dedicated himself to political issues more explicitly, both in writing (writing for left-leaning publications and publishing poetry) and visual art.

Simryn Gill
Born in 1959 in Singapore, lives and works in Sydney, Australia and Port Dickson, Malaysia.

Simryn Gill makes objects and photographs. Often the artist works with books or plants as carriers for discourse in relation to her research into the politics of space, the migration of forms, the circulation of knowledge and the inscription of subjectivity. The artist provides rejected, old objects or dried plants with new life, investigating the concepts of presence and absence, space, place and identity and the cultural inhabitation of nature. Photographs form distinctive bodies of work that support the artist's other wanderings in art, extending her ways of engaging with the world. Mostly she is interested in hidden histories of places and things and sometimes relies on performative and playful strategies to disclose new relationships, as is the case in *Vegetation*. The artist critically uses photography, a medium with a long modern and colonial history, as a pragmatic way to fixate time or as documentation. Gill has participated in a range of international art shows and events such as the Berlin Biennial (2001), the Sydney Biennial (2004 and 2008), and *documenta 12* in Kassel. She has also shown solo projects at Berkeley Art Museum, California (2004), Tate Modern, London (2006), the Museum of Contemporary Art, Sydney (2008) and the Museum of Modern Art, Oxford (2009).

Walon Green
Born 1936 in Baltimore, USA.

Walon Green is an American screenwriter, director and producer best-known for his work for television. Green entered the film business in the 1960s as a director and screenwriter and has worked on several successful productions over the course of the years, including *The Wild Bunch* (1969), *Hi-Lo Country* (1998) and *Robocop* (1990) and several episodes of *Law & Order*, *Emergency Room* and *NYPD Blue*. He directed documentary features for National Geographic and the documentary-cum-science-fiction-film *The Hellstrom Chronicle* (1971), which depicts the inevitable victory of insects over the human species in the struggle for survival. *The Secret Life of Plants* (1979) is the film

version of the eponymous book by Peter Tompkins and Christopher Bird. Its thesis that despite lacking a central nervous system and brain, plants are sentient beings is backed up by several experiments in the film. Visually impressive time-lapse sequences—new and exciting to the public at the time—create an analogy between the blossoming of plants and human movements.

Victor Grippo
Born in Buenos Aires, Argentina, 1936, died in Buenos Aires, 2002.

Victor Grippo was one of the first South American artists to engage with conceptual art. The son of Italian immigrants, he studied chemistry at the Universidad Nacional de La Plata and participated in seminars at the Escuela Superior de Bellas Artes in Buenos Aires. In 1971, he became a member of the artist group CAYC, which engaged with South American history of ideas. In the following three decades, Grippo made installations in which he aimed to show that dead materials could be "animated" through the "power of alchemy." The processes behind his works are often humble, and the materials often borrowed from the everyday life of the working man. Energy is garnered from potatoes via zinc and copper electrodes, a table covered with wood shavings bears testimony to the carpenter's labor. Grippo's work was included in several Sao Paulo Biennials (1979, 1991, 1998), at the Venice Biennale (1986) and Documenta 11 (2002) and was granted several major retrospectives.

Brion Gysin
Born 1916 in London, UK, died 1986, Paris, France.

The British-Canadian artist Brion Gysin was prolific, among other things, as a writer, painter, musician and performance artist. In the 1950s he ran a music venue in Tangiers and then experimented with collage in what came to be known as the Beat Hotel in Paris. The "cut-up" technique which Gysin re-discovered (and which his friend William Burroughs famously appropriated from the Surrealists) would characterize both his written poetry and spoken-word performances. With Ian Summerville he conceived the "dreamachine," a simple light device which was intended to offer a drug-less high to the world. Gysin's novels, including The Process (1969) achieved cult following and he is seen as a significant influence for artists of the beat generation and generations thereafter.

Luis Jacob
Born in Lima, Peru, 1970, lives and works in Toronto, Canada.

Luis Jacob is a Canadian artist, curator, writer and educator. The work of Jacob, who graduated from the University of Toronto in 1996, oscillates between photography, video, performance and actions in public space. The question of how alternative forms of social participation can be created stimulates his enquiry, which extends beyond that of artistic pro-

duction in the strict sense, to curatorship and political activism. In particular, he engages with anarchist ideas and is involved in the community education collective, the Anarchist Free University in Toronto. Recent exhibitions include: "Dance with Camera," Institute of Contemporary Art, University of Pennsylvania, Philadelphia (USA); "7 Pictures of Nothing Repeated Four Times, in Gratitude," at Städtisches Museum Abteiberg (Mönchengladbach, Germany); "The Order of Things," Museum van Hedendaagse Kunst Antwerpen (Antwerp, Belgium); "Luis Jacob: Habitat," Kunstverein in Hamburg (Hamburg, Germany); documenta 12 (Kassel, Germany); and "Haunted: Contemporary Photography/Video/Performance," Solomon R. Guggenheim Museum (New York), 2010.

Ken Jacobs
Born in New York City, USA, 1933, lives and works in New York City, USA.

Ken Jacobs is known for his work in experimental film, video and moving image performances. While studying painting under the Abstract Expressionist Hans Hoffmann in the mid-fifties, he discovered filmmaking and became a part of the 1960s New York underground film scene. An early friendship with Jack Smith yielded several collaborations. In 1967, with his wife Florence and others he created The Millennium Film Workshop, a not-for-profit film cooperative. Shortly afterwards, he established the State University of New York's first Department of Cinema with Larry Gottheim. Ken Jacobs has always been interested in using technology to explore the relationship between the eye and the brain, a preoccupation which resulted in the production of Tom Tom the Piper's Son (1969), recognized as a structuralist masterpiece, among other films. With his film, Ontic Antics Starring Laurel and Hardy: Bye, Molly (2005), Jacobs has taken an analog process into the digital realm. The American Museum of the Moving Image in Astoria, Queens, hosted a full retrospective of his work in 1989, The New York Museum of Modern Art held a partial retrospective in 1996, as did The American House in Paris in 1994 and the Arsenal Theater in Berlin in 1986.

Darius James
is a writer and spoken-word performance artist who has authored and published Negrophobia, That's Blaxploitation, Voodoo Stew, and Froggie Chocolates' Christmas Eve. With the filmmaker Oliver Hardt, and Stoked Film, Frankfurt am Main, he is currently working on "The United States of Hoodoo," a documentary which explores how the African-based religion of Voodoo impacted and changed popular culture in America. One day he would like to see Sun Ra named patron saint of the city of Berlin.

Joachim Koester
Born 1962 in Copenhagen, Denmark, lives and works in New York City, USA.

Joachim Koester is a Danish artist whose work can be situated where documentary and fictional representation meet. Koester, who graduated from the Royal

Danish Academy of Art in 1993, works predominantly with the mediums of film and photography, often invoking themes from history and literature. As Koester has stated, he pursues an interest in how stories and history materialize, approaching history and time as material. Koester sometimes provides short texts to function as a "user guide" for the viewer, outlining the "basic rules" of his work. At the same time, Koester insists that he operates in the space between language and non-language, each of his photographs and films offering only the surface elements of a narrative. In Time of the Assassins (2009), for example, the ruins of the eleventh century Persian Alamut castle which the photographs represent are but one element of a layered narrative which, centuries down the line, involves Charles Baudelaire's and Alexandre Dumas' Hashish Club and then the United States Federal Bureau of Narcotics.

Isuma Productions
Zacharias Kunuk: Born in Kapuivik, Canada, in 1957, Norman Cohn: Born in New York, USA, in 1946.

Isuma Productions (Inuktituk for "to think") is Canada's first Inuit production company co-founded by Zacharias Kunuk and Norman Cohn in Igloolik, in the Nunavut federal territory of Canada in 1990. The company aims to preserve Inuit culture, stimulate economic development in the territories of Igloolik and Nunavut, and to promote Inuit culture to audiences worldwide by way of the internet, television and cinema. In 1999, the company produced the supernatural historical thriller "Atanarjuat," which won multiple prizes, including the Caméra d'Or for Best First Feature Film at the 2001 Cannes Film Festival. This success led Isuma Productions to obtain funding from the Canadian cultural agency Telefilm Canada, enabling the company to develop multiple scripts, and to attain further successes. Isuma Productions runs Isumatv, a free video site dedicated to indigenous filmmakers and intended to help Native communities around the world become connected.

Louise Lawler
Born 1947 in New York City, USA, lives and works in New York City, USA.

Louise Lawler is an American artist whose work grapples with questions of feminist enquiry and institutional critique. Lawler graduated from Cornell University in 1969 and has produced work in the role of installation photographer, picture editor and curator since the late 1970s. Her famous sound installation Bird Calls (1971/1981), in which she rattled off the names of prominent male conceptual artists as birdcalls, offered both a satirical comment on the exclusion of women from the art world, and a more general challenge of the convention of authorship. In the Tremaine series (1984–2007), Lawler's dead-pan installation shots of canonical twentieth century artworks as arranged by their collectors, question authorship as she appropriates the works for herself, while naming the secondary actors and posing as mere installation photographer.

Len Lye

Born in Christchurch, New Zealand, 1901, died in Warwick, Rhode Island, USA, 1980.

Len Lye was an avant-garde filmmaker, painter and sculptor who remains best-known for his pioneering role in kinetic art and direct film animation. Born and raised in New Zealand, Lye decided early on in his career that he was going to dedicate himself to the study of motion—inspired partly by the Futurists' engagement with the subject. After brief periods of study at the Wellington Technical Institute and Canterbury Art College, Lye lived in Samoa and Sydney and in 1926 traveled to London as a coal trimmer on board a steamship. In London, Lye quickly integrated into the art scene, exhibiting at the Five and Seven Society in 1927 and at the International Surrealist Exhibition in 1936. In 1929 Lye made *Tusalava*, an animation film inspired by indigenous art of the South Pacific, which marked the beginning of his experimentation with film. Lye relocated to New York in 1944, where chiefly through his sculptures he became a leading figure of the kinetic art movement. In the 1950s alongside his sculpture he started to make animation films without the use of a camera, scratching directly onto celluloid. Lye's innovations in the manual handling of celluloid proved vastly influential to both British documentary and American avant-garde film.

Lutz & Guggisberg

Andres Lutz, born 1968 in Wettingen, Switzerland, Anders Guggisberg, born 1966 in Biel, Switzerland. Both artists live and work in Zurich, Switzerland.

This artistic duo use a variety of media and materials for their interventions. Their multi-faceted work is mainly characterized by a lively sense of humor, surprising confrontations of different sorts and references to everyday life. The sparse and simple series of black and white photographs entitled *Eindrücke aus dem Landesinnern / Impressions from the Interior* depicts curiosities and details and confuses viewers' routine perceptual mechanisms of classification into big and small, model and reality, the uncanny and the archived. The two artists, who have been working together since 1996, have shown solo exhibitions at, among other venues, the Kunsthalle Zürich (2004), Ikon Gallery Birmingham (2008), the Museum Folkwang in Essen (2008) and the Centre Culturel Suisse in Paris (2009). They have participated in many international group shows and are also pursuing musical, literary and comedic projects.

Mark Manders

Born 1968 in Volkel, The Netherlands, lives and works in Arnhem, The Netherlands and Ronse, Belgium.

Since 1986, Mark Manders has been engaged in an ongoing project he refers to as *Self-Portrait as a Building*, mapping his artistic persona through site-specific renegotiations of physical materials in space. Manders' visual language is at once strangely familiar and utterly foreign. Highly contained sculptural constellations

seem to refer to historical objects at an excavation site but also to the imaginary world of an individual, wherein the ordinary gains an unexpected, often mysterious meaning and power. From 2007–2009 the major solo exhibition "The Absence of Mark Manders" was held at Kunstverein Hannover, Germany, Kunsthaus Zürich, Switzerland, Kunsthall Bergen, Norway and S.M.A.K. in Ghent, Belgium. Four 2010/2011 solo exhibitions are planned at Hammer Museum, Los Angeles, USA, at the Aspen Art Museum, Aspen, USA, The Walker Art Center, Minneapolis, USA and at the Carillo Gil Museum of Art, Mexico City, Mexico.

Étienne-Jules Marey

Born in Beaune, France, 1830, died in Paris, France, 1904.

Étienne-Jules Marey was a French physiologist who was a pioneer in photography and lay the foundations for the development of film. Marey was a professor at the Collège de France from 1869 to 1904 and became a member of the French Academy of Sciences in 1878. His research led to his interest in motion in the living species—the internal movement of the muscles and the nerves at first, and then that of bodies in motion. After his encounter with the work of the English photographer Eadweard Muybridge, whom he met in 1881, photography became one of Marey's research tools. In 1882, Marey invented chronophotography, which enabled him to record the movement of light objects on a black background through a single lens and the multiple exposure of a single photographic plate. Marey's work proved influential in a number of technical and scientific fields, including scientific cinema, biomechanics, physical education and aviation.

Chris Marker

Born in Neuilly-Sur-Seine, France, 1921, lives and works in Paris.

Born Christian François Bouche-Villeneuve, Chris Marker is a French filmmaker credited principally for developing the cinematic essay form. In the late 1940s Marker travelled extensively as a journalist and produced documentaries on the countries he visited, seeking to record "life in the process of becoming history." His 1953 film *Les statues meurent aussi*, co-directed with Alain Resnais, was banned in France as an attack on French colonialism. His influential film *La Jetée*, which consisted mainly of photographs pieced together, was one of the first to blur the boundary of documentary and fiction. In recent years, Marker has taken a keen interest in the possibilities of technology, producing the CD ROM work *Immemory* for the Centre Pompidou in 1997 and the Second Life archipelago *Ouvroir* and museum, for the Zurich Design Museum in 2008.

Daria Martin

Born 1973 in San Francisco, USA, lives and works in London.

Daria Martin is a London-based artist who has dedicated herself to film-making

since the 1990s. Martin trained in humanities at Yale University and painting at the University of California, Los Angeles. The mediums of painting and dance exert a strong influence on Martin's mode of filmmaking, which reveals an acute attention to technique, material and timing. The object of Martin's films is often the human body, observed in relation to sculptural objects and robots for example, in a reflection about its position between nature and culture. As Martin has remarked, her works often refer to the process of artmaking, as the films' protagonists engage in processes of experimentation and making. Martin has had solo exhibitions at the SMAK, Ghent (2006) and the Stedelijk Museum, Amsterdam (2007), a touring exhibition in MCA Chicago, New Museum, New York, Hammer Museum, Los Angeles (2009–2010) and a solo exhibition of hers will be held at Portikus, Frankfurt am Main, in 2011.

Maurizio Lazzarato is an Italian sociologist and philosopher. He is co-founder of the magazine multitudes.samizdat.net. His last book, *Expérimentations politiques* appeared in September 2009.

Angela Melitopoulos is a German artist who engages with issues of migration, mobility, and collective memory. Since 1985, Melitopoulos has produced video-essays and other works in time-based media such as photography, video and documentary film. She publishes theoretical essays and is involved in political networks in Europe and Turkey. Melitopoulos studied at the Düsseldorf Academy under Naim June Paik and is currently teaching at the Universität der Künste Berlin. Her work has been exhibited at the *Antoni Tàpies* Foundation in Barcelona, at KW Institute for Contemporary Art Berlin, Manifesta 7, Forum Expanded Berlin, Centre Georges Pompidou Paris and the Whitney Museum in New York, among others. Maurizio Lazzarato and Angela Melitopoulos have been collaborating since 1989 on films, media art projects and publications. In 1990, their documentary *Voyages aux Pays de la Peuge* was awarded the Prix du Patrimoine by the Cinéma du Réel in Paris. In 1991, during the Gulf War, they founded the media activist group Canal Déchainé in Paris. They worked with Félix Guattari and recorded a one-hour interview with him before he died in the summer of 1992. The authors have worked on a number of other video-interviews, notably in their collaboration with the review *Chimères*, founded by Félix Guattari and Gilles Deleuze.

Wesley Meuris

Born in Lier, Belgium, 1977, lives and works in Antwerp, Belgium.

Wesley Meuris was educated in fine arts in Brussels and Antwerp. In the early nineties he started to make architectural models which then quickly gave way to full-scale constructions. Sanitary features were titled according to their function: *Urinal* (2002), *Footbath* (2004), *Swimming Pool* (2004). In 2006 Meuris published *Zoologi-*

cal Classification, an inventory not just of animals, but significantly, of the modes of their exhibition. Meuris subsequently built several enclosures, defined as structures for the display of specific species. Inspired by the German architect Ernst Neufert's classic *Bauentwurflehre* (1936) about rationalization through standardization and prescriptive types in architecture, his recent work reflects both a fascination with and a critical stance towards zoo and museum architecture which he sees as epitomic of "show society" and the "entertainment industry." Meuris' sculptures create both ideal spaces for their imaginary inhabitant and appear as ultra-modern tools of confinement.

Henri Michaux

Born in Namur, Belgium, 1899, died in Paris, France, 1984.

Henri Michaux was a Belgian poet, draughtsman and painter. He settled down in Paris in 1924, following brief experiences as a student of medicine and a sailor. During the 1920s and 1930s he travelled the world and published several travel diaries and poems, including "Ecuador" (1929) and "Un barbare en Asie" (1932). Alert to the Surrealists' objects of enquiry since his encounter with the works of Paul Klee, Max Ernst and de Chirico upon his arrival in Paris, in the 1930s Michaux began to make use of automatic drawing as a language. He made his marks on large sheets of paper in black and blue ink first and then turned to watercolors. In 1948, following the traumatic death of his wife, Michaux's painting became gradually more expressionist and informal. Famously, from 1955 to 1960 he produced drawings under the influence of mescaline, testing the possibilities of representing altered perception. From 1965 onwards Michaux's series of works bore agitated titles such as "Dessins de desegregation," "Arrachements," and "Batailles." In his last years Michaux painted in oil.

Santu Mofokeng

Born in Johannesburg, South Africa, 1956, lives and works in Johannesburg, South Africa.

Santu Mofokeng is one of South Africa's best-known photographers. He began his career as a street photographer in Soweto in the early 1970s. He worked for the newspaper *New Nation* and was a member of the collective Afrapix between 1985 and 1992. In 1991, he started collecting family photographs from black South African families, covering the period 1890–1950, in an attempt to counter-balance a kind of photography prevalent in those same decades, some of which was state-sponsored, which had portrayed black people as perpetually locked in old rural tribal cultures. Mofokeng's resulting archive, entitled *The Black Photo Album/ Look at Me*, exhibited at the 2nd Johannesburg Biennale in 1997, revealed a different reality, one showing the sophistication and richness of black family life. In his ongoing project *Chasing Shadows*, Mofokeng has engaged the relationships between identity, landscape, memory and religion.

Vincent Monnikendam

Born 1936, lives and works in The Hague, The Netherlands.

Tom Nicholson

Born in Melbourne, Australia, 1973, lives and works in Melbourne, Australia.

Tom Nicholson is an Australian artist whose work engages and elaborates archival material, often using public actions and focusing on the relationship between actions and their traces. Nicholson trained in drawing at the Victorian College of the Arts in Melbourne and at the University of Melbourne. His collaborations with the NY-based composer Andrew Byrne have been performed in Venice, Bath and Melbourne. Recent exhibitions include "Still vast reserves" in Rome in 2009, "Since we last spoke about monuments," at Stroom den Haag in 2008, "System Error: War is force that gives us meaning" at Palazzo delle Papesse in Siena in 2007, and the 2006 Biennale of Sydney. Nicholson is a member of the Melbourne-based artist's collective Ocular Lab and a lecturer in the Faculty of Art & Design at Monash University in Melbourne.

Otobong Nkanga

Born in Kano, Nigeria, 1974, lives and works in Paris, France and Antwerp, Belgium.

As a visual artist and performer, Otobong Nkanga works in a broad spectrum of media such as installation, photography, drawing and sculpture. In her pluridisciplinary approach the individual is constantly confronted with his own fragility. Nkanga puts forward personal autobiographical elements which accentuate and expose the frailty and instability of man in his environment. Nkanga studied at the Obafemi Awolowo University in Ile-Ife, Nigeria and then at the Ecole Nationale Supérieure des Beaux-Arts, Paris, France. She participated in the residency program at the Rijksakademie van beeldende kunsten, Amsterdam, The Netherlands. In 2008 she obtained her Masters in the Performing Arts at Dasarts, Amsterdam. She has exhibited widely, recently at AiM Biennale, Marrakech, Morocco (2009), Casa Arica, Gran Canaria, Spain (2009) and at Studio Museum Harlem, New York (2008). Her work featured in the touring exhibitions "Africa remix" (2004–2007) and "Snap judgments: New Positions in African Contemporary Photography" (2006–2008). In the last five years she had participated in the Sharjah, Taipei, Dakar, São Paulo and Havanna biennials.

Reto Pulfer

Born in Bern, Switzerland, 1981, lives and works in Berlin, Germany, Arlesheim, Switzerland, and London, UK.

Reto Pulfer's works, which consist chiefly of sculptures and one-man performances, solicit the participation of the viewer, while they eschew a straightforward reading. The titles of Pulfer's works follow a methodical codification system the rigor of which clashes with the banality of their references and the tongue-in-cheek Swiss-German dialect in which they are often formulated. Certain combinations of letters and numbers point to whether a work contains a zipper, for example, and a patchwork of blue canvas will bear the Swiss-German word for "whale." The basis of Pulfer's performances consists of narratives which come to him like dreams, which he uses as leads by way of mnemonic devices. In a larger sense, Pulfer sees his performances and sculptures as mnemonic devices which communicate things seen and felt. Sensually appealing, yet often unintelligible, Pulfer's art stands as a self-reflexive comment on its own role as mediator between the artist and his interlocutors.

Félix-Louis Regnault

Born in Rennes, France, 1863, died 1938.

Félix Regnault was a physician who applied the proto-cinematic time-lapse technique of chronophotography to study culture-specific human locomotion and is regarded as the trailblazer of ethnographic film. Regnault documented the movements of West African performers at the 1895 Exposition Ethnographique de l'Afrique Occidentale in Paris, motivated by his belief in the necessity of building an evolutionary typology of races. The art historian and filmmaker Fatimah Tobing Rony has written about Regnault as the forerunner of the modern understanding of the human body as an object to be looked at and studied. Significantly, Regnault argued that all museums must collect "moving artifacts" of human behavior for study and exhibition. Film, said Regnault, "preserves forever all human behavior for the needs of our studies." Regnault's efforts fuelled a development in the early twentieth century towards film's status as the ultimate authentic document in anthropology.

Alain Resnais

Born in Vannes, France, 1922, lives and works in Paris.

Alain Resnais is an influential French film director associated with the Left Bank Group. Having trained at the Institut des hautes études cinématographiques, in the late 1940s Resnais began his directing career making short films on works of art and artists, including *Van Gogh* (1948) and *Guernica* (1950). His acclaimed 1955 short film *La nuit et le brouillard* on the German concentration camps thematizes the relationship of memory and history, a preoccupation which underlies many of his subsequent films. Further acclaimed films include *Hiroshima mon amour* (1959) and *L'année dernière à Marienbad* (1961). Resnais' strategy of multiple temporality and fragmented point of view has expanded the understanding of film's ability to blur the boundaries of past and present, imagination and reality.

Hans Richter

Born in Berlin, Germany, 1888, died in Minusio, Switzerland, 1976.

Hans Richter was an influential painter, filmmaker and art theorist best known for his involvement with the Dada movement. Having come into contact with Cubism and Expressionism as an

art student in Berlin and Weimar, in 1916 Richter settled in Zurich, where he first became associated with the Dada group. Back in Berlin in 1921 Richter made the film *Rhythm 21*, which consisted of geometrical shapes in motion and is considered one of the first abstract films. Richter left Germany in 1933 and lived in France and the Netherlands, before emigrating to the United States via Switzerland in 1941. There, Richter became director of the Institute of Film Techniques at the City University in New York, and created several films in collaboration with fellow former Dada artists, including the surrealist feature films *Dreams that Money can buy* (1944–47) and *8x8. A chess Sonata in Eight Movements* (1952–1957). Richter contributed considerably to the theorization of Dada both through his life-long art criticism and through retrospective accounts such as *Dada: Art and Anti-art* (1965). Richter conceived of Dada as a critique of the dominance of rationality, through an attempt to restore the lost balance between reason and unreason.

Józef Robakowski
Born in Poznań, Poland, in 1939. Lives and works in Łódź, Poland.

Józef Robakowski is one of the pioneers of Polish experimental film. He studied fine arts at the Mikolaj Kopernik University in Torun and cinematography at the State Film, Television and Theatre Academy in Lódz, where he taught from 1970 to 1981 until dismissed from his position by the Communist authorities. An interest in Constructivism and the historical avant-gardes has informed Robakowski's oeuvre, as has a structuralist concern with the language and mechanics of film, linking his 1970s work to Western European and American avant-garde film-making of those years. At the same time, some of his films address the history of Poland as well the author's own history. *From My Window*, 1978–1999 (2000) was filmed from Robakowski's apartment for two decades and shows history unfolding itself on the square below. Referring to this dualism in his practice, Robakoswki has stated: "This is where I want my art to be: sometimes very close to reality, and sometimes just the opposite."

Natascha Sadr Haghighian
Born 1966 London, UK, lives and works in Wimbledon.

In place of her biographical note Natascha Sadr Haghighian wishes to draw readers attention to bioswop.net. On www.bioswop.net artists and other cultural practitioners can borrow, exchange and compile CVs for various purposes. The site went online in October 2004 and is a work in progress. The artist is preoccupied with socio-political questions within media culture and the control society. She has worked in the mediums of video, performance, computer animation and sound installation among others. Her work frequently takes the form of exchanges and discussions with others—academics and representatives of the very structures that she critically reflects upon in her work.

Paul Sharits
Born in Denver, Colorado, USA, 1943, died in Buffalo, New York, USA, 1993.

Paul Sharits was an American painter and filmmaker noted for his film-projector installations and regarded as an important figure of the Structural film movement. Sharits studied painting at the University of Denver's School of Art and visual design at Indiana University, founding experimental film groups at both institutions. Sharits' filmic work primarily focused on film installations using film loops, multiple projectors and experimental soundtracks. His 1960s color "flicker" films such as *Ray Gun Virus* (1966), *Piece Mandala/End War* (1966) and *T,O,U,C,H,I,N,G* (1969), the effect of which was compared to the infliction of erotic violence, won him wide acclaim. In the early 1970s, he established a film curriculum at Antioch College in Yellow Springs, Ohio and was director of undergraduate studies at the Center for Media Study at the State University College at Buffalo from 1973 to 1992.

Yutaka Sone
Born 1965 in Shizuoka, Japan, lives and works in Los Angeles, USA.

Yutaka Sone's great love and fascination for nature, combined with a totally open approach to life and art, galvanizes a highly unconventional art. Working in various media, Sone makes installations, performance art, and films. He also paints and, like a traditional sculptor, carves hard marble and crystal. Part of Sone's sculptural work comprises cities and sceneries carved into large blocks of marble and oversized snowflakes carved out of single pieces of natural crystal. Sone's work does not exploit the heritage of one particular culture, drawing rather on the artist's extensive travels and striving to create a singular poetic vocabulary connected to culture at large. Sone, who studied architecture at Tokyo Geijutsu University, has been included in numerous international exhibitions, including the 2003 Venice Biennial where he had a solo exhibit in the Japanese pavilion, and numerous important group exhibitions, including the 2004 Whitney Biennial. The artist was the focus of solo exhibitions at Parasol Unit, Foundation for Contemporary Art, London, England in 2007, and at The Renaissance Society at The University of Chicago, Illinois in 2006.

Jan Švankmajer
Born in Prague, 1934, lives and works in Prague, Czech Republic.

Jan Švankmajer is a Czech film-maker heralded as one of the most original animators of today. He trained at the Institute of Applied Arts from 1950 to 1954 and then at the Prague Academy of Performing Arts' department of puppetry. Soon thereafter he became involved in the Theatre of Masks and the famous Black Theatre, before entering the Laterna Magika Puppet Theatre where he first encountered film. In 1970 he met his wife, the surrealist painter Eva Švankmajerova, and the late Vratislav Effenberger, the leading theoretician of the Czech Surrealist Group, of which Švankmajer became a member. Irrational montage, purposeful fragmentation and a tactile quality are characteristic of Švankmajer's short and feature films, which often feature inanimate objects brought to life through the use of clay-motion. These include, among others, *Alice* (1988), his acclaimed adaptation of the Lewis Carroll classic. Švankmajer's reluctance to participate in mainstream cinema, and the relative obscurity of animated film allowed him to accumulate a body of work denied to other Czech artists who worked in fields with higher visibility.

David Gheron Tretiakoff
Born in 1970, lives and works in Paris (France), Sana'a (Yemen) and Abu Dhabi (UAE).

The film editor, director, author, performer and journalist David Gheron Tretiakoff is concerned with developments in politics and social life such as the effects of the Algerian war, the perception and identity of the Islamic states and the political and psychological consequences of international terrorism. Questioning the idea of an objective documentation and intermediation of such complex topics his work ranges between documentary and experimental film. Tretiakoff has been living and travelling in the Middle East for years and, as is apparent in his work, he is familiar with the everyday life and the fate of individuals in Algeria, Egypt or Yemen beyond the headlines of newspapers and television. Tretiakoff's filmic, stage and photographic work has been presented at several venues, including at the Maison du geste et de l'image, Paris, the Fringe Festival at PS122, New York, and the Centre National de la Danse in 2005, at Le Rex, Paris and galerie MAP, Bruxelles in 2006, at the Musée du Quai Branly and Ateliers Varan, and Kunsthall Bern in 2007.

Rosemarie Trockel
Born in Schwerte, Germany, in 1952. Lives and works in Cologne.

Rosemarie Trockel studied anthropology, sociology, theology and mathematics in Cologne, having been denied admission to Düsseldorf Academy, where she was later appointed as professor. In the early eighties, Trockel began to draw and sculpt personal imaginary and erotic universes and soon turned to wool to make more political statements, notably revolving around issues of feminism. First Trockel appropriated emblematic symbols from politics, the media and the consumer market, repeating them on long stretches of woollen fabric ad infinitum. Subsequently the knitted works became three-dimensional, thriving on the tension between the traditionally domestic medium and the works' affirmative artistic presence. Since the nineties, Trockel has been producing sculptures, works on paper, wall compositions, videos and drawing. Her drawings often show hybrid characters, and oscillate between the auto-biographical and the political.

Artists' Biographies

Authors' Biographies

Anne-Mie Van Kerckhoven
Born in Antwerp, Belgium, 1951, lives and works in Antwerp, Belgium.

Anne-Marie Van Kerckhoven studied graphic design at the Fine Arts Academy in Antwerp and has been prolific in her output of drawings and other works on paper and synthetic material, as well as short videos, since the early eighties. A straightforward feminist tone pervades in all her works, in which the erotic meets machine-fetishism. Interior, if not domestic spaces often serve as settings for her drawings and collages, from which dream-like futuristic enactments between human and machine-like forms unfold. In the nineties, hand-made paper works gave way to computer graphics, while text has always featured alongside images, underlining the message of Van Kerckhoven's proud, sometimes exhibitionist female figures like song-lyrics. Music plays an important role in Van Kerckhoven's creative production in parallel to her visual output, and she and Danny Devos have stood as a key element of the Antwerp experimental music scene under the band names Club Moral (1981–2005) and Bum Collar (since 2005).

Dziga Vertov
Born in Białystok, Congress Poland, 1896, died in Moscow, Soviet Union, 1954.

Dziga Vertov, born Denis Akadievitch Kaufman, was a Russian filmmaker who expounded the theory of the Cine-Eye, which held that film can capture truth more deeply than the human eye. Having trained in music in his birth-town Białystok, while studying medicine in St Petersburg, Vertov began writing poetry and satire and set up a lab for the study of sound in 1916–17. He soon adopted his pseudonym, which translated as "spinning top," and stood for dynamism and speed. In 1917 Vertov began to work as an editor for *Kino-Nedelya*, the Moscow Cinema Committee's weekly film series. Later, Vertov edited the *Kino-Pravda*, in which he portrayed everyday experiences, at first with unelaborated cinematography, and then increasingly making use of such techniques as stop-motion and freeze-frames. His experimentation became more dramatic in *Man with a Movie Camera* (1929), while at the same time Vertov continuously criticized dramatic fiction of any kind. Through camera techniques Vertov aimed to render the honest truth of perception, while at the same time the Cine-Eye, he believed, would make man evolve "from a bumbling citizen through the poetry of the machine to the perfect electric man."

Klaus Weber
Born in Sigmaringen, Germany, in 1967. Lives and works in Berlin.
Klaus Weber graduated from the Hochschule der Künste in Berlin in 1995.

Through the frequent use of nature as medium in what could be characterised as metaphorical set-ups, Weber presents the viewer with examples of quiet subversion with the implicit promise that they could be supplanted onto real political life. The cunning and sometimes humorous use of such elements as sun-light, water and fungi in various installations and actions of Weber's compel the viewer and invite his or her complicity. In 2003 Weber created *Public Fountain LSD Hall*, a fountain exuding homeopathic LSD, for the Frieze Art Fair. For the Cubitt space, in 2004, he invited gallery visitors to help him disseminate microscopic "side-walk mushroom" seeds in the streets of London. Apparent in these and other works of Weber's is an underlying attitude of rebellion against functionalist rationality.

Apichatpong Weerasethakul
Born in Bangkok, Thailand, 1970, lives and works in Bangkok, Thailand.

Apichatpong Weerasethakul grew up in Khon Kaen in the North East of Thailand and obtained a degree in architecture from Khon Kaen University and a Master of Fine Arts in film-making from The School of the Art Institute of Chicago. In the early nineties he began to produce his own films and videos, becoming one of the few Thai film directors to work outside the bounds of the conservative Thai film tradition. Thai television drama, radio, comics and other popular art forms as well as Thai rural life find their way into the content and form of his films. The lines between documentary and fiction are blurred as he chooses to work with non-professional actors and improvised dialogue. His feature film *Syndromes and a Century* (2006) was the first Thai film to be selected for competition at the Venice Film Festival. Through his company Kick the Machine, founded in 1999, Weerasethakul promotes experimental and independent filmmaking.

Agency
See artists' biographies

Irene Albers is Professor of Comparative Literature and Romance Philology at the Free University Berlin. Her main research topics are 1) relations between literature and photography in nineteenth and twentieth century (in Zola, Proust, Claude Simon and others), 2) literary ethnography and literary primitivism in French Surrealism, Michel Leiris and magical realism, 3) the meaning of affective body language in narrative literature, especially in the genre of the novella from Boccaccio to Madame de Lafayette. She has published two books on literature and photography, edited books on French visions of Africa, on Leiris, and the magic of photography. Selected articles: "Mimesis and Alterity: Michel Leiris's Ethnography and Poetics of Spirit Possession," in *French Studies* (July 2008); "Pour une lecture poétique de La Langue secrète des Dogons de Sanga," in *Cahiers Leiris* (November 2007); "'Passion Dogon': Marcel Griaule und Michel Leiris. Die Geheimnisse der Dogon (und der Franzosen)," in *Black Paris*, ed. T. Wendl et al. (2006); and "Alterität und Mimesis: Michel Leiris und Raymond Roussels Impressions d'Afrique," in *Blicke auf Afrika nach 1900* (2002).

Bart De Baere
Bart De Baere is director of the M HKA, a contemporary art museum in Antwerp. Since its merger with the Centre for Visual Culture in 2003, it has also been dealing with visual culture at large.
From 1999 till 2001 De Baere was advisor for cultural heritage and contemporary art to the Flemish Minister of Culture. Before that, he was chair of the Flemish Council for Museums. From 1986 till 2001, he was curator in the Museum of Contemporary Art in Ghent, a period during which he curated numerous exhibitions, such as "This is the show and the show is many things" in 1994.
He was curator of *documenta 9* in Kassel, Germany. As consultant for the city of Johannesburg, he was involved in establishing a biennial in South Africa. He was also a member of the International Advisory Council for the network of Soros Institutes for contemporary art in Eastern Europe. He is founding member of the association Centrum voor Hedendaagse Kunst, Brussels, which established the Kunsthalle Wiels in Brussels. He studied

History of Art and Archaeology at Ghent University. His theoretical texts include "Linking the present to the Now," in Art & Museum Journal, 1994, 6; "The integrated Museum," in Stopping the Process?, NIFKA, Helsinki, 1998, and "Potentiality and public space, archives as a metaphor and example for a political culture," in Interarchive, Verlag der Buchhandlung Walther König, Lüneburg/Köln, 2002

Oksana Bulgakowa is a Moscow-born scholar living in Berlin. She is Professor of Film Studies at the Gutenberg University in Mainz. She has published several books on Russian and German cinema, including Sergei Eisenstein: Three Utopias. Architectural drafts for a Film Theory (1996); FEKS – The Factory of Eccentric Actors (1997); The Adventures of Doctor Mabuse in the Country of Bolsheviks (1995); The White Rectangle: Kazimir Malevich on Film (1997, English edition 2002); Sergei Eisenstein: A Biography (German 1998, English edition 2003); Factory of Gestures, (2005). Bulgakowa has also directed several films, including Stalin: a Mosfilmproduction (1993) and The Different Faces of Sergei Eisenstein (1998). Moreover, she has curated exhibitions and developed multimedia projects, including a website, The Visual Universe of Sergei Eisenstein, Daniel Langlois-Foundation, Montreal (2005) and the DVD Factory of Gestures: On Body Language in Film (Stanford Humanities Lab, 2008). Previously, Bulgakowa has taught at the Humboldt University and the Free University Berlin, at Stanford, Berkeley and the International Film School in Cologne.

Edwin Carels is a teacher and researcher at the KASK/Faculty of Fine Arts of the University College in Ghent, Belgium, where he is currently working on the PhD project "The Living Line: animation and the visual arts, a media-archeological approach." For more than a decade he has been working as a film programmer and curator, with a special interest in the relationship between the visual arts and film, video and photography. He works for the International Film Festival Rotterdam, the Museum of Contemporary Art in Antwerp and as a freelancer. As a writer Carels has published essays on media-archeology, visual arts, film and animation. Recent exhibitions have involved collaborations with Imogen Stidworthy, Dora Garcia, Luc Tuymans, Chris Marker, The Brothers Quay, Robert Breer, Al and Al, Ken Jacobs, among many others. Thematic shows have included "Not Nothing" (Mechelen, 2009), "Aspect Ratio" (Rotterdam, 2009), "Die Lucky Bush" (Antwerp, 2008), "Borderline Behaviour" (Rotterdam, 2007), and "The Projection Project" (Antwerp, 2006).

Didier Demorcy
See artists' biographies

Brigid Doherty is Associate Professor of German and Art & Archaeology at Princeton University, where she is also a member of the core faculty of the Program in Media + Modernity and the Program in European Cultural Studies. She is co-editor of Walter Benjamin. The Work of Art

in the Age of Its Technological Reproducibility and Other Writings on Media (Harvard University Press, 2008). She often writes about Rosemarie Trockel's work; other recent publications include essays on Walter Benjamin (Paragraph, 2009), László Moholy-Nagy (Bauhaus 1918-1933, 2009), and Rainer Maria Rilke (Literarische Medienreflexionen, 2007). In 2008, Doherty created "The Museum of Learning Things" for the Trento section of Manifesta 7, curated by Anselm Franke and Hila Peleg.

Sergei Eisenstein (1898-1948) was a Soviet film and stage director, stage designer, draughtsman and film theorist. His films Strike (1925), Battleship Potemkin (1925), October: Ten days that shook the world (1927), The General Line (1929), revolutionised the language of film. Eisenstein worked in Moscow, Hollywood and Mexico, but was denied the possibility of producing a script in the United States and to edit the material for his Mexican film, ¡Que viva México! (produced by Grigory Alexandrov in 1979). Upon his return to the Soviet Union he realised commissions for the Soviet state: Alexander Nevsky (1938) and Ivan the Terrible (1946/48), which conveyed Eisenstein's thoughts on the filmic counterpoint and colour dramaturgy. Eisenstein's most important pieces of theoretical writing—Montage (1937), Method (1932-1948) and Pathos (1946), as well as his Memoirs (1943-1946) were not published during his lifetime. Neither was his large body of drawings shown, parts of which were first presented in the exhibition Sergei Eisenstein: The Mexican Drawings at Extra City in 2008.

Anselm Franke
Anselm Franke is a curator and writer based in Brussels and Berlin. He is the Artistic Director of Extra City, Center for Contemporary Art in Antwerp, and he was a co-curator of Manifesta 7 in Trentino-Alto Adige, Italy, in 2008 (Trento). Previously, Franke acted as curator of KW Institute for Contemporary Art in Berlin until 2006, where he organized exhibitions such as Territories. Islands, Camps and Other States of Utopia (2003); Image Archives (2001/2002); The Imaginary Number (2005, together with Hila Peleg), and B-Zone – Becoming Europe and Beyond (2006) and he co-developed the project No Matter How Bright the Light, the Crossing Occurs At Night (2006). At Extra City, he has curated exhibitions such as Mimétisme and several solo presentations. He has edited and published various publications and is a contributor to magazines such as Metropolis M, Piktogram, and Cabinet.

Masato Fukushima is a professor of social anthropology and science studies at the University of Tokyo, where he currently organizes the Science Studies Unit (SSU) research team. He is interested in how the human mind works in various cultural and social contexts. He has done extensive field research on religion in Indonesia and Thailand, on medical institutions such as psychiatric wards and an emergency medical center, and most recently on a

research laboratory of chemical biology in Tokyo. He is the author and editor of Constructing the Body Socially (1995), The Anatomy of Tacit Knowledge (2001), Religion and Society of Java (2002), The Praxis of Anthropology in the Age of Science and Technology (2005), The Ecology of Learning (forthcoming, all in Japanese), and articles on the issues of sociology of religion, cognition and learning, as well as social studies of science and technology.

Avery F. Gordon is a Professor of Sociology at the University of California, Santa Barbara and Visiting Faculty at the Centre for Research Architecture, Goldsmiths College, University of London. She is the author of Keeping Good Time: Reflections on Knowledge, Power and People (2004), Ghostly Matters: Haunting and the Sociological Imagination (1997), and the editor of Mapping Multiculturalism and Body Politics (1996), among other works. She is currently writing about captivity, war and other forms of dispossession and how to eliminate them. She is the co-host of "No Alibis," a weekly public affairs radio program on KCSB 91.9 FM Santa Barbara. She divides her living time between France and the United States.

Richard William Hill is a curator, critic and art historian and teaches art history at York University, Toronto. As a curator at the Art Gallery of Ontario he oversaw the museum's first substantial effort to include North American Aboriginal art and ideas in permanent collection galleries. He co-curated, with Jimmie Durham, "The American West" at Compton Verney, UK in 2005. His most recent curatorial project is "The World Upside Down," which originated at the Walter Philips Gallery and traveled to a number of Canadian venues. He is currently writing a book on the problem of agency in the art of Jimmie Durham, the subject of his PhD thesis.

Darius James is a writer and spoken-word performance artist who has authored and published Negrophobia, That's Blaxploitation, Voodoo Stew, and Froggie Chocolates' Christmas Eve. With the filmmaker Oliver Hardt, and Stoked Film, Frankfurt am Main, he is currently working on "The United States of Hoodoo," a documentary which explores how the African-based religion of Voodoo impacted and changed popular culture in America. One day he would like to see Sun Ra named patron saint of the city of Berlin.

Gertrud Koch teaches cinema studies at the Free University in Berlin. She was visiting professor and scholar at Columbia University, NYU, Washington University, at UIC, UPenn, the Getty Research Center in Los Angeles and the Sorbonne III in Paris and many others. Her many books and articles deal with aesthetic theory, feminist film theory as well as with questions of historical representation. Books on Herbert Marcuse and Siegfried Kracauer, the latter came out in English 2005 Princeton UP, on Feminist Film Theory and on the representation of Jewish history. Editor of volumes on Holocaust representation,

perception and interaction, art and film theory. Koch is co-editor and board member of numerous German and international journals like *Babylon*, *Frauen und Film*, *October*, *Constellations*, *Philosophy&Social Criticism*. She is currently working on a book about the aesthetics of illusion in film and the other arts.

Joachim Koester
See artists' biographies

Bruno Latour
is a philosopher and anthropologist working in Paris. His many books on science and culture include *We Have Never Been Modern*, *Pandora's Box: Essays in the Reality of Science Studies*, *Science in Action*, *The Pasteurization of France*, and *Laboratory Life*. He was curator of the ZKM exhibit *ICONOCLASH* and co-edited the accompanying MIT Press book *ICONOCLASH: Beyond the Image Wars in Science, Religion, and Art.*

Vivian Liska is professor of German Literature and Director of the Institute of Jewish Studies at the University of Antwerp, Belgium. Her research focuses on German and comparative modernist literature and literary and cultural theory. Her recent publications include, as editor or co-editor, *Modernism* in the ICLA series "History of the European Literatures" (2007), *The Power of the Sirens* (2007), *Contemporary Jewish Writing in Europe* (2007), *Walter Benjamin und das Wiener Judentum* (2009), and *What does the Veil Know?* (with Eva Meyer) (2009), and, as author, *Giorgio Agambens leerer Messianismus* (2008) and *When Kafka says We. Uncommon Communities in German-Jewish Literature* (2009.) She has written numerous articles about Nietzsche, Blanchot, Adorno, Sarah Kofman, Uwe Johnson, Paul Celan, Hannah Arendt and others. She is currently working on a book derived from the conference *Walter Benjamins Treue – True to Walter Benjamin*, and on a project about Kafka and Philosophy.

Angela Melitopoulos & Maurizio Lazzarato
See artists' biographies

Henri Michaux
See artists' biographies

Santu Mofokeng
See artists' biographies

Philippe Pirotte has been artistic and managing director of the Kunsthalle Bern, Switzerland since 2005. He has worked as a curator and art critic since 1996, and is founding director (1999) of the contemporary art centre objectif_exhibitions in Antwerp, Belgium. He is also senior Advisor at the Rijksakademie, Amsterdam, the Netherlands. Recent exhibitions at Kunsthalle Bern have included group shows like "The Conspiracy," "Voids" and "Slow Movement" (all 2009), the retrospective exhibition "Allan Kaprow – Art as Life" (2007) and solo exhibitions with Owen Land, Deimantas Narkevicius, Rita McBride, Stefan

Brüggemann, Marine Hugonnier, Jutta Koether, Pavel Büchler, Anne-Mie Van Kerckhoven, Corey McCorkle, and Carla Arocha among others. He also curated "Camuflaje" (2005) at the Fundación Celarg in Caracas, Venezuela and "IDYL - As to answer that Picture for the Middelheim Museum in Antwerp", Belgium (2005), "Involved" at the H-Space in Shanghai, China (2008), and "United Technologies" at Lismore Castle Arts in Ireland (2009). His writing on contemporary art and artists was included in *Afterall*, *Nka Journal of contemporary African Art*, *Temaceleste*, and in various books and catalogues.

Florian Schneider is a filmmaker, writer, and curator. His work may be characterized by an interest in the border-crossings between mainstream and independent media, art and activism, theory and open source technology.As a filmmaker he directed award-winning documentaries and designed and realized two theme-evenings for the German-French TV station arte on the topics of migration and activism. He is one of the initiators of the KEIN MENSCH IST ILLEGAL (no one is illegal) campaign at documentaX and subsequent projects such as the "noborder network" and the internet platform KEIN.ORG. He initiated and co-organized the new media festivals MAKEWORLD (2001), NEURO-networking europe (2004), "Borderline Academy" (2005), "SUMMIT – non a-ligned initiatives in education culture" and the multimedia performance project "DICTIONARY OF WAR" (2006-now). He has lectured at universities, museums, and conferences worldwide. Since 2006 he teaches theory at the art academy Trondheim. Since autumn 2008 he is advising researcher at Jan van Eyck Academie Maastricht. At the moment he is working on his PHD-project on "Imaginary property" at the Institute for Research Architecture in Goldsmiths College, London. Most recently he has participated with performances and video installations at the biennales in Gwangju, Taipei, Brussels, as well as manifesta 7 (Trento and Bolzano) and Spasport (Banja Luka). In 2009 he curated "Of a people who are missing - On films by Danièle Huillet and Jean-Marie Straub" in Extra City Kunsthal Antwerpen (in collaboration with Annett Busch).

Erhard Schüttpelz completed studies and research periods at universities in Hanover, Exeter, Bonn, Oxford, Cologne, New York, Constance and Vienna. He has been Professor of Media Theory at the University of Siegen since 2005. His current research focuses on the history of science, media anthropology and world literature. His latest books include *Die Moderne im Spiegel des Primitiven. Weltliteratur und Ethnologie 1870-1960* (2005), *Schlangenritual. Der Transfer der Wissensformen vom Tsu'ti'kive der Hopi bis zu Aby Warburgs Kreuzlinger Vortrag*, edited with Cora Bender und Thomas Hensel (2007), *Bruno Latours Kollektive*, edited with Georg Kneer und Marcus Schroer (2008), *Trancemedien und Neue Medien um 1900*, edited with Marcus Hahn (2009) and *Akteur-Me-*

dien-Theorie, edited with Tristan Thielmann (2010).

Michael Taussig was trained as a medical doctor in Sydney and now teaches in the Anthropology Department of Columbia University, NYC. He has lived on and off in Colombia and written several books of ethnography, theory, and fictocriticism, including *Mimesis and Alterity* (1993); *Defacement* (1999); *Shamanism, Colonialism and the Wild Man* (1986); *Law in a Lawless Land* (2003); *The Nervous System* (1992); *My Cocaine Museum* (2004); and *Walter Benjamin's Grave* (2006).

Eduardo Viveiros de Castro teaches anthropology at the Museu Nacional of Rio de Janeiro. He worked in different parts of Amazonia as a field anthropologist; his major study was conducted among the Araweté (1981-1983), a then recently contacted Tupian-speaking group of Eastern Amazonia. Viveiros de Castro was Simon Bolívar Professor of Latin American Studies in the University of Cambridge (1997-98) and Directeur de Recherche at the CNRS in Paris (1999-2001). His publications include *From the Enemy's Point of View: Humanity and Divinity in an Amazonian Society* (1992, University of Chicago Press), *A Inconstância da Alma Selvagem e Outros Ensaios de Antropologia* (2002, CosacNaify [São Paulo]) and *Métaphysiques cannibales* (2009, P.U.F., Paris).

Martin Zillinger works as a researcher at the research center Media Upheavals, University of Siegen, Germany. He has conducted field work in both Morocco and Belgium on spirit possession, migration and small media. His publication include (with Thomas Hauschild und Sina Kottmann) "Syncretism in the Mediterranean: Universalism, Cultural Relativism and the Issue of the Mediterranean as a Culture Area" in *History and Anthropology*, vol. 18, issue 3 (September 2007). His dissertation was awarded the Frobenius research prize 2009 and will be published as *Die Trance. Das Blut. Die Kamera. Trance Medien und Neue Medien im marokkanischen Sufismus* by Transcript, Bielefeld, in 2010.

Acknowledgements

Extra City

Director: Anselm Franke
Managing director: Katrien Reist
Team: Lotte De Voeght, Chiara Marchini Camia, Kristin Rogghe, Caroline Van Eccelpoel
Installation: Glenn Geerinck, Cas Goevaerts, Gary Leddington, Vincent Surmont, Jeroen Van Esbroeck, Christoph Van Damme and team, Klaas Verhulst
Intern: Oona Maes
Exhibition architecture: Kris Kimpe

M HKA

Director: Bart De Baere
Administrative director: Eric Krols
Team: Jürgen Addiers, Raoul Amelinckx, Katrien Batens, Maya Beyns, Carine Bocklandt, Bram Bohez, Els Brans, Marcel Casneuf, Cecilia Casariego, Tom Ceelen, Ann Ceulemans, Celina Claeys, Christine Clinckx, Jerina Colyn, Rita Compère, Leen De Backer, Han De Swert, Jan De Vree, Martine Delzenne, Liliane Dewachter, Gustaaf Dierickx, Sophie Gregoir, Ria Hermans, Sabine Herrygers, Joris Kestens, Nico Koppe, Renilde Krols, Christine Lambrechts, Hughe Lanoote, Ben Lecok, Viviane Liekens, Maja Lozic, Alexandra Pauwels, Ghislaine Peeters, Joost Peeters, Anne-Marie Poels, Aïcha Rafik, Ruth Renders, Emmy Rijstenbil, Dieter Roelstraete, Iris Roevens, Gustaaf Rombouts, Marnix Rummens, Peggy Saey, Rita Scheppers, Katleen Schueremans, Vincent Stroep, Georges Uittenhout, Jos Van Den Bergh, Chris Van den Broeck, Ria Van den Broeck, Frank Van der Kinderen, Carine Van Dyck, Willy Van Gils, Lut Van Nooten, Roel Van Nunen, Gerda Van Paemele, Lutgarde Van Renthergem, Annemie Van Roey, Kris Van Treeck, Sofie Vermeiren, Nine Verschueren, Jan Vertommen, Grant Watson, Thomas Weynants, Magda Weyns, Kathleen Weyts, Hans Willemse, Abdel Ziani
And interns: Kaat De Meulder, Danae Kaplanidi, Laura Potenti

Kunsthalle Bern

Director: Philippe Pirotte
Team: Andrea Graf, Pascale Keller, Karin Minger, Elfriede Schalit, Tobias Schalit, Werner Schmied, Ines Schweinlin, Jana Steger, Julia Strebelow, Julian Reidy
Installation: Werner Schmied, David Brühlmann, René Frick, Aleardo Schüpbach, Working Tiger

The lenders

Animate Projects Limited, Anna Schwartz Gallery, Athanor - Film Production Company, Llc., Balice Hertling Paris, Birch Libralato Toronto, Cinémathèque française, Collectie Frans Oomen, Collectie Inge en Philip van den Hurk, Collection Galerie de France Paris, David Zwirner Gallery, Estate Marcel Broodthaers, Fundacja Lokal Sztuki, Galerie Daniel Buchholz, Galerie Nelson-Freeman Paris, Greene Naftali Gallery New York, Inhotim Collection Minas Gerais Brazil, Jan Mot Brussels, Johann König Berlin, Lisson Gallery London, M HKA, Maureen Paley London, Musée des Arts Contemporains de la Communauté française de Belgique, Grand-Hornu / MAC's, NPS and Beeld en Geluid, Sprüth Magers Berlin London, Ngā Kaitiaki O Ngā Taonga Whitiāhua, KIT Tropenmuseum Amsterdam, Zeno X Gallery Antwerp

Special thanks to:

Irene Albers, Oksana Bulgakowa, Katie Bethume-Leamen, Francoise Bonnefoy, Marie-Puck Broodthaers, Annett Busch, Kathleen S. Curry, Corinne Diserens, Jimmie Durham, Matthew Evans, Barbara Fischer, Peter Friedl, Maria Gilissen, Graham Harvey, Nanna Heidenreich, Luc de Heusch, Dietmar Hochmuth, Tom Holert, Judith Hopf, Hannah Hurtzig, Ana Janevski, Thomas Keenan, Michael Kohn, Franck Leibovici, Matthias Lilienthal, Magdalena Magiera, Hila Peleg, Micheline Phankim, Irit Rogoff, Suely Rolnik, Frank Rynne, Natascha Sadr Haghighian, Ines Schaber, Bernd Scherer, Friederike Schuler, Stefanie Schulte Strathaus, Eyal Sivan, Valerie Smith, Isabelle Stengers, Micheline Swajcer, Catherine Tieck, Javier Tellez, Dieter Thomä, Fatimah Toby Rony, Rute Ventura, Anton Vidokle, Eyal Weizman. Catherine de Zegher, Evelyne Zehr and the Members of the Roundtable at the Center for Research Architecture, Goldsmiths College, London, the Members of the Board of Directors of Extra City–Kunsthal Antwerp, the M HKA and the Kunsthalle Bern.

as well as:

De Pury & Luxembourg Art Zurich, Lumen Travo Gallery Amsterdam, Sprueth Magers Berlin London, Yüksel Arslan, Santral Istanbul, Deutsches Filminstitut - DIF, Frankfurt am Main, Duke University, Press,Gallimard, SABAM.

Colophon

Editor: Anselm Franke
Managing editor: Chiara Marchini Camia

Copy-editor: Erik Empson
Proof-reader: Matthew Evans
Translators and transcribers: Brían
Hanrahan, Mary-Alice Farina,
Genial Translations, Veronika Köver,
John Tittensor

Design: NODE Berlin Oslo
Printing and binding: Die Keure, Bruges

© 2010 Extra City, M HKA,
Kunsthalle Bern, Sternberg Press
© 2010 The Authors
All rights reserved, including the right
of reproduction in whole or in part in
any form

ISBN: 978-1-933128-95-5

Sternberg Press
Caroline Schneider, Tatjana Günthner
Karl-Marx-Allee 78
D–10243 Berlin
1182 Broadway #1602
New York, NY 10001
www.sternberg-press.com

Animism (Volume I) is published on the
occasion of the exhibition Animism, at
Extra City – Kunsthal Antwerpen and
the Museum of Contemporary Art, Ant-
werp (M HKA), January 22–May 2 and
Kunsthalle Bern, May 15–July 18, 2010.
Animism (Volume II) will be published in
conjunction with the exhibition in Vienna
(2011) and Berlin (2012).

Animism is a collaboration between Extra
City – Kunsthal Antwerpen, the Museum
of Contemporary Art, Antwerp (M HKA),
the Kunsthalle Bern, the Generali Founda-
tion, Vienna, the House of World Cultures
in Berlin, and the Free University Berlin.

Concept: Anselm Franke

Curators:
Antwerp: Anselm Franke, Edwin Carels,
Bart De Baere
Bern: Anselm Franke, Philippe Pirotte
Vienna: Anselm Franke, Sabine Folie
Berlin: Anselm Franke in cooperation
with the Animism-research group at
the Free University in Berlin.

The project is supported by:
Pro Helvetia, Arts Victoria and
KASK/Hogeschool Gent

Extra City – Kunsthal Antwerpen
Tulpstraat 79
BE–2060 Antwerp
Belgium
www.extracity.org

Extra City is supported by the Flemish
Ministry of Culture, Youth and Sport,
the City of Antwerp, <H>ART, Klara,
Bureau Bouwtechniek, Mampaey, Jaga,
Zumtobel, Akzo Nobel Decorative Coat-
ings – Levis, and the King Baudouin
Foundation.

Museum of Contemporary Art, Antwerp
(M HKA)
Leuvenstraat 32
BE–2000 Antwerp
www.muhka.be

M HKA is an initiative of the Flemish
Community and is supported by the
Province of Antwerp, the City of Antwerp,
the National Lottery of Belgium, Akzo
Nobel Decorative Coatings – Levis,
Ethias and Klara.

Kunsthalle Bern
Helvetiaplatz 1
CH-3005 Bern
www.kunsthalle-bern.ch

Kunsthalle Bern is supported by
the Kultur Stadt Bern, the Education
Programme is supported by the
Burgergemeinde Bern.

Extra City **M HKA** Kunsthalle Bern